THE SCIENCE
OF
PHOTOGRAPHY

THE SCIENCE OF PHOTOGRAPHY

H. BAINES

D.SC. (LOND.), F.R.I.C., F.I.B.P., HON. F.R.P.S.

Revised and edited by E. S. Bomback

FOUNTAIN PRESS

13-35 Bridge Street, Hemel Hempstead,
Hertfordshire, England

HALSTED PRESS

A Division of JOHN WILEY & SONS, Inc.,
605 Third Avenue, New York, N.Y. 10016

Fountain Press,
Model and Allied Publications Limited,
Book Division,
Station Road, Kings Langley,
Hertfordshire, England

Published in the USA by Halsted Press,
a division of John Wiley and Sons, Inc., New York

First Published 1958
Second Impression 1960

Second Edition 1967

Third Edition 1970

Second Impression 1971
Third Impression 1974

ISBN 0 85242 210 5

L.C. No. 73-19208

Printed and Made in Great Britain by
Oxley Press Limited, Long Eaton and Edinburgh.

EDITOR'S NOTE

A T the time of his death in 1963, Dr. Baines had already started on a new edition of 'The Science of Photography'. From the notes which he left, it was obvious that he planned considerable revisions in those sections which dealt with the practice of photography. It is therefore chiefly along these lines that I have amplified the book.

The introduction of new material, without expanding the physical size of the book, has necessitated some condensation of existing material as well as some rearrangement of chapters. New material includes chapters on Light Sources in Photography, Photographic Exposure, Printing the Negative, Cinematography and Stereophotography. The chapters on the Camera Lens and the Camera have been expanded to include modern equipment.

The task of revision has been undertaken with diffidence since Dr. Baines was an acknowledged master of the art of explaining clearly and simply subjects of a scientific and technical nature. I am indebted to Mr. E. W. H. Selwyn of the Kodak Research Laboratories for much helpful advice and to many other members of Kodak Ltd for helping me to obtain suitable illustrations.

E. S. B.

CONTENTS

Speed—Fractional gradient criterion-B.S. and A.S.A. speed—Tone reproduction—Relation between tone values of the original view and those of the print.

CHAPTER 14

Colour sensitivity of photographic materials—Extension of sensitivity into the ultra-violet—Spectrograms—Use of light filters—General properties of light filters—Correction filters—Haze filter—Over-correction—Contrast filters—Neutral density filters—Polarizing filters—Safelight screens.

CHAPTER 15

The Bunsen-Roscoe law—Reciprocity failure—Experimental determination of reciprocity failure—Cause of reciprocity failure—Latensification—Intermittency effect—The Clayden effect—The Herschel effect—Solarisation.

CHAPTER 16

Constant brightness level—Speed of sensitive materials—Method of assessing exposure—Photo-electric exposure meters—Methods of using exposure meters—Exposure value system—Guide number system for flash—Subject movement.

CHAPTER 17

Oxidation of metallic silver—Potassium permanganate—Potassium dichromate—Ferric chloride and potassium ferricyanide—Iodine—Potassium persulphate—Photographic reduction—Intensification—Spots and stains—Other defects in negatives.

CHAPTER 18

Graininess—Measurement of graininess—Graininess density relation—Granularity—Granularity-Density relation—Print graininess—How to obtain minimum print graininess—Fine grain development—Low activity developers—Solvent developers—Other fine grain developers—Use of fine grain developers—Turbidity and image sharpness—Resolving power.

CHAPTER 19

Characteristics of printing materials—The base—Contrast grades—Maximum black and tone range—Contact printing—Optical printing—Enlarging technique—Processing.

Chapter 1

HOW PHOTOGRAPHY BEGAN

O F THE FIVE SENSES man possesses, perhaps that which gives him the most satisfaction and pleasure is sight. Certainly some of the early records of his existence on this planet consist of his attempts to perpetuate in the form of paintings on flat (two dimensional) surfaces the three-dimensional scenes around him. Although this method of representation seems so commonplace, we should not under-estimate the genius of the first inventor. We can imagine his primitive companions examining the results—to some they may have seemed no more than marks on stone, while others would stare until by some quirk of the brain the marks suddenly became transformed into deer, bison, and mammoth. Many such paintings must have been obliterated, but some of those painted on cave walls have survived some 15,000 years or more. Methods of representing three-dimensional subjects in a two-dimensional plane, by painting on a flat surface, improved, until in the seventeenth and eighteenth centuries artists were so skilful that further improvement in realistic rendering may well have seemed impossible. Perhaps for this reason the last two or three centuries have seen a movement in the direction of non-realistic representation in an attempt to capture and portray the essential feeling of a particular subject. The efforts themselves have certainly been successful in evoking a variety of emotions—intended and otherwise.

For at least four centuries, however, we have known an alternative method of representing a view on a flat surface, which gives results truer to the original view in form, colour and range of tones than any painting can possibly give. This is achieved by throwing an optical image of a view on to a flat surface by means of a lens. The apparatus used for this purpose is called a *camera obscura,* and consists of a box or room with a lens at one end and a flat surface at the other. If the *camera obscura* is so small that the image must be viewed from outside, a translucent screen such as ground glass is used, but if the apparatus is large enough to enter, the image is thrown on to a white reflecting surface for viewing (Fig. 1). Such an image, even though

inverted, takes on a kind of magical reality and it is no wonder that artists despaired when they saw such perfection of drawing, detail and colour. It is not surprising that many of them used it as an aid to drawing or that some thought in terms of fixing this transient image to make a permanent, transportable picture.

It is doubtless to such emotions that photography owes its existence, since the first two successful processes of photography were invented, almost simultaneously, by men familiar with the *camera obscura*: Daguerre, a French painter of *dioramas*; and Fox Talbot, a Wiltshire squire, who had been using the *camera lucida,* which, like the *camera obscura*, is an aid to sketching.

Photography consists essentially in producing an image of a subject by physical means, and a permanent facsimile of that image by chemical means. The image may be the shadow of an object cast by X-rays or gamma rays or the trace of a moving beam of cathode rays, but in more normal photographic procedure, it is the optical image produced by means of a glass lens in the camera, an apparatus similar to a *camera obscura*.

The Camera

Perhaps the first reference to the *camera obscura* with lens is that of Cardano in the sixteenth century, but similar devices may have existed much earlier. Glass has been known from very ancient times —as early as 1400 B.C. glass manufacture in Egypt had reached a stage comparable with hand-blowing methods of the present day. A lens was discovered in the ruins of Nineveh, and the use for optical purposes of glass globes filled with water was common practice for some three thousand years. The science of optics, too, is an ancient one—the formation of images by pinholes (p. 27) was mentioned by Aristotle about 350 B.C., and some fifty years later Euclid published a treatise on optics which contains the first known construction of an image by geometric means. Some five hundred years later, in the second century A.D., Ptolemy published tables showing the amount of bending of light at an air-water interface, but he failed to deduce the law governing such refraction. Although glass lenses may have been used for image formation and as an aid to vision for many centuries previously, it was not until about the end of the sixteenth century that they were combined to produce scientific intruments such as the telescope and microscope. The laws governing combinations of lenses were discovered by Kepler about the end of this century.

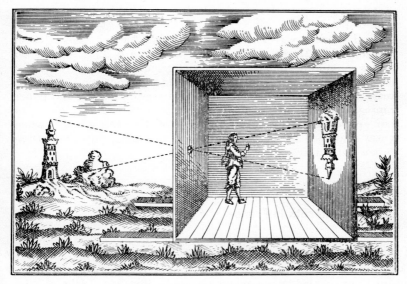

*Fig.*1. Early drawing of *Camera Obscura*.

Thus, knowledge of practical optics four hundred years ago, and perhaps much earlier, was adequate for the construction of a crude camera similar in essentials and principle to the modern photographic camera. Nearly three hundred years elapsed, however, before serious attempts were made to render the optical image permanent.

The Evolution of the Photographic Process

To make a reproduction of an optical image by utilising the light energy, one must employ a substance which undergoes some chemical or physical change when subjected to light action. Now it was early recognised that salts of the metal silver are outstanding in their sensitivity to light, and that three of these salts—silver chloride, silver bromide and silver iodide—are the most suitable for photographic purposes. Their nature and properties and the change they undergo on exposure to light will be described in later chapters, but in order to understand the evolution of photography, it should be known that they are insoluble in water, and are formed when silver nitrate (a soluble silver salt) reacts with soluble chlorides, bromides

or iodides such as sodium chloride (common salt), potassium bromide or potassium iodide.

Silver nitrate was known to Albertus Magnus before 1280. Schultze in 1727 recorded shadow images of opaque stencils on bottles containing chalk and silver nitrate, and Thomas Wedgwood and Sir Humphry Davy in 1802 described the production of shadow images of such objects as feathers and leaves on leather and paper impregnated with silver salts. However, no method was known of fixing the image to prevent the picture from darkening further when it was examined in the light. Attempts to make prints in a *camera obscura* were unsuccessful.

Early Experiments in France

Meanwhile in France experiments on very different lines were proceeding, with greater success. Nicephore Niepce in 1826 had succeeded in obtaining a record of a view by exposing in a camera asphaltum coated on to metal or stone (Fig. 2). Light renders asphaltum less soluble in aromatic oils, and after dissolving the unexposed portions of the layer, the plate could be inked up and used for printing. The process was not very practicable, and Niepce spent much time trying to improve it, both alone and after 1829 in partnership with Daguerre. When Niepce died in 1833, Daguerre reverted to the use of silver salts as the light-sensitive medium. In 1839 came the announcement of the Daguerreotype process whereby a silvered copper plate was exposed to the action of iodine vapour to form a surface layer of light-sensitive silver iodide. After an exposure in the camera insufficient to produce a visible effect, the image could be revealed by treating it with mercury vapour. The mercury was deposited preferentially on the exposed portions to give a positive image. The Daguerreotype process became very popular, but in competition with the wet collodion process invented in 1851 it withered and died in less than two decades.

The Beginnings of the Modern Photographic Process

It is to Henry Fox Talbot that the title inventor of modern photography is given. Also working with a *camera obscura* and a 'negative'

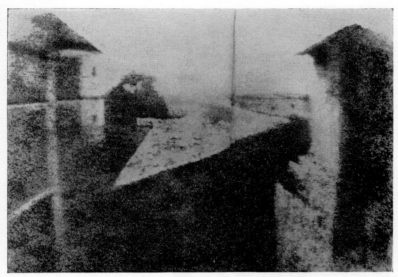

Fig. 2. Niepce's first photograph (1826). From the shadow positions, it is deduced that the plate was exposed for the whole of a sunny day.

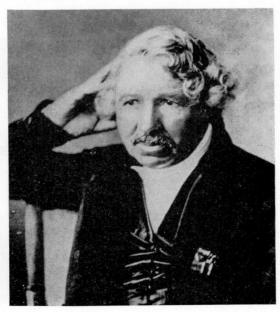

Fig. 3. Louis Jacques Mande Daguerre.

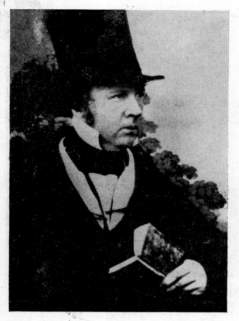

Fig. 4. William Henry
 Fox Talbot.

Fig. 5. Talbot's first
photograph (1835).

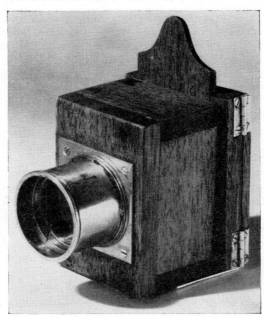

Fig. 6. One of Talbot's first cameras shown roughly life-size. They were nick-named 'Mousetraps'.

material consisting of paper coated with silver salts, he produced in 1835 a number of views of Lacock Abbey.

Unaware of Davy's work, his early experiments consisted in soaking paper in common salt solution and then in silver nitrate solution, thus forming silver chloride in the body of the paper. The dried paper required an hour's exposure before it was sufficiently darkened, but by repeating the impregnation of the paper in this order several times, and exposing wet, he was able to reduce exposure to ten minutes. He fixed the image by treatment with either potassium iodide or sodium chloride. In 1839 he used sodium thiosulphate (hypo) for fixation, and by 1840 he had substituted silver iodide for silver chloride as the light-sensitive medium. In his attempts to reduce the required exposure, he made a discovery of great importance. He found that he could make his silver iodide paper more sensitive by treating it with a mixture of silver nitrate and gallic acid. Moreover, after giving a short exposure (half minute), sufficient to produce only a faint image, this image could be built up or *developed* by further treatment of the exposed paper with his sensitising solution—silver nitrate and gallic acid. From this

2

observation has evolved the modern technique of exposing to give an invisible *latent* image, and its subsequent development.

The paper negative was impregnated with wax to make it more translucent, and prints were obtained by printing through the waxed negative on to similar sensitive paper, the whole process being known as the calotype process.

In essential principles it was identical with modern black-and-white photography in that a layer of light-sensitive silver salts is applied to a translucent support, exposed, developed, fixed and washed to give a negative, which is then printed on an essentially similar material to give a positive print. A series of improvements, discoveries and inventions has brought about the evolution of the calotype process into modern practice. The most obvious way of improving the calotype process was to replace paper as a support for the negative material by something more transparent, for example by glass. But since the silver salts could not be formed inside the glass, it was essential to devise another medium in which the silver salts could be suspended, and to apply this to the surface of glass. In 1847, Niepce St. Victor used white of egg (albumen) for this purpose. Albumen containing potassium iodide was coated on glass, sensitised immediately before exposure by bathing in silver nitrate, and exposed in the wet state.

The Collodion Process and the Gelatin Dry Plate

Numerous experimenters were attempting to apply media other than albumen to photographic practice, and two materials attracted particular attention. One of these was *collodion*, a solution in alcohol-ether of a material called *pyroxylin* or *cellulose nitrate* (sometimes erroneously termed *nitrocellulose*), which was first produced by Schoenbein in 1846. The other was gelatin, obtained from the hides, hooves and bones of animals. Success was first achieved with collodion, when Scott-Archer, in 1851, described the *wet collodion process* (Fig. 7). A solution of potassium iodide in collodion was coated on glass, allowed to set, and soaked in silver nitrate solution, thus forming silver iodide in the collodion layer, the excess silver nitrate acting as a sensitiser. If the collodion layer were allowed to dry, it became impervious to processing solutions, and therefore the plates had to be exposed and processed immediately after manufacture, while in the wet state. They were developed in ferrous sulphate solution, intensified and fixed in potassium cyanide.

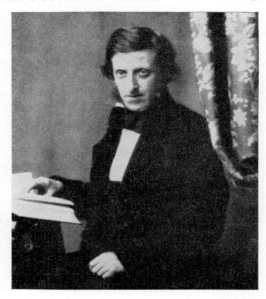

Fig. 7. Frederick Scott Archer. (Inventor of the wet collodion process.)

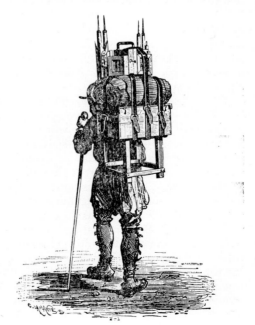

Fig. 8. Apparatus for the wet collodion process. (From a contemporary catalogue.)

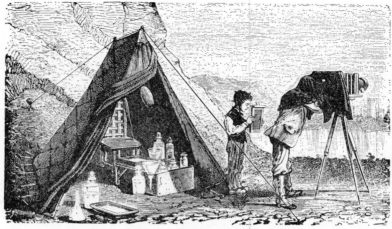

Fig. 9. The wet collodion process in the field.

The wet collodion process was fortunate in receiving unusual and immediate publicity, as examples were shown at the 1851 Exhibition, and it speedily displaced all other processes and reigned supreme for nearly thirty years. Photography became a fashionable pastime among the leisured and moneyed class; societies were formed (the Photographic Society of London in 1853—later becoming the Royal Photographic Society) and journals devoted to photography appeared (*The Photographic Journal* in 1853, and *The British Journal of Photography* in 1854).

The necessity for the photographer to manufacture his plates just before use was a great inconvenience in studio work, but the difficulties were greatly enhanced when the wet collodion process was applied to work in the field. Nevertheless enthusiasts were prepared to transport in a donkey-cart or on their backs not merely a processing dark room, but a small photographic factory, and catalogues of the period reveal an astonishing and amusing contrast with modern miniature camera technique (Figs. 8 and 9).

Another disadvantage was the extreme care necessary when handling the wet collodion coating, which was so fragile that it was damaged by the slightest touch. Experiments to produce the more robust dry plates using either collodion or gelatin as media gave, at the time, much less sensitive materials. The first successful attempt was the dry collodion plate of Dr. J. M. Taupenot in 1855, which required an exposure of about 30 seconds at $f/16$. The first successful use of gelatin in photographic emulsions (the name *emulsion* is

given to the light-sensitive preparation coated on glass, film or paper) is ascribed to Dr. Maddox, who described his experiments in 1871. This was the forerunner of modern emulsions, and caused the downfall of the wet collodion process. The latter, however, was so well established that several years elapsed before the dry plate gained ascendency, and indeed wet collodion plates are still used in the photo-mechanical industry.

The Photographic Industry

The invention of the gelatin emulsion caused a revolution in photographic practice. Wet collodion practitioners had perforce to manufacture their own plates immediately before use. Gelatin dry plates could be made at leisure and stored for future use. The photographer skilled in emulsion making could now produce more plates than he required and find a ready market for the excess among those unskilled or uninterested in this activity. Indeed some made the manufacture, rather than the use, of light-sensitive material their sole activity. Thus began the photographic industry as we know it today. A secondary change naturally followed. Prior to the 1870's it had been the usual practice to publish improvements in emulsion-making technique so that they could be generally adopted. Now that livelihoods depended upon the quality of material, the tendency to publish methods of improvement diminished, and as early as 1873, Burgess marketed a dry plate made according to a secret formula, thus setting the pattern for subsequent manufacturers.

Materials were sold in the form of emulsion (to be coated on plates by the user), of dried emulsion pellicles (emulsion sheets stripped dry from glass after coating, and sold in packets), or of coated glass plates. Among the early, successful manufacturers of dry plates was the firm of Wratten and Wainwright who marketed their London Ordinary Gelatin Dry Plate in 1877. It is recorded by Dr. C. E. K. Mees (who became a partner of the firm) that the emulsion was at one time made by Mrs. Wratten in her kitchen and was flowed on to the glass plates from the spout of a teapot!

The Roll Film

The second revolution in photographic practice was brought about by George Eastman, who had embarked on dry-plate manufacturing

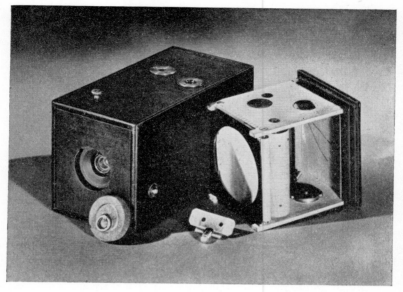

Fig. 10. The first Kodak camera, produced in 1888.

in Rochester, New York, U.S.A., in 1880. Although photographers had been relieved of the necessity of manufacturing their own sensitive material, they still had to do their own processing, which confined the art to those with some practical dexterity and sufficient capital to equip a darkroom. Eastman visualised a system whereby those with no inclination for processing material could load and unload a camera in daylight, and have the exposed material processed and printed commercially. For daylight loading, he used a method originally proposed by Spencer and Melhuish in 1854, whereby emulsion-coated paper was fitted into a camera in the form of a light-tight roll. The paper roll was waxed to give a transparent negative, but soon gave place, in 1885, to an emulsion which could be stripped from its paper support, and finally to emulsion coated on to cellulose nitrate film. The substitution of roll films for glass plates, the introduction of inexpensive but efficient hand cameras (the first 'Kodak' roll-film camera appeared in 1888) and film processing by the manufacturer made photography available to the masses anxious to take advantage of Eastman's proposition, 'You press the button—we do the rest'. (Fig. 10). The roll-film has gained in popularity and has been progressively improved. 'Non-curling'

Fig. 11. George Eastman (1854-1932), the founder of the Kodak Company.

film appeared in 1903, panchromatic roll-film in 1928, antihalo-backed roll-film in 1931, 35mm. perforated film on safety base for special miniature cameras in 1929; 'safety' (non-inflammable) base of cellulose acetate has of recent years been applied to all film products.

Positive Print Materials

Until about 1860 the calotype process used a similar material for both negative and positive stages. Parallel with the specialisation of negative materials which resulted in modern roll-films, sheet-films and plates, there has been an evolution of the positive paper to give the present chloride, bromide and chlorobromide printing papers. The decades 1850–70 saw the introduction of albumen-silver chloride, and of collodio-silver chloride papers, and in the following decade the elegant platinotype process and the silver bromide development paper made their appearances. Gelatin print-out paper was introduced by Abney in 1882, the image being produced solely by contact printing in bright daylight. The excess silver salt was removed by fixation in hypo, and the inclusion of a gold salt in the hypo bath converted the unpleasant colour of the finely divided silver image to the more satisfactory colour of a gold image.

Further advances were Eder's gaslight paper in 1873, and Backeland's 'Velox' paper in 1894. These were slow chloride development papers and were much more efficient in producing results than the printing-out papers, yet could be handled safely in weak artificial light thus obviating the need of 'darkroom' technique. Also the tone of the image—a deep blue-black—was held in great esteem. The invention of gaslight paper had far-reaching results, as it was ideally suited to the mass-production of prints. Thus it can be said to be one of the main causes of the rise and growth of commercial photofinishing which greatly popularised photography.

Other processes were introduced. The *carbon process* of 1864 and Manley's modification, the *Carbro process* of 1905, depend on the production of relief images in pigmented gelatin (by rendering insoluble bichromated gelatin); Welborne-Piper's *bromoil process* of 1907, depending on the differential acceptance of ink by image-wise hardening of gelatin, gives superb results and is still practised by pictorial workers.

The chlorobromide papers, intermediate in speed between chloride and bromide papers, were introduced in 1914. They are capable of giving a wide range of image colours from warm black to red, and are deservedly still growing in popularity.

It has been common practice for many years to eliminate the natural grain of paper by pre-coating the paper with a layer of finely divided barium sulphate suspended in gelatin (the so-called *baryta* coating). This gives a highly reflecting white surface which can be made matt or glossy at will. The slightly yellow tinge due to the gelatin of baryta and emulsion coats was counterbalanced by incorporating a blue dye, but in recent years the blue dye has generally been replaced by a fluorescent dyestuff which converts invisible ultra-violet radiation into blue light, and thus gives an overall higher visible reflectance.

The evolution of the calotype process into modern pictorial black-and-white photography is thus a straightforward story. When we consider colour photography, cine photography, radiography, nuclear track recording, document copying and a score of other applications, we find that both materials and processing have been greatly modified to suit the manifold applications of photography today. But the fundamental basis, though disguised, is still that of Fox Talbot's calotype process—the exposure of a light-sensitive layer containing a silver salt, its development to give a desired image, and the fixation of the image in a manner which will give the required permanence.

Chapter 2

THE BEHAVIOUR OF LIGHT

IN THE PREVIOUS chapter we saw that photography consists essentially of the production of an image by physical means, and the formation of a permanent facsimile of that image by chemical means. In pictorial photography, the physical image is an optical one, produced in a camera by a lens. Before we can study the functioning of a camera in detail, we must learn something of the fundamental nature of light, and the formation of optical images.

Light has always had a fascination for man. Artists have striven to reproduce its effects, poets have praised it and philosophers have speculated on its nature. But experimental science alone has provided reliable evidence to give it substance. In the seventeenth century, Newton concluded from his studies that light consists of tiny particles emitted at high speed from a light source, and that the impact of these corpuscles on the eye produces the sensation of sight. Huygens on the other hand considered light as a form of wave motion in a hypothetical medium which pervades all space—empty or full—and which is called the *ether*. Further evidence accumulated during the succeeding two centuries supported the wave theory, so that nineteenth-century physicists were convinced of the correctness of Huygen's wave theory; and the incorrectness of Newton's corpuscular theory. The present century has produced a great deal of further evidence which can be adequately explained only if light is emitted in discrete particles, a postulate which is known as the *Quantum Theory*. It is now considered that both theories are correct—there is a border region where subatomic particles show wave-like characteristics; where waves and particles are indistinguishable.

Most of the normal optical phenomena, however, are adequately explained on the wave theory. Indeed, energy may be transmitted through space by a form of wave motion of electromagnetic origin, the energy manifesting itself in different ways according to the wave-length (that is, the distance between corresponding parts of adjacent waves, as for example from crest to crest), though the velocity of the waves through empty space is the same for all wave-lengths—186,000 miles per second.

25

Prior to 1801, the only form of such energy transference recognised by man was that of visible light, which has a range of wave-lengths from 400 to 700 mμ, an mμ or millimicron being one millionth part of a millimetre. Not only can the eye detect this range of electromagnetic waves, but it can distinguish between radiations of

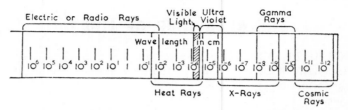

Fig. 1. Complete spectrum of electromagnetic radiation.

different wave-lengths within the range, since these are perceived as differences in colour, from red at 700 mμ through orange, yellow, green, blue and violet at 400 mμ. This range of colours, which is called the *visible spectrum,* occurs in nature as the rainbow.

In 1801 two discoveries of profound importance were made. Herschel discovered that beyond the red end of the visible spectrum were rays which have a heating effect and which are termed *infra-red* rays. A few months later Ritter found beyond the violet end rays which could blacken silver chloride, and which are called *ultra-violet* rays. Thus one can almost claim that even before it was invented, photography discovered the ultra-violet! Since that time means have been found of generating, detecting and utilising an enormously wide band of electromagnetic waves ranging in wave-length from one-millionth of a millionth of a centimetre to some five hundred miles. They included cosmic rays, gamma rays, X-rays, ultra-violet, visible, infra-red, heat rays, and wireless waves (Fig. 1).

Rectilinear Propagation of Light

Light travels from a luminous source in all directions and in straight lines. A point source, therefore, sends out rapidly expanding spherical waves of light. Normally we should be concerned only with a portion of the wave-front such as that passing through an opening, and this is referred to as a 'beam' (for a wide band) or a 'pencil' (for a narrow band) of light. It is often convenient to consider the behaviour of a beam of light so narrow that it may be considered

as a straight line of zero width, and this is called a 'ray' of light—Fig. 2. As a beam of light may be considered as composed of an infinite number of rays of light side by side, the study of one or

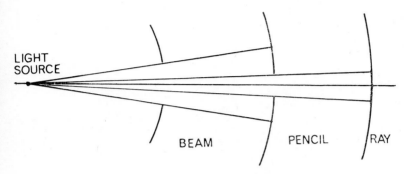

LIGHT
SOURCE

BEAM PENCIL RAY

Fig. 2. Propagation of light.

two critical rays may define the behaviour of a beam. Beams and pencils can, of course, be divergent, parallel or convergent, but a ray of light having theoretically no dimension other than length can neither diverge nor converge.

The conception of a ray of light is not easy on the wave theory, as it is difficult to imagine a wave front of zero dimensions. It is much easier on the corpuscular theory as it would then represent a stream of minute bullets. However, our Victorian wave-propagandists

Fig. 3. The Pinhole camera.

saw nothing anomalous in using the simple conception of light rays to explain light behaviour, so that we, whose faith in the corpuscular theory has been restored will certainly use it in the present chapter and in the chapter on lenses.

Rectilinear propagation of light explains why a pinhole camera will give an inverted image of an illuminated or luminous object—Fig. 3.

Reflection

Light falling on a flat polished surface is reflected so that the *angle of incidence* (the angle between the incident ray and the *normal* —the perpendicular—to the surface at the point of incidence) is the same as the angle of reflection. The reflected ray is in the same plane as the incident ray and the normal (Fig. 4). This reflection is termed *specular* reflection.

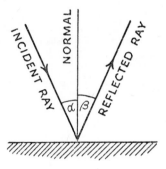

Fig. 4. SPECULAR REFLECTION. Angle of incidence (α) = angle of reflection (β).

A matt or rough surface, such as that of paper, is characterised by micro-irregularities. Different parts of a parallel beam of light therefore meet the surface at different angles and may be reflected at almost any angle to the main plane of the paper. Such reflection is termed *diffuse* or *scattered*. Many surfaces, such as varnished wood, show both specular and diffuse reflection; the former from the semi-transparent polished surface, and the latter from the underlying structure.

Absorption of Light

In most cases only a portion of the light falling on a surface is reflected; part is absorbed. Light falling on a highly polished surface is strongly reflected at a certain angle (equal to its angle of incidence) unchanged in its spectral composition. Thus white light is reflected as white light irrespective of the characteristic colour of the surface except in the case of metallic surfaces. For example, specular reflections of white light from copper take on the characteristic colour of the metal. White light reflected from a matt white surface is reflected in all directions from the plane of the surface, while surfaces which appear grey or black, appear so because all parts of the spectrum are absorbed by about the same amount.

Most surfaces, however, selectively absorb one or more regions of the spectrum more than others giving rise to the appearance of colour. Thus a surface appears red when illuminated by white light because it strongly absorbs blue and green light and reflects red.

With most surfaces part of the total light is reflected unchanged in spectral composition, part reflected after penetrating the pigmented surface and part absorbed. Thus the characteristic colour of a surface will appear more saturated (unmixed with white light) if it is highly polished as in the case of a varnished or wet surface and viewed at an angle to avoid specular reflections. Similarly a coloured surface will appear more saturated if illuminated with strongly directional light.

Transparent substances have the property of allowing light to pass through them. Clear substances, such as glass, transmit freely all the visible wave-lengths and a certain part of both the ultra-violet and infra-red regions. Coloured glass and photographic filters have the property of selectively absorbing some parts of the spectrum and thus form a valuable means of modifying 'white' light, p. 192.

Refraction and Critical Angle

It is sufficient to note that when light passes from one transparent medium to another (air to glass, water to air, etc.) it is bent *towards* the normal on passing from a rarer to a denser medium, and *away* from the normal when passing from a denser to a rarer medium.

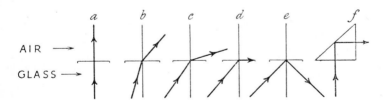

Fig. 5. REFRACTION. (*d*) represents critical angle, (*e*) total reflection and (*f*) a reflecting glass prism.

Different media may cause different amounts of deviation depending on the optical property called the *refractive index* of the medium.

When light passes from a denser to a rarer medium it is refracted *away* from the normal, thus as the incident angle increases, it will reach a value when the emergent ray skims along the boundary

plane between the two media. This incident angle is termed the *critical angle,* and light striking the boundary at a greater angle than this suffers total reflection. As the critical angle for a glass to air surface is 40°, light striking the boundary at 45° is totally reflected. This property of glass is utilised in the reflecting prism found in binoculars and document copying cameras (Fig. 5).

If light passes normally through a block of glass with parallel plane sides, it will be undeviated, but if it passes at an angle, the emergent ray will be parallel to the incident ray, but displaced (Fig. 6). (This effect is utilised in some high-speed cameras, in which a rotating block of glass causes the image to move in line with continuously moving film).

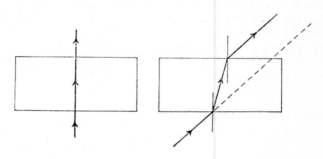

Fig. 6. Refraction by glass block with parallel sides.

A block of glass with non-parallel plane sides, for example a prism, will cause a change in direction of the light towards the base of the prism (Fig. 7). The amount of refraction, or bending of the light will depend upon the angle of the prism, the angle of incidence of the light, the refractive index of the glass and, finally, the wavelength of the light.

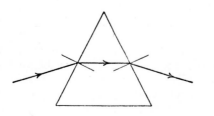

Fig. 7. Refraction by glass prism.

Dispersion

Since different wave-lengths are refracted to different extents, white
light, which is a mixture of all wave-lengths, will be analysed into
its component wave-lengths on passing through a glass prism.
This is known as dispersion. The resultant beam, projected on to a
white surface will appear as a spectrum, the longer wave-lengths
(red) showing less refraction than the shorter (violet) ones (Fig. 8).

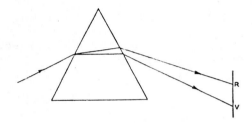

Fig. 8. Dispersion by glass prism.

The Lens

A lens is a device whereby a large cone of light from a point may
traverse a large disc and be refracted so that it is once more con-
centrated to a point to give a very bright, sharp image. The rays
passing through the centre of the lens must not be refracted, and the
tangential planes at the centre of the lens must therefore be parallel.
The rays passing through the other parts of the lens must be re-
fracted as through prisms of increasing angle as they approach the

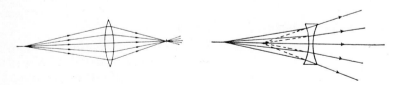

Fig. 9. Refraction of light by (a) convex lens (b) concave lens.

edge of the lens. The typical lens-shape is given by the continuous
merging of an infinite number of such prisms (Fig. 9a).

If a lens were concave instead of being convex, light from a
point source would diverge as though it came from a point between

the lens and the light source. Such lenses are termed concave, dispersive, divergent or negative lenses, as distinct from convex, collective, convergent or positive lenses—Fig. 9(a) and (b). Our only concern with concave lenses is in their use as components in complex photographic lenses, as discussed later.

Focus

The point at which light from a point on the object is converged by a lens is called the *focus*. The position of the focus depends on the position of the object. If the object is so distant that the rays of light from it are practically parallel (as for example, light from a star), the focal point is called the *principal* focus, and its distance from the lens is called the *focal length* (Fig. 10).

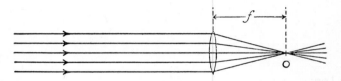

Fig. 10 Refraction by a lens of parallel light. O is principal focus; f is focal length.

It is comparatively easy to measure the focal length of a fairly thin lens. With a compound lens of considerable overall thickness, however, we must first determine the position of a particular plane of the lens (called the *node*), and then measure the distance from this plane to the focus of parallel light.

Brightness of Image

The brightness of an image formed by a lens depends on two factors—the amount of light transmitted by the lens, and the area over which that light has to be spread. The amount of light transmitted by a lens, assuming that it is perfectly transparent, is proportional to its area, which is proportional to the *square* of its diameter.

From Fig. 10 it is clear that the *height* of an image of a distant object is proportional to the focal length of the lens; the *area* of the image (that is, the area over which the light passed by the lens has to spread) is thus proportional to the *square* of the focal length. Thus, the wider the lens aperture, the brighter the image; but the longer

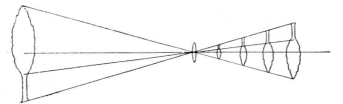

Fig. 11. Images formed by lenses of different focal lengths.

the focal length, the dimmer the image. Hence the brightness of an image is proportional to

$$\frac{(diameter\ of\ lens)^2}{(focal\ length)^2} \quad or \quad \left(\frac{lens\ diameter}{focal\ length}\right)^2$$

Object Distance : Image Distance

All rays reaching a perfect lens from a point on the object are refracted so that they intersect at a point. If therefore we can trace the path of two rays and find their point of intersection, we know that this will define the position of the image, since all other rays will also intersect at this point. Now we have already seen that the ray which passes through the centre of the lens will be undeviated (actually it will be displaced by a very small distance, but will be parallel to the incident ray), and we have also seen that the ray parallel to the axis of the lens will be refracted so that it passes through the principal focus of the lens (that is, the focus for parallel light). The intersection of these two rays defines the position of the image (Fig. 12).

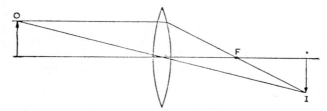

Fig. 12. Geometric construction of an image.

It is clear that as the object approaches the lens from an infinite distance, the image recedes from the principal focus of the lens. By simple geometry, it can be shown that if we call the distance of the

2

object from the lens u, the distance of the image from the lens v, and the focal length of the lens f, then these three values are related according to the important fundamental equation:

$$\frac{1}{f} = \frac{1}{u} + \frac{1}{v}$$

Let us consider a special case—photographing an object at *unit magnification*, that is, so that the image is exactly the same size as the object. It will be seen from the diagrams that the ratio of image size to object size is the same as the ratio of image distance to object distance. If image and object sizes are to be equal, then image and object must be equidistant from the lens, or u must equal v. Substituting u for v in the equation, we find that:

$$\frac{1}{f} = \frac{1}{u} + \frac{1}{u} = \frac{2}{u} \quad \text{or} \quad u = 2f.$$

Thus both image and object, when photographing at unit magnification, will be twice the focal length away from the lens.

From this special case we can make another important deduction. When the light entering the camera is focused at a plane twice the focal length from the lens, it is spread over an area 2^2, or four times that of an image at the principal focus, and has therefore only a *quarter* of its brightness. This must be taken into account when copying at unit magnification.

Light and Spectral Energy Curves

The spectral analysis of a pencil of light can be made by means of a prism in the manner first demonstrated by Newton. There are other ways of breaking light into its component wavelengths as we shall see later in this chapter.

The spectral composition of light has important photographic (and scientific) considerations. For any given light source it can be expressed by measuring the energy at various regions of the spectrum by means of a spectrophotometer and plotting the values as shown in Fig. 13. This curve shows the energy distribution for noonday sunlight and a tungsten filament lamp. It shows at a glance that sunlight has a maximum in the green region (550 mμ), while tungsten light shows very little energy in the blue (400-500 mμ) but increasing energy towards the red region (600-700 mμ). Both light sources are accepted as white light, yet when directly compared with each other at the same intensity level, the sunlight will appear bluish and the tungsten yellowish.

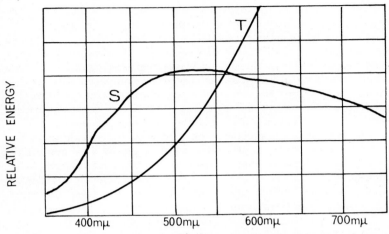

Fig. 13. Spectral energy curves of sunlight (S) and a tungsten lamp (T).

The Diffusion of Light

When light passes through a foggy or smoky atmosphere, the sus-
pended particles of water and dust absorb a part and diffuse or
scatter a further part. If the particles are large in comparison with
the size of a wavelength, all regions of the spectrum are equally
scattered and the light will appear as white, diffused light. If the
particles are small compared with the size of wavelengths, diffusion
on a selective basis takes place, the shorter wavelengths being
affected most. When this happens the diffuse light appears blue and
the transmitted light yellow. This can be readily seen by directing
a beam of light through tobacco smoke which consists of very fine
particles. Similarly, diffusion caused by atmospheric haze explains
why the sky appears blue and why light from the sun appears
yellowish or red when it passes through greater densities of haze
when it is near the horizon. It also explains why photographs made
with infra-red radiation give much better penetration through
haze—see the illustrations on page 194.

Diffraction and Interference Phenomena

The diffraction of light is of relevance to photography since it can be
used as a means of splitting light into its component wave-lengths
(e.g. in a wedge spectrograph, an instrument for measuring the

colour sensitivity of photographic materials, p. 190) and in certain cases can be the cause of loss of sharpness of an optical image.

It occurs when light encounters a very small obstacle or passes through a very small aperture. Instead of travelling in a straight line, it tends to bend, the shorter wave-lengths being most affected. Thus if the aperture of a lens is very small compared with its distance from the film, the image of a point source takes the form of a small disc. The diffraction of light is commonly seen in the iridescent colours reflected from the surface of long-playing records.

Interference phenomena can be explained by considering what happens when two rays of light are out of phase. This commonly occurs when light is reflected from a very thin transparent layer such as that of a soap bubble or oil on water. The light reflected from the inner surface travels farther than that from the outer surface and if the extra distance is an odd number of $\frac{1}{2}$ wave-lengths, part of the spectrum is reduced or cancelled out and we see the sum of the remainder. This effect is put into use in the coating of optical surfaces as a means of reducing surface reflections. As the effect can only hold good for a particular wave-length, the thickness of the coating is made that best for yellow light. This explains why coated lenses have a bluish colour when viewed with reflected light. The Lippman colour process was based on light interference.

Polarized Light

The electromagnetic nature of light offers an explanation for the polarization of light. We may consider unpolarized or 'natural' light as vibrating in all directions in a plane at 90° to the direction of propagation (Fig. 14). If such a beam of light is made to pass

Fig. 14. 'Natural' light after passing through a polarizing filter (P.1) becomes polarized. With a second filter (P.2) at right-angles to the plane of polarization it is almost completely absorbed.

through a device which absorbs all vibrations except those in a single plane, the transmitted light will have an electrical field of fixed direction and is said to be polarized. If a similar device is

now placed in the path of a beam of polarized light, it will transmit the maximum amount of polarized light when its plane of polarization coincides with that of the light, transmitting less at other angles and zero when the two planes are at right-angles to each other (Fig. 14).

Light may also be polarized by reflection and refraction. Polarization is almost complete when reflection occurs from a polished non-metallic surface at an angle of about 34° (Fig. 15). A polarizing filter can therefore be used to control reflections from glass, water, glossy paint, etc.

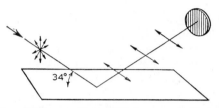

Fig. 15. Light reflected from a surface which is non-metallic is strongly polarized at an angle of about 34°

Polarization also occurs through the scattering of light by the atmosphere, maximum polarization being in a region of the sky at right-angles to a line between the camera and the sun.

The use of polarizing filters is especially valuable in colour photography where it offers control of reflections without interfering with colour rendering, see Plate II, p. 258.

Certain crystals, such as Iceland Spar, act as very efficient polarizers, but in photography it is usual to use a filter which consists of a plastic material containing minute crystals of quinone iodosulphate which are uniformly orientated. For practical applications see p. 198.

Chapter 3

LIGHT SOURCES USED IN PHOTOGRAPHY

WHILE THE PHOTOGRAPHER can make use of almost any light source—and occasionally does—a number of light sources have been developed specially for photography. Daylight in one form or another is still the principal light source and the only practical one for general outdoor photography, if we except the use of moonlight. Artificial light sources become practicable when the area to be illuminated is relatively small. At one extreme it is used to illuminate a microscopic specimen, at the other a large film studio where batteries of lighting units (each of the order of 10 KW) may be used. Indeed it is true to state that only a fraction of present day applications of photography would be possible without some kind of artificial light source.

The Standard Candle

It is useful to start a discussion of light sources with some reference to the standard on which measurements of intensity and illumination are based.

A candle was chosen as the standard illuminant when it was a much more common means of illumination than it is today, and so that comparison would be made with candles of exactly the same light output (termed *luminous intensity*), the composition, dimensions, and rate and conditions of burning were carefully specified. A candle made to these specifications is called a *standard candle*.

In 1940 a new standard of luminous intensity was adopted internationally. It is based on the luminous intensity emitted by one square centimetre of a black body heated to the temperature at which the metal platinum freezes (2042·2 °K). This was allotted a luminous intensity of 60 *candelas*. However, the new unit differs very little from the old standard.

Photometry

This is concerned with the measurement of light sources and the illumination which they give. For our present purpose we need only concern ourselves with the *metre-candle* which is the intensity of illumination of a surface at a distance of one metre from a light source equal to 1 candela. (The corresponding British unit is the foot-candle, based on a distance of 1 foot). Thus 100 metre-candles is the intensity falling on a surface one metre distant from a 100 c.p. lamp.

If we consider a point source of light, it is possible to demonstrate with a simple diagram the well-known law of light propagation which says that the intensity of light falling on a flat surface from a point source is inversely proportional to the square of the distance, Fig. 1. For practical purposes, the law holds good for artificial light

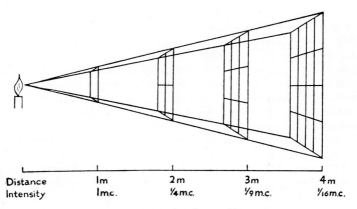

Distance	1m	2m	3m	4m
Intensity	1m.c.	¼m.c.	⅑m.c.	¹⁄₁₆m.c.

Fig. 1. The Inverse Square Law.

sources used in photography having a small area and can thus be applied to the use of tungsten lamps and flashbulbs. In the latter case advantage is taken of this law in the *guide number* exposure system. This takes into account the fact that the intensity of an image formed by a lens is inversely proportional to the square of the f/number, so that by multiplying the distance of the flashbulb-to-subject by the f/number we arrive at a constant for any given flashbulb and film speed. To give an example, with a guide number of 56, a flash-to-subject distance of 10 foot would call for a lens aperture of $f/5\cdot6$. In practice other factors have to be taken into account and these are dealt with in the Chapter on exposure, p. 215.

The inverse square law does not apply to light sources such as a spotlight which embodies an optical system whereby the light is focused into a narrow beam of near-parallel light. Sunlight reaching the earth after a journey of 93,000,000 miles may also be regarded as parallel light and therefore unaffected by terrestrial distances. The fact that it varies in intensity at different altitudes above the horizon results from atmospheric absorption.

Colour Temperature

The advent of modern colour photography has made it necessary to take into account the spectral composition of a light source. This can be done photometrically by measuring the intensity at various wave-lengths and presenting the values in the form of a curve such as that shown on p. 35, Fig. 13. An alternative method is that of relating its colour to temperature. If we gradually raise the temperature of a black body, the first visible rays emitted are red—when the material is *red hot*. As the temperature rises, the output of the first rays increases, and in addition other rays of shorter wave-length successively appear and the region of maximum emission moves towards shorter wave-length. When the temperature is such that appreciable amounts of all the visible radiations are emitted, the material is *white hot*. *White*, however, is a relative term. The glowing filament of an electric lamp is white hot, but it is yellowish in colour compared with the hotter carbon arc, which is in general yellower than sunlight. The colour of an incandescent body is thus dependent on its temperature, becoming less yellow (that is, more blue) as the temperature rises. The colour of white light emitted by an incandescent body such as a candle flame, an electric light bulb, an arc light, or the sun may be defined in terms of the temperature of the incandescent body.

The temperature of an incandescent body could be defined in degrees centigrade or Fahrenheit, but these scales are arbitrary and a more absolute scale is used. It has been discovered that if we continuously abstract heat from a body, its temperature will progressively decrease until it reaches a limit of —273° C. At this temperature it has parted with its whole heat content, and there are no temperatures below —273° C. This, therefore, represents zero on an absolute scale. The choice of the value of a degree, however, is still quite arbitrary, and the centigrade degree has been selected, one hundred degrees representing the temperature difference between melting ice and boiling water. Temperature on the absolute scale

is represented in degrees Absolute or degrees Kelvin*(°A or °K), and the corresponding values are shown in the table:

Scale	Absolute zero	Melting ice	Boiling water
Centigrade	—273° C	0° C	100° C
Absolute or Kelvin	0° K	273° K	373° K

Any centigrade temperature is thus converted into absolute degrees by the addition of 273.

The quality or colour of light emitted by an incandescent black body may thus be defined in degrees Absolute by the *colour temperature* of the light, which is the temperature of the incandescent body. Some sources of illumination, such as mercury or sodium vapour lamps, emit light of a quality entirely different from that of an incandescent black body, so that it is impossible to describe it in terms of colour temperature. Fluorescent (cold cathode) lighting approaches more nearly that of an incandescent body, but cannot be accurately defined by colour temperature. Some fluorescent sources designed to imitate daylight approximate to a body at a temperature of 6,500° K.

Colour Temperature Filters

Colour films have specific colour sensitivities and are currently available in three 'types'. Those balanced for daylight (sunlight plus blue sky) corresponding to a colour temperature of 5,500°K., those balanced for high efficiency tungsten lamps of 3,400°K. and those balanced for tungsten lamps of 3,200°K. For critical colour rendering with tungsten lamps even a difference of 100° becomes important and in cases where it is not possible to use lamps of the correct colour temperature, it becomes necessary to use filters which are designed to modify the colour temperature. These filters are known variously as colour temperature, or light-balancing filters. Instruments designed to measure colour temperature are commonly based on the use of a photocell which indicates the relative amounts of blue and red light emitted by the light source. They are usually calibrated in *mireds,* an abbreviated term for the reciprocal of the colour temperature multiplied by 1,000,000. For example, a colour temperature of 3,400°K. equals a mired value of

* After Wm. Thompson, Lord Kelvin.

294. It is also possible to allocate mired-shift values to colour temperature filters, the shift value being roughly the same irrespective of the initial temperature of the light source. A filter which lowers the colour temperature is said to have a positive shift value and one which raises it a minus shift value.

Colour temperatures and mired values for a typical range of light sources are given below in Table I. The mired shift values for Wratten filters designed for colour photography are given in Table II. To give an example of the use of the mired system let us suppose that a colour film balanced for light of 3,400°K. (294 mireds) is to be exposed with lamps of 2,800°K. (357 mireds). To raise the colour temperature, a filter giving a minus shift of 61 is required. This can be achieved with a combination of Wratten filters Nos. 82A and 82C (−18 and −45 equals −63).

TABLE I

Colour Temperatures and Mired Values of Light Sources

Light Source	*Colour Temp.°K.*	*Mired Value*
Candle	1,900	530
100 watt household lamp	2,800	357
Photopearl and C.T.C. studio lamps	3,200	312
Photoflood lamps	3,400	294
Clear flashbulbs	3,800	263
Noon sunlight plus blue sky	5,500	182
Blue flashbulbs	5,500	182
Electronic flash	6,000	167
Blue sky	11,000 to 20,000	—

TABLE II

Mired-shift values for Wratten Filters

Filter No:	81EF	81C	81B	81A	81	82	82A	82B	82C
Mired-shift:	+53	+35	+27	+18	+10	−10	−18	−32	−45

Daylight

Daylight may be considered as two different sources of light: the light coming directly from the sun and the light coming from the sky. When the sun is unobscured by cloud or mist it forms the main source of light except at sunrise and sunset. However, before reaching the earth's surface, sunlight must pass through the atmosphere

and for this reason is subject to variations both in intensity and colour. Thus on a clear summer's day, the intensity of sunlight at midday is about 7 times greater than the light from the sky, falling to as little as half that of the sky immediately before sunset. At altitudes of 55° degrees or more above the horizon, its colour temperature is 5,400°K, but this can drop to as low as 2,000°K at sunset. The combination of sunlight and light from a blue sky gives a colour temperature of about 5,500°K and it is to this value that most colour films intended for daylight use are balanced.

Objects in open shadow illuminated by a blue sky receive light of a considerably different nature. Due to the scattering by the atmosphere of the shorter wavelengths (p. 35), it is far more rich in blue and the colour temperature may range from 11,000 to 20,000°K. As compared with sunlight, it is diffused by nature and arrives from a very large area

The term daylight may also refer to various kinds of overcast sky where the two light sources—sunlight and blue sky—become merged to form a large area of diffused light. The existence of a cloud layer which covers the sun has three main effects: it reduces the intensity of illumination, it converts all illumination to diffused light and it changes the colour temperature.

Various attempts have been made to measure the intensity of sunlight on a daily and seasonal basis, culminating in the publication of tables by the British Standards Institute which covered variations for the time of day, season of the year and geographical latitude.

As well as its visual content, daylight contains variable amounts of ultra-violet radiation which can frequently have disturbing effects in colour photography where it reacts on the blue-sensitive layer to record a degree of blueness not visible to the eye, p. 193. However, as it is readily scattered by the atmosphere, it normally only becomes troublesome at altitudes greater than 7,000 feet, or when the atmosphere is exceptionally 'clean' after a heavy fall of rain. Its presence can be dealt with by using an ultra-violet absorbing filter over the lens, p. 193.

Flashbulbs

The combustion of magnesium as a photographic light source was practised as early as 1870 and the use of magnesium flash powder became almost the standard light source in many portrait studios. Its use has now almost died out in favour of flashbulbs, though there are still a few stalwarts who enjoy the spectacular 'explosion' and

smoke cloud that follows the combustion of a few spoonfuls of magnesium powder.

The flashbulb is a similar but vastly more controllable light source. Modern flashbulbs consist of a quantity of shredded aluminium foil inside a glass envelope containing oxygen. The metal is ignited by an explosive primer which is itself fired by a small electric filament. Recently, zirconium has been used as the combustible material for small bulbs as it gives a greater light output.

The light output of a flashbulb depends on its size and nature, but is extremely high compared with continuous light sources. A small bulb may be compared with other light sources in terms of luminous flux, that is, in terms of the rate of light emission, as follows:

Standard candle	12·5 lumens
100-watt lamp	1,200 ,,
275-watt Photoflood	8,000 ,,
Small flashbulb	1,000,000 ,,

Its short duration is, in most cases, an advantage in photography.

The total light output in lumen-seconds covers a range of from 7,500 (for small bulbs) to 95,000 for a large bulb such as the P.F.100.

Clear flashbulbs emit a light of roughly 3,800°K., a colour temperature higher than that of tungsten lamps and considerably lower than that of daylight. This presented something of a problem for the exposure of colour films of the reversal type since these require a close match between the spectral quality of the light source and the colour balance of the film. One approach to the problem was to coat the glass envelope of the flashbulb with a blue-tinted lacquer so that the light emitted was roughly the same as daylight. However, this was open to two objections. Firstly, the blue-coating more than halved the light output of the bulb—a serious disadvantage with the existing slow films, and, secondly, the filtering effect of the blue coating varied considerably, often giving excessively blue results. As an alternative, some brands of colour film were provided with an additional version which was specially balanced for clear flashbulbs. This was labelled Type F to distinguish it from films balanced for tungsten lighting. However, as the method of coating bulbs improved and the speed of colour films increased, the need for a Type F film vanished and today all except the very large bulbs are of the 'blue' type, thus making them equally suitable for exposing black-and-white and colour films intended for daylight exposures. Indeed, with the introduction of zirconium as the combustible material, very small flashbulbs can be made having

a light output equal to the larger clear bulbs which were based on aluminium foil.

Flash Synchronisation

Equally as important as its very large light output, is the feasibility of synchronising the flash with the camera shutter. Flashbulbs are made to have specific burning characteristics so that the firing of the bulb can be coupled with the shutter release mechanism. The combustion curve of a typical flashbulb is given in Fig. 2 using a time

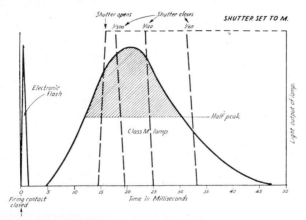

Fig. 2. Combustion curve of class M flashbulb showing synchronisation with diaphragm shutter set to 'M'.

base in milliseconds. The broken lines show the opening of a diaphragm shutter. It can be seen that from the closing of the flash circuit to half-peak output there is a time lag of about 14 milliseconds. Thus if the shutter opening is delayed by this amount, effective use of the flash can be made over a range of shutter speeds from 1/50 second to the shortest given by the shutter. In this case the effective exposure of the flash is proportional to the time of exposure. Maximum use of the flash is obtained with a shutter speed not less than 1/30 second and in this case, assuming the flash is the only light source, it does not matter if the shutter is open for a very much longer time—the result will be the same. Under these conditions any camera, synchronised or not, can be used to make a flash exposure.

The synchronisation of flashbulbs with focal plane shutters is less simple owing to the fact that the shorter speeds—1/50 or less—are

usually obtained by reducing the shutter blind to a slit which then travels across the film. It is therefore necessary to use a flashbulb which will give roughly the same output of light for the whole time that the slit takes to exposure the film. Special bulbs, such as the P.F. 24 and P.F. 45 are made for this purpose. To allow for the even longer time taken for large focal plane camera to operate, slow burning bulbs such as the P.F. 60 and P.F. 100 are made.

Electronic Flash

The development of electronic flash was pioneered by Dr. Edgerton primarily as a light source of extremely short duration. For this reason they were first named speed lamps and exposures as short as one millionth of a second could be obtained. Their application as a potentially very powerful light source received an impetus in the last war when units with an output of up to 60,000 watt-seconds were used for photographic reconnaissance at night from the air.

High speed electronic flash is still of great value to technical photography, but is of limited interest in general photography. The very short exposure times also prove a disadvantage in terms of reciprocity failure (p. 199), producing very low contrast images. The trend in development has therefore been towards the production of units giving relatively longer flash times (1/500 to 1/750 second) and large output in terms of weight and bulk, for use as general-purpose light sources.

Fig. 3. Small electronic flash unit shown about half-size.

Fig. 4. The splash of a drop of milk photographed at about 1/300,000th second.
Photo Edgerton, Germeshausen and Grier.

Electronic flash is a kind of discharge tube which is supplied by the energy stored in a condenser. The tube is usually filled with xenon gas and the discharge is triggered off by means of a current which ionises the gas. The output of the flash in watt-seconds or joules depends principally on the capacity of the condenser, but its efficiency as a light source will also depend on the design of the reflector. The colour temperature closely approaches that of daylight (6,000°K) and may be used without a filter with daylight type colour films. Portable units operated with a battery and with an output of 20 to 30 watt-seconds are small enough to be carried in the pocket. They will deliver up to 50 flashes with fully charged batteries. Units designed for professional studios provide output sockets for a number of flashheads and often incorporate a pilot lighting system.

Synchronisation of electronic flash with a diaphragm shutter presents no problem as there is no appreciable delay after closing the flash circuit (as there is with flashbulbs). As the duration of the flash is less than the shortest shutter speed available, the full effect of the flash is obtained at all speeds with a diaphragm shutter. On the other hand it is unsuitable for exposure with a focal plane shutter except at speeds which uncover the whole picture area at one time (1/30 second or longer).

On occasions when normal visible flash is impossible, undesirable or prohibited, the exposure can be restricted to the infra-red radiation which is emitted by both flashbulbs and flash tubes. This is known as 'dark-flash' and involves covering the front of the lamp with a filter and using infra-red sensitive material in the camera.

High Efficiency Tungsten Lamps

The high melting point of tungsten (3,700°K) makes it possible to operate tungsten filament lamps at temperatures as high as 3,400°K while still giving a useful working life. The advantage in terms of working life lies with lower voltage lamps, since for the same wattage a more robust filament is possible. One of the limiting factors at very high temperatures is the deposition of evaporated tungsten on the glass envelope causing a blackening of the glass. This has recently been overcome by the introduction of iodine in the lamp. At a temperature above 250°C. iodine combines with tungsten to form tungsten iodide, but above 2,000°C. the reverse action takes place with dissociation into tungsten and iodine of the tungsten iodide. The property of the iodine combining with tungsten on the envelope of the lamp thus keeps the surface clean,

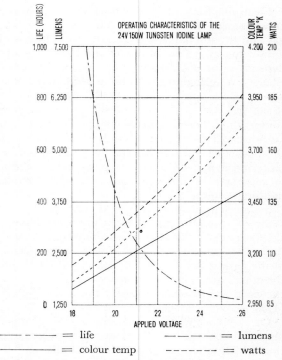

OPERATING CHARACTERISTICS OF THE
24V 150W TUNGSTEN IODINE LAMP

—— · —— = life ————— = lumens
————————— = colour temp ------- = watts

Fig. 5. Tungsten iodine lamp of 150 watts (24 volts) shown actual size. Operating characteristics are shown in the diagram. *Courtesy: Atlas Lighting Ltd.*

permitting full light output throughout the life of the lamp. At the same time it prevents the rapid destruction of the lamp which follows blackening, since in this case the envelope absorbs a great deal more heat. Yet another advantage of the tungsten-iodine cycle is that the envelope can be made smaller as a large envelope is no longer needed as a means of reducing the effect of tungsten evaporation.

The advantage of operating a tungsten lamp at high temperatures is a two-fold one: it gives a whiter light, more suited to the requirements of colour photography, and its efficiency in lumens per watt is greatly increased. This is shown by the following values:

40-watt tungsten lamp	10·7 lumens per watt	2750 °K
500-watt ,, ,,	19·6 ,, ,, ,,	2960 °K
1500-watt ,, ,,	22·0 ,, ,, ,,	3225 °K
250-watt Photoflood lamp	32·8 ,, ,, ,,	3475 °K

Typical operating characteristics of a tungsten-iodine lamp are shown in Fig. 5.

Tungsten lamps designed for photographic illumination often incorporate an internal reflector thus dispensing with the need of a separate reflector. Lamps for general studio work are usually operated at a colour temperature of 3,200 °K as this gives a greatly extended life. However, the output of the lamp and its colour temperature depend on the voltage applied to the filament and for exacting work some form of voltage regulator is necessary. For example a drop of 10 volts with a 240-volt lamp will cause a reduction of 50 °K in colour temperature and a 10 per cent drop in output.

For photographic lighting tungsten lamps may be used as single units, as banks to give a wide area of uniform lighting or as a spotlight. The spotlight, which employs a fresnel lens, is designed to give a highly directional beam of light and is often used as a key lighting in display photography.

Fluorescent Lighting

Although chiefly of use for general illumination, fluorescent lighting may be employed as a cheap and relatively efficient means of providing uniform illumination over a large area. One advantage is that it emits very little heat and is therefore ideal for illuminating large colour transparencies of the kind used for display. The fluorescent lamp is a low-pressure mercury vapour discharge tube generating ultra-violet radiation which is converted into visible light by means of phosphors. Such lamps are made in a range of colour qualities (chiefly to meet the needs of interior illumination) which include a variety which approximates to daylight. This, in fact, has a colour temperature which corresponds to 6,500°K.

Mercury Vapour Discharge Lamps

Because of their high emission of ultra-violet, high pressure mercury vapour lamps are commonly used for exposing process materials of the kind used in preparing line and half-tone printing blocks. For black-and-white printing, process films and plates are chiefly sensitive to this region of the spectrum.

A form of mercury vapour lamp screened with Wood's glass (glass dyed with nickel oxide), emits only the near ultra-violet in the region of 360mμ and is used to illuminate fluorescing materials and also in technical and forensic photography making use of ultra-violet records.

THE CAMERA LENS

THE COST of a camera for amateur use may vary from a few shillings to some hundreds of pounds, a range which may seem very wide considering that even the most expensive camera is essentially a light-tight box incorporating a lens which can focus an image of a view on to a sheet of light-sensitive photographic material. The lens is one of the most expensive components of a camera, and again the range of prices is very wide. If one expects an expensive lens to give a greatly improved photograph in normal outdoor use, compared with an inexpensive one, disappointment is in store. A simple box camera costing little more than a pound, will give with its single meniscus lens (one whose cross-section is crescent shaped) surprisingly good results for nearly all the photographs that the amateur normally desires to take, and it is an ideal camera for the beginner. An expensive camera *will* give better results, but the difference is not very obvious, and because of misadjustment of its many controls it is likely to give worse results in inexpert hands. The main difference is that the expensive camera can be used under conditions when an inexpensive one cannot; for example, for interior snapshots, for theatre lighting, for scenes in the shade on dull days, and so on. But even this disadvantage is diminished by fitting flash contacts to inexpensive cameras. We can summarise by saying that inexpensive cameras should give good results in perhaps 90 per cent of the average amateur shots. An expensive camera should give excellent results in a greater percentage, according to price.

Lens Aberrations

A single lens suffers from a number of defects called aberrations. Only the main ones will be mentioned here. In general the effect of lens aberrations increases with increasing aperture, and the simple meniscus lens fitted to an inexpensive camera gives satisfactory results only because it is used at small aperture. Most aberrations

are corrected, or partly corrected, by a suitable combination of positive and negative (concave) lenses of different types of glass and of carefully computed radii of curvature.

Chromatic Aberration.—Since different wave-lengths are refracted to different extents, the shorter wave-lengths (violet) will be brought to focus nearer the lens than longer (red) wave-lengths. The defect can be corrected by combining a positive lens with a negative one of different glass. A colour-corrected lens is called an *achromat*. In what is known as *transverse colour aberration* a light point, off axis, is stretched out into a little spectrum. It is important that the lens should be corrected for this defect when used for colour photography.

Spherical Aberration.—A simple lens with spherical surfaces brings marginal rays to a focus nearer to the lens than rays passing through the centre of the lens. Like chromatic aberration, spherical aberration gives rise to lack of definition in the image. The defect is corrected by combining positive and negative lenses in a fashion rather similar to that used in constructing achromats.

Curvilinear Distortion.—Rays reaching the edge of an image, that is, traversing the lens at a considerable angle to the axis, will use different parts of the lens, according to the position of the aperture. If this is in front of a simple lens, *barrel* distortion results, for example a square is imaged with bowed-out sides; if the aperture is behind the lens, an opposite effect, *pin-cushion* distortion, is obtained. One way of curing this defect is to place the aperture midway between two identical lenses. This method was used in *rapid rectilinear* lenses, and is still in use in some modern lenses. Fundamentally the correction of distortion involves the use of separated elements, though it is not necessary that the system should be symmetrical.

Other aberrations that can be wholly or partly corrected are known as *coma* (which gives a sort of *skewed* spherical aberration), *curvature of field,* and *astigmatism.* The cure for astigmatism is, again, separated elements. A lens with flat field and corrected for astigmatism is called an *anastigmat.*

The Evolution of the Camera Lens

The first step forward from the convex lens was the Wollaston meniscus which was originally designed in 1812 to give improved definition for the *camera obscura.* Used with a small stop, aberrations including astigmatism are reduced to a level which makes it suitable for snapshots. The meniscus lens is still used for inexpensive cameras.

The next step was in the direction of chromatic aberration and took the form of a lens with two components of different glasses, (Fig. 1). It was invented in England either by Dolland or Chester Moore-Hall (records are uncertain), but was first applied to early photographic cameras by Chevalier in 1829. Lenses of this type, but cemented together, are known as *achromats* and are still used on the better snapshot cameras. As with the meniscus, a fairly small stop is needed.

Fig. 1. Diagram showing the history of lens development. *Courtesy: Kodak Museum.*

The year 1840 saw an advance in lens design which was so remarkable as to be almost anachronistic. A German lens designer, Josef Petzval, worked out a complete theory of the primary aberrations and computed a lens which reduced them to such an extent that it could be worked at an aperture of $f/3\cdot6$.

Although most of the aberrations were cured, the lens still retained considerable curvature of field and astigmatism. Petzval knew how to correct for these faults, but could not do so as he was limited to two kinds of glass—crown and flint. In consequence, the lens gave good definition in the centre of the image, but definition fell off rapidly towards the edges. This defect was unimportant in

portraiture. Lenses of this design are still in use for purposes where only a narrow field is required, for example as both taking and projecting lenses for amateur cine cameras and for very long focus lenses (300-600 mm) for 35 mm. cameras.

For landscape work the achromat continued until 1866 when a further step was made. Certain aberrations such as coma, curvilinear distortion and oblique chromatic aberration give precisely opposite effects according to whether the stop is in front of or behind the lens. The idea of using two identical achromats placed symetrically about a central stop seems to have occurred to two designers simultaneously and independently, Dallmeyer in England and Steinheil in Germany. The lens became known as the Rapid Rectilinear as it permitted a stop of $f/8$ to be used. Since it was, in fact, two lenses in one, one component could be unscrewed and the remaining lens used as one of twice the focal length and f/number. If two components of different focal length were used, the photographer had at his disposal lenses of three different focal lengths. It was from this practice that the term 'convertible' lens arose.

The Rapid Rectilinear lens offered little or no correction for spherical aberration, curvature of field and not a great deal for astigmatism. In fact with only two kinds of glass it was possible to correct for astigmatism or for curvature of field, but not for both, so that it was impossible to obtain large-aperture lenses giving a sharp image over the whole field.

New vistas were opened, however, by the discovery at Jena in 1886 of new glasses with characteristics different from any previously known. This led to improvements on the Rapid Rectilinear lens by adding further components, and lenses of this type, involving six, eight or even ten components, made it possible to correct for both astigmatism and curvature of field. Such lenses became known as *anastigmats*.

The last fundamental and substantial advance was made in 1893 by H. D. Taylor, who calculated that three components only, suitably separated, are necessary to correct all the primary aberrations. Disregarding traditional lines, he designed a triplet of high performance and aperture. The lens was named after the manufacturer, T. Cooke, for whom Taylor worked.

It was the beginning of a new approach to lens design and others, based on the triplet design, appeared in rapid succession. In 1901, Aldis simplified the lens by cementing two of the components, while Dr. Rudolph improved secondary aberrations by using a cemented doublet in place of one of the components, thereby inventing the well-known Zeiss Tessar lens in 1904. Many modern

lenses are based on the triplet design, though some, such as the Sonnar $f/1\cdot5$, employ more components.

The discovery in 1934 of another set of new glasses—the rare-earth glasses—has led to still further improvements both in lenses of fairly simple structure and others of complex design.

Lens Aperture—*f/numbers*

We have already seen (p. 32) that the brightness of an image formed by a perfectly transparent lens is proportional to:

$$\left(\frac{lens\ diameter}{focal\ length}\right)_2$$

But since the lens diameter is almost always smaller than the focal length, this function would be a fraction. To avoid this, the image brightness produced by a lens is normally taken as the ratio between focal length and lens diameter, the value being termed the f/number. In this case the image brightness is inversely proportional to the f/number squared. Thus if we compared two lenses, one of $f/2$ and the other of $f/4$, a little arithmetic shows that the image of the $f/2$ lens will be *four* times as bright than that of the $f/4$ lens.

The maximum aperture of a lens is, however, seldom used in practice. There are a number of reasons for using a smaller opening such as control of exposure, increasing depth of field and obtaining maximum lens performance which are discussed later in this chapter. This reduction in the opening was originally obtained by inserting metal discs known as Waterhouse stops in the plane occupied by the normal lens stop. These were graded to give a ratio of 2, and the term 'stop' is still commonly used to denote a change in exposure of this magnitude. However, the Waterhouse stop was replaced by a variable iris diaphragm which could be adjusted in size against a scale of f/numbers calculated to give a ratio of 2 (or one stop) between one number and the next. Two scales of numbers were in use, as shown below:

British: $f/2$, $f/2\cdot8$, $f/4$, $f/5\cdot6$, $f/8$, $f/11$, etc.
Continental: $f/2\cdot2$, $f/3\cdot2$, $f/4\cdot5$, $f/6\cdot3$, $f/9$, $f/12\cdot5$, etc.

It can be seen that they differ by about a third of a stop. However, since the last war the British scale has been adopted on an international basis.

The f/number system is open to criticism on the grounds that a lens is not perfectly transparent and absorbs some of the light. In practice this is negligible as a total thickness of 5 cm of glass absorbs only 2·5 per cent of the visible light. A more serious loss occurs by reflection of light at the air-to-glass interfaces. For an uncoated lens, loss by reflection is roughly 5 per cent at every air-to-glass interface, and is thus about 10 per cent for a single lens, but can be as high as 40 per cent for a complex lens having 10 interfaces. This loss of light is known as the *flare factor*. It was to allow for losses from both causes that a new system of calibrating lenses—known as T stops—was proposed, based on the actual transmission of the lens. However, the coating of lenses, which was started at about the same time, proved so effective in reducing the loss of light by reflection that the T stop system proved an unnecessary refinement (see below).

The f/number system holds good in practice for most general photography since the distance between the lens and film is roughly the same as the focal length of the lens. However, when the object to be photographed is at a distance less than ten times the focal length, the lens-to-film distance becomes significantly greater than the focal length. In this case the effective f/number is found by means of the following equation:

$$nominal\ f\ /number\ \times\ \frac{lens\text{-}to\text{-}film\ distance}{focal\ length}$$

Lens Coating

This is based on the phenomenon of light interference already referred to on p. 36. The thickness of the layer is usually adjusted to give maximum transmission in the green-yellow region of the spectrum. At first calcium floride was used for lens coating, but the layer was physically soft and was easily rubbed off. Other fluorides are now used which are as durable as the glass itself.

Coated lenses have the desirable characteristics of virtual absence of flare spots and ghost spots which are due to unwanted surface reflections. It might be imagined that because more light is transmitted by the coated lens some decrease in exposure would be needed. This is not so in practice. Surface reflections cause light from the brightest areas of the subject to be scattered over the shadows of the image formed in the camera thus increasing their density (in the negative). Thus if exposure is based on the shadows,

more exposure would be needed to produce the same density because of the reduction of scattered light. The main effect of a coated lens is to give increased contrast and 'cleaner' colours when using colour materials. All complex lenses used in photography are now coated.

Lens Angle

If we return for a moment to the pinhole camera, it can be readily seen that the angle of view obtained will depend on the distance of the sensitive material from the pinhole (Fig. 2). The same principle holds good for camera lenses irrespective of their aperture.

WIDE

NORMAL

NARROW

Fig. 2. The angle of a pinhole camera varies with the film distance. The same situation applies to lenses.

For general still photography, the practice is to use a lens whose focal length is approximately equal to the diameter of a circle which will just fit the rectangle of the picture area of the camera. This gives an angle of 53° as the normal, though in practice it may vary between 45° to 60° with different cameras. It follows that if the definition is to be equally good over the whole picture area, the lens must be corrected to cover this angle of view. But as we have seen, lens aberrations tend to increase with the obliquity of the light rays and few lenses fulfil this requirement at maximum aperture.

The 'standard' focal length of a cine camera lens is usually twice that for still photography and therefore gives an angle of about 26°. Such a lens would be considered a moderately long-focus lens for a still camera. However, many of the better class miniature

cameras and nearly all technical cameras are designed to allow lenses of different focal length to be fitted according to the requirements of photography. For portraiture, a lens of twice or three times the normal focal length may be used in order to obtain a pleasing perspective: lenses of even longer focal length would be used for distant subjects, such as big game, or in the press photography of sports events. On the other hand, for interiors or other subjects with restricted working distance for the camera, lenses of shorter focal length or a wider angle of view will be used. In both cases certain requirements must be met.

Long-Focus and Telephoto Lenses

In designing a long-focus lens for a given picture size, it is possible to take into account the smaller angle of oblique rays and hence smaller amount of correction needed for aberrations which occur at the edges of the field. With very long focus lenses, relatively simple designs can be used. However, for miniature cameras the problem is more one of bulk: the long tube of a 'straight' lens would tend to unbalance the camera. For this reason the majority of long focus lenses are of telephoto type which is based on a combination of a convergent and divergent lens, as shown in Fig. 3. A converging

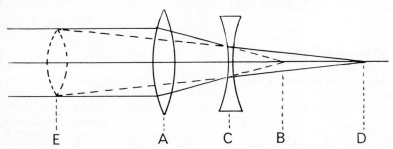

Fig. 3. Optical diagram of telephoto lens.

lens A would bring parallel light to a focus at B. Between A and B is inserted a divergent lens which makes the focus recede to D. By projecting the boundary rays from D until they meet the boundary rays of the parallel beam at E, it is seen that the compact arrangement of back focus is equivalent to a lens of much longer focal length placed at E.

Indeed one can go a stage further by moving A away from or towards C, making it possible to vary the focal length of the com-

bination. This is the principle of the 'zoom' lens used in cine photography for obtaining the effect of dollying to or from a subject.

For such a lens to be effective, the movement must be so adjusted that the focus falls accurately on the film at all focal lengths. Moreover, the f/number of the lens must remain unchanged and aberrations must be corrected at all focal lengths. Such lenses are therefore very complicated (and hence expensive). A typical zoom lens for a 16 mm. cine camera is shown in Fig. 4, the focal length vary-

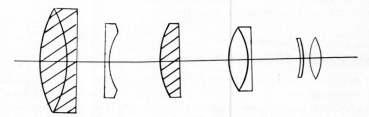

Fig. 4. Diagram of variable focus or zoom lens.

ing from 20 to 60 mm. at a constant aperture of $f/2\cdot8$. The movable components are shaded. Lenses of this type, more appropriately known as variable focus lenses, are now being applied to miniature still photography as a means of replacing a number of interchangeable lenses of different focal length.

Wide-Angle Lenses

Lenses which take in an angle of 65° or more are usually classified as wide-angle. It is here that the lens designer must reconsider the effect of aberrations. So that all rays strike the lens as nearly normally as possible, many wide-angle lenses tend to be strongly meniscus and arranged on each side of a small stop. The required standard of correction is often only obtained by limiting the maximum aperture to $f/8$ or even $f/16$, though in recent years lenses have appeared which give acceptable performance at $f/2\cdot8$. One of the 'classic' wide-angle lenses is the Ross $f/5\cdot6$ which covers an angle of about 100°.

Standard lenses for use with view cameras must also possess a much wider covering power than normal to allow for various camera movements, such as rising front and back tilt, see p. 70.

An alternative wide-angle lens design is the 'reversed telephoto' type. By reversing the lens, an effect equivalent to looking through

the wrong end of a telescope is obtained and so includes much more of the field of view.

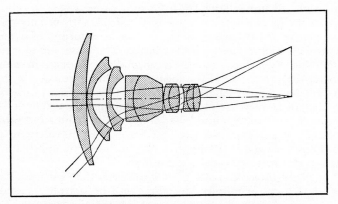

Fig. 5. Diagram of the f /4, 20 mm. Flektogon wide-angle lens.

Convertible Lenses

The modern convertible lens (not to be confused with the early type mentioned on p. 52) was developed to simplify the interchanging of lenses in an eye-level reflex camera by interchanging the front component of the standard lens with either a telephoto or wide-angle component. Though this simplified the mechanical construction of the camera in leaving the shutter and pre-set lens diaphragm unchanged, the interchangeable lens components are anything but simple and involve as many as six elements (Fig. 6).

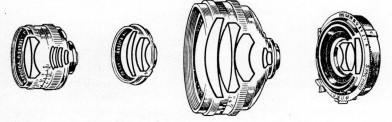

Fig. 6. Convertible lens system with interchangeable wide, normal and telephoto front components for use with a common rear component mounted at the rear of the shutter.

Supplementary Lenses

These are thin lenses of either positive or negative character which can be placed immediately in front of a camera lens to reduce or increase the focal length. Positive lenses of this sort, usually referred to as *close-up* lenses, are commonly used as a means of extending the near focusing range of hand cameras. The lenses are of meniscus design and their focal length is normally expressed in dioptres, namely, the reciprocal of the focal length in metres. A +1 dioptre lens thus has a focal length of 1 metre. This method of expressing focal length is very useful since the combined focal length of two or more lenses can be found by adding positive values and subtracting negative values. Thus two +2 lenses are equivalent to a +4 lens. Lenses of up to +10 dioptres may be used, though better class lenses of this sort are usually achromats.

A point of interest to the photographer is that with the camera lens set to focus at infinity, an object will be sharply focused at a distance equal to the focal length of the supplementary lens. Thus a +2 dioptre lens will give a sharp image of an object ½ metre (19½ in.) from the supplementary lens.

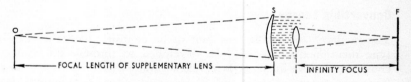

Fig. 7. Positive supplementary lens used for close-up photography.

One advantage of using supplementary lenses for close-up photography is that the effective f/number of the camera lens is unchanged whereas by a normal extension of the lens, as we have seen, the effective f/number becomes greater (the relative aperture smaller).

Perspective

Since (ignoring minor errors caused by lens aberrations) the camera records a view exactly as seen from a certain viewpoint—that of the camera lens—the perspective of the final print *must* be correct, provided the prints are viewed correctly. Most of the apparent distortion produced by wide-angle and telephoto lenses is due to viewing the print at the wrong distance.

It is obvious from Fig. 11 (p. 33) that, irrespective of focal length, the print will represent the view as the eye saw it, provided that a contact print is held at a distance from the eye equal to the distance of the image from the lens. For most subjects, this distance is very nearly equal to the focal length of the lens. If a print is enlarged by *x* diameters, then the viewing distance of the print to subtend the same angle at the eye, and thus to give correct perspective, should be *x* times the focal length. Now the normal distance for viewing a hand-held print is about 10in., so that cameras of about 10in. focal length are the only ones which will give a *contact* print showing correct perspective. Such cameras are hardly ever used nowadays, so that virtually all contact prints give distorted perspective. Fortunately, the distortion is unnoticeable except when near objects are included, and even then they must be such that a distortion in size is obvious—thus a part of the body near the camera will show up distortion if it is out of proportion with the rest of the figure, but a bush or gate would not make it obvious since they may have any dimension relative to other objects.

From this consideration of distortion of perspective, we can draw an interesting conclusion. Since we shall view a print at about 10in. from the eye, correct perspective will result if we enlarge a print from a negative by a factor of ten divided by the focal length in inches. Thus a print from a miniature camera of 2in. focal length should be enlarged five diameters. It will then be identical with a contact print from a negative taken from the same viewpoint in a 10in. focal length camera. But the angle of view of most cameras is fairly constant, about 50°, which is approximately that subtended by 8 x 6in. print viewed at 10in. from the eye. One can therefore formulate the rule that a print of this size from the whole of the negative gives about the correct perspective for hand-viewing. Exceptions are, of course, cameras with wide-angle or telephoto lenses, or indeed with any lens whose angle of view is very different from 50°. Obviously if only a portion of the negative is used, then the dimension must be reduced accordingly. Again, if prints are exhibited on a wall, the normal viewing distance is about 3ft., and the longer side should therefore be increased to about 24in.

Converging Verticals

A photograph showing parallel horizontal lines converging as they appear to do so to the eye, is completely acceptable as a true representation of the view. This is true whether the horizontal lines are

Fig. 8a and b. Convergence of horizontal lines is acceptable.

side by side, as in railway tracks (Fig. 8a) or one above the other as in the facades of buildings (Fig. 8b). On the other hand, vertical lines showing convergence of a relatively small amount, as occurs in a photograph if we tilt the camera up a small amount to include the whole of a building, look anything but right and suggest that the building is toppling backwards, compare Fig. 8c and d.

Fig. 8c and d. Convergence of vertical lines due to tilting the camera is usually unacceptable.

The explanation seems to lie partly in the fact that the eye sees such converging verticals only when looking up, whereas the photograph is normally viewed on the level. If the print is held vertically some distance above eye level, the convergence becomes more acceptable. There seems also to be something of the preconceived idea in the way we see verticals: knowing they are vertical, we tend to see them as such. This rarely applies to the viewing of a print for the simple reason that the parallel sides of the print draw attention to the convergence.

The remedy, apart from not tilting the camera, is to 'correct' the verticals when a print is made from the negative, see page 248. However, certain cameras of the 'view' or technical kind, allow the lens to be raised relative to the picture area of the camera, so

as to include more of the top and less of the foreground in the recorded image. Alternatively the camera can be tilted upwards and the focal plane tilted so that it remains vertical or the adjustment may consist of applying something of both movements. Cameras of this sort are commonly used for architectural photography and will be dealt with more fully in the next chapter, p. 69.

Circle of Confusion and Depth of Focus

A perfect lens in perfect focus would render a point on the object as a point on the image. But since perfection is unattainable, a point is rendered as a small circular area of light, called the *circle of confusion.* The size of this circle will depend on the quality of the lens and the accuracy of focusing. Obviously, the smaller the circle of confusion the better the definition of the image. However, at the normal viewing distance of 10in., a circle of about $\frac{1}{100}$in. in diameter appears as a perfectly sharp point, so that an image appears to be in sharpest focus if a point is rendered as an area not greater than this dimension. With a given lens, there will thus be a certain latitude in focusing within which the circle of confusion is less than this minimum, and the distance between the front and rear limits is termed the *depth of focus.*

Depth of focus should not be confused with *depth of field* which is discussed later. Depth of focus is concerned solely with the permissible movement of the sensitive material in the camera, relative to a fixed focal plane of the image. It therefore concerns a photographer only in regard to accuracy of focusing with, for example, a ground glass screen. Since most photographers do not possess cameras of this sort, they have no practical interest in depth of focus, and have to rely on the camera manufacturers for ensuring that the sensitive material is positioned within the tolerable depth of focus.

From Fig. 9, it is clear that the depth of focus is increased by decreasing the aperture. Conceptions of depth of focus may be clarified by an analogy. If the cone of light from lens to focus is imagined

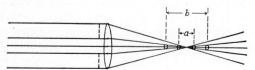

Fig. 9. Depth of focus (*a*) at full aperture; (*b*) with lens stopped down.

to be solid, and the circle of confusion a ring of $\frac{1}{100}$in. internal diameter, then the depth of focus is given by the distance through which the ring will slide before jamming at the limits. Lenses of different focal lengths have the same depth of focus at the same f number, since the angle of the cone of light is the same.

These considerations of circle of confusion and depth of focus apply to the optical image produced by the lens. Clearly they also apply to the image on the negative, and similarly to the paper print, *provided that the latter is a contact print.* If the negative is to be enlarged, a circle of $\frac{1}{100}$in. on the negative will be seen on the print as an area rather than a point, so that the permissible circle of confusion in the camera, and hence the depth of focus, is reduced in proportion to the enlargement of the print. Thus if we make prints *of the same size* from negatives exposed in cameras of different focal lengths, but at the same f number, then the depth of focus will be *smaller* for the *shorter* focal lengths. To produce prints of equal size and sharpness the depth of focus will be directly proportional to the focal length.

Depth of Field

We have seen that there is a certain amount of latitude in the position of the sensitive material relative to the plane of the optical image in the camera (depth of focus). There is similarly a degree of latitude in the position of an object while still retaining sharp focus on sensitive material in a fixed position in the camera. This latitude is known as *depth of field,* and is of much greater practical importance to photographers. If an object O is accurately focused in the camera at I (Fig. 10) there will be positions in front of, and behind the object, which will still be in acceptable focus. The limits will be those positions L_1 and L_2 at which a point on the object will be rendered as a circle of $\frac{1}{100}$in. diameter. The distance between these subsidiary limits is called the *depth of field.*

Now a circle of $\frac{1}{100}$in. diameter at I would be formed by a circle of $\frac{1}{100} \times u/v$in. diameter at O (*see* p. 35). The limits L_1 and L_2 are therefore those points which form cones of light with the lens as base, such that the plane of O will intercept a circle of diameter $\frac{1}{100} \times u/v$in. As the object O approaches the lens, the depth of field will rapidly decrease, because not only will the angle of cone increase, but also the circle which gives an image of $\frac{1}{100}$in. diameter must decrease in size as u decreases and v increases.

Moreover, it will be seen from Fig. 10 that by stopping down the

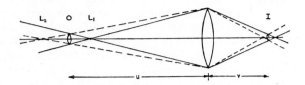

Fig. 10. Diagram showing depth of field—L_1 to L_2.

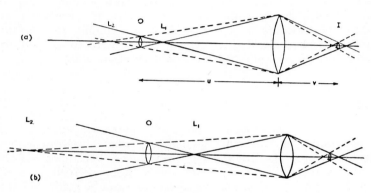

Fig. 11. Diagram showing increased depth of field
with shorter focal length.

lens, we should decrease the angle of the cones and hence *increase* the depth of field.

When we compare lenses of different focal lengths, working at the same f number, the advantage lies with short-focus lenses. The circle at O forming an image $\frac{1}{100}$in. diameter at I has a diameter of $\frac{1}{100} \times u/v$in. but u decreases with focal length (for all but near objects, v is practically equal to f), hence the size of the intercepting circle at O will increase as f decreases, giving much longer cones intercepted, and therefore much greater depth of field (Fig. 11).

There is, moreover, a second independent factor operating in the same direction, viz. that the diameter of the lens, and hence the base of the cone, is less, increasing the depth of field once more by a factor of f.

3

The depth of field for the camera image, and hence for contact prints, is thus inversely proportional to the *square* of the focal length. Enlarging the print from the short-focus camera to compare prints of equal size eliminates one of these factors, but the short-focus lens still has an advantage in inverse ratio to the focal length.

A special condition of depth of field arises when the lens is focused for objects at infinity. While this gives an image at the principal focus of the lens, there will be a certain distance from the lens where a point source will produce at the principal focus, a circle of $\frac{1}{100}$in. diameter. This distance is termed the *hyperfocal distance,* and every object beyond this will be in sharp focus at the principal focal plane. From the arguments advanced in considering depth of field, it will be seen that hyperfocal distance decreases when a lens is stopped down, and is shorter with shorter focus lenses. If a lens is focused on the hyperfocal point, then any object from infinity to a distance of *half* the hyperfocal distance will be in sharp focus, and this principle is utilised in inexpensive fixed-focus cameras.

Lens Performance

Almost the only advantage of lenses of large relative aperture is the brighter image. On the other hand, they give less latitude in depth of field and depth of focus, and the effect of lens aberrations becomes much more marked as aperture increases. Large-aperture lenses wholly or partially corrected for aberrations can be made, but they are both complex and expensive. We can therefore make the rough generalisation that in paying a high price for a camera lens, we are not buying a lens giving higher image quality, but a lens giving a *brighter* image. This is chiefly of advantage to the photographer who wishes to take photographs under very poor lighting conditions. As a general rule, a well-corrected lens will give its best performance at about 2 stops below its maximum aperture. Further reduction of the aperture may, indeed worsen its performance due to the effect of diffraction, p. 36.

Having decided on the relative aperture, he requires a lens which will give a sharp image, reasonably free from distortion, with adequate rendering of the detail of the original object. Image distortion can be measured by photographing a cross-line screen in a suitable optical system, but the practical photographer can assess his lens by photographing a distant rectangular subject, such as an architectural feature. The ability of a lens to record detail of the original object is not easily measured. Numerous test objects have been

devised with sets of equally spaced black and white lines at different scales. When these are sharply focused, the *resolving power* of the lens is given as the number of black lines per millimetre which can be separately seen in the image plane. This number varies greatly, according to whether the resolving power is measured near the centre or the edge of the field. Moreover, further research has shown that lenses giving high resolving power for black and white lines do not necessarily give the sharpest result nor the best differentiation of the low contrast detail of a distant subject (Chap. 18). Test objects in which the contrast between light and dark is low or graduated according to a *sine wave* function have been more successful and were used in testing aero lenses during the war.

While the experienced practical photographer can soon form an idea of the performance of his lens by a subconscious statistical assessment of many photographs taken with it, there is no simple way of measuring absolutely its ability to give a sharp image, and certainly no way of expressing it as a single figure. Even comparative tests have their pitfalls. Photographing lens test charts, or sheets of newsprint will give some information about the lens, but it will not *necessarily* correlate with sharpness of image, or the rendering of low-contrast detail in distant views.

The best way of comparing lenses is under normal conditions of use. For example, the detail in a distant view which is always available, a distant building taken from the office window perhaps, can be photographed with the lens under examination—first so that some specific detail is in the centre of the picture and then so that it is at the edge. At the same time comparative photographs are taken using a lens which has been chosen as a permanent standard.

THE CAMERA

THE EARLIEST cameras were adaptations of the *camera obscura* —little more than boxes with a lens at one end and the sensitive material at the other. The aperture of the lens was so small and the sensitivity of the material so low that exposures of an hour or more were necessary. There was thus no need for a mechanical shutter: the lens could be uncapped and capped by hand. With the arrival of wet plates, cameras tended to become massive structures. Studio cameras were based on 'whole-plate' size ($8\frac{1}{2}$ x $6\frac{1}{2}$ in.) or larger, and a field camera on 'half-plate' ($6\frac{1}{4}$ x $4\frac{3}{4}$ in.). However, by the end of the nineteenth century, the Kodak box camera invented by George Eastman was already popular and a wide variety of cameras ranging from cabinet-made studio cameras to miniature 'detective' cameras was available.

The manufacture of hand cameras, initiated by the Kodak Company—still among the most active producers—became one of the specialised industries of Germany where it took the form of precision engineering. In 1925 the first Leica appeared, a miniature camera based on the use of 35mm. wide perforated motion picture film and giving a negative 36 x 24 mm. It proved surprisingly popular and has since become the standard size for small hand cameras. During the 1930's a number of miniature camera 'systems' appeared. These included a range of accessories, lenses, attachments and adaptors designed to increase the versatility of the miniature camera. They were intended as much for the professional and technical user as for the amateur.

Since the last war, the German camera industry has found a powerful rival in Japan and in recent years the market has been inundated by an ever-increasing range of small cameras which almost defy classification.

Nor has the technical camera been forgotten. From the hands of the cabinet-maker, it has become the concern of the engineer and can take equal place with other optical instruments.

Fig. 1. The M.P.P. Mk. VIII Micro-Technical camera. It gives a wide range of camera movements.

Technical and View Cameras

It is convenient to start a survey of modern cameras with the view camera as it embodies all the basic features of a versatile camera, and several features which do not exist in the vast majority of small hand cameras. Current sizes range from $3\frac{1}{2}$ x $2\frac{1}{2}$ in. to 10 x 8 in. so that the smallest may be considered portable, while the largest is restricted to studio use. They are intended to take plates or sheet film, though smaller sizes may be used with adaptors to take roll film.

Basically the view camera consists of a base plate or rail on which the two 'ends' of the camera are mounted and may be moved, either towards or away from each other, by means of a rack and pinion. The two ends are joined together with a light-tight bellows and the extension of the bellows between the back and the lens panel is normally twice the focal length of a 'standard' lens (double extension) though in some cases it may be three times (triple extension). The back is square so that the focusing screen or plate-holders can be fitted in either a vertical or horizontal position. A lens-shutter unit, mounted on a small panel, can be fitted into a slotted recess in the front of the camera and readily changed when desired for one of different focal length. Fig. 1.

Focusing and composing the picture is done by observing the image thrown by the lens on to a ground glass. It is, of course, inverted and to obtain maximum brilliance must be viewed under a dark cloth, though most cameras are fitted with a collapsible hood for casual viewing. For viewing, the shutter is set to 'bulb' and kept open by a locking cable release.

Perhaps the most important features of a view camera are the movements which enable the axis of the lens (which is normally centred at 90° to the plane occupied by the sensitive material) to be displaced both vertically or laterally and also rotated about its centre, and other movements which enable the film plane to be tilted.

Fig. 2. Diagram illustrating the effect of a rising front. The outer circle indicates the covering power of the lens and the rectangle the area of the negative. For convenience the image is shown the right way up.

It can be seen from Fig. 2 that an object partly outside the field of view with the camera level and in its normal lens-film position can be centred on the film plane by displacing (in this case raising) the lens by a certain amount. One can, in fact, visualise the lens as covering a much wider field of view than that given by the film plane, and that displacement of the lens amounts to the same thing as moving the film plane to the required area. The useful limit, of course, depends on the angle for which the lens has been corrected. This movement can be used to avoid tilting the camera upwards to take in the whole of a building. This feature, known as a rising front, was often to be found on amateur hand cameras and has recently shown signs of returning.

The other movements (vertical and sideways tilt of the back and the same for the lens) all amount to what can be called a tipped image plane. We take the simple case of the image plane tipped back so that the top is farther away from the lens than the centre of the

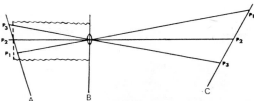

Fig. 3. A tilted film plane and its corresponding object plane. The planes A and C intersect at the same point on a line B at right angles to the lens axis.

plane and the bottom is nearer, as in Fig. 3. Bearing in mind that objects nearer the lens are brought to a focus at a greater distance than those farther away, an object plane giving a sharp image would be represented by a line sloping in the opposite direction to the image plane. If the lens is rotated either vertically or horizontally about its centre, this is equivalent to tilting and at the same time moving the film plane off the lens axis.

Fig. 4. Vertical lines in an object plane B—A will appear vertical on a film plane A₁—B₂ which is vertical, irrespective of lens tilt.

The combination of these movements offers several possibilities. For example, parallel lines in an object will normally only be parallel in the image if the camera is pointed squarely at the object. Any tilt of the camera upwards, downwards or sideways will give some degree of convergence. However, the lines will be parallel in the image if the image plane is kept parallel to the object plane (Fig. 4.). Since this movement of the image plane is the reverse of what we want for obtaining a *sharp* image over the whole plane, it is advantageous to rotate the lens to a certain extent in the same direction. In this way it is no longer necessary to use a very small lens stop to obtain sufficient depth of field for an object fairly near the camera. If the object is at a considerable distance, as in the case of a building, the problem of depth of field does not arise.

Fig. 5. Instamatic camera with simplified film loading and built-in flash-firing mechanism. The flash cube contains four bulbs which can be fired in rapid succession.

The possibility of varying the distance between the image plane and the lens also makes the technical camera an ideal instrument for close-ups and photomacrography (magnifications of the object). With an extension equal to twice the focal length of the normal angle lens, same-scale images are possible. However, by using a lens of much shorter focal length, the same extension makes it possible to obtain images of considerable magnification.

Roll Film Cameras

It is convenient, rather than logical, to deal with the overwhelming majority of cameras on the basis that they are designed to take roll film. It might be more logical to describe them as cameras which do not make use of a ground-glass screen or cameras in which the film plane is fixed in relation to the lens except for normal focusing movement. But perhaps the real difference is that they are designed to be used in the hand as a convenient instrument for general photography.

Film Loading

Films designed for daylight loading fall into two classes, those spooled on a flanged core with a much greater length of opaque paper for protection against light fogging, and those loaded in

Fig. 6. Alpa 9d eye-level reflex camera giving 36 × 24 mm. on 35 mm. film. It embodies three cadmium sulphide cells to control exposure.

Fig. 7. Rolleiflex camera giving 6 × 6 cm. format on 120 roll film.

cassettes or cartridges. The former, commonly referred to as 'roll films', are loaded into the camera by attaching the paper to the take-up spool and after closing the back of the camera, winding on until number 1 appears in a small safelight window in the back of the camera. Successive frames of film are brought into the image plane in the same way and when the last exposure has been made the remaining length of paper is wound off and the film may be taken out of the camera. Some cameras dispense with the inspection window and employ a toothed wheel which 'measures' the required length of new film for each frame, thus speeding up the operation. As the use of 35mm. perforated film does not call for a visual frame numbering system (the perforations themselves are used for measuring the required length for each frame), the film is contained in a light-tight cassette with a slot through which the film can pass. The film is attached to the take-up spool, and after the camera back has been closed, two or three frames wound on to dispose of the part which has been fogged. Cassettes may contain sufficient film for 12, 20 or 36 frames based on a format of 36 x 24mm. A frame counter is embodied in the winding device and when this shows that the last exposure has been made, the film is wound back into its cassette and may then be safely removed from the camera.

As a method of simplifying the loading operation, the film may also be in the form of a cartridge or magazine which embodies its own take-up spool. A single perforation to mark the position of each frame, enables the film to be transported, frame by frame, by the simple action of a lever.

Size and Format

Since the beginning of the century, when a hand camera giving a postcard size negative was regarded as normal, there has been a steady trend towards a smaller negative size. This has been partly due to the improvements in the 'graininess' of negative films which permit enlarged prints to be made from small negatives, partly on the grounds of increased portability (smaller negatives permit the camera to be smaller) and partly through the advent of colour films which give direct colour transparencies (small transparencies are equally good and less expensive). Current sizes range from 11 x 8 mm. (based on the use of 16mm. cine film) to 6 x 6 cm. (based on the use of 120 roll film or 70mm. wide perforated film). Cameras based on 35mm. perforated film are regarded as 'standard' when they

give a picture format of 36 x 24mm., but there has been a recent trend towards 'half-frame' cameras giving a picture of 24 x 18mm.

While it is usually considered that a rectangular format (either horizontal or vertical) with an aspect ratio of 4 : 3 gives the most satisfying shape for a picture area, no standard has ever been adopted for general purpose cameras. View cameras approach more closely to the ideal, and we find such sizes as 8½ x 6½ in., 12 x 9cm. etc. A great many small cameras give a square picture, while the standard for 35mm. (36 x 24mm.) gives a 3 : 2 aspect ratio. For a negative which is to be enlarged, the format is not important. Indeed, there is something to be said for the square format which makes fuller use of the covering power and angle of the lens. For small transparencies, however, a rectangular format is preferable to a square one on the grounds of composition.

The Lens

Here again there is considerable variation. In the cheapest of cameras, the lens will consist of a single meniscus lens of fixed aperture and permanently set at the hyperfocal distance (p. 66). This is only feasible for a small aperture lens or one of very short focal length such as that fitted to a camera giving an 11 x 8mm. picture or narrow gauge cine cameras based on 8mm. width film. In the case of the cheap snapshot camera, photography is practical on the basis of using a film whose speed is about right for well-lit exterior views at a small aperture and fixed shutter speed. However, such a camera is usually synchronised for flashbulbs, and may thus be used for snapshots indoors without recourse to 'time' exposures.

If we skip by a number of intermediate-priced cameras, we come to a large group, ranging in price from £10 upwards, which have a fixed lens of fairly large aperture and reasonably good correction. As depth of field decreases with larger apertures, the camera will embody some means of focusing the lens over a range of distances from about 3 feet to infinity. The lens mount will also incorporate a variable speed shutter of the diaphragm type, p. 81. Some cameras in this group offer limited changeability of focal length by means of convertible lenses, p. 59.

In the third group, with prices often exceeding £100, the lens is made detachable so that others of different focal length may be fitted. In this case the shutter is usually of the focal plane type, p. 81, though in a number of cameras a diaphragm shutter is fitted

immediately behind the lens. This places certain limitations on the use of lens extensions (in photomacrography), but gives the advantage of shutter synchronisation at all speeds with electronic flash. Since many cameras in this group embody pre-set lens diaphragm control, additional lenses tend to be very expensive.

Focusing

We have already seen that focusing with a view camera is done visually by observing the image on a ground glass screen. This method is obviously not convenient for a hand camera, but the same effect is obtained by a system known as reflex focusing. This can take various forms, but basically, it consists of inserting a hinged mirror between the lens and the image plane so as to re-direct the image to a ground-glass screen at the top of the camera (Fig 8a).

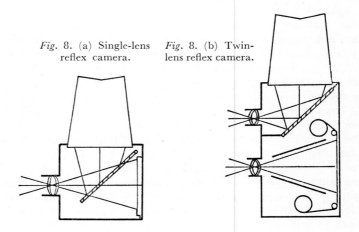

Fig. 8. (a) Single-lens reflex camera.

Fig. 8. (b) Twin-lens reflex camera.

As the optical distance of the ground-glass screen is identical to that of the focal plane, an image which appears sharp on the reflex screen will be sharp in the negative. The act of releasing the shutter first causes the mirror to hinge upwards to the roof to leave the optical path clear and seal off the viewing screen. It has the minor disadvantage that the image disappears from the screen a moment before the exposure is made. Rather more serious objections are that the image is reversed left to right and is therefore misleading

in trying to follow a subject in motion and, with a small camera, the image is too small for critical focusing and needs an auxiliary magnifier.

A considerable improvement in this system was introduced in 1950 by embodying a pentaprism and eye-lens so that the ground-glass screen could be viewed at eye-level to give an image of roughly natural size. The purpose of the five-sided prism is to present an erect image which is also the right way round (Fig. 9).

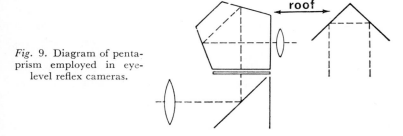

Fig. 9. Diagram of penta-prism employed in eye-level reflex cameras.

The great advantage of the reflex system is that it can be used to focus lenses of any focal length as well as for using extension devices and supplementary lenses. A recent development has been the use of semi-silvered mirrors to obviate the need to raise the mirror for making the exposure.

An interesting variation of the reflex system employs a second lens in the camera of the same focal length and situated above the taking lens (Fig. 8b). As the lens is only used for viewing it needs only moderate correction.

The need for accurate focusing increases rapidly as the scale of the image increases (closer working distances or longer focus lenses) and also as the lens aperture is increased. As we have seen, the cheapest cameras offer acceptably sharp images for objects 7 feet or more from the lens. For subjects at closer distances, a lower-power positive lens—sometimes known as a portrait attachment—extends the near distance range to about 4 ft. In this case the distance must be measured with reasonable care and objects in the distance will be rendered slightly out of focus.

With lenses of larger aperture some means of focusing becomes necessary. In early hand cameras, the lens panel could be moved forward for objects at closer distances against an engraved distance scale. But the distances involved are small and become smaller still with short focus lenses. To overcome this, a screw thread has been

adopted as the most satisfactory method of making the small adjustments quickly and accurately. Depending on the amount of forward movement needed, the thread can be either fine, moderate, or coarse and, indeed, in some cases takes the form of a helical thread. The forward movement, now accomplished by slightly less than a complete rotation of the thread mount, can be shown against a distance scale on the face of the mount. With more modestly-priced cameras only the front component of the lens is moved, the effect being to change the focal length in such a way that the fixed distance between the rest of the lens and the film fits subjects at closer distances.

Usually the focusing movement only extends to a near distance equal to about ten times the focal length. If the camera lens is a fixture, nearer object distances can be obtained by the use of supplementary lenses, p. 60. If the lens is detachable, an extension tube or a bellows attachment is fitted between the lens and the camera body.

Focusing by means of a calibrated scale is quite accurate if the object-to-lens distance can be assessed accurately. While this can be paced out or measured with a tape measure, a more convenient method is to use a range-finder. This device measures distance on the basis of parallax between two separate views of a small area. In one type two images are adjusted until they exactly overlap, in another type the image is split into two halves which must be brought into register. The distance can then be read off a scale and applied to the distance scale of the camera. A rangefinder is often built into the camera and coupled to the focusing movement of the lens.

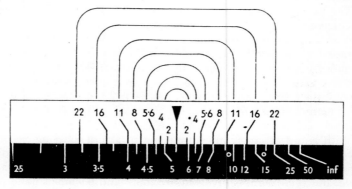

Fig. 10. Depth of field scale adjacent to the distance scale of a camera lens.

A third type of rangefinder usually fitted to eye-level reflex cameras as an alternative to ground-glass focusing, employs two semi-circular wedges of glass mounted in a circular hole in the centre of the focusing screen so that the thin end of one wedge lies alongside the thick end of the other. The point where the two surfaces cross lies in the plane of focus so that where a line or other sharp edge is out of focus the object is displaced after the style of a split-image rangefinder of the type already referred to.

The rangefinder gives no clue to the extent of depth of field and this is also true for most reflex cameras except at maximum aperture. To compensate for this, the distance scale of the lens normally lies alongside a depth of field indicator (Fig. 10). Properly used, the depth of field indicator can be a valuable aid to focusing since at the small apertures ($f/8$ or $f/11$) normally used for outdoor photography, 'zones of focus' can be selected according to the kind of subject being taken.

The Viewfinder

The focusing screen of the view camera and for that matter of all reflex cameras also serves the purpose of knowing what area of the view in front of the camera will be included in the recorded images However, some reservation must be made in the case of a twin. lens reflex camera, as the viewing lens introduces parallax error- at close distances. Compensation for parallax is normally included up to the nearest focusing distance, but for still closer distances with the use of a supplementary lens, it becomes necessary to make some allowance or to employ special viewing lenses such as those designed for the Rolleiflex camera which correct for parallax.

Having dealt with the ideal viewfinder, it is only necessary to add that most other hand cameras make use of an optical device built into the top of the camera body which defines the picture area and in some cases may also embody the image of the rangefinder and the reading of an exposure meter if it happens to be a semi- or fully-automatic exposure controlled camera. With cameras designed to take interchangeable lenses, an additional accessory viewfinder is needed. Such viewfinders often give parallax correction over the normal range of focusing. The simpler kind of viewfinder generally includes a notch on one of the lenses of the eyepiece to indicate the true area covered by the lens at close or moderately close distances.

Probably the simplest, and in some cases most effective method
of aiming the camera is with a 'frame' or sports finder. This merely
consists of a frame which, when viewed through a peep sight, gives
the field of view covered by the lens. It is commonly used by press
photographers and others concerned with action subjects. Its
advantage is that the subject can be easily observed while still
outside the frame area. A framefinder or field frame is also a valuable
aid to close-ups, though here it is employed in a different manner
(Fig. 11).

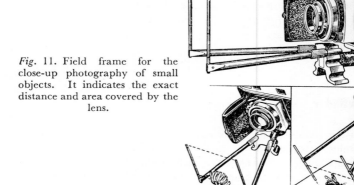

Fig. 11. Field frame for the
close-up photography of small
objects. It indicates the exact
distance and area covered by the
lens.

The Shutter

The amount of exposure given to a film in the camera is a product
of the average intensity of the light falling on the film and its time
of action. The methods of assessing exposure are dealt with in a
later chapter and we have already discussed the function of the iris
diaphragm as a means of controlling the intensity of light falling
on the film, p. 54. We need therefore only concern ourselves at
present with the second means of controlling exposure, the shutter.

The first photographic portraits required an exposure of as much
as an hour in bright sunlight. The exposure mechanism was nothing
more than a light-tight cap which was removed at the beginning
of the exposure and replaced either at the end of the exposure or
when the sitter fainted. Increased speeds of photographic materials
and the evolution of large-aperture lenses have brought the exposure
down to a small fraction of a second, and made it necessary to buipį

into the camera a mechanical device for opening and closing the
lens.

Shutters have evolved along two lines: the *lens shutter* which
intercepts the light just in front, just behind or between the lens
components, and the *focal-plane* shutter which intercepts the light as
near to the sensitive material as possible. Each type has its advant-
ages and disadvantages.

Lens shutters: The snapshot camera has a very simple type of
shutter in which pressure on the release button compresses a spring
until it flicks a thin metal plate from one position to another just
behind the lens. A hole in the centre of the plate uncovers the lens
for about $\frac{1}{40}$sec. The removal of pressure from the button causes
the plate to return to its original position but a capping plate
prevents exposure on the return journey.

A more elaborate shutter makes use of the movement of a circular
metal plate and is known as the sector shutter. The duration of
exposure can be varied either by changing the angle of the sector
or its speed of rotation. Shutters of this type are commonly used in
cine cameras.

The most commonly used lens shutter (if we ignore the numerical
superiority of snapshot cameras) is that known as the *diaphragm*
or *leaf shutter*. This consists of three or five thin metal blades, inter-
leaved and capable of rotating round pivots round the lens. The
motive power is a spring which is pre-tensioned, either by a separate
lever or by the action of winding on the film. Pressure on the release
button allows the spring to rotate the blades of the shutter so that
each in concert uncovers part of the lens. The action of the spring
is controlled by a small gear train enabling exposure times of from
1 to $\frac{1}{500}$sec. to be made. In some cases an additional gear train can
be brought into play as a delayed action release with the object of
allowing the photographer to feature in his own photographs. In
an alternative and simpler version known as the *ever-set shutter*, the
first part of the shutter release action tensions the spring and the
continued pressure of the button then releases the blades.

Focal-plane shutters: These consist basically of an opaque blind with
a transverse slit which passes across the film, as near to the film as
possible. A range of speeds is obtained either by varying the speed
of travel of the blind, or the width of the slit. In practice the speed
range is obtained in two stages. Slow speeds from 2 to $\frac{1}{30}$ sec.
are obtained by varying the time during which a slit equal to the full
width of the picture area remains in front of the film. In this case the

action of the shutter is similar to that of a diaphragm shutter, in that the whole of the film is being exposed at the same time. The faster speed range from $\frac{1}{60}$ to $\frac{1}{1000}$sec. is obtained by varying the width of the slit, while the actual time of travel remains constant at around $\frac{1}{30}$sec. Thus, although the effective exposure in terms of light action may be only $\frac{1}{1000}$sec., the duration for the whole picture area is $\frac{1}{30}$sec. This factor can introduce distortions in the image of a fast-moving object. If the image of the subject, which in the camera is upside down and reversed left to right, moves in the same direction as that of the slit, the subject will be somewhat elongated, with the reverse effect when the image moves in the opposite direction. A more complex distortion occurs with the slit moving vertically to a horizontal movement of the image. In this case the upper part of the image will be displaced in relation to the lower, either backwards or forwards depending on its direction. However, such distortions will be avoided if the camera is swung or panned in the direction of the moving object at the time of exposure.

Shutter Efficiency

The blades of a diaphragm shutter necessarily take time to open and close, so that the shutter is not fully open during the whole of the shutter action. The action of a good modern shutter is shown in Fig. 13, which has been obtained by the use of an electronic shutter-testing machine.

The total amount of light let through by the shutter (represented

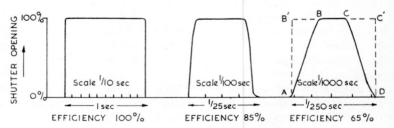

Fig. 13. Shutter efficiency diagram.

by the area *ABCD*) is thus less than the light which would have been passed had the opening and closing of the blades occupied no time (represented by the rectangle AB^1C^1D). Shutter efficiency is represented by the ratio of the former to the latter, and for a good between-lens shutter set at $\frac{1}{50}$sec. should be about 85-90 per cent.

The time taken to open and close the blades is largely independent

of the total exposure time, so that the shorter the exposure, the greater the *proportion* of it occupied by opening and shutting. This naturally lowers efficiency of the shutter.

Again, if a lens is stopped down to a low aperture, the shutter blades will uncover this smaller central area during the first part of their opening; opening and closing a stopped down lens will therefore be a more rapid operation. Efficiency thus increases with decreasing aperture.

There is a popular misconception that the time taken to uncover or cover a point on the sensitive material by the leading and following edges of the slot in a focal-plane shutter is virtually zero, and hence that the efficiency of a focal-plane shutter is practically 100 per cent. This would be true if the shutter were in the same plane as the film, or if it had to intercept a *single* ray of light from the lens. In practice, it has of course, to be displaced towards the lens, and the edges of the slot take an appreciable time to travel across the convergent beam of light from the lens to a point on the film (Fig. 14).

The efficiency of a focal-plane shutter is about the same as that of a good diaphragm shutter. As with lens shutters, stopping down and using longer exposure times will increase its efficiency, since either adjustment will decrease the ratio between the diameter of the circle of light intercepted and the width of the slot.

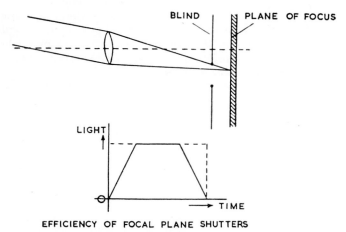

EFFICIENCY OF FOCAL PLANE SHUTTERS

Fig. 14. Efficiency of focal plane shutters.

To sum up, we can say the focal-plane shutter offers a greater speed range and being well-removed from the lens, does not create complications in changing from one lens to another. It presents the

disadvantage of possible distortion of a fast-moving object and is also more difficult to synchronise for flashbulbs exposures over the shorter speed range ($\frac{1}{50}$sec. or less) and unsuitable for electronic flash over the same speed range, see p. 45. The diaphragm shutter presents no difficulties in flash synchronisation, flashbulb or electronic, and does not give distortion (other than blurring) in moving images. On the other hand it has a more restricted speed range and presents complications in the interchangeability of lenses (unless each lens is fitted with its own shutter). However, as we have already mentioned, p. 75, diaphragm shutters can be used just behind the lens for normal distance photography.

Is there an Ideal Camera?

It is a question that might well be asked by the enquiring reader who has the purchase of a fairly expensive camera in mind. It is, of course, an incomplete question and it is necessary to add 'Ideal for what kind of photography?'. Herein lies the answer. No single camera can expect to embody all the features required at some time or another by people who make use of cameras. If you require nothing more than the occasional family record photograph, then the inexpensive snapshot camera could be the ideal. For architectural and commercial display photography, some kind of view camera is the ideal. The portrait photographer might also choose a view camera, but if he specialises in the photography of children or the informal portrait, then a small reflex camera might be the best choice. Most full-time professionals have several cameras and in this lies the real answer to the question.

Chapter 6

THE CHEMISTRY OF PHOTOGRAPHY

W E CANNOT STUDY the chemistry of photography with-
out understanding the fundamental ideas underlying
chemical change, composition and structure, and how they
are conventionally expressed and formulated. The first few pages
of this chapter are therefore devoted to a simple exposition of them.

Chemical and Physical Change

In their studies of natural materials the earlier experimenters were
able to distinguish between two types of change. One is typified by
that taking place when water is converted into ice or steam. Al-
though ice, water and steam have extremely different properties,
their chemical composition is identical—each consists of hydrogen
and oxygen combined in the same proportion. There has been no
chemical change, and this type of alteration is called a *physical
change.*

Diamond, graphite and lamp black would seem to be entirely
different materials—they cover an enormous range in physical
characteristics, from the hardest to the softest, from the brightest
to the blackest—yet examined chemically, all are proved to consist
of pure carbon in three different physical forms. Most pure sub-
stances can exist in different physical forms of very different physical
characteristics but identical chemical composition.

A Seidlitz powder consists essentially of sodium bicarbonate and
tartaric acid. When sodium bicarbonate is dissolved in cold water
the change is physical, but if tartaric acid is added there is the
characteristic *fizz*, due to the evolution of a gas, carbon dioxide.
Chemical examination shows that the final products are very differ-
ent from the initial ones. Sodium bicarbonate and tartaric acid
have, in fact, reacted chemically to produce sodium tartrate and
carbon dioxide.

Elements and Compounds

In our study of the chemistry of photography we shall be consider-
ing a number of substances, such as silver bromide, silver, water‘

85

hydroquinone, hypo, etc. Many of these can be split by normal chemical treatment into two or more different substances. Silver bromide, for example, can be *decomposed* to give silver and bromine. Hypo may be split up into water and anhydrous hypo, and these in turn can be decomposed—water giving two gases, hydrogen and oxygen, and anhydrous hypo giving sodium, sulphur and oxygen. However, a point is soon reached where the constituents cannot be further divided by any ordinary chemical or physical means—we cannot subdivide silver, bromine, hydrogen, oxygen, sodium or sulphur; these are examples of the hundred or so elemental substances of which everything in nature is composed. We call these substances *elements*, and the materials made by chemical combination of elements *compounds*. Thus silver bromide, hydroquinone, gelatin, sodium sulphite and hypo are all examples of chemical compounds.

Atoms and Molecules

When elements combine they do so in certain fixed proportions by weight, thus water always contains one part by weight of hydrogen combined with eight parts of oxygen to give nine parts of water. Silver bromide contains 108 parts silver and 80 parts bromine— any attempt to induce different proportions to combine will give silver bromide of this composition with an unreacted excess of one or the other element. Such observations gave rise to the idea that elements consist of a mass of extremely minute particles of the element—called *atoms*—and that compounds are built up of agglomerates of one or more atoms of each of the individual elements, such agglomerates being called *molecules*. The relative weights of the atoms were deduced from a study of the composition of a large number of compounds, and when related to the lightest element, hydrogen, as unity, provided a list of what are called *atomic weights*. Thus hydrogen has an atomic weight of one, oxygen 16, sodium 23, sulphur 32, and so on.

The correctness of this conception of atoms and molecules has been fully confirmed by later work, and we can now measure the absolute weight and size of the atoms of all elements, and their arrangement and distance apart within the molecules.

Chemical Nomenclature

The chemist has given symbols to the elements, H for hydrogen, O for oxygen, S for sulphur, Br for bromine, Ag for silver (*Lat.*

argentum), Na for sodium (*Gr.* natrium), K for potassium (*Ar.* kalium), etc. A compound can therefore be specified by the symbols for its constituent elements, with small numeral suffixes showing the number of atoms of each element in one molecule of the compound. The compositions and formulae of some typical photographic chemicals are given below:

Compound	*Composition*	*Formula*
Water	2 atoms Hydrogen	H_2O
	1 atom Oxygen	
Silver bromide	1 atom Silver	$AgBr$
	1 atom Bromine	
Anhydrous hypo	2 atoms Sodium	$Na_2S_2O_3$
(sodium	2 atoms Sulphur	
thiosulphate)	3 atoms Oxygen	
Anhydrous sodium	2 atoms Sodium	Na_2SO_3
sulphite	1 atom Sulphur	
	3 atoms Oxygen	

Many crystalline compounds contain water combined with the molecule, called water of crystallisation; thus crystalline hypo contains water combined in the ratio of five molecules of water to one molecule of anhydrous hypo, and it is therefore formulated as:

$$Na_2S_2O_3.5H_2O$$

It is much clearer to differentiate in this way the oxygen in the hypo molecule from that in the combined water. Alternative formulae for crystalline hypo, such as $Na_2H_{10}S_2O_8$, or even $Na_2S_2O_3,H_{10}O_5$, although correct, would be less informative and much more confusing.

Chemical Equations

Not only can chemical compounds be formulated in this way, but also the chemical reactions which such compounds undergo. The initial compounds are formulated on one side of an equation and the products of the reaction on the other. Since matter is indestructible, the number of atoms of each element must be identical on either side of the equation. The reaction between sodium carbonate and hydrochloric acid, for example, is represented thus:

Na_2CO_3	+	$2HCl$	=	$2NaCl$	+	H_2O	+	CO_2
1 mol. Sodium carbonate		2 mols. Hydrochloric acid		2 mols. Sodium chloride		1 mol. Water		1 mol. Carbon dioxide

Often the equality sign is replaced by an arrow to indicate in which direction the reaction normally proceeds. Some reactions are reversible, the direction depending on conditions of temperature, relative concentrations, etc. Reversibility is expressed by replacing the equality sign by double arrows, thus: ⇌. Chemical nomenclature thus fulfils two main functions. It is as useful to a chemist as shorthand is to a stenographer, and at the same time it embodies his knowledge of compounds and their reactions.

After this brief review of the fundamentals of chemistry, we may now proceed to a consideration of the chemistry of photography, where further examples of chemical equations will be found.

The Chemistry of Photography— Light Sensitivity of Silver Salts

Photography is the name given to processes in which pictures are produced by the agency of light. To produce such pictures we must employ a material which is *sensitive* to light, that is to say, one that suffers some chemical or physical change when light acts on it. There are scores of such materials: some materials fade under light action, others darken; some are changed because their molecules are decomposed by light, others because their molecules condense and *polymerise*, that is, join together to form very large molecules; some are rendered more soluble in certain solvents, others less soluble. Any one of these changes could be harnessed to make a photographic process. The pioneers, however, were seeking the most efficient process to produce really good images, and their attention naturally turned to a group of salts which are outstandingly *sensitive* to light—the salts of the metal silver. Many silver salts will darken on exposure to light, a characteristic with three main causes:

(1) Most silver salts are light in colour.
(2) Most silver salts are unstable, many of them decomposing under such mildly disrupting influences as irradiation by light.
(3) When silver salts decompose, metallic silver is usually formed.

The silver is produced in a finely divided state and shows none of the bright metallic appearance characteristic of polished massive silver. It is, in fact, usually jet black in colour, and this accounts for the darkening of silver salts.

The Silver Halides

Of all the silver salts, three were found to be outstandingly suitable for photographic purposes. These are *silver chloride, silver bromide* and

silver iodide, compounds in which silver is chemically combined with the elements chlorine, bromine and iodine respectively. These three elements have very similar chemical properties (they are all members of the same family or group of elements) and are known by the collective term *halogens.* Similarly, the generic name *halide* is given to a chloride, bromide or iodide, together with other salts of the same type which need not concern us here. These three silver halides are very similar in chemical and physical properties, any difference usually showing a transition from chloride, through bromide, to iodide. Thus their colours are white, pale yellow and lemon yellow respectively, and although they are practically insoluble in water, their solubilities decrease in this order.

The silver halides can be made by direct chemical reaction between metallic silver and a halogen, and indeed this was the method used by Daguerre in preparing his plates. He sensitised a polished silver plate (actually silvered copper, for economy) by exposing it to the action of iodine vapour and so produced a thin layer of light-sensitive silver iodide on the surface. One atom of silver combines with one of halogen, so that the reaction is:

$$Ag + X \rightarrow AgX,$$ where X represents chlorine, bromine or iodine.

Double Decomposition

There is, however, another method of preparing silver halides which in many respects shows advantages over the previous method. Metallic silver dissolves easily in dilute nitric acid to give silver nitrate which is, in its turn, easily soluble in pure water to give a clear colourless solution. If this solution is mixed with a solution of an alkali (e.g., potassium, sodium or ammonium) halide, the metallic *ions* exchange their acid *ions.* Thus silver nitrate mixed with potassium bromide will form silver bromide and potassium nitrate. Such a reaction is called *double decomposition,* and in this example would be expressed by the equation:

$$AgNO_3 + KBr \rightarrow AgBr + KNO_3$$

(It will be noted that the nitrate *radical* has the formula NO_3, showing that one atom of nitrogen is combined with three of oxygen. This group of atoms may undergo a series of chemical reactions similar to the above without itself breaking up into its component parts.)

Unless the silver nitrate and potassium bromide are present in exact equivalence, there is bound to be an excess of one or the other remaining.

Fig. 1. Precipitation of silver bromide.

The reaction under examination has one curious characteristic. If we consider the solubility in water of the initial and final products, we find that three of them (silver nitrate, potassium bromide and potassium nitrate) are freely soluble in water, while one, silver bromide, is virtually insoluble. The reaction, therefore, is somewhat spectacular in that on mixing two clear, colourless solutions a pale yellow solid is produced immediately. It takes the form of myriads of minute crystals which immediately *coagulate* or clot together and settle to the bottom of the vessel as a heavy pale yellow curd (Fig. 1). The formation of a solid from solution in this way is called *precipitation* and the solid itself the *precipitate*.

The Photographic Emulsion

It is easy to prepare light-sensitive silver halide in bulk in this way, but it is rather more difficult to arrange for its even spread over the

Fig. 2. Silver bromide precipitated in the presence (*left*) and absence of gelatin.

surface of a support such as glass, film or paper for use in making a photographic image. It was known that the coagulation and settling of a precipitate could be prevented by the presence of a *colloid* (that is, a complex viscous material usually of animal or vegetable origin such as starches, gums, glues, etc.), and when silver halide is precipitated with gelatin dissolved in the alkali halide solution, each crystal or *grain* of silver halide remains substantially separated from its neighbours in perpetual suspension (Fig. 2). Such a suspension can be stored, handled and coated with little or no settling out of the grains; it can in fact be treated almost as though it were a homogeneous liquid. The suspension of minute silver halide crystals in gelatin was called a *photographic emulsion*. This was an unfortunate name, as the term *emulsion* is normally reserved for a dispersion of a liquid in another non-miscible liquid; for example, milk or paraffin emulsion. The term *photographic suspension* might have been more accurate, but the old name is now so traditional and so universally used that any attempts at correction would be quite futile (Fig. 3).

Fig. 3. Photomicrograph of an emulsion (×2,500).

When Dr. Maddox precipitated silver halide in the presence of gelatin, he conferred an inestimable boon upon every photographer from 1871 to the present time, and perhaps for generations to come. Gelatin is so outstandingly suitable as a medium for photographic emulsion that in spite of eighty years of continual work, and the expenditure of vast sums in attempting to discover or to synthesise a better medium, its position has never been seriously challenged. Not only is it an excellent protective colloid (that is, it most effectively

prevents coagulation), but its solution has the useful property of being liquid when warm, and setting to a jelly or *gel* when cool, a characteristic which is utilised in the washing and coating stages. It dries down to a hard, compact, uniform layer which on treatment with water or processing solutions merely swells and does not dissolve or disintegrate. In this way the emulsion can be *processed*, that is submitted to certain chemical reactions without in any way disturbing the position of the image. Gelatin can be hardened by such agents as formalin or chrome alum so as to raise its melting temperature in water or processing solutions, and as if this catalogue were not sufficient in itself, it also contains minute quantities of extremely powerful sensitising agents, which greatly increase the light sensitivity of gelatin emulsions relative to that of emulsions made in other media.

Effect of Light on Silver Halide

There is, of course, much more to the manufacture of a modern photographic emulsion than the precipitation of silver halide in a gelatin medium, and the whole process will be described later. For the present, however, we need note simply that an emulsion consists essentially of minute crystals of silver halide embedded in gelatin. The light-sensitive constituent is the silver halide, which decomposes under light action into its constituent elements, metallic silver and the halogen (chlorine, bromine or iodine). However, as has been shown, these constituents will, unless prevented, re-combine, so that on shutting off the light the reverse action takes place and the original silver halide is re-formed. Taking silver bromide as an example, the reversible reaction may be expressed by the equation:

$$\underset{\text{dark}}{\overset{\text{light}}{AgBr \; \rightleftharpoons \; Ag+Br.}}$$

If pure silver halide is exposed to light in an open vessel so that the liberated halogen, being volatile, can diffuse into the air and be lost, or alternatively if we expose silver halide mixed with some substance which reacts immediately with free halogen to give a stable product, the complete re-combination of the liberated silver and halogen cannot possibly take place, and the action of light results in the permanent formation of some metallic silver. Among the many virtues of gelatin is its ability to combine readily with small quantities of free halogen, to give stable products. When intimately mixed with silver bromide, for example, as in a normal photographic emulsion, it functions as a *bromide acceptor* rendering the action of light on silver bromide permanent. If the action of light on a photographic emulsion

is sufficiently prolonged silver may be formed in such amounts that the emulsion darkens in colour, giving a print-out effect; but a mixture of silver halide and gelatin alone does not give a satisfactory print-out material because, although gelatin may be an excellent acceptor for very small quantities of halogen, it becomes saturated when the emulsion is only slightly tinted. For satisfactory print-out effect it is therefore necessary to incorporate considerable quantities of a second halogen acceptor with the gelatin such as silver citrate, which reacts with the liberated chlorine to form silver chloride. In print-out methods, light provides the whole of the energy necessary to form the silver of the image and hence long exposure to high intensity is required. Fortunately alternative methods of image formation are available.

Development

One of the most striking advances made by Fox Talbot was the observation that when light had produced only a weak image on his photographic paper, it was possible to intensify it by treatment with a mixture of gallic acid and silver nitrate (*see* p. 17). This was an indication that light need not do the whole of the work in producing an image of silver, but that a subsequent chemical process would *develop* the initial feeble image which light forms.

Development has been improved to such an extent since Fox Talbot's day that light performs a negligible amount of the work, the change produced by light being so small that no chemical or physical difference can be found between exposed and unexposed grains of silver halide, other than their reaction to a photographic developer. The fact that a photographic developer is the most sensitive test for light exposure of an emulsion is very fortunate as far as the photographic process is concerned, but not very helpful when we try to find the nature of the change in the grains. When we try to discover by direct evidence why a grain develops, all that we can ascertain is that it does. However, there is a mass of indirect evidence (which will be considered in Chapter 8) which all points to the fact that exposure to light forms a minute amount of metallic silver—only a few atoms of silver in each grain is necessary to cause a difference in the action of a developer on the grain.

A developer is a compound or mixture of compounds capable of converting a silver salt into metallic silver. In chemical parlance, materials which are capable of forming a metal from its salt or oxide are called *reducing agents*, and the metallic salt is said to be *reduced* to the metal. Their action is the opposite of that of *oxidising agents*,

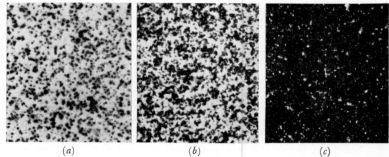

Fig. 4. Photomicrograph of developed densities (\times 370). (*a*) Density = 0.04; (*b*) density = 0.4; (*c*) density = 2.0.

which can convert metals into their oxides or salts. There are scores of reducing agents which are capable of reducing silver bromide to metallic silver, but comparatively few are satisfactory photographic developers. These will, when correctly compounded with other ingredients, reduce even unexposed silver halide of a photographic emulsion to metallic silver, given time, but the small amount of metallic silver formed by light action will accelerate the reduction of exposed grains by a factor of between ten and a hundred times. Hence the action of a developer for a limited time differentiates between exposed and unexposed grains, the former being largely converted to metallic silver, while the latter are substantially unaffected. The developer merely amplifies the work initiated by light, but the amplification factor is enormous—about one thousand million times. The action of a gun can be taken as a rough analogy, light representing the energy required in pulling the trigger, while the enormously greater energy supplied by the explosive in propelling the projectile is analogous to the energy supplied by the developer.

If the silver process had advantages over others in relation to print-out aspects, the introduction of development raises the advantage by a factor of one thousand million, and it seems unlikely that in the near future the paramount position of silver in photography will be seriously challenged.

In exposing a film or plate in the camera, different parts receive different exposures, depending on the intensities of light reflected from different portions of the view. Different parts of the film therefore have different proportions of the crystals or grains rendered developable. After developing, and removing unchanged silver halide grains by dissolving them in hypo, we are left with different population densities of the minute grains of black metallic silver, which produce the light and dark tones of the negative (Fig. 4).

Chapter 7

EMULSION MAKING AND COATING

PREPARING A PHOTOGRAPHIC emulsion is an art which in spite of extensive scientific study over many years, still remains largely empirical. In attempting to produce certain specified characteristics, the emulsion-maker goes into his darkroom and makes scores of emulsions, trying the effect of all sorts of different physical treatments and chemical additions. Finally he selects by trial and error those conditions which give him an emulsion of the desired photographic quality. His work is all the more difficult as the effect of each stage of the process is dependent upon the other stages, so that the introduction of any particular modification may give different results with different emulsions. An experienced emulsion-maker is naturally able to arrive at a desired result after far fewer experiments than a tyro in the art, and the application of scientifically trained minds even to hit-and-miss methods has resulted in the very high standard of present-day materials. But the fact is that in the emulsion-making branch of photographic science, the theorist lags behind in his endeavour to explain results obtained by the practician. Only very occasionally can the theorist forge ahead to point the way to better photographic emulsions.

The Objects of Emulsion Making

It has been explained that an emulsion consists of minute crystals or *grains* of silver halide, suspended in gelatin. The characteristics of an emulsion depend upon the sensitivities of the constituent grains. If, for example, all the grains of an emulsion had the same sensitivity, they would all be substantially unaffected below a critical exposure, and all rendered developable above that exposure. The contrast would be nearly infinite and exposure latitude very small, and a negative would be divided into areas of no density and areas of maximum density, with little or no half-tone. Conversely an emulsion with a wide variation in sensitivity between the grains would have a low contrast and great exposure latitude. The *fog* or *veil* is a measure

of the number of grains spontaneously developable, and the speed depends on the sensitivity of the more sensitive grains.

The way in which sensitivity varies between the grains of an emulsion is called the *grain sensitivity distribution*, and the object of emulsion making is to produce a population of silver halide grains of such sensitivity distribution as will give the desired speed, contrast, exposure range, etc., with minimum average grain size and minimum fog. The sensitivity of an individual grain depends upon its composition, the condition of its surface and external conditions such as alkalinity of the gelatin and concentration of excess alkali halides. When these have been adjusted to the optimum, it is found that the sensitivity of a grain generally varies with its size. We can, therefore, restate the objects of emulsion making as the preparation of an emulsion of the requisite composition and grain *size* distribution, and (in the case of negative materials) the adjustment of conditions so as to produce the maximum sensitivity which each grain is capable of giving.

The composition of the grains, that is, the choice of halide, depends on the type of emulsion being made. Silver chloride is used for slow development papers of the 'Velox' type and for slow lantern plates. A mixture of silver chloride and bromide is used for warm tone development papers of the chloro-bromide type, and silver bromide (usually with a small proportion of silver iodide to enhance speed) for the remaining materials—negative materials of all types, X-ray films and paper, process plates and films, cine positive films, bromide papers, etc.

Grain Size Distribution

Grain size distribution, upon which the potential characteristics of an emulsion depend, is determined by the first two stages in emulsion making—*emulsification* and *ripening*. Emulsification is the name given to the precipitation under safelight conditions of silver halide in gelatin (as previously described). To ensure good reproducibility from batch to batch, this and all subsequent operations must be carried out under the most precise chemical and physical conditions. A silver nitrate solution of specified volume, concentration and temperature is added to a solution of alkali halide and gelatin under controlled conditions of stirring, the alkali halide almost invariably being in chemical excess over the silver nitrate. The silver nitrate solution may be added rapidly, or slowly at a prescribed rate through a jet, or in several portions at controlled intervals, and ammonia may or may not be added to the silver nitrate.

Immediately after emulsification the grains of silver halide may be too small to be resolved by optical microscopes, and the emulsion is usually very insensitive. It is therefore given a specified heat treatment known as *ripening*, usually of the order of 30–60 minutes at 55 °C. During this treatment the grains gradually increase in size and decrease in number (Fig. 1.).

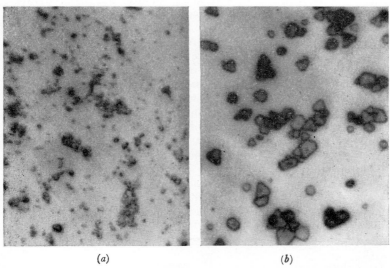

(a) (b)

Fig. 1. Emulsion grains (× 2,500). (a) After emulsification, (b) after full ripening.

The reason for this change, known as *Ostwald ripening*, is that the grains are slightly soluble in the excess alkali halide and in the ammonia, if present. It is found that the solubility of extremely small crystals varies with crystal size, the smaller ones being somewhat more soluble. They therefore pass into solution and crystallise out on the larger crystals. Small grain size distribution, and hence high contrast, is usually obtained by rapid emulsification and short ripening; large grain size dispersity by jet or multiple emulsification with more intense ripening. Since continued ripening gives higher average grain size, it follows that it is more difficult to make fast emulsions of high contrast, or slow, fine grain emulsions of low contrast. One cannot always differentiate between effects due to emulsification conditions and those due to ripening conditions, since in many emulsion formulae (as in jet addition or multiple silver addition), the two processes proceed simultaneously. Although increase

in ripening increases average grain sensitivity and average grain size, it cannot increase the speed of an emulsion indefinitely. For some reason at present unknown, grains begin to lose sensitivity when they exceed a certain size.

Conditioning the Grains

Having adjusted the grain size distribution to the required value, that is, having obtained the *potential* characteristics, it is usual to *realise* the desired characteristics by suitably adjusting surface and external conditions of the grains. At the end of the ripening period the gelatin in which the grains are suspended contains excess alkali halide, alkali nitrate (formed as a by-product from silver nitrate and alkali halide) and frequently ammonia. The presence of alkali halides in the concentrations which normally obtain has a depressing effect on speed, though low concentrations are desirable. The alkali nitrate is present in such concentrations that it would craze the emulsion by crystallising out when coated and dried on film or glass, and the continued presence of ammonia would tend to a slow continuance of ripening. These may all be removed by adding more gelatin, setting the emulsion to a stiff gel, shredding through a perforated silver or stainless steel plate to give *noodles* of up to $\frac{1}{4}$in. diameter (Fig. 2) and washing them in a mesh basket or canvas bag immersed in running water.

Fig. 2. Emulsion noodles.

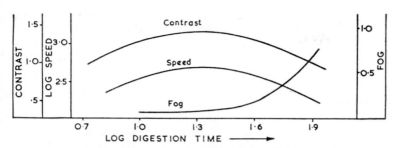

Fig. 3. Variation of speed, contrast and fog with digestion time.

The presence of the soluble salts is not so deleterious when the emulsion is to be coated on paper, as they migrate from the emulsion into the paper base. Moreover, the highest speeds are not necessary for papers, so that many *paper* emulsions—especially chloride emulsions—are unwashed. After ripening, they are merely doctored and coated.

Negative emulsions, which are almost all coated on glass or film, have to be washed, and after the concentration of soluble salts has reached a sufficiently low figure, the shreds are remelted and given a second heat treatment, known as *digestion* or *after-ripening,* times and temperatures being of the same order as in the ripening treatment. The mild solvents for silver halide have been removed during the washing process, so after-ripening has little or no effect on grain size distribution. It has, however, a most marked effect on the sensitivity of the grains. One of the virtues of gelatin as a medium for emulsions is the presence of minute quantities of somewhat unstable organic compounds containing sulphur, which are *adsorbed* (p. 143) on to the surface of the grains and during after-ripening decompose to form silver sulphide. Minute traces of silver sulphide on the surface of the grains are apparently the cause of the greatly increased speed which after-ripening imparts (p. 113). The presence of sulphur-containing bodies in gelatin made from cow-hide is, it would seem, due to the fondness of cows for hot-tasting plants, such as mustard, which contain sulphur. Gelatin made from the hide of animals such as rabbits, which avoid hot-tasting plants, does not give the same high sensitivity, so that, to quote Dr. Mees, 'if cows didn't like mustard, we couldn't go to the movies'.

Excessive after-ripening forms an excess of silver sulphide which gives rise to fog. During after-ripening, speed and contrast increase to a maximum, at which point fog starts to increase at a very rapid rate (Fig. 3). After-ripening is, therefore, accurately controlled so that

optimal characteristics are reached. Anti-bacterial preservatives are added, and the emulsion is immediately chilled to prevent further change and stored in a refrigerated room.

Doctoring

Samples of each emulsion batch are hand-coated and tested to ensure that the photographic properties are as they should be. When the approved batch is required for coating, it is melted and certain solutions, known as *doctors*, added to facilitate coating and to modify the physical and sensitometric properties of the final film. Alcohol, for example, may be added to reduce froth formed during coating, glycerin to make the dried layer more pliable, surface active agents such as saponin or synthetic surface-tension removers to make the dried film more easily wetted by processing solutions and reduce the risk of air bell formation, hardening agents such as chrome alum and formalin to decrease the solubility and swelling in warm solutions, sensitising dyes to extend the natural range of colour sensitivity of the emulsion to give *orthochromatic* or *panchromatic* emulsions, a small addition of alkali halide to give reduction of fog and better keeping properties, gold salts to give increased sensitivity, and other additions may be made for special purposes.

Commercial emulsion-making methods may differ between different manufacturers, and each manufacturer uses certain processes or additions which are guarded as trade secrets, but emulsion making generally follows the broad pattern which has been described.

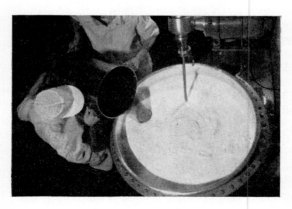

Fig. 4. An emulsion in preparation —the silver nitrate solution is being added.

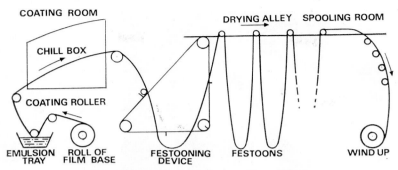

Fig. 5. Film or paper coating machine. (Diag.)

Coating

The *doctored* emulsion is piped to a coating machine in liquid form and applied to the *support* or *base* which may be of the glass, film or paper.

Film- and paper-coating machines are very similar in principle, and necessarily differ markedly from plate-coating machines, because of the difference in flexibility and continuity of the *base* to be coated (Fig. 5). Films and papers are coated in rolls up to four feet in width and two thousand feet in length by passing the base under a roller which just dips into liquid emulsion in a shallow trough, though several alternative methods of applying a uniform layer of liquid to one side of the base have been used in the industry. From the coating unit, the coated paper or film is led over chilled drums, or through a *chill box* containing refrigerated air, whereupon the

Fig. 7. The coating head of film coating machine.
Courtesy: Kodak Ltd.

Fig. 7. Looping in-
to festoons.

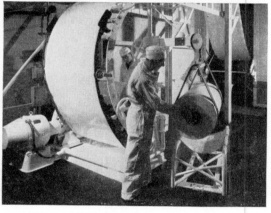

Fig. 8. Delooping
and spooling.

*Photos: Courtesy
Kodak Ltd.*

liquid emulsion sets to a *gel*. The material is then automatically
looped into festoons about six feet deep by two feet wide, by period-
ically hooking up the coated base on wooden poles. The poles with
their dependent festoons are transferred to slowly moving endless
chains which pass down a drying track some three hundred feet in
length. Meticulously clean air of controlled temperature and humid-
ity is led into the drying track, at the far end of which the dry film
or paper is somewhat rehumidified before being automatically de-
looped and spooled, prior to slitting and chopping to the required
size.

Plate-coating machines are built on different lines. The plates to
be coated, butted end to end on an endless band, are fed on to the

machine. The emulsion is fed on to them through a narrow slot across the track and immediately above the plates and set by leading them through a chill box, or on chains over a water bath such that cold water comes in contact with the back of the plates. The set plates are removed, transferred to racks and dried in cupboards.

Fig. 9. Plate coating machine. (Diag.)

The amount of silver halide per unit area of film (coating weight) is an important factor in emulsion coating. Since it affects the photographic quality of a film it should be as uniform as possible over the whole coating, and should approximate closely to the value prescribed for the product coated. This is adjusted to the optimum, that is, to that value at which further increase in coating weight produces no further improvement in characteristics—indeed excessive coating weight introduces adverse properties.

Multiple Coating

Many modern fast negative materials are double-coated, the film first receiving a coating of a slower emulsion before the extremely rapid emulsion is applied. When the exposure is such that the maximum density of the rapid top coat is reached, the slower undercoat comes into play registering a further range of exposures and giving the material extreme exposure latitude. Under conditions of overexposure which would give a uniform maximum density on a single-coated product, a double-coated material would give degrees of intenser blackness which would merely require longer printing time to give a reasonable positive print.

With modern colour films and papers where the sensitivity of the emulsion is divided into three separate layers, coating may involve more than ten stages. This, among other things, explains the much higher cost of colour materials.

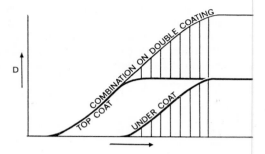

Fig. 10. Double coating.
(Diag.)

Super Coating

If a coated and dried emulsion is subjected to slight surface abrasion, as for example by rubbing lightly with the back of the finger nail, the grains affected become developable, and on development the track of the abrading body shows as a black line. Normal handling of paper or film products, especially the former, would give numerous marks of this type. Fortunately this is merely a surface defect, and can be removed from a developed and fixed film or paper by vigorous rubbing with wet cotton wool. Such abrasion marks could not be produced if the surface were free from silver halide grains. Accordingly most film and paper products are supercoated with a thin layer of gelatin, applied on the set but undried emulsion coating. Plates are seldom super-coated—the rigidity of the support allows

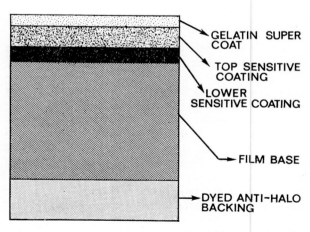

Fig. 11. Cross section of coated film.

handling which does not subject the emulsion surface to such danger, and horizontal coating may allow slight settling of grains from the surface layer.

Baryta and Substratum Coating

A gelatin emulsion will adhere satisfactorily to paper base, but not to untreated film or glass. Nevertheless photographic paper base is usually coated with a layer of barium sulphate, suspended in gelatin, prior to emulsion coating. Barium sulphate, or *blanc fixe*, or *baryta* (although this last term is more commonly applied to barium hydroxide) is an inert, intensely white compound which forms an ideal reflecting surface and which can be modified to give matte or glossy effects. For certain products, however, emulsion is coated direct on to paper.

Emulsion coated on to untreated glass or film would tend to peel off when dry, or frill off when wet. This is probably due to the tendency of the emulsion to swell and contract when wet and dry, and the sudden differential in this respect between the support and the rear layer of emulsion in contact with it weakens any bond between the two. Adhesion to glass is secured by having in contact with the glass a layer of hardened gelatin which shows less tendency to vary in dimensions. This is achieved by coating the glass with an extremely thin substratum of gelatin hardened with chrome-alum, or even of chrome-alum solution alone, which hardens the underlayer of the subsequently applied emulsion.

Adhesion of emulsion to film base is secured by a different method. Film base is made from derivatives of cellulose—the complex organic material which forms the structural part or skeleton of most plant life, and is met in daily life in the form of paper or cotton. If cellulose is treated with acids a cellulose *salt* may be formed, but as such organic *salts* have few of the properties normally associated with inorganic salts, they are given a special name—*esters*. The cellulose ester formed by treating cellulose with nitric acid, for example, is cellulose nitrate* which, suitably plasticised, was used for many years as film base. However, it has gradually been superseded by *safety* or *non-flam* base, which consists of cellulose acetate and/or other closely related esters. Adhesion to film base may be obtained either by etching the base with solvents to give a roughened surface to which gelatin will *key*, or more usually, by a method depending on the following principle.

*Also called collodion, celluloid, pyroxylin or erroneously, nitrocellulose

Cellulose esters are soluble in certain organic solvents, such as acetone, which can mix with water, but if water is added to a cellulose ester solution in acetone, the ester is precipitated. Similarly gelatin disperses in warm water, but with the addition of acetone it precipitates. However, it is possible, with difficulty, to obtain a solution of a small quantity of both cellulose ester and gelatin in a mixture of acetone and water. Such a solution is very unstable as the slightest variation in composition of the solvents (for example, by evaporation) results in the precipitation of either gelatin or cellulose ester. If a very thin layer of such a solution is coated on to film base and allowed to dry, the organic solvent being more volatile will evaporate first, depositing cellulose ester which naturally adheres to the base. At a later stage in the drying process, an intimate mixture of gelatin and ester is deposited and the residual water which finally evaporates leaves a surface deposit rich in gelatin, to which emulsion will adhere.

Non-curl Backing of Films

On drying the set emulsion layer, there is a shrinkage to about one-tenth of the original volume. This shrinkage is almost entirely unidimensional, but the tendency to decrease in area as well as in thickness causes curl of the material, with the emulsion side inward. On film base the curl is most marked; paper, because of its lower dimensional stability, shows much less tendency to curl, while glass plates show a degree of curl which, though measurable, is negligible for normal purposes.

On film base this trouble is counteracted by giving the rear side an equal tendency to curl in the opposite direction. The rear side of roll film and sheet film is subbed (substratum coated) and coated with a layer of gelatin comparable in thickness with the emulsion coat. Gelatin backing would have disadvantages if applied to cine and miniature film, so the rear side is given a tendency to shrink by treatment with solvent mixtures. X-ray film needs no anticurl treatment, since both sides of the base have an emulsion coating.

Antihalo Backing

If a point source of light is focused on to a photographic plate or film, the photographic image extends beyond the confines of the optical image because light is scattered sideways in the emulsion, due to inter-reflection between the grains of silver halide. This sideways scatter of light in emulsions is called *irradiation* and its significance is discussed more fully in Chapter 18. Some of the light which passes

through the emulsion will be scattered in all directions into the film or glass. The light which deviates by not more than the critical angle from the direction of the incident light (*see* p. 29) will pass out of the film or plate to be absorbed by the black backing paper or dark slide. Light striking the black surface of the film or plate at more than the critical angle will be totally reflected and will again strike the emulsion, forming a ring or halo around the original image—hence the name *halation* (Fig. 12). The distance of the halation ring from the central spot will increase proportionally to the thickness of the base, so that halation is more noticeable on glass plates (Fig. 13). On thin films, the rings are so small that they usually fuse with the initial scattered image.

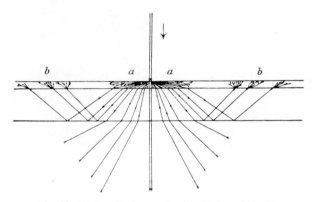

Fig. 12. (a) Irradiation and (*b*) halation. (Diag.)

Halation can be cured by preventing reflection of light by the rear surface of the base. This can be achieved by coating the rear surface with a layer containing a dye which will absorb the longest wavelengths to which the emulsion is sensitive (since these, owing to their superior penetrating power, are the rays generally responsible for halation). Ortho materials require a green-absorbing backing, such as a magenta or red dye; pan materials require a red-absorbing dye, such as blue or grey. Antihalo dye backings are applied to plates in a medium which either dissolves in a processing solution (usually the developer), or can be easily removed by swabbing. In film products the antihalo dyes are incorporated in the gelatin anti-curl backing, and as the backing is not removed, dyes are chosen which are decolourised by sulphite solution, and thus disappear during processing; 35mm. negative film, having no backing, is often coated on a grey film base, which reduces halation.

(a) (b)

Fig. 13. Night photographs on (a) unbacked and (b) antihalo
backed plates. *Photo: M. Gill.*

Testing Photographic Materials

The only way of testing the photographic quality of a material is to
expose and develop it, whereon it is destroyed for future use. The
disadvantage of manufacturing materials which can be tested only
by destructive methods is that it is impossible to guarantee the qual-
ity of any sample manufactured. One can merely take every pre-
caution, test frequent samples and assume that if they are satisfac-
tory, then the material between samples will also be good. It is
usual practice in the industry to test samples of emulsion before
coating and samples from each roll immediately after emulsion
application, and again when dry. The examination includes tests
of physical characteristics as well as tests of photographic behaviour
and tests for mechanical defects. If faults are suspected, then more
frequent tests are made until defective material is located and re-
moved. Every roll of base and packing paper, every batch of gelatin,
bromide, silver nitrate—in short every material which goes to make

or comes in contact with the finished product—is tested not only chemically, but for its photographic action; and not only its immediate photographic action, but by exhaustive incubation tests for its probable future action. Impurities may be present in amounts which are undetectable by chemical analysis and yet exert a powerful photographic action.

Difficulties of Manufacture

The difficulties of manufacturing photographic materials are very great, and are increased by the conditions of illumination—often total darkness—under which most of the operations have to be performed. Photographic reproducibility does not imply merely chemical identity from batch to batch, but physical identity of an astonishingly high order. The enhanced sensitivity to light of modern materials has unfortunately, but not unnaturally, involved increased sensitivity to other conditions such as moisture, heat, pressure and traces of impurities. The last named are most troublesome, especially when concentrated in specks, since most impurities produce black or white spots. Impurities which would be undetectable if uniformly distributed could ruin a product if concentrated in specks, since the area affected by a speck may be very much greater than the area of the impurity, and three of four such spots per half plate would render a material quite unusable. Impurities in speck form are usually either water-borne or air-borne, and so elaborate precautions have to be taken to filter these two commodities. Even after most careful air filtration, dust may be introduced by operatives, and for this reason they are dressed from head to foot in lintless clothing. Indeed, the general standard of cleanliness is much higher, for example, than is necessary or usual in the food industry, and is more comparable with that in a biochemical laboratory or an operating theatre.

Chapter 8

THE PHOTOGRAPHIC LATENT IMAGE

THE PHOTOGRAPHIC latent image presents a fascinating and intricate problem which has puzzled chemists and physicists for the past hundred years, and although we have amassed quite a lot of information about the subject, certain aspects are likely to puzzle chemists and physicists for a long while to come.

In the first place let us state what we mean by latent image. The suspension of silver halide grains in gelatin which constitutes the photographic emulsion is only very slowly reduced to metallic silver by alkaline solutions of certain amino or hydroxy derivatives of benzene, that is, by photographic developers. Exposure to a minute amount of light causes a change in the crystals whereby the velocity of reduction to silver is increased by ten to one hundred times. It is this change which is called the latent image. The minimum amount of such change (or the critical exposure) necessary to initiate the development of a grain will vary with the developing solution and time and temperature of development, so that reference to *latent image* has little meaning unless it is assumed to imply the developability of a grain under some arbitrarily standardised development condition.

It has already been pointed out (p. 93) that the most delicate test of latent image formation known at present is the action of a developer, so that it is impossible to investigate directly or even to detect the change induced by minimal light exposure, by any other chemical or physical means. Nevertheless we can obtain a great deal of indirect evidence. Thus the change in the silver halide system which we term latent image could conceivably be a physical one (as for example a local disturbance or a general change in the crystal structure of silver halide), or it may be a chemical one (as for example decomposition into silver and bromine)—there is no other reasonable alternative. Let us see how these two alternatives—physical or chemical change—are supported by certain aspects of the behaviour of the latent image.

In the first place, silver bromide is less soluble than silver chloride, and if the latter is treated with a solution of potassium bromide, silver bromide and potassium chloride are produced—another example of *double decomposition* (*see* p. 89). Now an exposed silver chloride emulsion may thus be converted into silver bromide which is still capable of image-wise development (indeed a latent image has been produced on thallous bromide, which was developed after conversion to silver bromide). This evidence points to a chemical change as an explanation of latent image, since it seems most unlikely that a change in physical state could survive such disrupting reactions.

Again, if an exposed emulsion is fixed in hypo, the latent image remains in the gelatin, and is capable of so-called *physical development* (p. 131) in a developer containing soluble silver salts. In this case the whole of the silver halide has been removed, and with it of course any physical change in the system, yet the latent image survives. One must conclude that latent image formation is a chemical change which has given rise to a foreign substance insoluble in hypo. Since prolonged action of light results in the formation of sufficient metallic silver to be detectable chemically and confirmed by such methods as X-ray crystallography (p. 292), it is reasonable to assume that the latent image similarly consists of metallic silver but in quantities too small to be detected. The chemical behaviour of the latent image supports this view. For example, treatment of an exposed emulsion with reagents capable of oxidising and thus destroying metallic silver (for example, halogens, acid permanganate, acid dichromate, etc.) will destroy a latent image. Treatment of an emulsion with certain reducing agents (for example, sodium arsenite) which are capable of reducing silver halide to metallic silver can, under controlled conditions, give a developable latent image. More confirmatory evidence could be cited, all pointing in the same direction, so that it is now considered well established that the latent image consists of metallic silver. The decomposition of silver halide by light is termed *photolysis*, and the silver so formed *photolytic silver*.

Development Centres

If the development of an emulsion is observed under a high power microscope it will be seen that while unexposed grains show no change, the development of exposed grains begins at one or more points on the surface of the grain, and spreads therefrom through the grain (Fig. 1).

Exposure to light thus seems to have formed certain *development centres* on the grain at which development is initiated. Since exposure

Fig. 1. Electron micrograph (×25,000) showing development centres and the etching out of silver bromide to provide the material for the developed silver.
Photo: R. B. Flint, Research Laboratories, Kodak Ltd.

to light also forms metallic silver, it is evident that the photolytic silver is concentrated at certain specks on the grain surface, and confirmation of this deduction is afforded by prolonging light action until the silver specks are detectable by the electron microsope, or even the optical microscope.

This immediately sets us a poser. Light is doubtless absorbed throughout the whole of the grain, why then is the photolytic silver not formed as a uniform cloud throughout the grain? How and why do the atoms of photolytic silver travel through the grain to meet at certain rendezvous on the grain surface? Perhaps the first question to be answered is—are these points on the grain surface at which silver collects merely random places on a uniform surface where silver atoms, mutually attracted by some mechanism, happened to meet, or are they in some way different from the remainder of the crystal prior to light exposure? That is to say, do certain *sensitivity specks* upon which the photolytic silver is encouraged to collect exist on the grains of normal emulsion, prior to exposure?

Sheppard's Classical Work

To obtain evidence on this point, let us review briefly the isolation by Sheppard in 1925 of the sensitising constituents of gelatin. It had been known, since the introduction of gelatin into emulsion making by Dr. Maddox, in 1871, that emulsions made in this medium had enhanced sensitivity (pp. 92, 99). Sheppard was able to show by most laborious and painstaking work that the sensitising properties were due to *labile* (that is, unstable, reactive) sulphur compounds in concentration now known to be of the order of one part labile sulphur per million parts of dry gelatin. He showed that the type of sulphur compound which he isolated formed 'addition products' with silver bromide, which easily decomposed on warming, to give silver sulphide (Ag_2S). Therefore he postulated that the unexposed grain contains on its surface sensitivity specks consisting of silver sulphide formed during emulsion manufacture by adsorption and decomposition of the labile sulphur compound of gelatin. Subsequent work in this country has given quantitative support to this qualitative picture. Sheppard went on to suggest that during exposure the photolytic silver concentrated itself on the silver sulphide specks, a postulate which has become known as the *concentration-speck hypothesis*. This was as far as a chemist was able to go. The suggestion of a suitable mechanism for the mobility of silver through the grain so as to concentrate on silver sulphide specks completely baffled him.

The Structure of the Atom

The stage was set for the entry of the theoretical physicist, but before we consider his contribution, we must learn something about his work on the structure of the atom. In general he had determined that atoms consist of a central, positively charged nucleus round which revolve in different orbits a number of electrons, that is, particles with unit negative charge and with much smaller mass than the nucleus.

Since atoms are electrically neutral, the positive charge of the nucleus equals the total charge on the electrons. As we pass through the chemical elements in order of increasing atomic weight, so the mass and positive charge of the nucleus increase, with corresponding increase in the number of electrons revolving round it. They are thus similar to solar systems of increasing complexity, but with one very significant difference: whereas each orbit in the solar system is occupied by one planet, the electron orbit will accommodate up to a

prescribed number of electrons before it is completed, and a new outer orbit is formed. The electrons in the usually incomplete outer orbit are those which function in chemical reactions, by borrowing electrons from other atoms to complete the orbit, or parting with the electrons of the outer orbit, hence the outer electrons are called *valency* electrons (p. 124). Those elements with a completed outer orbit neither part with nor borrow electrons, and therefore undergo no chemical reactions whatever—they are the inert gases.

The outer orbit of the bromine atom will accommodate eight electrons, but contains only seven. The silver atom contains only one electron in its incomplete outer orbit. The total positive charge on the nucleus plus the inner electron orbits of the bromine atom is therefore seven, and that of the silver atom one. When bromine and silver atoms come into contact, the bromine atom borrows the spare electron from the silver atom and thus incompletion of the outer orbits of both atoms is avoided. The resulting modified atoms are called ions, and have very different properties from the original atoms. Moreover the ions are no longer electrically neutral; that from bromine has an extra electron, and therefore has a unit negative charge, that from silver has lost an electron and therefore has a unit positive charge. The two ions therefore attract one another and together form the neutral compound silver bromide (Fig. 2).

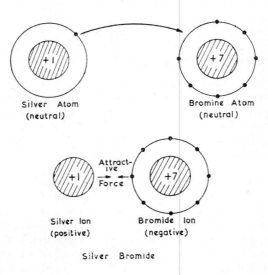

Fig. 2. Atom of Ag+atom of Br→Ions of Ag Br.

When salts such as silver bromide, sodium chloride (common salt) and sodium carbonate (washing soda) are produced in the solid state, the ions which compose the salt arrange themselves into a geometric pattern which manifests itself in the crystalline form of the salt. In solution in water, however, the ions *dissociate* so that most, if not all, of them are present as independent charged particles.

The crystal structure of a material is termed the *crystal lattice*. The crystal lattice of silver chloride and silver bromide is cubic in form, each bromide and silver ion being arranged alternately and occupying the corner of a tiny cube—or more accurately the common corner of eight tiny cubes. Thus every silver ion is surrounded by six bromide ions, and similarly every bromide ion by six silver ions (Fig. 3).

Fig. 3. Crystal lattice of silver bromide.

Electrical Conductivity of Silver Halide

This simple account of atom and crystal structure was necessary before we could consider further work on the latent image. There is one further matter which requires clarification—we must distinguish between two types of electrical conductivity—*electronic* and *ionic*—in which, as their names imply, the current is carried by a flow of electrons and of ions respectively. They are easily distinguished in that the former is virtually independent of temperature, whereas ionic conductivity ceases at temperatures approaching that of liquid air. This is not surprising—one would expect the ions, which are very large compared with electrons, to become immobile at such low temperature.

Silver bromide in the dark has only a very low conductivity at normal temperatures and none at liquid air temperatures. The

current is therefore carried through the crystal by ions, and since there are only two ions present, it must be carried by silver ions or bromide ions or both. By an ingenious experiment proof was obtained that the whole of the current was carried by silver ions, and moreover that they needed no energy to drag them out of their positions in the silver lattice. The current-carrying silver ions were therefore not part of the silver bromide crystal lattice. It was concluded that at normal temperatures a small equilibrium proportion of the silver ions is out of position and wandering through the crystal—their relatively small size would allow them to do this. Some would drop back into positions vacated by other silver ions, while fresh silver ions would be jerked out of position by the thermal energy of the crystal. Always there would be a small proportion of silver ions wandering in interstitial positions—the *interstitial* silver ions. Thus it has been concluded that the conductivity of silver bromide in the dark is ionic, the current being carried by interstitial silver ions (Fig. 4).

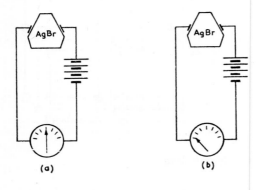

Fig. 4. The conductivity of silver bromide in the dark at (*a*) normal temperature, (*b*) low temperature, *Ionic Conductivity*.

Photoconductance

As soon as the crystal of silver bromide is illuminated, however, there is an immediate increase in conductivity, which persists practically unaltered at liquid air temperature. This conductivity induced by light, termed *photoconductance*, is therefore electronic (Fig. 5). What is the source of the electrons released by light action? It must be either the silver ion or the bromide ion. The strong probability, amounting almost to certainty when one considers the energies involved, is that the electrons come from the negatively charged bromide ions (which thus revert to elemental bromine) rather than

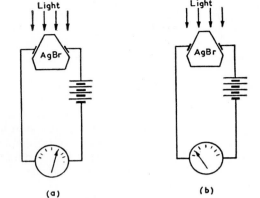

Fig. 5. The conductivity of silver bromide in the light at (*a*) normal temperature, (*b*) low temperature, *Electronic Conductivity.*

from the inner orbits of the silver ion to leave a silver residue with a *double* positive charge.

When the photoconductance effect was compared with the photographic effect, it was found that the ultimate sensitivity of silver halide to light was of about the same value for the two effects; moreover, the spectral sensitivity (that is, sensitivity to different colours) was found to be identical in the two cases. It therefore seemed to be most probable that the two effects were related, and that photoconductance may play some part in the formation of the photographic latent image.

The Gurney-Mott Theory

In 1938, Professor N. F. Mott and Dr. R. W. Gurney of Bristol University examined the evidence so far reviewed, and propounded a theory which has had a most profound effect upon work and thought in photographic science. We have seen that the first action of light on the silver bromide grain of an emulsion is to cause some of the bromide ions to eject electrons, leaving bromine atoms. These electrons cannot immediately enter the structure of adjacent silver ions to form metallic silver atoms, simply because there is insufficient room within the crystal structure for the formation of a relatively large silver atom. The electrons drift through the crystal with extreme rapidity, being deflected at the surface by boundary effects, and they have three possible fates:

(1) They can combine with silver ions under conditions where the formation of atoms of metallic silver is possible—at interior defects in the crystal, for example.

(2) They can recombine with bromine atoms formed by the ejection of electrons from bromide ions.

(3) They may be trapped in a portion of the crystal of lower energy level than the rest of the crystal.

The specks of silver sulphide formed on the grain surface during emulsion-making may be expected to constitute efficient electron traps, and the mobility of an electron is so high that many of those released by light would immediately come into contact with the silver sulphide specks. Such specks, having acquired one or more electrons, would be negatively charged, and we know from the experiments previously described that under the influence of the resulting electric field, electrolysis of the silver halide will take place, the current being carried by interstitial silver ions. The positively charged interstitial silver ions are thus attracted by the trapped electrons and move to the silver sulphide specks, where they are neutralised to give metallic silver, thus forming bigger and better traps for more electrons (Fig. 6).

The Gurney-Mott theory thus gives us a logical mechanism, each

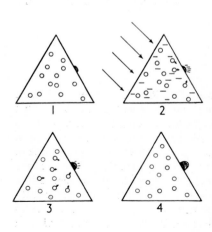

Fig. 6. The formation of latent image, according to the Gurney-Mott theory. 1. Silver bromide grain showing sensitivity speck of silver sulphide on surface, and interstitial silver ions (represented by circles). 2. Light releases electrons (represented by minus signs) from bromide ions. The sensitivity speck traps electrons, becomes negatively charged, and attracts the positive interstitial silver ions. 3. The attraction and neutralisation of silver ions continues after exposure until all the trapped electrons are neutralised. 4. Lattice silver ions have moved into interstitial positions to maintain equilibrium concentration. The neutralised silver ions have formed metallic silver at the sensitivity speck, which has now become sufficiently enlarged to act as a development centre.

step of which can be independently supported, explaining the concentration of photolytic silver at the sensitivity specks on the grain surface. From other evidence it is known that the photolytic bromine can *in effect* wander through the grain by the transfer of an electron from an adjacent bromide ion to a bromine atom (so that their positions are reversed), until the bromine atom reaches the surface, where it is removed from the sphere of action with gelatin. Latent image formation is thus postulated to occur in two stages—a primary rapid electronic stage, followed by a secondary slower ionic stage which may continue after illumination has ceased. This theory is supported by its reasonable explanation of other characteristics of photographic materials, such as reciprocity failure which will be considered later.

The publication of the Gurney-Mott theory immediately led to a number of critical photographic experiments by other workers in which liquid air temperatures were used to differentiate between electronic and ionic stages, and the two-stage (electronic and ionic) nature of latent image formation has been so fully confirmed that certain aspects of the Gurney-Mott theory are not completely satisfactory and much further work and new theories have been propounded. They are not without objections and have not been universally accepted.

Latent Image Distribution

According to the Gurney-Mott theory an electron released by light action moves throughout the crystal with extreme rapidity. It cannot normally move outside the crystal boundary, but bounces about inside the crystal until it is trapped in a region of lower energy level than the rest. During its travels, the electron doubtless makes the acquaintance of numerous interstitial silver ions, but combination cannot take place to form the larger silver atom owing to the limited confines of the silver halide lattice. The electron traps—the regions of lower energy level—are formed by foreign bodies, fissures, caverns or other defects in the crystal itself, which differ from the remaining crystal. Such traps may occur on the surface or inside the crystal, and when an electron is trapped therein, there is usually sufficient space for it to combine with a positive silver ion attracted to the electron. The resulting silver atom makes a still more efficient trap, and the process may be repeated several times to form a speck of silver consisting of a group of atoms that is, to form a photographic latent image. Now if the speck is on the surface of the silver halide crystal, it can *catalyse* or accelerate the action of a developer, and function as

a development centre in the normal way, but if the latent image speck is in the interior of the crystal, it will not be reached by a normal developer, and cannot initiate development.

This story of external and internal latent image is one which the reader is entitled to receive with scepticism. He is entitled to ask, 'How do you *know* all this? Is it mere guess-work, or have you any evidence about the position of inconceivably small specks of silver on crystals which are themselves less than a thousandth of a millimetre in diameter?' The answer is that we have so much evidence that it would be difficult to contrive any alternative explanation to fit the facts.

In the first place, the overwhelming evidence that the latent image consists of silver metal has been viewed previously. The *position* of the latent image in grains has been established by experiments, of which the following is typical:

An emulsion is given a full exposure, such as would give a high density on development. If instead of developing the grains, they are treated with an oxidising agent (for example, acid dichromate which will destroy metallic silver) and then thoroughly washed, the latent image is destroyed, and the grains are as undevelopable as they were prior to exposure. On the other hand, an emulsion so treated differs from an unexposed emulsion in its behaviour to a developer containing a proportion of hypo or other strong silver halide solvent. An unexposed emulsion merely dissolves gradually, while the exposed and treated emulsion may after a while produce a considerable density. This is taken as evidence of the existence of latent image specks in the interior of the grain. The specks are protected from the action of ordinary (virtually non-solvent) developers, but they become unprotected when the outer layers of silver halide are dissolved in a solvent developer, and then they initiate development of the remainder of the silver halide grain.

More refined experiments can indicate the proportions of grains in an emulsion which form internal only, external only, and both internal and external latent image. Moreover, methods of manufacture have been devised to produce emulsions which under normal exposure conditions give anything from total external to total internal latent image.

From the point of view of normal photographic procedure, internal latent image is a waste of effort and any means which will encourage latent image to form on the grain surface will make the process more efficient. It is perhaps for this reason that the after-ripening process (*see* p. 142) is so effective in increasing emulsion speed.

The distribution of the latent image—that is, the relative amounts formed on the surface and in the interior of the grain—will depend not only on the properties of the emulsion but also on the intensity and time of exposure. Under ordinary exposure conditions, the electrons are released at a moderate rate such that they will tend to be trapped preferentially at the more efficient sites, on the surface. where they will be rapidly neutralised to form more efficient traps, The general tendency will therefore be towards surface latent image formation. Very high intensities acting for short periods will, on the other hand, give rise to the sudden formation of a dense cloud of electrons in the crystal. All the available trapping sites, both on the surface and in the interior, will immediately be saturated. High intensities therefore give rise to a higher proportion of internal image.

Latent Sub-Image

By giving a series of increasing exposures to portions of a sensitive material, one can determine the exposure which produces a just perceptible density above fog on normal development. It might then be deduced that exposures less than this value have failed to cause any change in the silver halide grain. This deduction would be wrong. Considerable prolongation of development (for example, *development to finality*) or the use of more active developing agents would show a perceptible density difference at a lower exposure value. There are more refined methods which show that exposures undetectable even by a vigorous direct development have nevertheless caused a change in the grain. It is on such evidence as this that the postulate has been made that the latent image speck must reach a certain size before it functions as a development centre, but it is clear that the limiting size (that is, limiting number of silver atoms) will depend upon the degree and vigour of development. A latent image speck which is too small to act as a development centre is called a *sub-latent* image, and a sub-image for one condition of development may be a full latent image for more vigorous development.

Experiments on sub-latent image formation have shown that in its very early stages—probably when it exists as a single atom of silver —it is unstable. It is liable to emit an electron and revert to a silver ion. On the other hand it is an efficient electron trap, and therefore alternatively may grow rapidly during exposure to form a stable sub-image

of perhaps three or four silver atoms, which on continued exposure becomes sufficiently large to be a full latent image. The proportion of sub-latent image formed, like that of internal images, will depend not only on the properties of the emulsion, but also on exposure conditions. The same arguments can be advanced for both. Under exposure conditions which occur in practice, the electrons are liberated at a moderate rate and the speed at which silver ions can move through the crystal is such that they can rapidly neutralise trapped electrons to give a more efficient trap. Once latent image formation starts, therefore, it will proceed rapidly to give full latent image specks, and comparatively few sub-latent image specks. High intensity exposure will give a high concentration of electrons, which saturate all trapping sites, and before the silver ions can ease the congestion by neutralising the trapped electrons, the brief exposure is over. Many electrons are wasted so far as photographic efficiency is concerned by being repelled from the saturated sites and recombining with bromine atoms to re-form bromide ions, thus undoing the work of exposure. Since the exposure time at very high intensities is usually too brief to allow several cycles of trapping and neutralisation at one site, high intensity will give a high proportion of sub-images scattered throughout the grain.

These considerations of sub-latent image and latent image distribution may be applied to explain a number of otherwise inexplicable phenomena which we shall study in Chapter 15.

Chapter 9

DEVELOPERS

THE MOST SUCCESSFUL and the most commonly used developers are organic compounds. To understand their composition and the way in which they function, we must know what is meant by organic chemistry.

Organic Chemistry

The reason for the division of the science of chemistry into, *inter alia*, organic and inorganic chemistry is the unique characteristics of the element carbon, which can combine with itself (and other elements) to form chains of atoms of extreme length, or configurations of extreme complexity. Some five hundred thousand compounds containing carbon are known to date—far more than the total sum of all the compounds of all the remaining elements. The study of the carbon compounds is thus a science in itself, and has been given the name *Organic Chemistry* because of the occurrence of carbon compounds in all animal and vegetable life.

The grouping together of all the remaining chemical elements under the title *Inorganic Chemistry* (literally *not organic chemistry*) may seem a little disrespectful to exponents of this branch of science, but, titles apart, the classification is a very serviceable one.

The carbon atoms in organic compounds may be arranged in a line or *chain*, which may or may not be branched, or in a ring, or in combinations of chains and rings. Compounds containing rings are called *cyclic compounds*, and among the most common configurations of cyclic compounds is a ring of *six* carbon atoms. The simplest and most typical example of this formation is the compound *benzene*, the familiar inflammable, volatile liquid. It contains in its molecule six carbon atoms in ring (or hexagon) formation, with a hydrogen atom attached to each carbon, and its formula is therefore C_6H_6.

Valency

It was recognised that different elements had different combining powers, long before the electron theory afforded a satisfactory explanation. This combining power was called *valency*. To take typical examples, it was found that the valency of hydrogen (H) is one; oxygen (O), two; carbon (C), four; and sulphur (S), six; though under different circumstances certain elements may exhibit different valencies. Structural formulae were evolved which illustrated the manner in which the atoms of a molecule are linked together. The actual positions of the elements in a structural formula have no significance, provided that the linkages, or *valency bonds* connect the elements correctly; thus formalin, CH_2O may be represented:

All are correct; in each, hydrogen has one valency bond, oxygen two, and carbon four.

Typical structural formulae are:

H —	—O— or	H — H	O = O	H — O — H
Hydrogen	O =	Molecule of	Molecule of	Water
Atom	Oxygen	Hydrogen gas	Oxygen gas	
	Atom			

| Methane | Sulphuric Acid | Sodium Thiosulphate (Hypo) | Alcohol |

The valency bond may be represented by a dot, or merely by the juxtaposition of symbols, thus ethyl alcohol (above) may also be represented as $CH_3.CH_2.OH$ or C_2H_5OH.

The structural formula for benzene, to satisfy the valency of four for carbon may be expressed below as (*a*), but is more usually represented diagrammatically as a plain hexagon (*b*).

(*a*) (*b*) (*c*) (*d*)

Benzene Phenol

(*e*) (*f*) (*g*) (*h*)

Aniline Methylaniline

A number of *derivatives* of benzene can be obtained by replacing the hydrogens by groups of elements of which the *hydroxyl* group (–O–H, or –OH) and the *amino* group (–N$\overset{\text{H}}{\underset{\text{H}}{}}$, or –$NH_2$) are typical. Thus, by replacing one of the hydrogens (any one—they are all equivalent) by a hydroxyl group, we obtain the compound *phenol*, or carbolic acid, whose structural formula is (*c*), but which is diagrammatically expressed as (*d*), or as C_6H_5OH. The substitution of an amino group for one of the hydrogens of benzene gives us the material *aniline* (*e*), (*f*), or $C_6H_5NH_2$.

It is also possible to substitute one or both of the hydrogen atoms of the amino group ($-NH_2$) by a group of atoms, to give a *substituted amino group*. Thus we may replace a hydrogen by a methyl group ($-CH_3$), to give methylaniline (*g*), (*h*), or $C_6H_5.NH.CH_3$.

Developing Agents

The function of a developer is to convert to metallic silver those silver halide grains which have been exposed to light. A developer must therefore be a chemical reducing agent (p. 94); moreover, since the silver in silver bromide exists in the form of silver ions, its conversion to metallic silver must involve the acquisition by each silver ion of an electron (p.114), and hence reducing agents in general and developers in particular function as electron donors. A large number of reducing agents will convert silver halide to metallic silver, but comparatively few will differentiate satisfactorily between exposed and unexposed silver bromide. Successful developing agents in common use are generally derivatives of benzene in which two or more hydrogens have been replaced by hydroxy, amino, or substituted amino groups*. The hydrogens which have been replaced are normally in opposite (*para*) positions in the hexagon, though they may be in adjacent (*ortho*) positions.

The formulae of some typical developing agents are as follows:

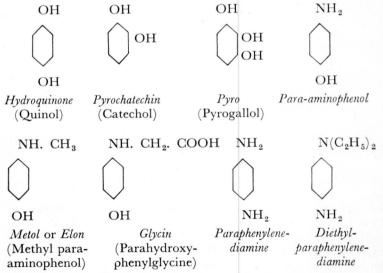

Hydroquinone (Quinol)	*Pyrochatechin* (Catechol)	*Pyro* (Pyrogallol)	*Para-aminophenol*

| *Metol* or *Elon* (Methyl para-aminophenol) | *Glycin* (Parahydroxy-phenylglycine) | *Paraphenylene-diamine* | *Diethyl-paraphenylene-diamine* |

*The Ilford discovery 'Phenidone', of complex structure, is an important exception. It has certain advantages over metol when used with hydroquinone (p. 130).

Needless to say, many attempts have been made to determine the essential characteristic distinguishing a successful developing agent from other reducing agents. Some reducing agents are more active in forcing electrons on to silver ions than others, a property which can be accurately measured and is known as *reduction potential* or *redox potential*. When the redox potential is too negative, all silver grains are reduced, exposed and unexposed alike; when it is too positive, there is difficulty in reducing even the exposed grains. It was thought that a reducing agent would be a photographic developer if its redox potential fell within certain limits, but this hypothesis had to be abandoned as there was no rigid correlation between developing action and redox potential. Probably the best classification of a developer is the generalisation that most developers have the general formula $X—[\overset{|}{C}=\overset{|}{C}]_n—X$, where X is either hydroxyl,

amino, or substituted amino, and n is zero or a whole number. When n is zero, the compounds are $HO.OH$ (hydrogen peroxide), $HO.NH_2$ (hydroxylamine), or $NH_2.NH_2$ (hydrazine), all of which may act as developers, and all the formulae of developers listed above will be found to fit in with the general formula, the $—[C=C]_n—$

being part of the benzene ring. There are, however, certain compounds which act as developers but do not conform to this generalisation, so that we cannot yet predict with absolute certainty whether a particular organic reducing agent will act as a developer.

Other Constituents of a Developing Solution

Accelerator.—When the hydroxyl group is attached to a benzene ring, as in many developing agents, it imparts a mildly acidic character to the compound, so that it forms salts with alkalis. In the presence of alkalis such as caustic soda, sodium carbonate (pure washing soda), borax, etc., some of the developing agent is converted into its sodium salt, in which the hydrogen atom of the hydroxyl group is replaced by sodium. These alkali salts of the developing agent are much more active than the original agents; thus while a plain aqueous solution of a developing agent may partially develop a normally exposed material in several hours, the presence of an alkali will reduce development time to a few minutes. Even developers which do not contain a hydroxyl group develop more rapidly in alkaline solution. An alkali such as caustic soda, sodium carbonate, borax, ammonia, etc., is therefore an essential constituent of nearly all developers, and is known as the *accelerator*; and on the nature and

concentration of the accelerator, among other things, depends the energy of a developer.

Restrainer.—When the sodium salt of a developing agent reduces silver bromide, the reaction may be rather crudely represented:

Na(D)	+	AgBr →	Ag	+	NaBr	+	(D)
Sodium salt of developer		Silver bromide	Metallic silver		Sodium bromide		Oxidised developer residue

Generally, chemical reactions are slowed down by the presence of the end products of a reaction in accordance with what is known as the *Law of Mass Action,* and if the concentration of end products is high, the reaction may be stopped or even reversed. In photographic development, the presence of one of the end products, alkali bromide, thus retards the developing action. Indeed, when a developer is exhausted, it is not so much that the developing agents have been used up as that the solution has ceased to function owing to the retarding effect of the accumulated alkali bromide. In the complete absence of soluble bromide, however, many developing solutions are too active to be controllable and unexposed grains are likely to be reduced, with consequent chemical fog. This excessive activity is eliminated by the addition of a small concentration of potassium bromide (which is equivalent to sodium bromide) which functions as a *restrainer.*

Of recent years other restrainers have come into use, and are sold as *developer improvers* or *antifoggants.* In general they are organic compounds of a ring structure, containing nitrogen, and they react with silver salts to form a very insoluble complex.

Preservative.—An alkaline solution of a developing agent rapidly absorbs oxygen from the air, and this, in turn, oxidises the developing agent with the formation of insoluble brown oxidation products. A developer consisting only of developing agent and alkali, with or without bromide, would thus be unsatisfactory in use, since it would become weak and discoloured on exposure in a dish or tank. It is, therefore, common practice to include in a developer a *preservative,* which hinders oxidation, and prevents the formation of coloured oxidation products. Sodium sulphite functions admirably in this capacity.

It is frequently explained in photographic literature that sodium sulphite has a greater affinity for atmospheric oxygen than the developing agent, and therefore reacts preferentially with dissolved oxygen in the solution, leaving the developing agent substantially

unchanged. Were this explanation correct, the absorption of atmospheric oxygen would be even greater after the inclusion of an ingredient with greater affinity for oxygen than the developing agent, whereas it is actually many times less. The true explanation is that on oxidation a developing agent produces successively several different products corresponding to progressive oxidation stages between the unchanged developing agent and the brown resinous final product. The earlier oxidation products, once they are formed, apparently have a *catalysing* or accelerating action on atmospheric oxidation. Sulphite, however, reacts with these earlier oxidation products to form relatively inert colourless compounds (sulphonates), and thus prevents not only their accelerating action but also their subsequent conversion into brown final products.

However, sulphite is not included in all developers, because developer oxidation products have properties which may on occasions be useful. They may, for example, render unhardened gelatin insoluble, and development of an unhardened emulsion in a *tanning* developer, followed by washing in water sufficiently hot to dissolve the unhardened portions of the emulsion, will result in a *relief* image. (p. 271).

Again, developer oxidation products may combine with certain organic compounds (*couplers*), which may be included in the emulsion or introduced in the developer, to form brightly coloured dyestuffs along with the silver image. Such dye images are used in making colour photographs (p. 264). If sulphite were present in the usual concentration, developer oxidation products would react with it in preference to reacting with gelatin or with colour couplers. Hence in tanning and colour developers, sulphite must be either absent or in low concentration.

A normal developer thus consists of an organic *developing agent* (metol, hydroquinone, etc.), an *accelerator* (sodium carbonate, caustic soda, borax, ammonia, etc.), a *restrainer* (potassium bromide, antifogging agent, etc.) and a *preservative* (sodium sulphite).

M.Q. Developers

Different developing agents have different characteristics. Hydroquinone will develop only when the solution is quite strongly alkaline, when it functions vigorously to give a high contrast. Metol, on the other hand, does not require such high alkalinity, and gives lower contrast and higher speed (that is, the critical exposure which makes a grain developable is less for metol development than for hydroquinone development). It might be expected that a developer com-

5

pounded with a mixture of metol and hydroquinone (M.Q.) would have photographic properties which were about the average of the two. An optimist might hope that the virtues of each would be combined. In practice its properties are superior to even the optimist's dream. For example, on development of an exposed material, it will produce a density higher than the sum of the two densities produced by two similar developers, one containing only the metol as agent and the other only the hydroquinone. This phenomenon has been called *super-additivity* and its empirical discovery accounts for the great popularity of M.Q. (and of recent years, Phenidone-Hydroquinone) developers.

Many attempts have been made to discover its cause. It was found that metol and hydroquinone could be crystallised in the form of a complex compound containing two molecules of metol and one of hydroquinone, and indeed this compound was sold at the beginning of the century under the name of *metoquinone*. Not unnaturally it was assumed that this complex existed in solution, forming a new developing agent with characteristics superior to metol and to hydroquinone. Further investigation, however, showed this hypothesis to be untenable, and it was not until recent years that some evidence on the true mechanism of the M.Q. developer was discovered.

Although hydroquinone is a more vigorous developer than metol (that is, it has a higher reduction potential), at normal alkalinities it has a high *induction period* and it will not readily begin development —though once development starts, it proceeds rapidly through any one grain. Metol, on the other hand, will readily begin reduction, after which it proceeds more slowly, giving lower contrast and finer grain. In a metol developer, the oxidation products will combine with sulphite in the usual way, to form relatively inert colourless sulphonates, but when hydroquinone is present as well, the oxidised metol reacts with the hydroquinone more readily than with sulphite, and so re-forms metol, the hydroquinone itself being oxidised in the process.

The total effect is therefore that the silver halide is reduced to silver, the hydroquinone oxidised remaining substantially unchanged. The full vigour of hydroquinone development is thus applied to silver halide, the metol functioning as a *catalyst* by accelerating the hydroquinone attack and bridging the induction period.

'Chemical' and 'Physical' Development

So far, we have considered a type of development in which the metallic silver is formed from silver halide. This development is generally

described rather inappropriately as *chemical development*. It is possible, however, to supply an alternative source of silver, by including in the developer solution a soluble silver salt, from which the silver of the image is preferentially formed. This is known, even more inappropriately, as *physical development*, although it is just as chemical as *chemical development*.

The difference between *chemical* and *physical* development is simply that the former defines the reduction of silver ions of the silver bromide crystal lattice, and the latter the reduction of silver ions in solution. Pure physical development takes place when an exposed material is fixed and the residual latent image silver developed in a *physical* developer. Normal photographic development, however, represents a mixture of the two types, chemical development probably functioning largely at the beginning of the process, and physical development taking an ever increasing part as the process continues. The reason is that sodium sulphite is a mild solvent for silver bromide, forming a complex acid ion containing silver, so that after the material has been immersed in developer for a little while, each grain will be surrounded by solution relatively rich in silver, forming effectively a physical developer. Although the concentration of silver ions $(Ag+)$ cannot be increased (owing to the limit set up by the solubility of silver bromide), the complex silver-containing sulphite ions may themselves be reduced, or they may act as a more ready source than silver halide for replenishing the solution with silver ions after they have been removed by reduction.

Even if the developer contains neither sulphite nor other solvent for silver halide, the alkali bromide formed during development will probably reach a sufficiently high concentration round each developing grain to act as a silver halide solvent, so that it would be difficult to devise conditions which would exclude the possibility of some physical development taking place.

Compact and Loose Grains—Filamentary Growth

It has been known for many years that different developers produce silver grains in somewhat different forms. In some the silver grain retains the size and shape of the original silver halide grain, in others a shapeless mass of dimensions considerably larger is produced (Fig. 1). Such silver used to be described in such terms as a *spongy amorphous mass*. In 1940, however, a new tool was applied to this problem—the electron microscope (p. 293). By using an electron

(a) (b)

Fig. 1. Photomicrographs showing (a) compact, (b) loose grains (× 2,500).
Photos: Mrs. J. H. Reed, F. Judd, Kodak Research Laboratories, Harrow.

beam instead of a light beam, much finer resolution of detail is
obtained and, as a result, much greater useful magnification. It
was then found that the spongy mass was really in many cases a
tangle of filaments (Fig. 2).

Development Effects

Time and Temperature.—The times and temperatures of develop-
ment recommended by manufacturers for their products represent a
compromise. As development time is increased, more and more
grains are developed. Speed and contrast increase until they reach
maximum values, after which a rise in fog causes them to decrease.
Graininess and fog increase, the latter slowly at first, later at an
increasing rate. The recommended time therefore represents devel-
opment to *less* than the maximum speed and contrast obtainable, but
to a point where fog and graininess are still reasonably low. Further
development will certainly give more speed (usually twice, and not
infrequently four times as much), but at the expense of high contrast,
fog and grain. Under normal exposure conditions the recommended

Fig. 2. Electron micrograph of developed silver grain, showing filamentary form (×45,000).

development should be adhered to, but if under-exposure is suspected, about twice the speed can be obtained by prolonging development—a technique which has recently been termed *development to finality.*

The temperature of the developer affects the rate of the chemical reactions occurring during development, so that over a limited range differences in temperature can be compensated by adjusting the development time. Fig. 3 shows a typical Time-Temperature Chart.

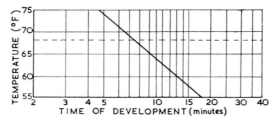

Fig. 3. Time-temperature chart of development. (Points on the inclined line give equivalent development conditions).

Bromide Effects.—One of the products of development is alkali bromide, itself a *restrainer* of development (p. 126). An area which has received a heavy exposure will on development form a local high concentration of alkali bromide which will tend to restrict later stages of development not only in the area of high density but, by diffusion, in adjacent areas. If the film is vertical (as in developing tanks), the high bromide concentration formed at high densities sinks in the solution because of its high specific gravity, and causes a streak where development has been restrained. Such effects are known as streamers' or 'top hats', and can be mitigated or avoided during

development by appropriate agitation. Uniform agitation, as for example the *uniform* rotation of film in a spiral holder, may cause bromide streaks in the wake of high densities. Some such technique as a vigorous periodic shake is found to be most effective.

Edge Effects.—While it is not difficult to eliminate extensive bromide effects, such as bromide streaks, it is more difficult to eliminate them over small areas. However, such effects are often beneficial and

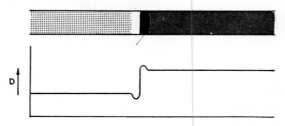

Fig. 4. Edge effect in development (Mackie lines).

are sometimes encouraged rather than suppressed. For example, they will sharpen the boundary between the areas of high and low exposure. The diffusion of bromide from the high density will cause a decrease in the adjacent lower density, and diffusion of fresh developer from the lower density will cause an increase in the adjacent higher density (Fig. 4). The lines at the border are called *Mackie lines.* An interesting special case of microbromide effects

Fig. 5. Dependance of density on image size (Eberhard effect). *Courtesy James and Higgins Photographic Theory,* 1948, *John Wiley and Sons, Inc.*

occurs when small, adjacent areas receive very different exposures, as in mosaic colour processes or photo-mechanical work. If the areas are sufficiently small the edge effect may extend over the whole area. Thus Fig. 5 shows corresponding macro and micro densities for the same exposures. This dependence of density on the size of small areas is called the *Eberhard effect*.

Developer Replenishment

The composition of a developer changes with use. Most of the constituents are gradually used up and therefore decrease in concentration. The alkali is gradually changed to sodium bromide and the sulphite forming sulphonates with the oxidised developer, but the concentration of sulphite and alkali are so high that even after prolonged use, the percentage change is small. Decrease in sulphite and alkali (sodium carbonate, borax, etc.) is therefore an almost negligible factor in the exhaustion of a developer. A more potent factor is the exhaustion of the developing agents due to oxidation and conversion to sulphonate, but in most developers the characteristics of exhaustion are due almost entirely to the increase in concentration of the bromide ions in solution, which seriously retards development.

Another factor is the decrease in *volume* of developer during use owing to its removal when developed film is passed on to the fixing bath. We could bring back the concentration of developers by topping up after use with a solution containing a calculated higher concentration of the exhausted ingredients. The bromide increase, however, presents a difficulty. It increases at such a rate that even if such a replenishing solution contained *no* bromide, the concentration would not be brought back to the original and it is necessary to throw away a calculated portion of the used developer before topping up with a bromide-free replenisher brings back the bromide concentration to the original. Such replenishment is practicable only in plants processing fairly large quantities. However, limited replenishment can be based on topping up with a replenisher until a volume of replenisher equal to the original volume of the developer has been added.

Reversal Processing

By a modification of processing, called *reversal processing*, a normal emulsion can be made to give a positive instead of a negative result. In principle, the method is very simple. Immediately after develop-

ment, the density (that is, the amount of silver halide converted to metallic silver) at any point will increase progressively with the exposure received at the point. The *remaining* silver halide will therefore *decrease* progressively with exposure, and form a *potential* positive image. The positive is realised by dissolving the silver image in acid permanganate (p. 218), exposing the residual silver halide to light, and developing (Fig. 6).

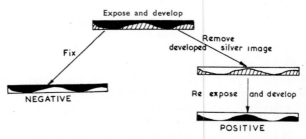

Fig. 6. Normal and reversal processing. (Diag.)

The reversal process is used mainly in processing narrow gauge (16mm., 8mm., 9·5mm.) black-and-white film, and also in processing colour film. In all these, the final positive is in the form of a transparency. A number of points in the process are worthy of consideration.

In the first place, if the transparency is to be satisfactory it must have clear highlights, that is to say, the original exposure must be such that the highlight exposes practically the *whole* of the silver halide in the layer; the negative density should therefore reach D_{max}. With normal negative materials, the camera exposure to reach D_{max} (Fig. 1d, Chap. 13) is some 300 times greater than the minimum exposure to give a good negative (Fig. 1b, Chap. 13). Now for camera work, a reversal material 300 times slower than corresponding negative materials could not be tolerated, and the difficulty is overcome by a combination of two devices. In the first place, a solvent such as ammonia or hypo is included in the negative developer. This helps to give clear highlights by dissolving some of the excess silver halide which would otherwise be subsequently developed to silver. Secondly, thin coatings of emulsions are used, such that the total exposure latitude is little more than that required to accommodate a normal view (log. E 1·5). The minimum exposure which then places the shadows at the foot of the characteristic curve also places

the highlights at the shoulder, near D_{max}. A typical negative and corresponding positive characteristic curve is shown in Fig. 7. Normally the positive curve is not quite a mirror image of the negative curve because of the inclusion of the silver halide solvent in the developer.

It will be seen, therefore, that the exposure latitude of a reversal emulsion is very small, in contradistinction from that of a negative emulsion (p. 172). Any exposure *less* than that in which the highlights expose the whole of the silver halide will give dense highlights, while anything greater will give bleached-out highlights, lacking in detail. There are, however, means of giving a limited latitude which are applied by manufacturers processing their sub-standard or colour films, and there is, of course, a certain tolerance so that exposures of half or double the correct exposure (one stop either way) still give tolerable results. Obviously, therefore, there can be no factor of safety in exposing reversal materials.

It should be emphasised that the acid permanganate solution must be free from soluble halides (p. 218), otherwise the silver of the negative image is partly reconverted to silver halide, which superimposes a weak negative image over the final positive. After the silver has been dissolved, and washed away, the residual silver halide has been made extremely insensitive by the acid permanganate, and it is usual to immerse the film for a short time in a solution of sodium sulphite,

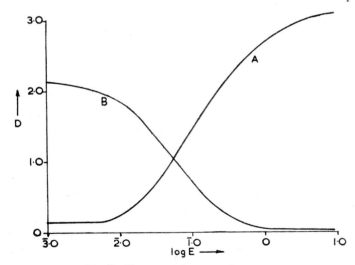

Fig. 7. Characteristic curves for reversal.
Curve A is the negative and B the positive.

which resensitises the residual halide. Finally, although the second development should theoretically convert all residual silver halide to metallic silver, there is often a residuum of silver halide (usually iodide) which escapes the attention of both developments, and consequently it is common practice to fix the reversal film before final washing.

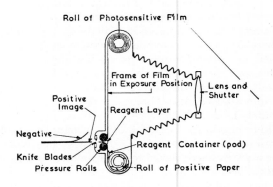

Fig. 8. The Polaroid Land camera.

The Solvent Transfer Method

The residual silver halide remaining after developing the negative may be used to form a positive in a layer *adjacent* to the sensitive material, rather than in the sensitive layer itself. Again the method is very simple in principle. An emulsion-coated paper is exposed, treated with a developer containing a solvent (usually hypo), and a piece of blank paper immediately squeegeed into contact with the emulsion surface. The first action of the solvent developer is to develop the negative in the sensitive layer. The residual silver halide is next dissolved to form a physical developer. Some of the silver-laden developer diffuses into the blank paper, where it deposits metallic silver in proportion to the residual silver halide in the corresponding part of the sensitive material. That is to say, a positive silver image is formed in the blank paper. Much of the positive image is deposited in the sensitive material, so that the negative is spoiled, and only the one positive print is obtainable from one exposure, athough the print can, of course, be copied.

The deposition of a positive image in the receiving paper is facilitated and the image colour improved by incorporating in the paper a minute amount of very finely divided metallic silver or silver sulphide, so little that the whiteness of the paper is hardly impaired. The particles act as nuclei upon which the metallic silver is readily deposited by the silver-laden developer. The inclusion of the solvent, hypo, in the nucleated receiving paper, and of the developing agents in the negative emulsion affords further improvements. It is then necessary to wet the negative with a solution containing only alkali and sulphite, before squeegeeing in contact with the receiving paper.

The solvent-transfer method has been applied in several forms to document copying, and also to camera exposures, where it has the advantage of giving a virtually dry positive paper print ten seconds after exposure. A specially designed camera—the Polaroid-Land camera—contains the sensitised paper in roll form, and also a roll of the receiving paper to which are attached at intervals plastic pods containing the developer in viscous form. After exposure, the two rolls are withdrawn in contact through two pressure rollers which burst the pod, and spread the developer evenly between the two papers. After sixty seconds the positive paper bearing a good quality silver image can be separated, dry enough for immediate use (Fig. 8).

Chapter 10

THE MECHANISM OF DEVELOPMENT

THE FUNCTION of silver specks in exposed grains is fairly clear. In some way they act as *catalysts* or accelerators for the reduction of the silver halide, resulting in metallic silver being deposited on to the original silver specks, which causes them to act as even bigger and more efficient catalysts. Once started, the reduction of a grain is thus *auto-catalytic*, or self-accelerating. What is not certain is the way in which silver functions as an accelerator. The first hypothesis which was generally accepted for several decades was the classical *Ostwald-Abegg theory*, but to understand this, we must consider in some detail the phenomena of solubility and supersaturation.

Solubility and Supersaturation

Although the silver halides are classed among the *insoluble* compounds, it is doubtful whether anything is truly insoluble in any solvent. Certainly silver halides are not truly insoluble in water—the minute quantities of silver halides which will dissolve can be accurately measured by physico-chemical methods, and have the following values for solubility in distilled water at $0\,°C$:

silver iodide	3×10^{-6}	grams/litre
silver bromide	$8\cdot4 \times 10^{-5}$,,
silver chloride	$8\cdot9 \times 10^{-4}$,,

The dissolved silver halide is completely dissociated into independent silver and halide ions, but we should not visualise a saturated solution of silver halide as something static. Thermal energy keeps the ions (and also the water molecules) in continuous motion. Silver and halide ions must be continually colliding both with each other and with the crystals of solid silver halides. Since measurement shows that dissociation of dissolved silver halide is complete, we know that when silver and halide ions collide in solution, there is no com-

bination to give a silver halide molecule—or if there is, the molecule immediately redissociates. But when either silver or halide ions collide with crystals of silver halide, there is a strong tendency to fit into place in the crystal lattice. At the same time, surface ions are going into solution, and we may imagine the coming and going of ions on the surface of silver halide as rather like bees in a hive near a clover field. Saturation is reached when the rate at which ions join the crystal surface just balances the rate at which they go into solution.

If we consider a unit area of solid silver halide, the rate at which ions go into solution will be constant at any given temperature. The rate at which silver halide is formed on the lattice will depend on the number of collisions the ions make on the surface, which in turn depends on the concentration of the ions in solution. This value is called the *solubility product* and will, of course, differ in value for each halide. It is usual in physico-chemical formulary to denote the *concentration** of ions in solution by square brackets round the symbol for the ion, so that the solubility products of silver halides at 18 °C. are:

$$S_{(AgI)} = [Ag^+] \times [I^-] = 0{\cdot}9 \times 10^{-16}$$
$$S_{(AgBr)} = [Ag^+] \times [Br^-] = 4{\cdot}1 \times 10^{-13}$$
$$S_{(AgCl)} = [Ag^+] \times [Cl^-] = 1{\cdot}0 \times 10^{-10}$$

If the solution in which the silver halide is dissolved already contains some of the halide or silver ions (if it contains some dissolved alkali halide or silver nitrate, for example), then less silver halide will dissolve before the solubility product is reached. The solubility of a compound is thus repressed by the presence of a common ion. (This ceases to be true of silver halide if the concentration of the common ion is sufficiently high, as soluble complex double salts are formed. Thus silver bromide may be *fixed* in strong potassium bromide solution.)

Thus when a chemical is thrown out of solution, either by precipitation or by cooling a warm saturated solution so as to decrease solubility, a precipitate is formed continuously until the product of concentration of the ions falls to the value of the solubility product. But the initial appearance of a solid from solution usually requires the presence of some point or points to act as nuclei upon which crystals may form. In ordinary solutions microscopic specks of dust or protuberances on rough walls of the vessel provide such nuclei, so that there is normally no difficulty in obtaining a solid precipitate.

*Expressed as the number of Mols (molecular, atomic, ionic, etc., weight in grams) per litre.

However, by carefully excluding nuclei, it is possible to delay pre-
cipitation until the amount of material in solution is greater than the
normal solubility. For example, if a hot concentrated solution of *hypo*
is meticulously filtered and carefully cooled without agitation in a
chemically cleaned glass vessel, crystallisation may be prevented, and
a *supersaturated* solution obtained. Violent agitation, or the introduc-
tion of a crystal of hypo to act as nucleus, would result in instantan-
eous formation of a mass of interlocking crystals which would
immediately make the contents of the vessel semi-solid.

The Ostwald-Abegg Theory of Development

This theory suggested that the reaction between silver ions and
developer ions takes place *in solution*, that is, the free, dissolved silver
ions are reduced by developer, and not the silver ions which form
part of the silver halide lattice. In its favour we should mention that
a large number of apparently *solid* reactions have been shown in
reality as reactions between ions in solution. If the reaction took
place *in solution*, we might expect that the metallic silver would be
deposited in a fine cloud between grains, but it was postulated that
the metallic silver forms a supersaturated solution of silver, which
will preferentially deposit on the nuclei of silver metal formed by
exposure of the grains. Where there are no exposed grains and there-
fore no silver nuclei, the reaction does not proceed, because silver is
not deposited from solution; where silver specks are formed by ex-
posure, they grow and reduction proceeds. The theory explains the
beginning of development at discrete points on exposed grains, but
the postulation that development is prevented by the inability of
metallic silver to nucleate in an unexposed emulsion is difficult to
uphold. However, it has now given place to more satisfactory
explanations of the mechanism of development.

A Parallel Problem

In order to throw light on the mechanism of development the reduc-
tion by developers of silver ions in solution (that is, soluble silver
salts) has been studied. There the reaction is certainly between silver
ions in solution and dissolved developer ions, and can take place only
when the ions collide. Although every collision may not result in
chemical reaction (and according to calculation *does* not), yet a fixed
proportion will do so, and anything which increases the probability
of collisions, such as rise in temperature or increase in concentration,
will increase the rate of the chemical reaction. The rate of collision and
hence the rate of reaction will clearly be proportional to the con-

centration of the reactants—thus if the concentration of one reagent is doubled, the chance of collision is also doubled.

This reaction is greatly accelerated by the presence of *colloidal* silver; that is, by the presence of a cloud of metallic silver particles so small that they will pass through filter paper, and remain in permanent suspension. It seems likely that the mechanism of this catalysis is the same as the mechanism of the development of exposed grains which contain similar particles of metallic silver on the surface. By solving the former problem, we should have good evidence on the mechanism of development.

When particles of metallic silver are suspended in a solution containing silver ions, some of the positively charged silver ions adhere to the surface of the silver (giving it a positive charge) by some physical or chemical mechanism which goes under the general term *adsorption*. Similarly, colloidal silver particles in a developer solution may *adsorb* developer ions. If both ions are present, as in the case we are considering, both ions will be adsorbed, and since the adsorbed ions are usually quite mobile on the surface of the adsorber, reaction between the two will be facilitated, to form metallic silver on the surface of the silver particles. The acceleration indicates that reaction between independent ions in solution has largely given place to a reaction in which the silver particles are involved, that is, to reaction between adsorbed ions on the surface of the silver particles. An increase in the rate of reaction is to be expected, since the chance of collision has been increased, and adsorbed ions held to the surface have a much greater chance of reaction than casually colliding ions. In other words, the chance of fruitful collisions is greater.

The only point left undecided is the mechanism of the transfer of the electron from the developer ion to the silver ion. Is contact between adsorbed developer and silver ions necessary, or can an electron be transferred from developer to silver ion through metallic silver, the latter acting as a tiny conductor? The evidence seems to favour the latter hypothesis. It has been shown that it is *possible* to reduce silver bromide when its only contact with developer ion is through a silver wire, but this does not prove that electron transfer through silver is necessarily the operative mechanism in photographic development.

Consideration of the adsorption of silver ions to metallic silver throws some light on the problem. In a mass of metallic silver, it is known that the valency electrons (p. 113) are not confined, each to its own silver nucleus, but are shared, and free to move throughout the mass. It is this attribute which gives silver its electrical conducting properties. When silver ions are adsorbed, the adsorbed silver nuclei

fit into place in the silver metal crystal lattice, and share the total electron content of the metal with the other nuclei. It becomes merely a mass of silver with some electrons missing (that is, a positively charged piece of silver) and there is no difference between the adsorbed silver nuclei and those forming the original silver metal. The adsorption of silver ions by silver is thus very different from the adsorption of other elements or compounds by silver. In the latter we have silver with another material on the surface; in the former the property of the whole system is modified to give a uniform mass, all the atoms of which are identical, viz. a mass of silver without its full complement of electrons.

For this reason it would seem that reaction between a developer ion and silver ion adsorbed to silver can take place anywhere on the surface of the silver metal—all parts of the surface are equivalent, and the original metallic silver thus acts as a conductor.

Let us apply the results of these experiments to the development of silver bromide. We have seen that exposing a grain to light produces specks of metallic silver on its surface. The only mobile ions in the interior of the grain are interstitial silver ions, which will probably be adsorbed to the underside of the silver speck, giving it a positive charge. This charge is spread over a number of silver atoms, so that it will not be as high per silver atom as the charge on a silver ion on the surface of the crystal. Emulsions invariably have an excess of akali bromide, and the negatively charged bromide ions in solution will be adsorbed on to the surface of the silver speck, but less strongly than on to any surface silver ions. The silver speck will therefore represent a point on the surface where the barrier layer of adsorbed bromide ions (which hinders access of developer ions to silver ions) is weakest. When the exposed material is immersed in developer, the developer ions will compete with bromide ions in adsorption to the silver bromide and silver speck. They will have a greater chance of adsorption where bromide ion adsorption is weakest, that is, at the silver speck. As soon as a developer ion comes into contact with a silver speck, it donates an electron, neutralising the silver to allow further silver ion adsorption, and the developer ion is thereby changed into a developer oxidation product. Further silver ions and developer ions are successively adsorbed, the former being reduced and the latter oxidised, so that the mass of silver grows at the expense of the silver ions in the crystal. As silver interstitial ions are removed, ions from the lattice positions take their place, so that the lattice structures become disrupted and the excess bromide ions of the lattice, having no corresponding silver ions to hold them in position, disperse into solution as free bromide ions.

This picture represents a probable mechanism for the first stages of development of a grain. If the mechanism continues throughout the development, one would expect the silver to be produced in the compact crystalline form. The formation of loose filamentary grains was originally explained on the hypothesis that the formation of relatively large silver atoms in the confined space between the latent image speck and the silver halide grain would tend to push out the speck and its accumulated silver in ribbon form. This explanation is not very satisfactory, especially in view of the fact that filament formation is not uncommon when silver is formed under entirely different chemical conditions—conditions to which the explanation could not apply. A more satisfactory explanation could be offered on the following lines:

The study of the reduction of silver ions in solution, catalysed by colloidal silver, shows that whether silver ions or developer ions were preferentially adsorbed to the silver particles depends on the particular developing agent. It also depends on relative concentrations and other conditions. At the beginning of development, the speck is likely to be charged with the more easily available interstitial silver ions, and development is likely to be *chemical*. As development proceeds, and the mass of silver grows, developer ions will be more easily adsorbed, and interstitial ions less easily. At the same time *physical* development will play a greater part, for the reasons already given. It is not unreasonable therefore to postulate in some cases a change-over during the development of a grain, from mainly *chemical* development of positively charged silver specks (that is, with silver ions adsorbed), to mainly *physical* development of the larger silver masses negatively charged by preferential adsorption of developer ions.

According to this hypothesis the later stages of development would be characterised by the attraction of positive silver ions from solution to negatively charged silver masses. Now when a conductor such as silver is charged, the charge is concentrated at any sharp protrusions, so that it is to these points that the silver ions would be preferentially attracted, giving a needle-like protuberance which would rapidly grow into a filament. A filament has a large surface for its volume, giving plenty of opportunity for developer ions to be adsorbed along its sides. This results in a very strong negative charge concentrated at the tip, and hence a very strong attraction for positive silver ions from solution at the end of the filament. On contact the silver ions are immediately neutralised to give metallic silver, and therefore a rapid filamentary growth.

Chapter 11

FIXATION AND STABILISATION

A FTER DEVELOPMENT a photographic material contains an image of metallic silver and a residuum of unchanged silver halide. The latter is light sensitive and on subsequent exposure would darken and spoil the photograph. The image may be rendered permanent or *fixed* by one of two methods: all residual silver salts may be completely removed leaving only the metallic silver image—a process called *fixation*—or the silver halides may be converted into some other colourless compound which is not light sensitive (that is, the image may be *stabilised*).

The Chemistry of Fixation

It has already been pointed out that when silver halide is immersed in water only a minute quantity dissolves—so little that for all practical purposes silver halides are stated to be insoluble in water. That which does dissolve is completely dissociated into independent positive silver and negative halide ions. The amount of soluble silver halide is such that the concentration of silver ions multiplied by the concentration of halide ions is a constant, called the *solubility product*. This varies, of course, with the different halides, decreasing in value from chloride, through bromide to the much more insoluble iodide (p. 140). Any addition affecting the concentration of either silver or halide ions will affect the total amount of silver halide in solution. Thus the repression of solubility of silver halide by the *common ion effect* has already been noted (p. 141). Conversely, the addition of anything which will *decrease* the concentration of either silver or halide ions will result in more of the solid silver halide dissolving until the solubility product is again reached.

Now sodium thiosulphate (originally called sodium hyposulphite, and still known to photographers as *hypo*) certainly interferes with the concentration of silver ions in a solution. Its structural formula is shown on p. 124. In solution it dissociates into sodium and thiosulphate ions, the latter having a double negative charge, thus:

$$Na_2S_2O_3 \rightarrow 2Na^+ + (S_2O_3)^=$$

146

The thiosulphate ion is a rather reactive one and will combine with silver ions to form complex ions with the silver strongly held in the acid radical. It will be seen from the structural formula that one of the sulphur atoms is not exerting its full valency, and it is on this spare combining power that the reactivity of thiosulphates depends.

The reaction between silver ions and thiosulphate ions gives rise to a series of complex *argentothiosulphates* containing varying ratios of silver to thiosulphate. The chemist has perhaps gone more astray in the chemistry of fixation than in any other section of photographic science, and the thiosulphate complexes they claim to have formed during the last hundred years are remarkable for their number and variety.

Two main methods have been used to determine their composition. The first is to isolate them in the solid state and analyse them. This has the advantage of leaving no doubt about the composition of the complexes, provided they can be obtained sufficiently pure; on the other hand, there is no rigid proof that the complexes isolated as solids exist as such in solution. The second method is to examine by physico-chemical methods solutions of hypo which have dissolved various amounts of silver salt, and deduce from the results the composition of the salts existing insolution.

The most important of these physico-chemical methods is that of *potentiometry*. When a silver wire is immersed in a solution a small difference in electric potential is set up between the wire and the solution, depending, among other things, on the concentration of free silver ions in the solution. By measuring how this potential varies with varying concentrations of thiosulphate and of silver salt, one can deduce the composition of the complexes formed under various conditions.

It is now known that the first reaction between a silver salt and hypo forms a compound $Na(AgS_2O_3)$, which is rather insoluble and only moderately stable. However, its existence is transient and it immediately reacts with another molecule of hypo to form $Na_3[Ag(S_2O_3)_2]$, which is very soluble and more stable. These are the essential fixation reactions, though there is in all probability a further post-fixation reaction with a further molecule of hypo, to give $Na_5[Ag(S_2O_3)_3]$, which is even more stable and soluble.

The reactions are ionic, and are:

$$\text{Fixation:} \quad (Ag^+ + S_2O_3^= \rightarrow (AgS_2O_3)^-$$
$$(AgS_2O_3)^- + S_2O_3^= \rightarrow [Ag(S_2O_3)_2]^=$$
$$\text{Post fixation:} \quad [Ag(S_2O_3)_2]^= + S_2O_3^= \rightarrow [Ag(S_2O_3)_3]^{v+}$$

The Mechanism of Fixation

The evidence points to the fact that these reactions take place on the surface of the grain of silver halide rather than in the solution between the grains, so that the most probable mechanism is that the thiosulphate ion $(S_2O_3)^=$ diffuses to the surface of the grain where it is immediately *adsorbed* (p. 143) to form with a silver ion $(AgS_2O_3)^-$ on the grain surface. Reaction with a further thiosulphate ion forms the soluble $[Ag(S_2O_3)_2]^\equiv$ which immediately *desorbs*, or dissociates from the solid surface and passes into solution. Halide ions of the silver halide grain structure pass into solution when they are liberated by removal of the lattice silver ions.

The first compound, $Na(AgS_2O_3)$, corresponding to the ion $(AgS_2O_3)^-$, thus fulfils only a very transitory role as an intermediate product in the formation of the more highly thiosulphated complexes; it probably exists merely as an ever-changing monomolecular layer on the surface of each shrinking silver halide grain. As soon as the grain shrinks to zero, any residual $(AgS_2O_3)-$ is immediately converted to $[Ag(S_2O_3)_2]^\equiv$. We could, therefore, almost neglect this intermediate compound and consider that the essential and fundamental reaction in fixation, in spite of the many varied complex reactions which have previously been advanced, is a simple one:

$$Ag^+ + 2S_2O_3^= \rightarrow [Ag(S_2O_3)_2]^\equiv$$

Factors affecting Fixation Time

(*a*) *Agitation.*—The fixation of a photographic material involves three main stages: (i) diffusion of the thiosulphate into the gelatin of the emulsion, (ii) the chemical reaction with silver halide to form soluble complexes, and (iii) the partial diffusion of the complexes and alkali halide out of the emulsion into the solution. Experiments have indicated that the chemical reaction is comparatively rapid, and that most of the fixation time is occupied by the diffusion processes. Now if a photographic material is left undisturbed during any processing operation, a stagnant layer of partially exhausted solution remains near the surface, acting as a barrier to rapid diffusion. This layer is disturbed and removed by agitation, so that such devices as rocking a dish, or brushing with a camel-hair brush greatly accelerate processing. In fixation, agitation prevents the collection of a layer of exhausted hypo near the surface, and reduces fixation time.

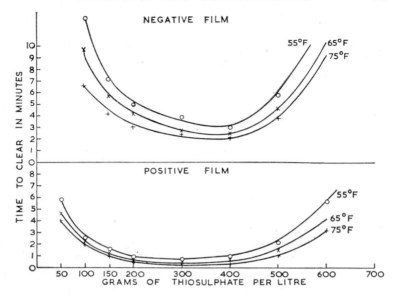

Fig. 1. Relation between fixation time and hypo concentration,
showing minimum when dry film is used.

(*b*) *Nature of Emulsion.*—In general the more soluble chloride
emulsions will fix more rapidly than chlorobromides, which in turn
fix more rapidly than iodobromides. Another emulsion factor affect-
ing fixation rate is grain size. Smaller grains present a much larger
surface area per unit weight of silver halide than larger grains, and
therefore will fix more rapidly. The hardness of an emulsion layer,
within limits, has comparatively little effect, due in part to the fact
that any hindrance to diffusion is largely offset by the reduced
swelling of a hardened layer, giving a shorter diffusion path.

(*c*) *Concentration of Hypo.*—The investigations on the dependence
of fixation rate on hypo concentration reveal a most remarkable
story. Careful experiments made at the beginning of the century, and
since confirmed on numerous occasions, indicated that the rate of
fixation increases up to a concentration of 20 per cent hypo. It then
remains roughly constant to a concentration of about 40 per cent,
beyond which it *decreases* rapidly (Fig. 1). This result was generally
accepted and appeared in all the standard textbooks, and gave rise
to the recommendation not to use hypo of greater concentration than
40 per cent which would result in slower fixing. In 1943, however, an
American investigator failed to confirm this result—he found no

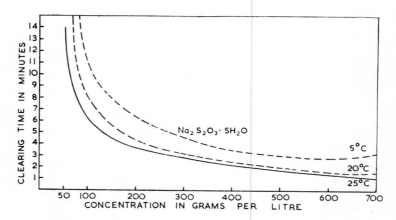

Fig. 2. Relation between fixation time and hypo concentration, showing no minimum under ordinary fixation conditions.

increase in fixation time when using up to 70 per cent concentrations of hypo. On further investigation it was observed that the classical minimum in fixation time is obtained with dry materials, but not with pre-soaked materials. On examining past records it was found that all earlier investigators had either used *dry* films or plates, or had not specified their condition, but from the results obtained there seems to be little doubt that the classical work had all been done with *dry* material, and the results wrongly applied to normal fixation conditions. It is not surprising that dry material fixes slowly in very strong hypo, since concentrated solutions of many salts have a depressing effect on the swelling of gelatin. However, in normal fixation the film is already swollen. More recent tests made with a large variety of materials at normal temperatures *under normal fixation conditions* show no decrease in rate of fixation when the concentration of hypo exceeds 40 per cent (Fig. 2).

(*d*) *Use of Thiosulphates of other bases—Rapid Fixation.*—Since the reactionbetween sodium thiosulphate and silver bromide is in reality one between thiosulphate ions and silver ions (p. 147), thiosulphates other than the sodium salt would be expected to behave like hypo, provided that they dissociate in solution and that the positive ion has little effect on the gelatin or silver halide. This is true for such salts as lithium, potassium and calcium thiosulphates, but ammonium thiosulphate dissociates to give the ammonium ion $(NH_4)^+$, which has a solvent action on silver salts and assists fixation. Rapid fixers therefore, usually consist of ammonium thiosulphate, or of a mixture

of hypo with an ammonium salt such as ammonium chloride. The ammonium argentothiosulphate formed during fixation is less stable than the corresponding sodium salt, but a silver image fixed in ammonium thiosulphate is no less stable than a normally fixed one, provided that it is thoroughly washed.

Certain organic compounds called *quaternary salts* are analogous in composition and properties with ammonium salts, and like the latter they accelerate fixation when added to a hypo bath.

(*e*) *Temperature.*—Most chemical reactions are accelerated by rising temperature, and this is true of the reactions occuring during fixation. There is, however, an adverse effect—raising the temperature will increase the degree of swelling and thus the diffusion path, so that there is an optimum temperature for fixation around 60–70 °F.

(*f*) *Degree of Exhaustion of Fixing Bath.*—There are three main chemical changes which occur in a fixing bath during use: (i) a decrease in concentration of hypo, (ii) an increase in concentration of agentothiosulphates; and (iii) an increase in concentration of soluble halides. All tend to slow down the reactions occuring during fixation to a greater or lesser extent. The third factor is not important in a bath used solely for fixing chloride emulsion, but the accumulation of soluble iodide in a fixing bath used for iodobromide emulsions has a marked depressing effect on silver ion concentration, and seriously slows down fixation.

Acid Fixing Baths

The transference of developed material direct to a fixing bath consisting of sodium thiosulphate would result in two undesirable effects. Development might continue to some extent during the early stages of fixation and cause *dichroic fog* (p. 224); and the developing agent transferred to the fixing bath might cause stain by oxidising to the brown resinous products, since the transferred sulphite becomes too diluted to prevent oxidation.

These defects may be partially prevented by an intermediate rinse in water or temporary immersion in a dilute acid bath (which stops further development) between development and fixation. However, it is now common practice to use an acid fixing bath.

All acid solutions dissociate to give hydrogen ions (hydrogen atoms which have parted with an electron and are therefore positively

charged). Indeed it is the presence of hydrogen ions which gives acid solutions their typical acidic properties. Thus:

$$\begin{array}{cccc}
\text{HCl} & \rightarrow & \text{H}^+ & + & \text{Cl}^- \\
\text{Hydrochloric} & & \text{Hydrogen} & & \text{Chloride} \\
\text{acid} & & \text{ion} & & \text{ion} \\
\text{H}_2\text{SO}_4 & \rightarrow & 2\text{H}^+ & + & \text{SO}_4^= \\
\text{Sulphuric} & & \text{Hydrogen} & & \text{Sulphate} \\
\text{acid} & & \text{ions} & & \text{ion}
\end{array}$$

Now sodium thiosulphate is unstable in acid solution, as the thiosulphate ion decomposes to give an acid sulphite ion and sulphur:

$$\text{H}^+ + \text{S}_2\text{O}_3^= \rightarrow \text{HSO}_3^- + \text{S}$$

This reaction is reversible—indeed sodium thiosulphate is manufactured by treating sodium sulphite with sulphur under conditions which force the reaction in the opposite direction.

According to the Law of Mass Action (p. 128), the reaction from left to right would be hindered by a high concentration of sulphite ions, so that sulphurous acid (which dissociates to give hydrogen ions and sulphite ions) can be used to acidify hypo without causing its decomposition to sulphite and sulphur. The sulphurous acid may be formed by adding to the hypo, sodium sulphite and a small amount of acid (usually acetic acid) which reacts with sodium sulphite to give sulphurous acid. Alternatively, sodium metabisulphite, an acid form of sodium sulphite, may be used in conjunction with excess of sodium sulphite, since in solution it is equivalent to sodium sulphite and sulphurous acid:

$$\begin{array}{cccc}
\text{Na}_2\text{S}_2\text{O}_5 & + & \text{H}_2\text{O} & \rightarrow & \text{Na}_2\text{SO}_3 & + & \text{H}_2\text{SO}_3 \\
\text{Sodium} & & \text{Water} & & \text{Sodium} & & \text{Sulphurous} \\
\text{metabisulphite} & & & & \text{sulphite} & & \text{acid}
\end{array}$$

Acid fixers have a further advantage—that hardeners such as alum or chrome alum which are effective only in acid solution may be incorporated. A well-balanced acid hardening-fixing bath contains sufficient hardener to maintain the hardening action until the bath is exhausted.

Practical Fixation

Although in theory a fixing bath may be used until it ceases to have any fixing action, it is not good practice to approach such degrees of exhaustion. Apart from the danger of contamination of the washed material by silver salts, it is uneconomic, since fixing time increases very greatly with exhaustion of the bath. It is usual to discard a fixing bath when its fixation time is about twice that of a fresh bath.

It has been found in practice that if a material is removed from a fixing bath immediately the emulsion is apparently clear, some combined silver (that is, some silver apart from the silver in the image) may be left in the material even after the most thorough washing. This is undesirable as the image is likely to deteriorate on keeping. This silver salt is therefore insoluble in water, and its presence may be shown by treating the material with sodium sulphide solution, and so forming silver sulphide, which is black and so insoluble that a dark stain will be shown with practically any form of silver other than metallic silver.

An erroneous explanation of this phenomenon, frequently given in photographic literature, is that fixation takes place in two stages. The silver halide is first converted into an insoluble (and presumably invisible) complex containing a high proportion of silver, after which the film appears clear; this subsequently dissolves in excess hypo to give a soluble argentothiosulphate. Based on this assumption, the advice given is to fix for twice the time required for the material to clear. The advice is good, but the explanation completely erroneous —if insoluble silver salts remain, they are a residuum of silver halide. The point at which a film or plate just clears is difficult to determine, especially when the material is fixed in a white dish. If a film or plate is removed just as it appears clear and is examined against a black background, a drop of hypo locally applied will generally produce an even clearer patch. The soundness of the advice to fix for twice as long as the clearing time is due to the tendency to underestimate.

Even sounder advice is to transfer material after clearing from the used fixing bath to a fresh fixing bath for the same time. This not only gives full assurance of complete fixation, but provides a fixed material for washing which is contaminated almost solely with hypo, the bulk of the argentothiosulphates having diffused into the first bath, and much of the small residue into the second. The method is not uneconomic; when the first bath becomes exhausted, the second bath is used as the first bath, and fresh fixer used for the second bath. Total fixing solution used is no greater than in normal one-bath fixation.

Washing and Hypo Eliminators

The purpose of post-fixation washing is, of course, to eliminate hypo
and the argentothiosulphates. If a trace of hypo is left in a material,
it is liable to decompose under the influence of air and humidity and
react with the silver image to form silver sulphide stain. Theoreti-
cally it is impossible to remove all the soluble salts by washing—each
period of washing will reduce the salt content of the emulsion to a
fraction of its former concentration, so that like the cat in the circle,
we approach nearer and nearer to our goal, but we never reach it.
However, normal washing brings the concentration to sufficiently
low values to ensure that materials will remain unchanged over long
periods. Paper prints retain hypo more firmly than films or plates,
as it is absorbed by either the fibres or sizing of the paper support,
but the quantity remaining after thorough washing does not produce
adverse effects during the normal life of a commercial or amateur
print. If extreme permanence of prints is required, as for archival
purposes, then hypo may be chemically destroyed by the use of
hypo eliminators.

Alkaline or salt baths are sometimes included under this heading,
but they merely accelerate the normal washing process. Hypo
eliminators oxidise the residual traces of hypo to sodium sulphate
(which is relatively innocuous) while having no action on the silver
image. A typical hypo eliminator is a mixture of hydrogen peroxide
and ammonia. This converts the hypo to sodium and ammonium
sulphate, which are removed by subsequent washing. Traces of
these salts left in the material have no adverse effect. The reaction,
which is quantitative, is as follows:

$$Na_2S_2O_3 + 4H_2O_2 + 2NH_4OH \rightarrow Na_2SO^4 + (NH_4)_2SO_4 + 5H_2O$$

Hypo	Hydrogen peroxide	Ammonia	Sodium sulphate	Ammonium sulphate	Water

Photographic literature contains frequent warnings against the
use of hypo eliminators. The difficulty is that the effect of a treatment
on the permanence of a photographic image can never be guaran-
teed. Single tests are unreliable; statistical experiments are required
on varying treatments of a variety of materials stored for many
decades under a wide range of conditions. Unfortunately, if such an
ambitious experiment were made, the final conclusions would refer
to materials which would be completely outdated, and could not be
applied with certainty to the new materials in common use. The use
of hypo eliminators cannot, therefore, be recommended as being
free from risk.

Stabilisation

An alternative process to fixation, called *stabilisation,* has assumed a growing importance of recent years. Whereas fixation and washing remove the unstable residual silver halide remaining after development, stabilisation converts the silver halide into comparatively stable colourless compounds. However, as these compounds do not have an extremely high degree of stability, a stabilised image will not last as long as a well-fixed and washed image. Moreover, as the silver compounds remain as a white deposit in the emulsion layer, stabilisation is normally applied only to photographic papers, where such a deposit would not be noticed. Stabilisation is especially useful in the rapid processing of papers used for document copying, when by applying a stabilising solution to the surface of the paper a brief, semi-dry process giving a damp print suitable for immediate use (p. 316) may be substituted for two lengthy wet ones (fixation and washing).

A stabilised print will last for two or three years under normal office conditions without appreciable change, and for many years before the print becomes illegible.

Stabilising agents may form insoluble or soluble compounds. The first have the disadvantage of leaving all the residual silver in the emulsion to give potential instability, while soluble compounds may diffuse partially into the stabilising solution and into the paper base. Moreover, a stabiliser forming a soluble complex will give a print which can at any subsequent time be fixed and washed to give a print of normal permanence.

Of the stabilising agents in use, perhaps the most important is hypo, which converts the silver halide into argentothiosulphates, though alkali thiocyanates or thiourea may be used as stabilisers. To photographers, who well know that a permanent print demands that all residual argentothiosulphates should be thoroughly washed away after fixation, it may be surprising to learn that hypo is used as a stabiliser. Let us examine this apparent anomaly.

The undesirable changes which occur in badly washed prints may be due to decomposition of residual hypo, but are more frequently caused by the more rapid decomposition of the sodium argentothiosulphate. This salt dissociates into sodium ions and argentothiosulphate ions, and there is also a very small further dissociation of the argentothiosulphate ion into silver ions and thiosulphate ions:

$$Ag(S_2O_3)_3^{V-} \rightleftharpoons Ag^+ + 3(S_2O_3)_3^{=}$$

The reactive silver ions are the cause of instability, owing to their tendency to react with atmospheric hydrogen sulphide or with decomposition products of thiosulphates to form silver sulphide. Small quantities of argentothiosulphate in prints would be much more stable if dissociation to give silver ions could be repressed. It has been mentioned (p. 127) that, in general, chemical reactions are favoured by high concentrations of reactants and hindered by high concentration of the products formed—a principle known as the Law of Mass Action. The dissociation of argentothiosulphate ion into silver ion and thiosulphate ion is, therefore, hindered by high concentration of thiosulphate ion, and the argentothiosulphate complex is consequently much more stable in the presence of excess thiosulphate. A photographic material fixed, blotted and dried without washing will contain the argentothiosulphate as well as a large excess of thiosulphate (hypo), and will therefore be considerably more stable than a badly washed material from which the bulk of the hypo has been removed, though it is not as stable as a well-washed material.

SENSITOMETRY

THE OBJECT of press and record photography is to produce by chemical and physical means as faithful a reproduction as possible of the original scene. The pictorial photographer, on the other hand, aims to produce a pleasing picture, and he may purposely emphasise or suppress portions of a view in order to convey some pictorial impression. Such photographic *control* is practised because the original subject is not considered to be ideal. Doubtless if the pictorial photographer found that subject, composition and lighting were perfect, then his aim would be the same as that of the press and record photographer.

It would seem, therefore, that the ideal photographic process would give accurate reproduction of a scene. Normal black-and-white photography, however, suffers at the outset from two very serious limitations—it does not reproduce colours, and since one lens produces one image only, it does not reproduce the stereoscopic effect obtained by the use of two eyes. At best, therefore, a view can be recorded only as a composition of neutral 'shades' or 'tones' such as might be seen by a one-eyed, completely colour-blind man.

A Perfect Photograph

Within these limitations, a perfect photograph may be defined as one reproducing tones so that they bear the same proportional relationship throughout as in the original. Thus in any view the tone value lying exactly half-way between the darkest and lightest tones should be rendered as the exact middle tone of the photograph, and every other interval of tone should be properly proportioned. Within limits an increased or decreased degree of contrast may be allowed, but providing that the intervals of tone value are proportioned exactly as in the original view, then the photograph can be defined

as perfect. Different tone values of a view differ only in the intensity of the light which they reflect or emit, and they can be accurately measured with a photometer (p. 163).

The Characteristic Curve

If adjacent areas of a strip of normal negative material are given a series of exposures starting from a very low value and increasing progressively so that the exposure received by each step bears a constant *ratio* to its neighbour (e.g., so that each step receives double the exposure of its predecessor), and if the strip is then processed uniformly and normally, we find that very small exposures have no effect on the material—that is, the density is not higher than the *fog* produced by developing an unexposed portion. After a certain critical exposure, however, subsequent steps of increasing exposure produce progressively increasing densities until a very high value is obtained, representing virtually the full development of all the silver halide, that is to say, representing the maximum density of which the material is capable. By plotting the densities against corresponding log E values, we obtain a curve. Fig. 1 shows a typical result.

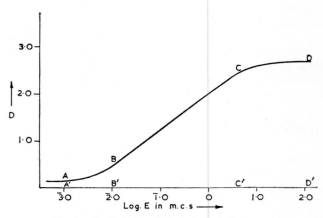

Fig. 1. Typical negative characteristic curve.

Such a curve is generally termed the *characteristic curve* or *H and D curve* of the material—the latter from the initials of the two pioneer

workers in sensitometry, Hurter and Driffield. The main thing to remember about the characteristic curve of photographic materials is that it is *not* characteristic of the material—it is characteristic of the combination of material, conditions of exposure and conditions of processing. A photographic material may have an infinite number of different characteristic curves ranging, on the one hand, from a curve of high density which would be obtained if the material were left in developer overnight, to a uniform zero density obtained by accidental development in hypo on the other. Between these two extremes the curve may vary in shape and position according to factors of colour, of light source, average level of illumination, intermittent or continuous exposure, nature of developing agent, formula of developer solution and time and temperature of development. A characteristic curve of a material, therefore, has no ultimate significance unless exposure and processing conditions are accurately defined. In order, therefore, to give information on the behaviour of a material in normal use, exposure and processing conditions used in preparing the sensitometric strip for determining a characteristic curve must approximate to those prevailing in practice.

For example, a strip taken from an amateur roll film should be exposed to light approximating to daylight in characteristics—not to tungsten light—and the time of exposure should be about $\frac{1}{50}$sec, the variation in exposure being obtained by varying the intensity. Development conditions must approximate to the average development conditions used by amateurs or by developing and printing establishments. Obviously a single characteristic curve will not represent the behaviour of the material under the varying conditions met with in practice, but it can at least represent its *average* behaviour.

The characteristic curve shows that the material begins to respond to increasing exposure by giving increased density at point A on the diagram, and ceases to respond only when the exposure reaches that corresponding with point D. The corresponding log exposures A' and D' are respectively $\bar{3}\cdot1$ and $1\cdot9$, and are, therefore, spaced apart by a log E value of well over 4.

A log scale is a scale where equal intervals represent equal ratios, and an interval of log $E = 4$ represents a ratio between the two extremes of 10^4, or exposure D' is over 10,000 times that of A'. This is by no means extreme—many negative materials have an exposure range of this order (though since the highest densities are not normally used, published curves may not indicate the fact). However, before discussing the information that can be gained from a characteristic curve, let us see how we set about producing one.

The Sensitometer

A sensitometer is an instrument capable of giving to successive portions of a strip of material a series of graded, accurately known and reproducible exposures, preferably so that each bears the same ratio to its neighbour. A ratio of $\sqrt[3]{2}$ is commonly chosen.

It is essential to use a light source which is constant in output, is of a suitable colour temperature and has been accurately calibrated. Hurter and Driffield, often known as the fathers of sensitometry, used a standard candle, and both benzene and acelylene lamps have been used for sensitometry. The present universal practice is to use specially constructed 'standard' electric filament lamps, run at a constant voltage, usually from accumulators.

Since the relative speeds of materials of different colour sensitivities will vary with the colour of the exposing light, we must use a light source similar to that to which the material will be exposed in normal use. Thus printing papers, usually exposed to incandescent tungsten filament lamps, should be exposed to a source of colour temperature 2,800 °K. Negative materials used for outdoor snapshot exposures should be exposed to a source of colour temperature 5,400 °K, that of the sun. As it is impracticable to use a tungsten filament lamp at this temperature, a light equivalent to mean noon sunlight is obtained by using a lamp run accurately at a colour temperature of 2,360 °K, and raising its colour temperature by means of a filter. As a normal filter of glass or gelatin is not sufficiently reproducible, a liquid filter consisting of two solutions (based on a formula evolved by Davis and Gibson) is used.

Exposure Modulation

Early sensitometers employed a time scale modulator which took the form of a constantly rotating disc of the kind shown in Fig. 2 (b). Originally the disc was rotated at high speed so that each part of the material received a series of intermittent exposures. This was to minimise the effect of long-period variability in the light sources then available. However, an intermittent exposure can itself introduce variations (*see* p. 204). With the availability of more constant light sources, it was possible to operate the sector so that a whole series of exposures could be obtained with a single revolution. Instruments of this type are still in use.

Time-scale sensitometers do not, however, reproduce normal exposure in a camera, where, for a given negative, density differences are the result of differences in the intensity of light falling on the

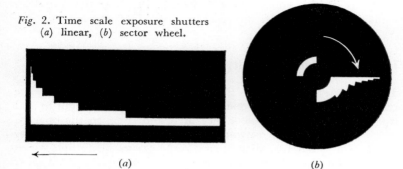

Fig. 2. Time scale exposure shutters (*a*) linear, (*b*) sector wheel.

(*a*)　　　　　　　　　　(*b*)

material. In using a time-scale, it is possible to introduce variations due to the failure of the reciprocity law (*see* p. 199). Thus, in recent years it has become the practice to use an intensity-scale sensitometer for negative materials. Differences in intensity are obtained by placing the material in contact with a step tablet. These are made by casting a dispersion of carbon in gelatin and resemble in appearance Fig. 3.

The exposure time with an intensity-scale sensitometer is usually based on the average used with a camera—usually between $\frac{1}{60}$ and $\frac{1}{120}$ sec. However, for routine sensitometry, such as the batch-to-batch testing of sensitive products, a time-scale sensitometer can be equally effective.

Fig. 3. Step tablet of a range of densities.

Other conditions, besides those of illumination, have to be taken into account. The density produced may be affected by the temperature and humidity of the material at the time of exposure and on the interval between exposure and development. Processing conditions must be similarly standardised in respect to the composition and temperature of the developer and method of development, and in the fixation, washing and drying of the sample under test. Typical specifications are given in such publications as the British Standards Institute's 'standard' for determining the speed of photographic

materials (British Standard 1380: Part 1: 1962), or the American equivalent published by the American Standards Association.

The Measurement of Density

The blackness of a given silver deposit in a negative may be measured in two ways. In one the ratio of the incident light to that transmitted by the deposit is measured and is called the opacity. If I_0 is the incident intensity and I that transmitted then the opacity is I_0/I. This is not a good choice if it is the *appearance* of prints which is important because equal increments in opacity do not appear equal to the eye. Equal increments of log opacity do (or very nearly so) and the response of photographic materials is almost universally measured by log opacity, called *density*.

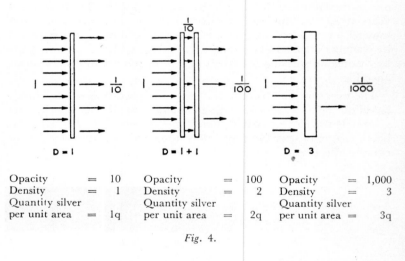

Opacity	=	10	Opacity	=	100	Opacity	=	1,000
Density	=	1	Density	=	2	Density	=	3
Quantity silver			Quantity silver			Quantity silver		
per unit area	=	1q	per unit area	=	2q	per unit area	=	3q

Fig. 4.

A silver deposit transmitting $\frac{1}{10}$ of the incident intensity will have an opacity of $1 \div \frac{1}{10}$, that is, an opacity of 10. The density, which is log opacity, will therefore be 1, since $10 = 10^1$. If two such deposits are superimposed, the light incident on the second deposit is $\frac{1}{10}$ that incident on the first, and the light transmitted by the second deposit will be $\frac{1}{10}$ of $\frac{1}{10}$, or $\frac{1}{100}$ of that incident on the combination. The total opacity of the combination is therefore 100, and the density is 2, since $100 = 10^2$. Similarly the density of a combination of three such deposits is 3, and since the amount of silver per unit area is the same in

each element of the combination, the total amount of silver per unit area in any combination is theoretically directly proportional to the density. In practice this relationship is affected by scatter of light between the grains, but holds over a fairly wide range. These relationships between opacity, density and silver per unit area are illustrated diagrammatically in Fig. 4.

The Densitometer

Any instrument which is capable of measuring light intensities could be used for measuring the opacity of a material, and hence its optical density. An instrument which measures light intensity is called a *photometer* and one applied specifically to the measurement of photographic densities is known as a *densitometer*. Most photometers function by comparing the intensity to be measured with the intensity of illumination from a standard source of known output. The latter intensity is adjusted (usually by adjusting the distance of the standard source) until the two intensities exactly match; the distance of the standard lamp and its candle power then gives a measure of the intensity of the unknown source in metre-candles. The point of equality of the two intensities is obtained by the use of a *photometer head*—a piece of apparatus which accurately indicates when two luminous intensities are equal. There are several forms of photometer heads, but in order to indicate the principle upon which they all work, we shall consider only the most convenient and most commonly used— the Lummer-Brodhun cube.

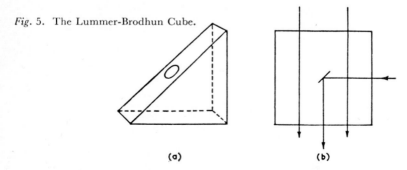

Fig. 5. The Lummer-Brodhun Cube.

(a) (b)

A 45°, right-angled glass prism has a small circle in the centre of its largest face silvered (Fig. 5a). It is then sealed to a similar prism to form a cube (Fig. 5b). On viewing the cube at right angles to one

face, we see light which passes normally from the opposite side of the cube, except in the centre (silvered) area, which reflects light coming at right angles. If the two luminosities are adjusted until the centre patch disappears, then the light from the centre area is of the same intensity as that from the surround.

(a)

(b)

Fig. 6. A graduated density wedge.

Now if we were to cast between two slightly inclined glass plates a wedge of finely divided lamp-black suspended in gelatin (Fig. 6a), we would obtain a graduated wedge varying in density from zero at one end to a high density at the other (Fig. 6b). By measuring on an accurate photometer, densities at specific points along the wedge, these could be plotted against distance along the wedge, and the wedge calibrated so that the density at any distance along the wedge is known.

Fig. 7. Optical densitometer. (Diag.)

A graduated wedge (which may alternatively be made by careful exposure and development of a photographic material) is often used in the construction of densitometers. Thus if light from a constant light source follows two paths of equivalent length to a photometer head (Fig. 7), the central area will be invisible. If an unknown density is now inserted in one path, and the calibrated wedge in the other part, the position of the wedge can be adjusted until the central

area of the head is again invisible. The two inserted densities must now be equal, and can be read directly from a scale showing the distance of the light beam along the wedge.

An advantage of this type of instrument is that, provided the light source is reasonably constant, its output need not be accurately known, since the same balance point would be obtained independently of the candle power of the lamp.

While a visual densitometer is useful for occasional work, in routine instruments the photometer head is replaced by a photo-electric cell which on illumination generates a current varying with the light intensity. A shutter device is fitted so that light from either path may illuminate the cell at will, and the position of the wedge is adjusted so that the deflection of an ammeter needle is the same for each path. Today automatic recording photo-electric densitometers are used for large-scale sensitometry.

Fig. 8. Parallel and diffuse densities.

Parallel and Diffuse Densities

The measurement of the density of a developed silver image is complicated by the scattering of some of the transmitted light. That is to say, when parallel light falls normally on to the image some of the transmitted light is deviated sideways and same proceeds in a normal direction (Fig. 8).

If we measure only the transmitted *parallel* light, we shall be measuring *less* transmitted light than if we measure the *whole* of the transmitted light, and hence the opacity and density in the former will be greater.

Density based on parallel transmitted light measurement alone is called *specular density* or *D parallel* ($D \parallel$), and is greater than density based on the whole diffuse light transmission, called *diffuse density* or *D diffuse* ($D \#$). One may ask which is the significant density in the photographic process? The answer is that it depends on how the negatives are printed. If they are printed with the paper in contact

with the negative in a printing frame, the whole of the transmitted light is used, and diffuse density is the operative density. Alternatively, if they are printed in a condenser enlarger, virtually only the parallel transmitted light will be used in printing, the sideways-scattered light being lost, so that specular density is operative. Since specular density is greater than diffuse density, a negative should, theoretically, yield an image of greater contrast when using a condenser enlarger than when contact printing; this effect does in fact arise in practice though it can to some extent be reduced by flare in the optical system.

Diffuse density can be measured equally well in two ways. One is that already described, by illuminating the density by parallel light, and measuring the whole of the transmitted light; and the other, more convenient in practice, is to illuminate by completely diffuse light, and measure the parallel component of the transmitted light. Illumination by diffuse light can easily be achieved by placing the density in contact with an optical diffuser such as opal glass. A diffusing enlarger thus makes use of diffuse density values of the negative. This value is the one normally measured in sensitometric practice by fitting an opal glass at the point at which the density to be measured is introduced.

A non-diffusing density would give no scatter, and specular and diffuse densities would therefore have the same value; and the more scattering the density, the greater the difference between these values. The ratio between specular and diffuse densities is called the *Callier coefficient*, which increases with increasing scatter of the image. As scatter in a photographic image is a function of grain size, the Callier coefficient has been proposed as a means of measuring the graininess of an image. However, other factors interfere and the proposal has been discarded as unreliable.

Reflection Density

When we make a positive print from a negative, the latter is illuminated uniformly and the transmitted light falls on to the printing paper. Different portions of the paper receive different exposures, because they receive different light intensities, according to the transmission densities of corresponding portions of the negative. On processing the paper, therefore, print density varies inversely with that of the negative, so that the print is a negative record of the negative, or a positive of the original subject.

The processed print, however, is examined under reflected light and we see light and shade because the silver deposit interferes not

with transmission but with the reflection. The characteristics of printing paper must therefore be measured in terms of reflection density and not transmission density. Since the amount of reflected light varies with the direction of incident and reflected light, conditions of measurement must be standardised, and it has been internationally agreed that the paper density to be measured shall be illuminated by light at 45° to the surface, while the component reflected at right angles to the surface shall be measured (Fig. 9).

When there is no silver deposit, the reflection density of the paper is naturally zero, and reflection density measurements must be related to the light reflected from the paper alone (say an undeveloped, fixed-out portion) as zero. When we considered transmission density we saw that:

$$\text{Transmission density} = \log \text{opacity} = \log \frac{\text{(incident intensity)}}{\text{(transmitted intensity)}}$$

Clearly this equals: $\log \dfrac{\text{(intensity transmitted by zero density)}}{\text{(intensity transmitted by density being measured)}}$

By analogy:

$$\text{reflection density} = \log \frac{\text{(intensity reflected from zero density)}}{\text{(intensity reflected from density being measured)}}$$

or

$$\text{reflection density} = \log \frac{\text{(intensity reflected from plain paper base)}}{\text{(intensity reflected from density)}}$$

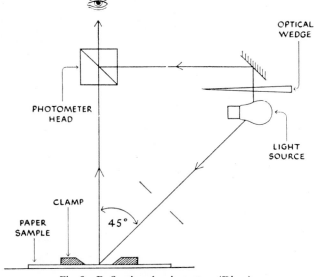

Fig. 9. Reflection densitometer. (Diag.)

Paper Density Range

If the amount of silver in a silver image is progressively increased, *transmission* density will also progressively increase, but not *reflection* density. The silver itself will reflect between 1 per cent and 2 per cent of that reflected by a plain paper base, so no matter how heavy the silver deposit, we are still left with at least 1 per cent reflection due to the silver grains. The maximum density (D_{max}) which a paper print can give is therefore about log $100/1 = 2$.

Let us consider a simple analogy. The light entering a room can be reduced by painting the windows black, and the number of coats of paint increased until virtually all the light is excluded. The transmission density can thus become very high. If a wall is painted with the same black paint, it will reflect an appreciable amount of light and will look grey in sunlight—and increasing the number of coats beyond that which obscures the original wall colour will not make it any blacker.

The range of densities which a photographic paper can record is therefore limited. Few papers exceed a maximum density of 2, and many less. In general, glossy papers have a higher maximum density than semi-matt papers, which in turn give higher densities than matt papers, whose maximum density may be as low as 1·4, corresponding to range of reflected intensities (highlight to shadow) of 1 : 25.

If adjacent areas of a printing paper are given a series of increasing exposures and, after processing, the reflection density plotted against log exposures, the characteristic curve of the printing paper is obtained. Fig. 10 shows two typical curves of bromide paper.

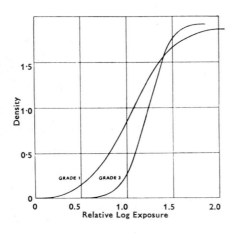

Fig. 10. Characteristic curves of two grades of bromide paper.

A maximum density of between 1·4 and 2·0 means that the highest possible highlight on the paper will reflect light of intensity between 25 and 100 times that of the deepest possible shadow, so that the camera image of a normal outdoor view (which has an intensity range of 30 : 1, *see* p. 170) can just be comfortably accommodated on an average printing paper. To obtain that accommodation, however, it is necessary to use the foot and shoulder of the curve, so that there must be local compression of tone values relative to camera image, and a great deal of overall compression relative to the view itself, whose intensity range may be several hundred to one (p. 246). Printing a negative on paper therefore inevitably involves some distortion of tone values, but fortunately this is not obvious in a good print. This distortion will be considered in the next chapter.

The usable density range of a paper from near zero to near D_{max} corresponds to a fixed log E range of the paper, and if everything in the negative is to be recorded the log E range of the paper must correspond to the density range of the negative. Indeed, those two values must be equal because, when a negative is uniformly illuminated, one unit of negative density causes a change of 10 : 1 in transmitted intensity, which is a change of one unit in positive log E. Thus, a negative with a low density range (that is, a flat negative) must be printed on to a paper whose complete density range is given by a correspondingly short log E range (that is, a contrasty paper) and vice versa, see page 246.

Chapter 13

THE CHARACTERISTIC CURVE AND ITS
INTERPRETATION: TONE REPRODUCTION

Subject Range

IF WE MEASURE the ratios of light intensities coming from the brightest highlight and from the deepest shadow in normal outdoor views, we shall naturally encounter considerable variation. The ratio will be greater on a sunlit day than on a dull one, and it will be greater for a view with heavy foreground than for a distant landscape. However, when a view is imaged on to the photographic material the ratio between shadow and highlight of the camera image is much less than that of the original view and, moreover, the variation from view to view is also reduced when the camera images are measured. This reduction in brightness range is due to interior reflections in the camera, and to scatter of light by the lens known as *lens flare*. Both spread some of the highlight illumination over the material and so lighten the shadow areas. Thus while the brightness range of an outdoor sunlit view may be several hundred to one, the range of the camera image of a typical outdoor view is only about thirty to one—and it is the range of brightness of the camera image, not of the original scene, which determines the relative exposures received by different portions of the photographic material. Since all portions of a material in a camera are exposed for the same time, a range of intensities between highlight and shadow of 30 : 1 means a range of exposures of this value, since $E = It$. We have seen that log $10 = 1$, and log $100 = 2$. Any intermediate figure similarly has an intermediate logarithm, and log $30 = 1.4771$, or approximately 1.5. A ratio of 30 : 1 is therefore represented on a log scale by an intercept of 1.5, and so the range of exposures covered in a normal outdoor view is represented by a section of the log E axis of 1.5 in length. The *position* of the section will depend on the time of exposure and on the average brightness of the camera image, governed by the brightness of the view and the aperture employed.

Camera Exposures and the Characteristic Curve

If the exposure is so small that even the highlights do not receive an exposure as great as that represented by A' in Fig. 1, page 158, then the whole of the section of log E 1·5, representing the exposure range of the camera image, will lie to the left of A'. The negative would be practically clear film, and show no trace of any image.

Relative exposure $= \frac{1}{4}$. Relative exposure $= 1$.

Fig. 1 *(a)* *Fig.* 1 *(b)*

On increasing the exposure, the log E intercept will move to the right, and we shall reach a point when the highlights fall to the right of A', while the shadows remain on the left of A' (Fig. 1a). The shadows of the negative will be represented as clear film, and the best print obtainable from such a negative is as shown in the figure.

When the exposure is increased so that the darkest shadows receive an exposure equal to A', there will clearly be differentiation throughout the whole of the negative, and the best print from the negative will be as shown in Fig. 1b.

With progressive increase in camera exposure, the values of exposure (in metre-candle-seconds) falling on the film increase, and the intercept of 1·5 log E, which represents the subject range of brightness, moves progressively to the right along the log E axis.

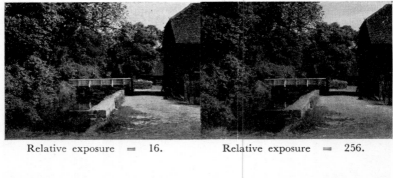

Relative exposure = 16. Relative exposure = 256.

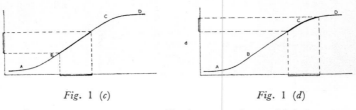

Fig. 1 (*c*) *Fig.* 1 (*d*)

Increasing camera exposures will give negatives which increase in average density, but while the whole of the intercept lies between A' and D', there will be a complete differentiation in density throughout the whole subject range, and the best prints from the negatives will show surprisingly little variation in quality (Figs. 1*c* and *d*). Only when over-exposure is so gross that the highlight exposure extends beyond D' will there be an absence of detail in the highlight portion of the view.

The limits of the useful range of camera exposure are thus represented by the two exposures shown in Figs. 1*b* and *d*. These are displaced by a log E distance of $4 - 1 \cdot 5 = 2 \cdot 5$ (as will be seen by comparing the positions of corresponding parts, say the highlights). This corresponds to a ratio of 300 : 1, which means that camera exposures extending over approximately this range can give acceptable photographic results with long scale negative material. This is usually referred to as *exposure latitude*.

Correct Exposure

It will be seen from Fig. 1, Chap. 12, that a typical negative characteristic curve consists of three main portions—the curved portion at the foot, AB, the straight line portion, BC, and the curved shoulder, CD. When density is directly proportional to log E, the relationship

is shown on the graph as a straight line, so that the straight line portion, *BC*, represents the range within which camera exposures should lie in order to obtain *perfect negatives*, according to our definition. This led many early sensitometric experts to advocate camera exposures within this range. The portion *AB* was termed the *under-exposure* portion, *BC* the *correct exposure* portion, and *CD* the *over-exposure* portion.

This advice is sound if the object is to produce a perfect negative, but a negative is merely a means to an end—the production of a perfect positive, usually in the form of a print on paper. As will be shown later, however, the characteristics of the printing paper introduce inevitable distortion in tone reproduction, so that the production of a perfect negative does *not* result in a perfect positive print. There are in fact definite disadvantages in camera exposures in the region *BC* compared with *AB*. In the first place the exposures are greater than are necessary, which means that the effective speed of the material is decreased. Secondly, the granularity of negatives exposed in the region *BC* is greater than that of negatives exposed in the region *AB*. Finally, a negative exposed in the region *BC*, so that the densities fall on the straight line portion of the negative characteristic curve gives somewhat *worse* tone reproduction on the positive since distortion of the negative introduced by the curved portion *AB* to some extent *counteracts* the distortion introduced by the characteristics of the positive material.

In short, the *optimal* camera exposure is the *minimum* exposure which will give detail in those shadows where detail is required. That is to say, camera exposure should be such that *shadow* exposure corresponds to, or is slightly greater than, point *A'*.

Interpretation of the Characteristic Curve

If the exposing and processing conditions used in determining the characteristic curve of a material are similar to those which the material experiences in practical use, then the characteristic curve should give a graphical representation of the practical photographic behaviour of the material, and it should be possible to deduce from it numerical values for such properties as fog, speed, contrast, maximum density and exposure range.

Fog or Veil: Fog is the density obtained on a material developed without exposure, and it is common practice to protect one step of the sensitometric strip of material from exposure for this measurement. Fog value is, of course, equal to the constant density of that

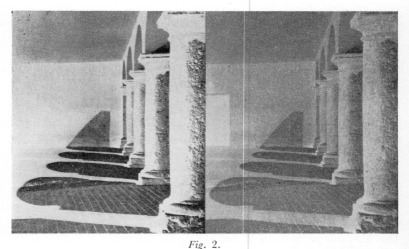

Fig. 2.

(a) Negative on material (b) Negative on material
 of high contrast. of low contrast.

portion of the characteristic curve well to the left of the foot, where the exposure has been insufficient to produce any measurable photographic effect. The density so determined would include both the emulsion fog and the low density of glass or film base. The latter value is normally determined separately by removing the emulsion completely from a small area, and it is usual to subtract this from all the densities used in plotting the characteristic curve, so that the curve represents the characteristics of the emulsion alone. The density of glass or film base is about 0·04, and although the fog of a good negative emulsion normally does not exceed 0·1, it can be much higher than this before image quality is affected.

Contrast: If we take two photographs of a scene on two different materials, we may find that the difference in density between highlight and shadow is much greater on one negative than on the other, as illustrated in Fig. 2. The material giving greater density difference is said to have greater *contrast*. Thus contrast may be measured in terms of the difference in density produced by a certain difference in log exposure (say, from shadow to highlight).

On the characteristic curve, log E is represented by distance along the horizontal axis, and density by the height above it, so that the amount of rise in density for a given horizontal distance in log E is a measure not only of contrast, but also of slope of the curve, just as the steepness of a hill may be measured by the vertical rise in a given

horizontal distance. The two negatives illustrated were obtained on materials of the characteristic curves shown in Fig. 3.

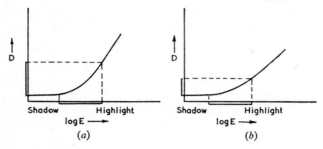

Fig. 3(*a*) Large density difference—high contrast.
(*b*) Small density difference—low contrast.

Contrast may therefore be measured as the *slope* of the character-istic curve, and it can be seen from Fig. 4 that as exposure increases, contrast rises through the foot of the curve until it reaches a con-stant maximum value corresponding to the slope of the straight line portion of the curve.

The contrast of the straight line portion is termed the *gamma* of the material and is given the symbol γ (the Greek letter, equivalent to

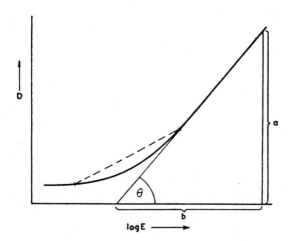

Fig. 4. The measurement of gamma.

the Roman C). Gamma, the slope of the straight line portion, is measured by continuing the straight line portion until it meets the log E axis, and then dividing the height at any point a, by the intercept b. The ratio a/b is constant, no matter where the measurements are taken, and this value is characteristic of the angle Θ, and called the *tangent* of the angle, or *tan* Θ (Fig. 4).

The gamma of a negative material is less significant than was at first supposed. It represents the contrast of a negative only if the exposure has been so full that the whole range of densities lies on the straight line portion.

In general, the optimum exposure lies partly on the foot of the curve where the slope is lower, so that the average negative contrast is lower than the gamma value. The average contrast of a negative, also known as the *contrast index*, may be measured by dividing the density range by the log E range of the subject; this is equal to the slope of the dotted line (Fig. 4) joining the lowest to the highest negative densities.

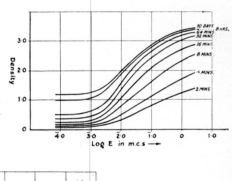

Fig. 5. Characteristic curves of negative material at different development times.

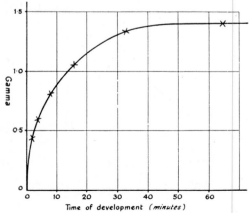

Fig. 6. Gamma-time corresponding to *Fig.* 5.

Gamma-Time Curves

In some types of work, the way in which the contrast of a material increases with time of development is important and can be calculated from a family of characteristic curves of the material representing a series of development times (Fig. 5). It is expressed graphically by plotting the gamma of each curve against the corresponding development time. The *gamma-time* curve, obtained in this way, is shown in Fig. 6.

Speed

Perhaps no aspect of sensitometry has given rise to more discussion and controversy than the determination of photographic speed. The characteristic curve gives the complete story of the relation between density and exposure for a given photographic material, processed in a certain way, and therefore it should be possible to form a numerical estimate of speed by the correct interpretation of the curve (if indeed photographic speed can be adequately expressed by a single number). This is generally agreed—disagreement has been concerned with the method of evaluating a *speed number* from the curve.

In photographic practice speed is assessed in terms of the minimum camera exposure which will give adequate detail in the shadows, and we have seen that at this minimum camera exposure, the lowest value in the log E range of the subject will lie in the foot of the curve. Our first step is, therefore, to define some significant point in the foot of the characteristic curve which can be used as a basis from which accurate speed numbers (and consequently camera exposures) can be calculated; the whole difficulty has hitherto been concerned with attempts to derive such a speed criterion from the characteristic curve. If the characteristic curves of all materials had the same shape, but differed only in position on the log E axis, there would be no difficulty in fixing corresponding points suitable for speed measurement. However, different materials give characteristic curves differing in shape as well as position, and because of shape differences, points chosen according to different criteria give different relative speeds. A brief review of methods which have been used in the past is interesting.

Scheiner Speed.—The Scheiner speed was based on the log exposure value which corresponded to the first just perceptible image (point S, Fig. 7), and the derived speed figures were expressed on a logarithmic scale. This system was most unsatisfactory—apart from the

impossibility of fixing with any accuracy the point at which the curve shows its first perceptible rise, this point has no real significance in determining speed, since the contrast at this point is too low to differentiate satisfactorily between different tone values in a view. Although this suggested criterion of sensitivity was unsatisfactory for the scientist and photographer, it was a godsend to the salesman. If it is difficult to determine a speed number with accuracy, it is equally difficult to disprove an exaggerated claim, and the skyrocketing of Scheiner speed numbers on the Continent about the 1930's was due to their determination in the advertising departments, rather than in the laboratory. Like all inflated currency, the Scheiner speed numbers became worthless, and the present so-called Scheiner speeds have nothing to do with the original criterion —they are simply completely unspecified figures (probably roughly determined by practical photographic tests) provided as guides to correct exposure. The original Scheiner system is quite defunct.

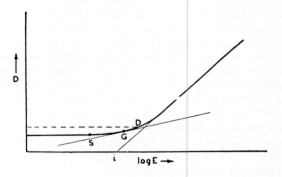

Fig. 7. Foot of curve showing speed criteria.

H. and D. Speed.—The criterion suggested by Hurter and Driffield was a function of the log E value where the continuation of the straight line portion of the characteristic curve met the log E axis (point *i*, Fig. 7). This criterion has been found to give false indication of speeds for modern usage of modern materials and therefore the published H. and D. figures have little or no relation to the original H. and D. method. They suffered slight inflation in this country, but on the Continent their speed figures increased at a rate comparable with the Scheiner inflation. This produced the phenomenon on the British market of imported Continental films having an H. and D. film speed of a different (and much higher) order from

that of similar British films, so that photographers had to distinguish between two systems—the so-called British and Continental H. and D. figures.

DIN Speed.—The first criterion for speed determination which could be fixed with comparative accuracy and which gave results more closely related to practical speed was that adopted in the German DIN system in 1931, though it had been used for some years previously in that country. According to this system, speed was derived from the exposure required to give a density 0·1 above the fog level (shown as point *D*, Fig. 7). This criterion is a practical one, as it indicates a point on the characteristic curve at or near which density begins to rise at a rate giving useful photographic differentiation of tone values. This criterion has now been modified somewhat in agreement with the American Standards Association and British Standards Institute, see p. 180.

Minimum Useful Gradient Criterion.—It was recognised, however, that the true criterion of tone differentiation is one of *contrast* (that is, *slope* of the curve) and not of *density*, so that an alternative method which has some theoretical merit was based on the exposure corresponding to that part of the curve which has a minimum useful gradient. The value of this minimum slope was taken as 0·2, and the corresponding exposure is shown as point *G* on the graph (Fig. 7).

Fractional Gradient Criterion—B.S. and A.S.A. Speed

The penultimate stage in the struggle to devise the most serviceable criterion of sensitivity followed the recognition that the minimum useful gradient will vary according to the contrast of the material. This if 0.2 represents the minimum useful gradient when the print is made on say Grade 2 bromide paper, a negative of the same subject on a more contrasty material would have to be printed on a softer paper, say Grade I. The gradient 0.2 would then fail to give the minimum differentiation of tone in the print. The minimum useful gradient is perforce greater than 0.2 on the more contrasty negative material. Thus the true minimum useful gradient is not the same for all negative materials, but is a fixed fraction of their effective contrast. Such a criterion is described as a fractional gradient criterion. Long studies of the various kinds of prints obtainable from each of a series of negatives, obtained by giving different exposures to each of a set of different negative materials, led to the following conclusion. The best criterion of speed is given

by the log E value corresponding to a point on the foot of the curve where the gradient is 0.3 of the average gradient over a log exposure range of 1.5 to the right of this point, as shown in Fig. 8. It is not easy to determine this point and the latest development, culminating in new standards, arose from the realisation that, if all films were developed to the same effective contrast, a fixed density above fog could be used instead of a fractional gradient to determine the speed. The new standards, agreed by the U.S.A., United Kingdom and Germany, therefore specify that speed shall be based on the exposure E required to reach a density of 0.1 above fog, subject to the condition that the film be so developed that the density at 1.3 log units greater than log E is 0.9. The arithmetic speed is then 0.8/E. (B.S.I. 1380 Part 1, 1962, A.S.A. PH 2.5, 1060, D.I.N. 4512 Part 1, 1961.)

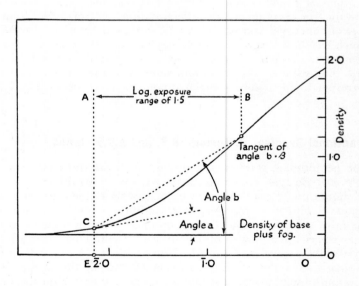

Fig. 8. Fractional gradient criterion (reproduced from B.S. 1380: 1947, by courtesy of the British Standards Institution).

When first introduced B.S. speed numbers were expressed in both log and arithmetical values, whereas the A.S.A. speeds were express-

ed only in arithmetical values. The scale of numbers does not really matter so long as it can be applied to exposure tables and meters. The subject is further discussed in the chapter on exposure, p. 210.

Tone Reproduction

While perfect tone reproduction is the photographic technician's ideal, it is unfortunately unattainable (or at least impracticable) by the negative-positive process, using materials available today. We have previously defined (p. 157) a perfect photograph as one in which the intervals of light and shade, or *tone values* are proportional to those of the original subject. We have also seen (p. 157) that a perfect negative is one in which only the straight line portion of the characteristic curve of the negative material has been used. We could obtain a perfect positive image from a perfect negative by using only the straight line portion of the *positive* characteristic curve. There are, however, serious objections to this practice.

From the curves shown in Figs. 1 and 10, Chap 12, it is seen that the lowest density on the straight line portion of either transmission or reflection curve is about 0·5. This means that a 'perfect' *transparency*, using the straight line portion of positive characteristic curve, would perforce transmit only one-third of the incident light in the brightest highlights. It would be far denser than could normally be tolerated.

When we consider reflection prints, the difficulties of confining the densities to the straight line portion of the characteristic curve of the printing paper are well-nigh insuperable. The whole range of densities is normally under 2·0. Densities up to about 0·5 lie on the foot of the curve, those above about 1·5 on the shoulder, leaving a straight line portion which extends from a density of 0·5 to one of 1·5 only.

If only the straight line portion were used, the brightest highlight on the print would appear intolerably murky, and the heaviest shadows insufficiently dark. Many papers have a straight line portion which corresponds to a density range of much less than 1·0— indeed in some cases the straight line portion is hardly more than a point of inflection between an enlarged foot of the curve and the shoulder.

For a normal type of subject, the most acceptable prints utilise practically the whole range of densities of which the printing paper is capable, even though some distortion of tone values inevitably results.

Tone Reproduction—The Relation between Tone Values of the Original View and those of the Print

The densities of different parts of the negative govern the light intensity (and therefore the exposure) on corresponding parts of the printing paper. Now zero density transmits the whole on the incident light, a density of 1 transmits $\frac{1}{10}$, density 2, $\frac{1}{100}$, etc., so that negative density is directly related to *log* transmitted intensity, and hence to log exposure of the positive printing paper, except that as the density of the negative increases, the log E of the positive paper decreases.

A density difference of 1 between two portions of a negative means a change of transmitted intensity in the ratio of 10 to 1, which corresponds to a change in log I (and therefore of log E) of 1 unit. The units of negative density are therefore identical with the units of positive log E, and the negative characteristic curve relates tone values of view with log E values of the positive printing process, as shown in Fig. 9.

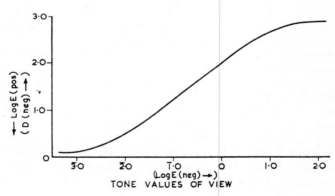

Fig. 9. Negative characteristic curve.

Now a normal view gives a camera image with an intensity range of about 30 : 1, that is a log E range of 1·5. If we give the smallest camera exposure in which all the densities lie on the straight line portion of the negative characteristic curve, the log E values will range from $\overline{2}$ to 1·5 and the densities from 0·5 to 1·6, as shown in Fig. 10. The range of log E (pos.) will thus be the same as the negative density range, which is 1·1, and since the best print will use practically the whole of the positive density range from clear paper to maximum density, the appropriate grade of paper will have an

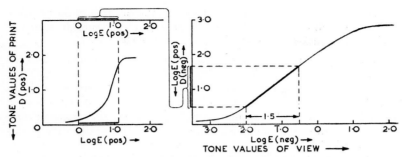

Fig. 10. Positive and negative characteristic curves, separately.

exposure scale of log E about 1·1, as shown in Fig. 10. The densities of the positive print represent the tone values of the print, except that as density increases, tone value decreases, as shown in the figure.

In plotting a characteristic curve (or indeed any graph) the actual positions of the axes have no fundamental significance. Log E merely denotes distance to the right, and D distance upwards. We can just as easily and as accurately plot a characteristic curve with the log E axis above the curve. By plotting both negative and positive curves in this way, and turning the positive characteristic curve through a right angle, we can combine the two graphs since we have a common axis in D (neg.), which is also log E (pos.). The result is shown in Fig. 11.

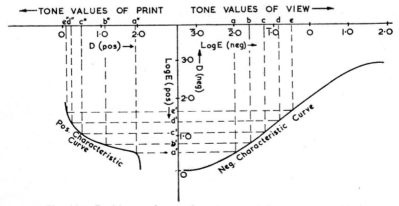

Fig. 11. Positive and negative characteristic curves, combined.

If the print has been correctly exposed, the position of the positive characteristic curve will be such that it just corresponds with the range of densities of the negative.

We can now trace through tone values of the original view to see how they are reproduced in the prints. If, for example, we choose five equally spaced tone values which cover the subject from highlight to shadow, shown as a, b, c, d, e on Fig. 11, we know that these give equally spaced log exposure values, and from the characteristic curve and the camera exposure we can deduce the negative densities (a', b', c', d', e') which these tone values produce. It will be clear from the graph that if we adjust the negative exposure so that we use the straight line portion of the characteristic curve, then the negative densities a', b', c', d', e', will be equally spaced. These negative densities determine the log exposure values which the positive material receives, and from the positive characteristic curve

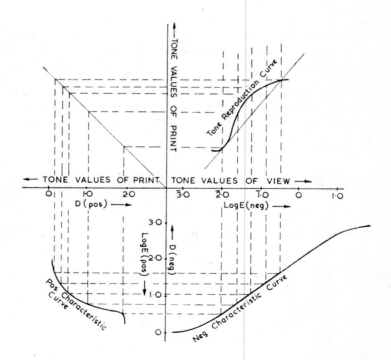

Fig. 12. Tone reproduction diagram, using straight line portion of negative curve.

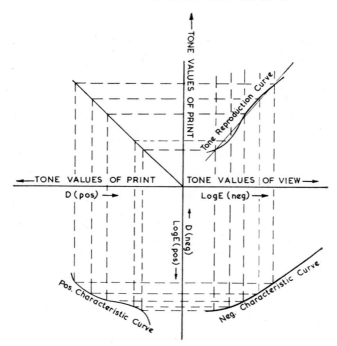

Fig. 13. Tone reproduction diagram, using foot of negative curve.

we can deduce the corresponding densities of the print, a'', b'', c'', d'', e'', and hence the tone values of the final photograph.

If there existed a printing paper with a straight line characteristic curve from zero to maximum density we could obtain perfect tone reproduction, that is, the tone values a'', b'', c'', d'' and e'' would be equally spaced, but as all positive paper characteristics are curved the print tone values become unevenly spaced as shown in the figure.

We could best express the distortion in tone values by means of a graph connecting the tone values of the original against those of the print, for example, by plotting points a, b, c, d and e against a'', b'', c'', d'', e''. In Fig 11 these values appear on the same straight line. One set of values must therefore be replotted at right angles before we can obtain one graph. This is conveniently done by using a line at 45°, as shown in Fig. 12. This gives the complete tone reproduction diagram. A perfect photograph would give a tone

reproduction curve which is a *straight line.* A straight line *at* 45°
indicates that the perfect print has the same visual contrast as the
original view, while deviations from 45° indicate increased or
decreased contrast in the print compared with the original.

It is clear from a consideration of Fig. 12 that since the whole of
the positive characteristic curve must be used, and since this is never
straight, the use of the straight line portion of the *negative* characteri-
stic curve can never result in perfect tone reproduction on a paper
print. The tone reproduction curve always reflects the distortion
introduced by the positive characteristic curve.

Fig. 13 shows the tone reproduction curve obtained when exposing
on the *foot* of the negative curve.

By comparing this with the curve of Fig. 12 it will be seen that
the former is nearer to a straight line. The use of the foot of the
negative characteristic curve has the advantages of requiring
minimum exposure, and giving minimum graininess. We now see
that far from giving poorer tone reproduction than the use of the
straight line portion, it actually gives improved tone reproduction,
since it tends to counter-balance the inevitable distortion introduced
by the positive characteristic curve.

Chapter 14

COLOUR SENSITIVITY AND FILTERS

W HEN WE LOOK at a spectrum produced by passing white
light through a glass prism, the various colours do not
appear equally bright. The yellow-green in the centre
looks brightest, and the remaining colours become progressively
dimmer towards the extremes of the spectrum.

If we were to photograph the spectrum on an 'ordinary' non-
colour-sensitised material, only the blue end of the visible spectrum
would affect it; but in addition the material would respond to the
ultra-violet rays (to which the eye is quite insensitive) beyond the
blue end of the spectrum.

It is therefore clear that the degrees of luminosity of the various
colours of the spectrum are very different when recorded by the eye
and by a non-colour-sensitised photographic material. For example,
an orange on a dark blue plate appears to the eye as a light object on
a dark background; a photograph taken on 'ordinary' material
insensitive to orange but fully sensitive to blue would show a dark
object on a light background. When the object is to produce as
accurate a reproduction as possible of an original view, this differ-
ence between eye and photographic material in interpreting the
luminous values of colours constitutes a defect which should, if
possible, be eliminated. This was recognised in the days of the wet-
collodion plate, and one of the critics who in 1873 made an out-
standing contribution towards the solution of the problem was H.
Vogel of Berlin. Since that date, it has been possible to exercise a
considerable degree of control in colour rendering in monochrome
photography. The luminosity value with which a particular colour
is rendered in a black-and-white photograph clearly depends on
two factors: (i) the sensitivity of the material to that colour, relative
to other colours, and (ii) the intensity of the colour, relative to other
colours. These factors can be independently controlled by two
techniques: colour sensitising on the one hand and the use of colour

filters on the other. A third factor, the use of light sources of different spectral energy, may also be employed in special cases.

Colour Sensitivity of Photographic Materials

In his study of the colour sensitivity of photographic materials, Vogel recognised that the several silver halides differed in this respect. While silver chloride is sensitive only to ultra-violet and violet, the sensitivity of silver bromide extends to the blue. The greatest range of sensitivity, however, is obtained by admixture of a small proportion of silver iodide with silver bromide, the resulting emulsion being sensitive throughout the blue to the blue-green. In 1873, Vogel was fortunate in accidentally discovering a means of extending the emulsion sensitivity to longer wave-lengths. In comparing the colour sensitivity of commercial materials, he noticed that some dry collodion plates obtained from England were more sensitive to green light than any others previously tested. Incorporated in their emulsion was a yellow dye to reduce halation, and Vogel correctly deduced that the dye had sensitised the emulsion to longer wavelengths. Although his observation and deduction were not immediately accepted, and caused considerable controversy, further experiment was stimulated, and new sensitisers were discovered by other workers.

The most important of the early sensitising dyestuffs was *erythrosin,* discovered by Eder and commercially applied in 1884. This was so successful that it was used almost exclusively as a green sensitiser for close on fifty years, and still has a limited use today.

Until the early part of this century, the added sensitivity did not extend beyond the green, and emulsions so sensitised were called *orthochromatic,* implying that, relative to unsensitised emulsions, gave *correct colour rendering* in monochrome. They were certainly a marked improvement and, as they were still insensitive to orange and red, could be handled in red safelight.

Although comparatively few successful sensitisers were known before this century, many materials were recognised as imparting sensitivity, though they were unusable because of other undesirable characteristics. Among them was a basic dyestuff known as cyanine, recognised as a sensitiser by Vogel. In 1901, certain related dyes of the cyanine group were found to be most successful as sensitisers. Since that date the cyanine dyes have established themselves as pre-eminently important in the sensitising field. Before the 1914-18 war, Germany was practically the sole source of cyanine sensitising

dyes, but the war stimulated production in this country and in the United States.

The first dye to impart sensitivity to the whole visible spectrum was produced in Germany in 1904, and such dyes are known as *panchromatic*. Since then intensive work has produced a range of sensitisers imparting high sensitivity to any desired part of the visible spectrum, and of the infra-red as far as 1,000mμ. The earliest *pan* dyes gave emulsions relatively insensitive in the green part of the spectrum, and a dim green safelight which gave maximum visibility with minimum fogging effect could be used. Most modern panchromatic materials, however, are so sensitive to all visible radiations that no light is really safe, and they should be handled and processed in complete darkness.

Extension of Sensitivity into the Ultra-Violet

For certain purposes it may be necessary to study the image produced by ultra-violet radiation, as, for example, in ultra-violet microscopy or in spectography. There is fortunately no need to extend the sensitivity of silver halide in the direction of shorter wave-lengths by colour sensitising, since it is sensitive, so far as we can ascertain, without a break to the shortest waves known. In normal use, however, an emulsion records only to 360mμ; shorter wave-lengths are absorbed by the glass of the lens or prism forming the image. The substitution of quartz for glass allows free transmission of ultra-violet rays below that wave-length, and sensitivity is then extended to 220mμ, below which the gelatin of the emulsion absorbs in the ultra-violet. Sensitivity below that wave-length is achieved by making emulsions that are virtually gelatin-free, or by incorporating a fluorescent material which converts the lower wave-lengths to higher wave-lengths that affect the emulsion. Extension of the usefulness of an emulsion into regions of shorter wave-lengths is thus not a question of sensitising silver halides to those radiations (for example, by sensitising dyes), but of removing those constituents of apparatus and emulsion (glass and gelatin) which prevents the short ultra-violet rays from reaching the silver halide.

Spectrograms

The colour sensitivity of a photographic material can be assessed by exposing the material in a *spectrograph*—an apparatus which throws a

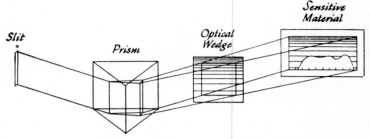

Fig. 1. Spectrograph. (Diag.)

Fig. 2. Spectrograms of typical 'ordinary', ortho and pan
materials. The wave-lengths of figures represent units of
10mμ.

white light spectrum on to the material, together with calibration
figures in terms of wave-lengths. For absolute results, the light should
be such that all wave-lengths are of equal intensity, but for purely
comparative purposes it is usual to use tungsten lighting. On pro-
cessing the material, the image and the calibration wave-length
markings would indicate the range of colour sensitivity. By exposing

the material in the spectrograph immediately behind a graduated optical wedge in which the density variation is at right angles to the spectrum, it is possible to assess the relative sensitivity at various wave-lengths by the height of the image at each wave-length (Fig. 1).

The resulting processed image is called a *wedge spectrogram* and Fig. 2 shows spectrograms of typical emulsions. Since tungsten light is much richer in the longer wave-lengths than daylight, or equal-energy light, the height of the image at the red end of the spectrum is greater than it should be, relative to the blue end, but that is not a serious matter if spectrograms are used merely for comparative purposes. From a normal spectrogram and from the relative intensities of the constituents of tungsten light, we can calculate and draw the spectrogram that would be obtained by using an equal-energy spectrum, when it will be found that, even in the most highly colour-sensitive material, we have not yet succeeded in producing an added sensitivity at any wave-length as high as the original sensitivity in the violet. (Fig. 3.)

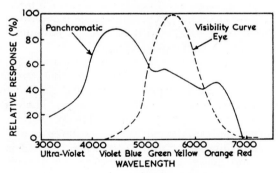

Fig. 3. Sensitivity curves of the eye and of pan material to an equal energy spectrum.

Use of Light Filters

Although much progress has been made in extending the sensitivity of silver halide emulsions to longer wave-lengths by means of sensitising dyes, there is no known method of simultaneously eliminating, or even seriously modifying, the initial sensitivity to the ultra-violet and the blue. We can, however, eliminate or reduce the effect of those wave-lengths—or indeed of any wave-length—by absorbing completely or partially the wave-lengths themselves by means of appropriate light filters.

A light filter is a non-scattering layer that absorbs some of the light falling on it and transmits the remainder. If the filter absorbs all wave-lengths equally it will be neutral grey in colour. If it absorbs some wave-lengths of the visible spectrum more than others, it will be coloured. Since the colour of the filter is due to the transmitted (that is, unabsorbed) light, it will be complementary in colour to the light absorbed. Thus a filter that absorbs blue light will be yellow in colour; one that absorbs red will appear blue-green. Modern photographic practice demands a wide range of light filters absorbing wide or narrow bands in various parts of the spectrum, according to particular requirements, so that whatever the task there is almost certainly a filter on the market that can be successfully applied.

General Properties of Light Filters

The light filter has to be inserted in the path of the light falling on the photographic material. The most convenient position is near the lens where, apart from other advantages, the area of filter required is smaller than in other positions. As easy attachment and removal are desirable, filters are generally used in a metal mount that can be screwed or pushed on to the front of the lens.

Light filters usually take the form of tinted glass or dyed gelatin mounted between two flat glasses. In order to avoid deterioration of image quality, the optical properties of the filters, apart from their selective absorption, must be of a high order. These properties become more critical with increase in focal length and in aperture, and filters are usually marketed in two or three grades, selected plate-glass being suitable for short-focus lenses as used in amateur photography, and higher quality optically-worked glass for more critical requirements such as telephotography or photo-mechanical work.

Correction Filters

Fig. 3 shows the relative sensitivity of the eye and of a modern panchromatic film to an equal energy spectrum. It will be apparent that, although colour-sensitising has rendered the emulsion sensitive to all the colours to which the eye is sensitive, and has thus given improvement over non-colour-sensitive materials, there is still a great disparity between the relative sensitivities of the panchromatic material and of the eye to different colours. The main difference lies

in the material's excessive sensitivity to the ultra-violet and blue, causing blue objects to be rendered too light in a print. The main object of a *correction filter*, designed to give to colours in a print the same luminosity as they present to the eye, is to eliminate the ultra-violet and diminish the amount of blue light. This is done by means of a filter which absorbs the ultra-violet light and some blue light and appears pale yellow in colour. Many such filters are marketed giving different degrees of correction. Some high-speed panchromatic materials are relatively over-sensitive to red (in comparison with green) and in this case a filter which absorbs also in the red region would give a more accurate monochrome rendering. Such a filter appears yellow-green in colour, (Fig. 4).

Fig. 4. Absorption curve of Wratten No. 11 filter.

Haze Filter

As we have seen in chapter 2 (p. 35), ultra-violet and blue light is scattered by the atmosphere to a greater degree than longer wavelengths and this accounts for the bluish veil in distant scenes and aerial views. True atmospheric haze scatters very little red and practically no infra-red.

Since all photographic materials are highly sensitive to ultra-violet, unfiltered pictures record more haze than is visible. This can be remedied by using an ultra-violet absorbing filter over the lens. Such filters are often made to absorb a small amount of blue light as well.

Still greater haze penetration may be obtained by suppressing all the blue and part of the green (a deep yellow or orange filter) and maximum penetration with a panchromatic film by using a red filter. The maximum possible penetration is obtained by using an infra-red sensitive material with a filter that absorbs all but the far red end of visible spectrum—see illustrations on page 194.

Fig. 5. The upper version was made with a normal pan film and the lower version with an infra-red sensitive material

Over-correction

By the use of deep yellow or red filters, the suppression of the blue end of the spectrum can be continued, so that the blues are rendered darker in the print than their visual tone values, and the yellows and reds correspondingly too light. Dramatic pictorial effects may thus be produced by accentuating unduly certain landscape features, and rendering clouds as stark white against a midnight sky. Slight over-correction, moreover, is sometimes useful for giving differentiation between a landscape feature (for example, a yellow sunlit building) and a background sky. Extreme over-correction is represented by the use of infra-red sensitive materials with a filter that eliminates the ultra-violet and blue to which the material is also sensitive, Fig. 6.

A colour filter functions by absorbing some of the light to which a material is sensitive. The exposure required to produce a correctly exposed negative must consequently be increased by a factor called

the *filter factor*. It should be emphasised however that, contrary to popular misconception, a filter has no specific filter factor—the appropriate factor depends on various other conditions. For example, a yellow filter will require much less increase in exposure if used in conjunction with a panchromatic film that is highly sensitive to the transmitted yellow than if used with an 'ordinary' (blue-sensitive) material. Again, the increase in exposure with a given material will be less if the view is illuminated by yellowish (for example, tungsten) lighting than by bluish (for example, daylight) lighting.

Thus the filter factor is significant only if the type of lighting (daylight or tungsten) and the sensitivity of the material ('ordinary', ortho or pan) are specified. Where they are not specified, it is usual to assume that the filter is to be used with pan material in daylight.

Contrast Filters

So far, we have considered correction filters (sometimes called *orthochromatic* filters), whose main function is to produce a photograph in which colours show the same luminosity value as they present to the eye.

Filters are also largely used deliberately to falsify such tone values, when occasion demands. While the eye can recognise colour contrast

Fig. 6. An interesting pictorial effect has been obtained in the right hand version by the use of a red filter.

Fig. 7. Elimination of colours on document.
 (*a*) Typescript with red and blue corrections.
 (*b*) Blue eliminated by photography on 'ordinary' film.
 (*c*) Red eliminated by photography on pan film through
 red filter.

as well as brightness contrast, the black-and-white print can differentiate only by the latter. The detail on a stained microscope specimen, or the lettering on a poster may be discernible only because of colour difference. Red lettering on a green background of the same luminosity would record on a fully corrected film as a uniform grey, and to meet that situation it might be considered preferable to sacrifice truth in tone values in order to bring out detail (viz. the lettering). A pan film with a red filter would give a print in which the red would appear lighter, and the green darker than their true visual luminosity values, to give quite legible light printing on a dark background. Alternatively an ortho film without filter would give a print with dark lettering on a light background. Filters so used are generally called *contrast filters.*

Detail in any one colour is usually enhanced by rendering the colour light on a print, that is, by using a filter of the same general colour as that being photographed. For example, in photographing furniture, it is usually desirable to give emphasis to details of marquetry, parquetry or wood grain pattern. Photographs on 'ordinary' or ortho material render the furniture too dark and lacking in detail. A pan film with correcting filter shows the grain or pattern as the eye sees it, but often a more pleasing effect can be produced by photographing the reddish or brown wood with a deep yellow or red filter to accentuate the pattern of the wood surface.

On other occasions, it may be desirable to suppress an undesirable pattern. This, too, may be achieved by the judicious use of filters. A white paper, with printing in two different colours (say, red and blue) may be copied so as to delete one of the printings by the use of appropriate filters. A deep-red contrast-filter with pan film, for example, would give a copy print in which the red lettering is rendered so light as to be indistinguishable from the white background, leaving only the blue lettering in bold relief. Conversely, copying on an 'ordinary' (blue-sensitive) material would eliminate the blue printing (Fig. 7). The success of such differentiation will of course depend on the separation of the colours. While it is easy to separate red from blue, it is more difficult to separate completely red from yellow.

In copying paintings, the most faithful reproductions are obtained by using full colour correction, but often old paintings have lost much of their original detail, and in the course of time colour values have been falsified by a brown discoloration of the varnish. The use of a deep yellow filter tends to eliminate this discoloration, show up detail not easily visible to the eye, and give a result in which colour luminosities approach more nearly to those of the original picture.

Often old documents and prints are disfigured by brown stains. If the original ink is black or bluish in colour, the stain may be eliminated and the printing preserved unimpaired in a copy by using a filter that transmits only the light reflected by the brown stain (for example, a deep yellow or red filter). Alternatively, if ink has faded to a brown colour, it may be recorded as black by the use of a complementary (blue) filter, or its equivalent, 'ordinary' (blue-sensitive) materials.

The applications of contrast filters are legion, and only one or two typical examples have been mentioned. The appropriate filters may be selected by remembering the principle that a filter of the same general colour as a portion of a view renders that portion lighter in the print, and shows up its detail. In the extreme it may be rendered so light as to be indistinguishable from a white background, and so eliminated. A filter that is complementary in colour renders the portion darker and suppresses detail. In the extreme case, it may give a uniform black.

Neutral Density Filters

These filters are designed to absorb visible light non-selectively and are useful when it is desired to reduce the brightness of an image

without resorting to a decrease in exposure either by using a shorter time or a small lens aperture. We could, for example, be using a film of very high speed for subjects in low illumination, but have occasion on the same film to photograph a subject in full sunlight. The necessary reduction in exposure may be outside the range of shutter speeds and lens apertures available. In this case a neutral density filter of 2 would reduce the effective speed of the film 100 times. In another case we may wish to use the full lens aperture to reduce the depth of field and the use of a neutral density filter of 1 would enable us to open the lens by just over three stops.

Polarizing Filters

Though not filters in the usual sense, they can be used as a means of darkening the sky, and to a limited extent, reducing haze. The nature of polarizing filters has been discussed on p. 36. Polarizing filters are especially valuable in colour photography when it is desired to obtain maximum colour saturation by the elimination of surface reflections from non-metallic surfaces. A basic increase in exposure of from 2 to 3 times is needed.

Safelight Screens

Mention has already been made (p. 24) of gaslight paper, so named because it can be handled in gaslight without fogging. However, in practice it is possible to employ filters of different absorptions for the handling and inspection during processing of materials of various sensitivities. Those which are sensitive only to ultra-violet and blue light can be safely handled in light from which this region of the spectrum has been removed. This applies generally to chloride emulsions and thus allows a very bright yellow light to be used. Somewhat greater screening is required for bromide and chloro-bromide printing materials, while orthochromatic materials require a very high absorption of light, up to about 640mμ. In general, panchromatic materials and colour films and papers must be handled in complete darkness, but very limited use of a safelight passing only 0·01 per cent of light around a wave-length of 520mμ for panchromatic and 0·1 per cent at 600mμ for colour film is possible.

Chapter 15

RECIPROCITY FAILURE AND OTHER PHOTOGRAPHIC EFFECTS

THE CHEMICAL CHANGE produced in a photographic emulsion on exposure to light is an example of a *photochemical reaction*—a reaction which does not take place in the dark, but does so when the emulsion is subjected to the action of light or other radiations. There are many such photochemical reactions occurring in nature, most of them of a highly complex character.

The Bunsen-Roscoe Law

In the course of a study of some simple examples, Bunsen and Roscoe found, as would be expected, that the amount of chemical produced during the reaction increased with increasing intensity of illumination, and also with increasing time of illumination. They found, moreover, that the quantity of material produced was dependent on the value of intensity multiplied by the time of exposure. Thus if a given amount of chemical is produced by a certain intensity over a given time, the same amount will be produced by half the intensity acting for double the time, or indeed for any values of intensity and time, provided that their product equals the product of the original intensity and time. Bunsen and Roscoe thus found that intensity and time were perfectly equivalent. This observation was generalised as the *Bunsen-Roscoe Law of Photochemical Equivalence.*

Reciprocity Failure

The photographer found that a similar relation holds over a limited range for the density produced on photographic materials. Thus in general, density increases with increasing light intensity and increasing exposure time; and the density produced by a certain intensity acting for a certain time is practically the same as that

199

produced by half the intensity acting for double the time, or for double the intensity acting for half the time. However, if marked changes are made in intensity and time, e.g. one-tenth or one-hundredth of the intensity acting for ten or a hundred times as long, the density produced may be markedly different, even though the *product* of intensity and time remains constant. For the density produced on photographic materials, therefore, there is failure in the true reciprocity of time and intensity, a phenomenon known as *Reciprocity Law Failure* or merely *Reciprocity Failure*.

This has been taken by some as evidence that the Bunsen-Roscoe Law of Photochemical Equivalence does not hold for the photo-chemical reaction occurring during the exposure of photographic emulsion, but such arguments are quite invalid. We have seen that the primary product of light action on a photographic emulsion is electrons, and we have no reason to doubt that these are formed quantitatively in accordance with the Bunsen-Roscoe Law. There are many subsequent and non-quantitative reactions before the liberated electrons give a photographic image—a proportion of the electrons combine with silver ions to form sub-microscopic specks of metallic silver (the latent image). Some of these may act as development centres and catalyse the reduction of some of the silver halide grains to metallic silver, which has an optical density depend-ing not only on the amount but also on the size and distribution of the silver grains. It is certainly not surprising that the production of optical density is not absolutely in accord with the Bunsen-Roscoe Law—the surprising part is that reciprocity between intensity and time, in respect of photographic density, remains to the extent that it does.

Experimental Determination of Reciprocity Failure

The reciprocity failure of a material may be determined by a series of time-scale exposures. For example, various portions of a strip of material may be exposed to the same intensity, with exposure time increased by the same ratio, say double, for each step. On develop-ment, a series of densities increasing with exposure time will be obtained.

If we repeat the experiment, using only half the intensity but giving each step twice the exposure of the corresponding one in the previous experiment, we shall find little change in the densities of corresponding steps. However, by giving the strip $\frac{1}{10}$, $\frac{1}{100}$, etc., of the

intensity and increasing the times to correspond, we shall probably find a considerable change in the density of a particular step, although the exposure of any step, measured as $I \times t$, remains constant. The series may of course be extended in the other direction, successively increasing the intensity while correspondingly decreasing the exposure of each step. Fig. 1 shows a typical result.

We could plot the way in which density varies with different intensities at constant exposure (It), that is to say, we could plot the densities along any horizontal set of steps in Fig. 1, but a very differently shaped curve would be obtained for each step. The curve would have little significance since it would depend not only on the reciprocity failure, but also largely on other characteristics of the material. A more significant way of plotting reciprocity failure from the experimental results of Fig. 1 is to plot the exposure required to produce a *constant* density at various intensities, which gives reciprocity curves as shown in Fig. 2.

Since we are plotting log It against log I, horizontal lines on the graph represent constant exposure (It) at different values of I and t, and vertical lines represent constant intensity but different times, and hence different It. Points representing constant time but different intensities will not only move along the log I axis, since intensities vary, but also along the log It axis, since constant time but varying intensity must mean varying exposure (It). They are represented by lines at $45°$, as shown in the graph.

Fortunately the minimum of the graph, which represents the least exposure required to produce a given density, and hence conditions giving the highest effective speed, occurs around those intensities normally incident on the material in photographic practice.

Cause of Reciprocity Failure

Considerable experiment and speculation have been directed towards an explanation of reciprocity failure and the evidence to date indicates an entirely different explanation of the inefficiency of the process at high intensities from that at low intensities.

With a brief high intensity exposure, the electrons are released too rapidly to be handled by the relatively slow second stage. The exposure is all over before more than a proportion of the electrons can be neutralised by the slower moving silver ions, the wasted electrons recombining with bromine atoms to reform silver bromide. Moreover, those electrons that do form latent image produce a high proportion of internal image and also much sub-latent image, both

of which are wasted so far as normal processing is concerned. Small wonder then that brief high intensity exposure is less efficient than exposure at normal intensities and times.

Low intensity inefficiency can also be explained by the evidence already reviewed. Electrons are released at a very low rate. They are trapped and neutralised and must remain as isolated silver atoms for much longer than in normal latent image formation. It has already been observed that such extreme sub-latent image is unstable, and it is postulated that inefficiency is caused by many isolated atoms of silver losing their acquired electrons during the period of instability.

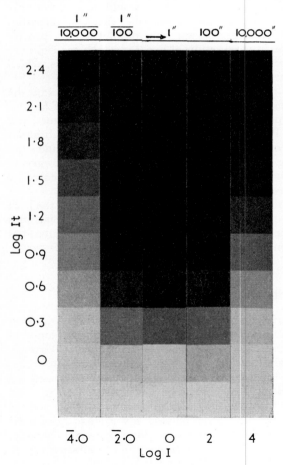

Fig. 1. Series of time-scale exposures showing reciprocity failure.

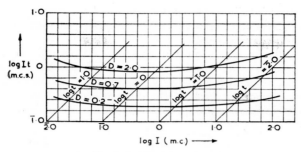

Fig. 2. Reciprocity curves.

An analogy, though not a very good one, can be offered by comparing electrons to bricks and the latent image to an edifice under construction. If the optimum number of bricklayers for the job is ten, and the job can be finished in ten days, a thousand bricklayers could not be expected to do the job in one-tenth of a day—there would certainly be high intensity failure in such brick-laying. Low intensity failure may be likened to the efforts of a very old and senile bricklayer who can work only at one-tenth of the normal rate. As he has to do the job alone, he might be expected to complete the building in a hundred times the time taken by the team of ten, that is, in a thousand days. Unfortunately he cannot maintain this performance because of *instability* in the early stages of construction—say, due to the destructive activities of small boys who kick the bricks off the wall under construction. This pastime is naturally limited to the first few courses, but while they can destroy the walls nearly as fast as the old man builds them, and thus account for low intensity failure, they have little effect on the rapid work of the ten-man team, which soon raises the walls to the stable limit.

Latensification

The analogy may be pushed a stage further. If the *first* few courses were built by the ten-man team, the old man could continue at his full efficiency, unhampered by the small boys' destructive efforts. So with the latent image; a uniform, very small exposure to medium or high intensity light, such as would produce only a low density on development, will provide sufficient latent and sub-latent image to act as stable nuclei for further low intensity exposure. Low intensity

failure is thereby eliminated and the reciprocity curve is as shown in Fig. 3. The low-intensity latent image is thus considerably intensified by a high-intensity pre-exposure.

The effect can be put to use in two ways. When the subject to be photographed is of such low intensity that exposure time extends over some hours, as in astronomical photography, a uniform small pre-exposure to normal intensity light will remove low intensity failure and therefore enhance the speed considerably to low intensity light.

Fig. 3. Elimination of low-intensity failure by pre-exposure.

In modern astronomical photography, however this treatment is rarely used, as special plates are now available in which low intensity failure has been eliminated by other means.

The effect can also be used to advantage when a material has been given extreme under-exposure to a normal-intensity view, so that on development the highlights produce only a low density. A subsequent *uniform* exposure to low intensity light will show no reciprocity failure where there is already latent or sub-latent image, and will therefore build up the latent image of highlights and mid-tones; failure will occur where there is no previous latent image and have little effect on the shadows of the original view. The original faint latent image will thus be intensified—a process covered by the portmanteau term *latensification*. To return to the bricklaying analogy, the original under-exposure to normal intensity would be represented by the team of ten men building up to a few courses on certain sections of the wall only, leaving gaps. Subsequent activity by the old man would be largely destroyed where there were no courses laid, but would build up unhampered on the sections where the team had laid a few courses.

Latensification was used during the war when important aerial photographs were suspected of being under-exposed.

Intermittency Effect

Another phenomenon now known to be closely connected with reciprocity failure is the *intermittency effect*. It was discovered by early

students of sensitometry, who used sector wheels to give time-scale exposures (Fig. 26, Chap. 12). They could give exposures by rotating the wheel slowly so that only one revolution was required, or they could give the same exposures by rotating the wheel x times as fast, and exposing for x rotations. In the latter the total exposure received by each step is the aggregate of x intermittent exposures, each at $1/x$ of the original time, that is, equal in all to the corresponding time of the single-revolution exposure. The intensity during the illumination is the same in each, and yet in terms of densities produced the results are different.

The reason is that the photographic material behaves like the eye; intermittent exposures of sufficiently high frequency are not recognised as such, but appear identical with a uniform exposure of lower intensity. The necessary frequency for the photographic material to record the exposure exactly as a continuous one whose intensity is the *average* over the total time, is much higher than that for the eye, so that most intermittent exposures give a photographic effect somewhere between two extremes. One extreme is that given by a non-intermittent exposure, that is, by the actual time and intensity of light action on the material; the other is given by the *average* intensity operative over the total time taken to give the intermittent exposure.

The explanation of the intermittency effect in terms of photo-graphic theory is simple. Exposure of a grain to light releases electrons from bromide ions, and the electrons exist in a free state for a short period before being trapped. The number of free electrons per unit volume (the concentration of electrons) during exposure will increase with increasing intensity. During intermittent exposure, the light is shut off after each exposure increment before the con-centration can reach the value appropriate to that intensity, and the total effect is equivalent to one of lower intensity and longer time.

The Clayden Effect

It has frequently been observed that a lightning flash occurring during a daylight exposure to a view may produce *less* density on the negative than the surrounding sky. The print then shows the curious phenomenon known as *black lightning*, also called the *Clayden Effect*, after an early observer (Fig. 4).

This effect remained a puzzle until recent studies of latent image afforded a simple explanation. The Clayden effect occurs when an emulsion is given a very high intensity exposure, followed by an

exposure at normal intensity. Black lightning thus appears on a photograph when the lightning occurs during the early stage of the daylight exposure. The initial high intensity exposure forms, as we have seen, a great deal of internal latent image which is an efficient

Fig. 4. Clayden effect. The black lightning occurred during the early stages of exposure, the white lightning later. *Courtesy: Kodak Museum, Harrow.*

electron trap for the subsequent exposure at normal intensity, competing with surface traps so that much of the subsequent latent image is wasted in the interior of the grain. Indeed the *surface* latent image produced by both exposures is less than that of the second (normal intensity exposure) alone. Density is thus lower where there has been initial high intensity exposure.

The Herschel Effect

In 1840, Sir John Herschel noted that red light had something akin to a bleaching effect on the print-out image of silver chloride paper. It has subsequently been discovered that the *latent* image on an exposed emulsion which is not colour sensitised to the red or infra-red is apparently destroyed on exposure to these radiations. The effect is known as the *Herschel Effect*.

Attempts to explain the phenomenon have caused much controversy, but investigations in the light of our present knowledge of

latent image formation indicated that latent image is not *destroyed* by red light—it is merely *redistributed* throughout the grain. After red-light illumination there is certainly less *surface* latent image, but internal latent image is increased, as also is sub-latent image. Moreover, if the surface latent image is destroyed by an oxidising agent, and the material with its residual *internal* latent image then exposed to red light, redistribution again takes place and surface latent image is formed at the expense of internal image.

Why does red light make the silver of the latent image mobile, so that it can wander throughout the grain? The answer is indicated by measurements of the wave-length of maximum absorption by latent image silver and the wave-length of maximum Herschel effect. It is significant that these are identical. The reasonable hypothesis has been advanced that the absorption of energy by the latent image speck causes the silver to emit an electron and revert to a silver ion. The electrons wander to other sites where they may be trapped and neutralised by a silver ion. The net result is that the larger clusters of silver atoms at the surface, which constitute normal latent image, are distributed throughout the grain as ineffective internal and sub-latent image.

Solarisation

There is yet one more important effect which a more complete knowledge of the mechanism of photolysis has enabled us to understand. Photographers well know that as exposure increases so too does the resulting density until it reaches a maximum value. This relationship is expressed quantitatively by the characteristic curve of a material under certain conditions of processing. If the exposure is increased well beyond that which gives maximum density, it is frequently found that *lower* densities result (Fig. 5). This *decrease* in density at very high exposures is called *solarisation,* and the degree of solarisation depends on the emulsion and the processing conditions.

Fig. 5. Characteristic curve showing solarisation.

Let us now consider the explanation of the effect and some further evidence upon which it is based.

In our previous considerations of the photolytic process, we have given much attention to the method of formation of metallic silver, the latent image. We have rather neglected the bromine which is also formed when silver bromide decomposes. We have seen that a bromine atom can, in effect, wander in the crystal merely by transference of an electron from a neighbouring bromide ion to a bromine atom, when their roles are reversed, the ion becoming the atom and the atom the ion. When a bromine atom reaches the edge of the crystal, we have seen that it reacts with reducing substances, most probably gelatin or a silver-gelatin complex. Gelatin is said to be a *halogen acceptor,* and a most efficient acceptor it is—for small amounts of bromine. Its capacity, however, is small and after destroying small quantities of bromine with avidity, it soon becomes saturated and will accept no more. Fortunately its capacity is ample for the quantities of bromine liberated in normal latent image formation, but not for the relatively very large quantities liberated during the excessive exposures of the solarisation region.

During these exposures large latent image specks are formed on the surface, and free bromine first saturates the surrounding gelatin, then builds up a concentration of free bromine in the spaces between the grains. On completion of the exposure, the excess bromine reacts with the latent image specks (as silver and bromine always do in the dark) to coat the latent image with a layer of silver bromide, thus isolating it from the developer, and rendering the grain undevelopable. The greater the exposure, the more free bromine is formed, the more the latent image specks are coated with silver bromide, and the lower the developed density.

If this explanation is correct, certain predictions are possible. We should expect that if we reinforced the halogen-absorbing capacity of the gelatin by adding a further halogen acceptor to the emulsion, solarisation would decrease. We find, in fact, that a halogen acceptor such as sodium nitrite, or certain organic dyestuffs, completely eliminates solarisation. Again we should expect an *internal* developer containing silver halide solvent to uncover the latent image specks and reduce solarisation. This again is found to be true. Solarisation is most marked with a developer containing no silver halide solvent. Normal developer which contains sulphite—a mild silver halide solvent—shows somewhat less solarisation, but a developer containing hypo may eliminate it completely. Other confirmatory experiments could be quoted which lead us to believe that rehologenation of the grains is a valid explanation of solarisation.

Chapter 16

PHOTOGRAPHIC EXPOSURE

IT HAS BEEN stated in an earlier chapter (p173.) that correct exposure may be considered as the minimum necessary to yield a negative from which a satisfactory print can be made. Before we review the methods for arriving at this value in terms of a given lens aperture and shutter speed, it is necessary to examine the problem of tone reproduction a little more closely. Not in respect of the linear reproduction of tones, since we have already seen that the characteristic curve of the printing material makes this impossible, but in the reproduction of a greater than normal range of brightnesses and also in the rendering of certain 'key' brightnesses such as brightnesses greater than white and in the rendering of light and shadow in such subjects as portraits.

Firstly, the brightness range may be considerably higher than the 30 : 1 already quoted as the average. Subjects photographed against the light, interiors lit by a single window and scenes which include both interior and exterior brightness levels may present brightness ranges as great as 1000 : 1. This may even exceed the exposure range of the negative material and is certainly far in excess of the tone reproduction capacity of a reflection print. In such a case there is obviously no such thing as 'correct' exposure but rather a compromise exposure in which either the lighter or darker brightness are sacrificed. True there are ways and means of tackling such a situation in the printing process: the use of long-scale printing papers, local exposure control, etc. These are discussed later in this chapter. But there is a more basic approach which can often be adopted before the exposure is made, namely that of reducing the brightness range. This can take the form of a fill-in light for the darker areas or, where this is impossible, the selection of a viewpoint where the brightness range is more manageable.

The task of the photographer in achieving an acceptable lighting balance is further aggravated by the fact that shadows appear darker in a photograph than when viewing an actual scene. The explanation is that the eye tends to look into the shadows of an

actual scene (making automatic adjustments to its diaphragm) while the brain tends to interpret the area in shadow on the basis of its actual tone rather than its apparent tone, a reaction known as *brightness constancy*. However, it does not react to anything like the same degree when viewing a photograph.

Because of this, an experienced photographer will endeavour to illuminate the shadows to a brightness level where they will appear right in a photograph. Methods commonly employed consist of the use of reflector boards placed to direct some of the main light on to the shadow areas or the use of supplementary lighting in the form of flash, etc.

Constant Brightness Level

One of the approaches to the problem of exposure is that of working to a constant brightness level. This can be achieved in the studio with artificial light sources and is a common technique in motion picture studios where scenes are lit to a given brightness and range of brightnesses known to give acceptable results in the projected print image. To some extent such a condition exists naturally in outdoor photography when the sun is well above the horizon and its light from the camera viewpoint is mainly frontal. In both cases it is possible to standardise exposure for any given film speed.

But in general photography based on existing lighting, the brightness level varies a great deal. For example, the exposure required for photographing a scene lit by moonlight (taking into account reciprocity failure) is more than a million times greater than that required for the same scene lit with noonday sunlight.

The Speed of Sensitive Materials

The various systems for expressing the numerical speed of a negative material have been discussed elsewhere (p.177). They are based on standard development and an exposure time of about 1/50 second. The use of a fine-grain developer may cause a reduction in speed and this must be taken into account when making the exposure. Extended exposure times to compensate for low intensities may also cause a substantial reduction in effective speed and where manufacturer's recommendations are not available, a series of trial and error must be made. For orthochromatic materials (which are insensitive to red) the speed number for tungsten illumination (which

is deficient in blue) will be only about half that required for daylight. On the other hand an infra-red sensitive film will be 'faster' to tungsten illumination as it is richer in infra-red radiation. The use of filters to adjust tonal relationships may also be considered as affecting the speed of the material, though it is more usual to treat any required increase in exposure as a filter factor.

Other factors may affect the speed number. Sensitised materials are subject to deterioration (depending on storage conditions). The manufacturer usually gives an expiry date on the box or carton after which he no longer guarantees the specified characteristics of the material. Among other things, there could be some loss of speed. The speeds of the camera shutter may be inaccurate and if an exposure meter is used, it may be giving misleading readings. A loss of speed may also result from reciprocity failure (p. 199), most commonly when exposure times of 10 seconds or more are needed. An experienced photographer, however, makes a practice of determining the speed of a new film on the basis of his own equipment and processing conditions.

Method of Assessing Exposure

The first serious attempts to eliminate guesswork from exposure were undoubtedly those of Hurter and Driffield, though during the latter half of the last century several kinds of exposure aids including tables, calculators and 'meters' were put forward.

Though exposure tables and calculators still exist and form a useful guide to exposure under various lighting conditions, the manufacture on a large scale of small, photocell exposure meters, either as a component of the camera or as a separate unit, has now taken guesswork out of exposure for the majority of serious photographers, amateur and professional.

The basis of exposure tables is that of classifying daylight under such headings as 'Bright Sun', 'Hazy Sun', 'Cloudy Bright' and 'Cloudy Dull', allowing an increase in exposure of times 2 (or 1 stop in aperture) for successively less bright conditions. Further sub-divisions are usually allotted to the kind of subject—light, average, or dark in tones—and for front, side and back-lighting. Calculators usually work on the basis of adding or subtracting log numbers, the final answer being applied to some kind of scale for converting the number into apertures and exposure times. Obviously the efficiency of such tables or calculators depends on the interpretation of the 'classes' and the care with which the conditions are assessed.

The fore-runner of the photocell meter took the form of an actinometer which measured the 'actinicity' of the light in terms of its action on a piece of sensitive paper. The time taken for the paper to blacken gave an indication of the intensity of illumination. Other devices took the form of a visual photometer in which a grey scale was used to 'extinguish' the detail in a selected shadow area. For this reason they were known as 'extinction' meters. Although quicker to use than the actinometer, they were open to errors due to the adaptation of the eye to low intensities.

Fig. 1. Photo-electric exposure meter.

Photo-Electric Exposure Meters

These made their appearance as photographic accessories in the early 30's and have rapidly become the standard method of determining exposure. The majority of such meters employ a selenium barrier-layer cell which converts light energy into a flow of electric current, which is used to deflect a highly sensitive galvanometer. The cell is effective over a wide range of intensity, but falls rapidly at low intensities. The deflection of the galvanometer needle can be used to give a numerical reading which is then applied to a calculator which takes into account the speed of the negative material (or colour film) and gives a range of shutter speed/lens aperture combinations which can be applied to the camera. When embodied in a camera, the deflection of the exposure meter may be shown in the viewfinder (allowing adjustment to be made to the lens diaphragm) or it may be directly coupled to the lens diaphragm or shutter speed selector so that the camera is automatically adjusted to the reading of the meter.

A more sensitive type of meter embodying a cadmium sulphide photo-resistor enables readings to be made of intensities as low as that of moonlight. In this case the cell acts as a variable resistor to a flow of current from a small battery connected to a galvanometer, the action of light reducing the resistance, Fig. 2.

A third type of exposure meter is based on a photometer which incorporates a 'standard' light source. Such exposure photometers are intended to measure brightnesses of small areas and are not suitable for integrated exposure readings.

Fig. 2. Cadmium sulphide cells (indicated by arrows) are built in the reflex view-finder as a means of ensuring correct exposure.
Courtesy Fi-cord. Ltd.

Methods of Using Exposure Meters

There are a number of ways in which a photo-electric exposure meter may be used for assessing exposure.

Incident light method: The meter is used to measure the intensity of the light coming from a region behind the camera, the meter being directed away from the subject. Thus the reading is related to the light falling on or incident to the subject. To integrate the light, the meter cell is covered with a diffusing device which often takes a conical or hemispherical form so as to collect light from a wide angle.

The incident light method is usually regarded as the most reliable as it is not influenced by unequal distributions of reflected brightnesses from the subject or its surroundings (when the acceptance angle of the meter exceeds that of the lens). On the other hand, it takes no account of overall tonal differences of the subject which in practice would require either a greater or lesser exposure.

Highlight method: The meter is used to read the light reflected from a matt white surface, such as a piece of card or white handkerchief, placed so as to receive the main light coming from behind the camera. It is similar to the incident light method and can be used with exposure meters not designed for incident light readings. The reading so obtained must be divided by 5 if it is to be applied to an average subject. However, it holds good for copying documents which consist of an image on a white paper base.

Grey-card method: This is similar to the white-card or highlight method except that the reflectance of the card is roughly equal to the average subject. The reading so obtained may thus be applied directly to an average subject. Both this and the white-card method can be useful when dealing with small subjects which do not provide sufficient area for a reflected light reading.

Reflected light method: The meter is directed towards the subject to be photographed so as to measure the light reflected towards the camera. It is by far the most common method in use and gives satisfactory results, chiefly because the majority of subjects show very little variation in the total reflected light under a given intensity of lighting. However, it is likely to give misleading readings (or incorrect exposures if the meter is embodied in a camera as an automatic exposure control) when the subject contains large light or dark areas. This situation can be greatly aggravated if the acceptance angle of the meter is substantially greater than that of the lens (invariably the case when using narrow angle lenses unless special precautions are taken). The most common example of an excessively light area (tending to give under-exposed results) is a general view containing a large area of sky. In this case it is advisable to tilt the meter down so as to exclude most of the sky from the angle of the meter. The reverse situation arises when a relatively small but light subject is placed against a dark background. In this case a reflected light reading would tend to give an over-exposed result.

To sum up, the experienced photographer will use an exposure meter as a guide, employing at times either one method or the other and modifying the reading indicated according to his experience of similar conditions and the kind of effect he desires to obtain.

Exposure Value System

This system originated in Germany and was first known as the light-value system after the word *lichtwert*. However, since it also

takes into account the sensitivity of the film, it was later, more correctly named exposure value system. It utilises a log scale of numbers—1, 2, 3, 4, and so on—in which a difference of 1 represents a factor of 2. The same ratio, in terms of light passing capacity, applies to the f/number scale, though in this case the numbers go in the series f/2, f/2·8, f/4, f/5·6 and so on. It remained to iron out the irregularities in the shutter speed scale so that these also were based on a ratio of 2.

The purpose of the exposure value system was to simplify the operation of setting the required exposure on the camera. The two movements for changing lens aperture and exposure time were made complementary so that as the size of the lens aperture was decreased the exposure time was increased by a compensating amount. The two scales were coupled and a third scale of exposure values was introduced which was related to the actual exposure (based on film speed and light intensity). The act of setting the exposure value scale temporarily uncoupled the aperture-shutter scales to enable them to be set to a basic relationship which gave the required exposure. However, once set, any combination of aperture and shutter speed could then be selected at will to give an equivalent exposure. For example, if a fast speed was required for an action subject, the lens aperture was opened up at the same time.

Guide Number System for Flash

The basis of this system has already been explained on p.39. In practice it is necessary to take into account the light reflected from surfaces adjacent to the subject. Guide number tables are normally based on an average room with walls of average brightness. Less exposure would be required if the flash were used in a small room with white walls (such as a bathroom or kitchen) and more exposure in a large hall or when the flash is used out of doors.

The validity of the guide number also depends on the type of reflector fitted to the flash holder. Small reflectors, designed for portability, may need 1 stop more exposure compared with one designed to give maximum efficiency.

Subject Movement

The effect of movement of part or whole of the subject at the time of exposure will be recorded in the photograph as a blurring of detail

in the direction of the movement. The extent to which this becomes apparent depends on a number of factors which include the duration of the exposure, the speed of movement, its direction relative to the lens axis and the scale of the print image. The amount of blurring is usually controlled by the time of exposure and tables of shutter speeds for photographing various kinds of action have been in existence since at least 1888.

With a fast-moving object such as a racing car, it is common practice to swing or pan the camera in the direction of movement at the time of making the exposure. By this means, relatively 'long' exposure times can be given while still retaining sharp detail in the subject. Stationary objects in the background become blurred because of the movement of the camera, but this usually enhances the pictorial effect.

Total elimination of blurring in an action photograph usually gives a 'frozen' effect and action is often conveyed better by retaining a certain amount of blurring. Indeed a kind of exaggerated movement blur obtained by using long exposure times has come to be known as 'fluid motion'.

Chapter 17.

AFTER-TREATMENT OF THE NEGATIVE

THERE ARE MANY ways in which a negative may fall short of the ideal required to produce a high-quality print. It may have been incorrectly exposed or processed, or it may be marred by stains, spots or other blemishes. Under-exposure may occur under poor lighting conditions, resulting in an excessively 'thin' negative, while excessive exposure may result from too much caution in making an estimate. While a dense negative may still yield satisfactory prints, it may also involve an excessively long printing exposure time. Variations in development result in differences in contrast and average density, but positive materials are nowadays supplied in such a wide range of contrasts that negatives covering very different density ranges can be accommodated.

Nevertheless, if desired, it is possible to reduce the density of a negative by oxidising some of the metallic silver of the image to a silver salt and dissolving the latter in a suitable solvent. This process, in which density is reduced, was quite logically called by photographers *reduction*. It is unfortunate that chemists use this same term for, among other processes, the production of a metal from its salt. Photographic reduction is achieved by oxidation, which is the exact converse of chemical reduction. Where ambiguity is likely to arise, therefore, the term *reduction* should be prefixed by the word *photographic* or *chemical*, as the case may be.

It is also possible to increase or intensify negative densities by image-wise deposition of silver or other material on the metallic silver of the image, or by conversion of the image silver into some other substance of higher photometric constant, that is, of greater light-stopping power. This process is known as *intensification*.

The Oxidation of Metallic Silver

Photographic reduction is carried out by treating the negative in a bath of oxidising agent (plus solvent if necessary) until sufficient

217

silver of the image has been removed. The end of the process is normally assessed by inspection.

Not all oxidising agents are suitable for dissolving the metallic silver of the photographic image. Nitric acid, for example, is a typical chemical oxidising agent which readily dissolves silver to form the soluble salt, silver nitrate (p. 89), but it also attacks gelatin, converting it into soluble compounds, so that its use would involve the danger of losing the whole of the image layer. Suitable oxidising agents for the silver of photographic images are, in fact, comparatively few in number. We will now consider the way in which some of the more important ones function.

Potassium Permanganate

Some elements are capable of forming compounds in which they exhibit very different valencies (p. 124). The valency of manganese may be as low as 2 in manganese sulphate, and as high as 7 in potassium permanganate; in other compounds it can also show intermediate valencies. The structural formulae for the two compounds named are:

$$Mn \diagdown_{O}^{O} S \diagup_{O}^{O}$$
Manganese sulphate

$$K-O-Mn{\overset{O}{\underset{O}{\parallel}}}=O$$
Potassium permanganate

In the presence of sulphuric acid, potassium permanganate acts as a powerful oxidising agent; it readily gives up its excess oxygen to compounds capable of being oxidised, and is itself converted into manganese sulphate. It will oxidise silver of the photographic image to silver oxide, which in the presence of the sulphuric acid, forms silver sulphate (soluble in water), thus:

| 2 $KMnO_4$ | + | 8 H_2SO_4 | + | 10 Ag | \rightarrow |
| Potassium permanganate | | Sulphuric acid | | Metallic silver | |

| | K_2SO_4 | + | 2 $MnSO_4$ | + | 5 Ag_2SO_4 | + | 8 H_2O |
| | Potassium sulphate | | Manganese sulphate | | Silver sulphate | | Water |

Acid permanganate has little effect on gelatin, so that the process is quite suitable for photographic use. The acid permanganate solution, and the image layer must, however, be free from soluble halides (for example, chlorides from tap water), which would react

with the silver sulphate to form silver halide in the image layer. Permanganate is seldom used in photographic reduction, but is used in reversal processing technique (p. 135).

Potassium Dichromate

In the presence of sulphuric acid, potassium dichromate reacts in much the same way as potassium permanganate, the chromium valency falling from 6 to 3, thus:

$K_2Cr_2O_7$ + 7 H_2SO_4 + 6 Ag →
Potassium Sulphuric Metallic
dichromate acid silver

K_2SO_4 + $Cr_2(SO_4)_3$ + 3 Ag_2SO_4 + 7 H_2O
Potassium Chromium Silver Water
sulphate sulphate sulphate

Chromium salts such as chromium sulphate and chrome alum (*see* p. 100) have the property of combining with gelatin to form a complex which is insoluble in hot water—in other words, of *hardening* gelatin, and since the amount of chromium sulphate formed at any point is proportional to the amount of silver, the hardening of the gelatin is imagewise. Dichromate is therefore often used when imagewise hardening is required, as in the Carbro process (p. 270). The same precaution against presence of soluble halides is necessary with dichromate as with permanganate.

Ferric Chloride and Potassium Ferricyanide

Iron can exist in the *ferric* form, with a valency of 3, or in the *ferrous* form, with a valency of 2. Ferric salts are capable of oxidising metallic silver, thus:

$FeCl_3$ + Ag → $FeCl_2$ + AgCl
Ferric Silver Ferrous Silver
chloride chloride chloride

$Fe_2(SO_4)_3$ + 2 Ag → 2 Fe_5O_4 + Ag_2SO_4
Ferric Metallic Ferrous Silver
sulphate silver sulphate sulphate

There is, however, an alternative and more convenient way of applying the ferric-ferrous reaction to the oxidation of silver. Both ferric and ferrous salts will react with potassium cyanide to form ferric and ferrous cyanides, respectively, but if more potassium cyanide is added, a complex salt is formed in which the iron atom is in the *acid* radical. Potassium cyanide forms soluble complex

metallocyanides of this type with a large number of metal salts, and indeed its fixative properties are due to the formation of soluble argentocyanide. The reaction of potassium cyanide with silver chloride, ferrous chloride and ferric chloride is thus a two-stage reaction in each case; but the total reactions are:

AgCl	+	2 KCN	→	KCl	+	KAg(CN)$_2$
Silver chloride		Potassium cyanide		Potassium chloride		Potassium argentocyanide (very soluble)
FeCl$_2$	+	6 KCN	→	2 KCl	+	K$_4$Fe(CN)$_6$
Ferrous chloride		Potassium cyanide		Potassium chloride		Potassium ferrocyanide
FeCl$_3$	+	6 KCN	→	3 KCl	+	K$_3$Fe(CN)$_6$
Ferric chloride		Potassium cyanide		Potassium chloride		Potassium ferricyanide

Potassium ferricyanide will oxidise metallic silver readily, forming potassium ferrocyanide and silver ferrocyanide, the latter being insoluble. In the presence of a soluble halide, potassium ferricyanide will convert silver to silver halide:

K$_3$Fe(CN)$_6$	+	KBr	+	Ag	→	K$_4$Fe(CN)$_6$	+	AgBr
Potassium ferricyanide		Potassium bromide		Silver		Potassium ferrocyanide		Silver bromide

Potassium ferricyanide is much less toxic than cyanides, and has several valuable properties. In spite of its ability to oxidise metallic silver, it is only a mild oxidising agent and, unlike permanganate and dichromate, will not oxidise sodium thiosulphate (hypo). A mixture of ferricyanide and hypo—known as *Farmer's reducer*—is used for oxidising metallic silver and simultaneously dissolving away the insoluble silver ferrocyanide which is formed. Another advantage of ferricyanide is that it does not readily attack organic compounds. It is used, therefore, for such purposes as removing silver from colour materials, while leaving dye images unaffected (p. 265).

Iodine

Halogens will, of course, react with metallic silver to form silver halides (p. 89). The most convenient to apply is iodine dissolved in potassium iodide; this is sometimes used as a *local reducer* (photographic) for prints, the silver iodide being subsequently fixed out by hypo. A mixture of hypo and iodine is impracticable as the two react

to form a substance which neither oxidises nor fixes, but an iodine-cyanide mixture can be used as a powerful photographic reducer. The two substances react to form *cyanogen iodide*, which is a powerful oxidiser of metallic silver. The reactions which occur are:

I_2	$+$	KCN	\rightarrow	KI	CNI
Iodine		Potassium cyanide		Potassium iodide	Cyanogen iodide

2 Ag	$+$	CNI	$+$	3 KCN \rightarrow	2 KAg(CN)$_2$ $+$	KI
Metallic silver		Cyanogen iodide		Potassium cyanide	Potassium argentocyanide	Potassium iodide

The disadvantage of cyanogen iodide is its extreme toxicity.

Potassium Persulphate

Potassium or ammonium persulphate is a powerful oxidising agent whose *super proportional* action (described later) makes it of value in photographic reduction.

$$
\begin{array}{c}
\text{O} \\
\parallel \\
\text{K—O—S—O—K} \\
\parallel \\
\text{O}
\end{array}
\qquad\qquad
\begin{array}{c}
\text{O} \qquad\quad \text{O} \\
\parallel \qquad\quad \parallel \\
\text{K—O—S—O—O—S—O—K} \\
\parallel \qquad\quad \parallel \\
\text{O} \qquad\quad \text{O}
\end{array}
$$

Potassium sulphate Potassium persulphate

From the structural formulae of potassium sulphate and potassium persulphate, it will be seen that the latter has two linked oxygen atoms. In the presence of metallic silver, this linkage is easily broken to form potassium and silver sulphates:

$K_2S_2O_8$	$+$	2 Ag	\rightarrow	K_2SO_4 $+$	Ag_2SO_4
Potassium persulphate		Metallic silver		Potassium sulphate	Silver sulphate

Photographic Reduction

Different reducing solutions act in different ways. Some lower all densities by an equal amount, and are called *subtractive reducers*. The contrast of the negative is thus substantially unaltered after reduction, so that this treatment is most suitable for those negatives which have been correctly developed to the right contrast but have a high density due to gross over-exposure. Farmer's reducer, made by adding sufficient strong potassium ferricyanide solution to plain hypo to colour it yellow, is a typical subtractive reducer.

Other oxidising agents oxidise silver roughly in proportion to the amount of silver locally present in the image, so that negative densities are reduced by the same proportion, irrespective of original density. Such reducers are called *proportional reducers*. A typical example is a mixture of potassium permanganate and potassium persulphate solution, acidified with sulphuric acid. Proportional reducers thus reduce the contrast of a negative as well as its general density, and are most suitable for correctly exposed, but over-developed negatives. As a rough generalisation it may be stated that proportional reduction undoes development.

Finally, some oxidising agents exhibit a third type of behaviour, in which oxidising actions seems to be strongly catalysed (or accelerated) by the metallic silver of the image. The reduction ratio is therefore greater for the higher than for the lower densities. These are the *super proportional reducers*, of which ammonium or potassium persulphate with sulphuric acid is an example. Super proportional reducers are most suitably applied to those negatives in which attempts have been made to correct for under-exposure by over-development, since here the aim is to reduce contrast while affecting the shadow densities as little as possible.

Recently (1952) a new and valuable reducer has been added to our armoury. It is well known that a negative left too long in a fixing bath is liable to undergo reduction of density. The silver image undergoes aerial oxidation and the hypo dissolves the resulting compounds. Density reduction is much more rapid in ammonium thiosulphate than in hypo (sodium thiosulphate) and more rapid still in acid solution. A solution of ammonium thiosulphate and hardener, acidified with citric acid, is a most controllable proportional reducer.

It should be emphasised once again that *general* reduction of a negative should be necessary only in special circumstances; on the other hand, *local* reduction of highlights of a negative is a very valuable technique. Interior views, for example, frequently embrace an extremely wide brightness range, which if compressed to the confines of the density range of printing papers would result in an unfortunate reduction in overall contrast. A much more pleasing effect may be produced by locally reducing the highlight densities and applying the reducer locally with, say, a swab of cotton wool.

Intensification

Intensification can be used only to raise contrast to the level necessary for successful printing. Since intensification merely increases

density, it cannot produce shadow detail where it does not already exist—it can merely enhance it and raise it from a non-printable to a printable level. Correction for under-exposure is therefore very limited.

Intensification may be achieved in several ways. The image may be enhanced by deposition of silver or mercury metal on the silver image by immersing the negative in a solution containing a chemical reducing agent (for example, developer) and a silver or mercury salt. The silver image grains act as nuclei for the reduction. The process is called *physical intensification* and is analogous to physical development.

In *chemical intensification* the silver image is oxidised to silver halide by an oxidising agent which is itself reduced to an insoluble compound. The augmented image is then chemically darkened. Mercury intensifier may be quoted as a typical example, though salts of mercury, chromium, copper, lead and uranium all act as intensifiers.

When a negative is immersed in a solution of mercuric chloride (corrosive sublime) the image becomes white. The silver has been converted to silver chloride and the mercuric chloride round each grain has been converted to insoluble white mercurous chloride.

$$HgCl_2 \quad + \quad Ag \quad \rightarrow \quad AgCl \quad + \quad HgCl$$

Mercuric	Silver	Silver	Mercurous
chloride		chloride	chloride

After thorough washing the white image may be blackened by ammonia. If the image is blackened by developing in a developer containing no sulphite, silver and mercury metals are quantitatively produced, and the process may be repeated as often as desired, every silver atom of the image acquiring 1, 3, 7 or (2^n-1) atoms of mercury after 1, 2, 3 or n stages of intensification respectively.

A valuable single-solution intensifier was described in 1945. It is known as the *quinone-thiosulphate intensifier*, and produces a greater degree of intensification than any other known single-solution intensifier, the maximum being of the order of ten times.

In general, intensification gives rise to increased graininess and, unless it is carefully carried out, is liable to produce local irregularities.

Spots and Stains

Every manual of photography emphasises the necessity for clean and careful working. Negatives may be so easily spoiled by spots and stains; it is much simpler to prevent their occurrence than to eliminate them once they are formed.

It is possible that spot-forming impurities may be present in the

sensitive material as purchased but, because of the elaborate pre-cautions and extensive testing by manufacturers, the chance of encountering such defects is reduced to negligible proportions. Spots are normally caused by particles of air-borne or liquid-borne impurities that come in contact with the sensitive material. Even inert dust may cause blemishes if it is present on the material during exposure. To avoid white spots on the negative, which are the shad-ows of such specks, the interior of the camera should be cleaned periodically. Other types of dust are more dangerous, as they may have an adverse chemical effect on the negative material.

Rusty pipes or corroded copper may give rise to specks which may be either air-borne or liquid-borne and which may cause serious damage to films or plates. Black spots may arise from particles of solid developer, if the developer has not been properly dissolved, or if a cloud of powdered developer results from careless weighing-out in the darkroom. Finely-divided oil globules may be present in air or liquid and, if they come in contact with sensitive material, they locally prevent development and fixation. Another fault that may arise takes the form of sharp-edged white spots caused by airbells trapped on the surface of the plate or film. This fault is overcome by careful introduction of the material into the developer, but the fault is much rarer than it used to be, owing to the prevalent use nowadays of wetting agents in processing solutions.

In general prevention is better than cure, but white spots can be removed from a processed negative by local application of a pig-ment by means of a brush, and black spots by removing local excess silver (and gelatin) with a knife blade.

Finger marks are a common defect on home-processed materials. While one can with relative impunity touch the surface of a dry negative material with clean dry hands, it is a practice that should be avoided as much as possible. If the fingers are damped by pro-cessing solutions, or even by perspiration, the finger-print will almost certainly appear on the processed negative. Dilute hypo introduced locally before development by a contaminated clip or by dirty hands usually produces devastating stains.

Under the category of stains may be considered *dichroic fog,* a deposit of finely-divided silver so called because it appears different in colour when viewed by reflected and transmitted light. Silver appears in this yellowish, finely-divided state when it is formed by the action of developer on silver salts that have gone into solution. It is thus liable to be formed when the developer contains a solvent such as hypo, ammonia, or excess of sulphite, but it is more com-monly formed if the film. saturated with developer, is passed with-

out intermediate rinse or stop bath into a neutral hypo bath, especially if the latter is exhausted.

Another form of fog blemish is known as *aerial fog*. It is formed if the material is developed near the surface of the developer, with insufficient agitation. The surface layer of developer, rich in dissolved oxygen (oxidised developer), can cause spontaneous fogging of the film. Although aerial fog is generally black in colour, it is, by the nature of its formation, usually patchy. Such silver fogs are, of course, best avoided but if formed they can be removed by the judicious application of a photographic reducer. The image is, of course, attacked to some extent, but the fog—especially the finely-divided dichroic fog—is preferentially removed.

Other Defects in Negatives

When a processed and washed plate or film is allowed to dry, the surface water may collect in droplets which require much longer local drying time. The result may be a permanent *drying mark* on the negative. These can be prevented by removing surface water, either by wiping with chamois leather before drying or by a final dip of the material in water containing a wetting agent. The latter reduces surface tension and allows surface water to drain uniformly without collecting in droplets. Drying marks, once formed, can sometimes be removed or decreased by rewetting and drying correctly.

Another negative defect is an opalescent appearance. There are several possible causes for this. A hardener bath that has been allowed to become too alkaline may cause a deposition of aluminium hydroxide and an acid rinse will remove this scum. Hard water, too, may cause a deposition of calcium carbonate during washing and that also may be removed by acid rinse. Again, gelatin of the emulsion or backing may become reticulated, that is, show a pattern of minute hills and valleys. The gelatin during processing is subjected to the action of solutions that cause alternate swelling and contraction, and if the contraction becomes too violent the surface may become permanently deformed. Swelling and contraction depend upon the nature of salts in solutions, their concentration, the degree of acidity or alkalinity, and the temperature; reticulation is normally avoided by ensuring that processing solutions and wash water are at approximately the same temperature. Another type of opalescence may be due to forced drying by immersion in alcohol after washing. To avoid this, it is recommended that the alcohol solution should not be stronger than 80 per cent. Opalescence caused by alcohol dehydration can be cured by re-immersion in water and normal drying.

THE GRANULAR STRUCTURE OF THE IMAGE

IF WE EXAMINE a photographic negative at progressively increasing magnification, as shown in Fig. 1, we shall eventually be able to see the individual silver grains making up the image. In any one negative there is a range of grain sizes; average size varies from negative to negative, according to the emulsion and type of development used.

Graininess

Many of the grains appear to occur in clumps, while between them there are relatively large empty spaces. Clumping may only be apparent; the grains forming the clumps may in fact be quite distinct and separate, but occupy different layers in the thickness of the emulsion. This unevenness in distribution is quite characteristic of a completely haphazard arrangement of particles. If we count the total number of grains in Fig. 4a, p. 94, and calculate the area of a square which *on an average* contains ten grains, we might fit this square over a relatively empty space so that it contains only one, or even no grains, or alternatively, by including a clump or two, make it cover many more than ten grains. Thus areas very much larger than the individual grain size will show a variation in light-stopping power, or density, which will give rise to a grainy appearance. This would not happen if we could give the grains a geometric distribution so that they were evenly spaced. However, as emulsion grains are *not* evenly spaced, there is a degree of enlargement, much less than that required to show individual grains, at which an unevenness in density shows itself as a granular structure of the image, called *graininess*. There is a rough correlation between the average size of the silver grain and the amount of enlargement necessary before graininess is apparent, so that in general fine grained emulsions show less graininess than coarse grained emulsions.

Fig. 1. Series of enlargements (*a*) × 1, (*b*) × 4, (*c*) × 16, (*d*) × 64. (*e*) × 250, (*f*) × 1,000 linear magnification. (*Photo. Dr. G. C. Farnell*).

Measurement of Graininess

The principle on which graininess is measured is simple and straightforward. It is to make a series of enlargements or enlarged optical images and estimate by eye that at which the grain just shows. In practice the estimation is far from easy and observers' criteria of visibility of grain vary from day to day, besides being different for different observers. The earliest method projected a much-enlarged image of the sample on a white screen which was observed by reflection in a mirror. By moving the mirror, the apparent position of the screen was moved away from the observer until he considered the graininess to have reached a certain low value. The distance at which this occurred was called the *blending distance*. Because of the variation from observer to observer, each observer also made estimates of the distance at which the pattern in the image of a half-tone screen disappeared. This enabled all estimates to be brought to a common standard.

The most elaborate example of this method of measuring graininess was described in 1951. The observer sat in a room in which the conditions of illumination were kept fixed, and estimated at which magnification the enlarged image of a small sample appeared grainless on a transparent diffusing screen. Again a standard sample was necessary as a reference standard.

Graininess Density Relation

If the graininess of different parts of a negative is measured it is found that its value is markedly dependent upon the density. At zero density where there is no deposit, it is non-existent; it then increases with density up to a maximum, beyond which it decreases. The density at which the maximum occurs is variable, according to the intensity of illumination.

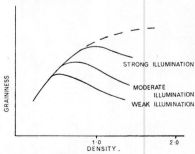

Fig. 2. Relationship between graininess and density.

At low levels of illumination the maximum graininess is at a density of 0·3. As the illumination is increased, the maximum moves towards higher and higher densities, as indicated in Fig. 2.

Granularity

We have reviewed some of the difficulties involved in measuring the visual impression of the pattern of unevenness called graininess. The pattern is certainly caused by density variation on a very small

Fig. 3. Variation of microdensitometer graph with aperture size.

scale, so that measurements of this density pattern by a *microdensitometer* (a densitometer with a very small aperture) ought to give us absolute readings which could be analysed to correlate with visual graininess values. We could, for example, scan a negative with a recording microdensitometer and so obtain a graph of the density variations. We can now compute from a graph such as Fig 3b how much, on an average, the density wanders on each side of the mean density line. This figure will, of course, vary with the size of aperture, but if it is multiplied by the square root of the area

of the scanning spot of the microdensitometer, the product is constant, and is known as the *granularity* of the sample. For the product to be constant, the scanning spot must be at least 10 or 20 grain diameters across, and, if it is much larger than this, the sample must be carefully prepared and chosen to display no coating, sensitivity or processing variations across it.

Any *physical measurement* of the density variation for a given aperture size (that is to say, the special variation in the density of the image, measured objectively in this way) is termed *granularity* to distinguish it from *graininess,* which is the *visual impression* of inhomogeneity in the developed image. Since both graininess and granularity stem from the same cause—the size and arrangement of the image grains—it should be possible to correlate them. The relation between the two, however, is not a simple one. The difference between them is well illustrated by considering the effects of density on each. The relation between density and graininess has already been considered (Fig. 2); that between density and granularity is different.

Granularity-Density Relation

When we measure the granularity of different densities of a negative, we find, naturally, no granularity at zero density, but thereafter it rises progressively with density (Fig. 4). There is, in general, no maximum granularity and certainly none at a low density.

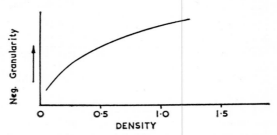

Fig. 4. Relation between negative granularity and density.

The two very different curves, Density-Graininess (Fig. 2) and Density-Granularity (Fig. 4), can be correlated. When we measured the graininess-density relation, the source of illumination was constant, so that the transmitted light meeting the eye, by which

graininess was measured, decreased progressively with increasing density, and the lack of *graininess* at higher densities was due to poorer perception under lower illumination conditions. If, however, as indicated in Fig. 2, we adjust the illumination at each density tested so that all samples appear equally bright, the graininess measured under these circumstances increases with density in much the same way as granularity.

Print Graininess

So far we have spoken of graininess and granularity in terms of measurement of negatives. This has been done essentially for convenience. But really, it is quite obvious that the printer is a physical device and what it deals with is the granularity of the negative. Now in making a print from normal negatives it is always observed that shadows and highlights are not so well produced as middle tones. Thus the granularity of the negative is not so well reproduced in the print in light and dark areas as in middle tones. This would tend to produce maximum *granularity* in the print in the middle tones (because the granularity of the negative increases with density). When we come to look at the print we find that the granularity is less well seen in the darker areas. This forces the maximum in the perceived granularity, that is to say, in the print graininess, still more towards the higher tones. In fact the maximum graininess is usually at around a print density of 0·6.

There is, of course, a small contribution to the print graininess by the print material, small because print materials are fine-grained, and smaller still if the print is an enlarged one.

How to Obtain Minimum Print Graininess

We have seen that print graininess is due to negative granularity, modified by the printing process. We will first, therefore, review the factors which give minimum negative granularity.

(a) *Minimum Negative Granularity.*—In the first place, materials of the finest grain should be chosen, consistent with other necessary qualities. In general, finer grain, and therefore lower granularity, is accompanied by lower speed, so that the material chosen should be of the lowest speed adequate for the particular photographic task. This is not always practicable. For example, a roll film must have sufficient speed for the most difficult exposure likely to be taken. A medium speed pan film, however, is adequate for all but exposures of rapidly moving objects in very poor light. A coarse grain material can give a finer grained image by special (fine grain) development,

but this involves loss of effective speed; there is no overall gain over a finer grain material with normal development.

Having chosen the finest grain material appropriate for the task, we should then try to obtain the lowest average density of negative by giving the maximum exposure, so that the densities lie well on the foot of the curve (p. 172).

(b) *Minimum Print Graininess.*—For a given degree of enlargement, graininess can be rendered less noticeable by the use of a diffusion disc in the enlarger, or by throwing the image slightly out of focus. This practice, however, usually results in an appreciable loss in definition, and is not normally recommended. There is little else which can be done in the printing stage—print densities, or the overall contrast, cannot be greatly modified since the grade of paper chosen should just accommodate the negative density range. However, if the subject can be represented reasonably well by a low range of positive densities, then the softest possible grade of paper will reduce graininess. Similarly a photograph taken under contrasty lighting to give a negative which can be printed on a soft grade of paper will give less graininess than one taken with soft lighting, and printed on harder paper.

The type of subject, however, may have a masking effect on print graininess. Prints with large areas of uniform medium densities (sea or sky) show up graininess markedly, whereas detail in a subject obscures it to a large extent.

Fine Grain Development

It has been mentioned that if development of an emulsion grain is observed under a microscope, it is seen to start at one or more points on the surface, and to spread therefrom throughout the grain (p.112). Under these conditions, once development has started, it proceeds with rapidity, and the whole grain is almost immediately converted into metallic silver. It was, therefore, concluded that a partially developed emulsion must consist largely of completely developed and completely undeveloped grains, with very few partially developed grains. This conclusion was erroneous and based on the assumption that conditions on a microscope slide are similar to those in the body of an emulsion layer. A partly developed film or plate does in fact contain a high proportion of partly developed grains—if it did not do so, there would be no such thing as fine grain development.

The exposed grains are *completely* converted to metallic silver only when the emulsion is given full development (Fig. 5a). When an

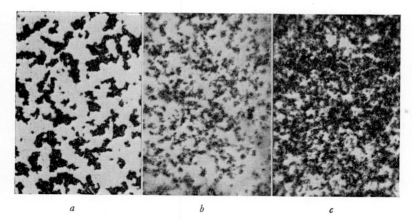

a *b* *c*

Fig. 5. Photomicrographs showing grains given (*a*) full development, (*b*) partial development, (*c*) partial development with fuller exposure, to give the same density as (*a*). *Photos: F. Judd, Kodak Research Laboratories, Harrow.*

emulsion is given partial development to a lower contrast, most of the exposed grains are only partially converted, to give smaller particles of metallic silver (Fig. 5*b*). This will result in a finer grained image of lower graininess, lower granularity, and (since less silver has been formed), lower density. In order to produce the *same* density at this partial development, more grains must be partially developed, and hence exposure must be increased (Fig. 5*c*). It is for this reason that *fine grain development is invariably accompanied by loss of speed.* The loss of speed for a given increase in fineness of grain may vary slightly with different developers, but the variations are of a second order magnitude. A number of proprietary *fine grain* developers claim to give very high speeds, and the claims are generally justified. Not only is the speed considerably higher than that given by a normal M.Q. developer, but the grain is correspondingly larger. They are actually high speed, coarse grain developers!

Roll films are not normally developed fully, as too high a fog and contrast would result, and hence normal development is to some extent fine grain development. However, special developers have been devised for producing fineness of grain.

Low Activity Developers

Such developers are normal M.Q. developers, with the sodium carbonate replaced by a less active alkali such as borax, and usually with the sulphite concentration increased; a typical example is that devised by Carlton and Crabtree in 1929, and marketed by Kodak as D.76 and by Ilford as ID.11. If such a developer is used to give the same contrast as a normal M.Q., it gives no loss in speed, and no marked improvement in granularity. However, it is normally used to produce a lower contrast and hence a lower granularity. It might be argued that this is no advantage, since the low contrast negative requires a harder printing paper which enhances in the print the reduced negative granularity.

However, it is generally considered that the use of such a developer gives a finer overall grain, and if this is true, there are two possible explanations. There might be a tendency to produce a softer print from a soft negative developed in a borax developer than from a plucky negative produced by normal M.Q. development; secondly, even if prints of the same quality were produced from each, the soft negative would normally have a lower average *density*, which may give an advantage in print graininess.

Perhaps the main justification for including borax type developers among fine grain developers is that their slower action gives greater control, and hence a desired degree of fineness of grain is much easier to achieve. However, there is no doubt, from the popularity of Borax developers, that they are considered advantageous, and the belief may be well founded.

Solvent Developers

A solvent such as hypo or potassium thiocyanate in a slow-acting developer will produce, at the same contrast, considerably lower granularity than a normal M.Q. developer. Presumably the silver halide grains partly dissolve during development, giving smaller developed silver grains. At the same time such solvent developers give much less effective speed than a normal M.Q. developer. They have another disadvantage: the silver halide dissolved by the solvent of the developer is liable to be reduced to metallic silver (that is, developed) and when silver is formed from solution in this way, it is liable to appear as dichroic fog (p. 224).

Other Fine Grain Developers

Although in general developing agents will function only in alkaline solution, the degree of alkalinity required varies from agent to agent.

Metol, for example, requires only a mildly alkaline solution. Indeed a strong solution of sodium sulphite is sufficiently alkaline to give development action with metol alone. D.23 is an example of this type of developer. Perhaps because of the solvent action of sulphite on silver halide it gives a finer grain than normal M.Q. developer, though of course, at the expense of speed. However, metol-sulphite developer is not so liable to give dichroic fog as fine grain developers containing solvents such as thiocyanate or hypo.

Paraphenylenediamine (p. 124) has a solvent action on silver halide, so that when normally compounded, it functions like a normal developer with added solvent, and gives finer grain, again at the expense of speed. It suffers, however, from the disadvantage of producing solutions that are highly toxic and liable to give dermatitis.

The Use of Fine Grain Developers

To summarise, lower granularity can be obtained in a negative by developing to a low contrast, but although this is common practice, the advantage obtained is largely offset because the soft negative requires a contrasty printing paper, which increases print graininess.

For comparison of the fineness of grain produced by different developers, negatives must be developed to the *same* contrast and the *same* average density. Under these conditions, the solvent and other developers described do definitely produce less negative granularity, but longer exposures are required to produce comparable negatives. Because of this effective speed loss, fast materials and fine grain development have no advantage over slower, finer grain negative material and normal development; in fact, the latter is to be recommended.

Turbidity and Image Sharpness

We have seen that the scattering of light within the emulsion layer by reflection and refraction from the silver halide crystals causes *irradiation*, or sideways spread of light beyond the confines of the optical image (p. 107). This phenomenon can be demonstrated by exposing a sensitive material with a knife edge in contract with the surface; on processing the emulsion, it will be found that the silver image extends into the shielded portion. The scatter of light within the emulsion is due to *optical turbidity*, and militates against image sharpness.

If by means of a microdensitometer we measure the way in which

density falls across the boundary between exposed and unexposed areas, we obtain curves of which Fig. 6*a* and *b* are typical.

The density begins to fall before the boundary is reached, because at any point within the exposed portion it is due to the incident light and light scattered in from either side, and near the boundary there

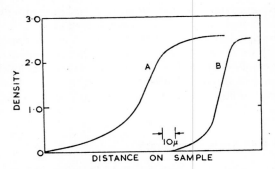

Fig. 6. Contours of density at sharp boundary.
$(10\mu = \cdot 01\text{mm.})$

is little light scattered in from the unexposed side. The shape of the curves showing the fall off in density will depend on two factors: firstly, the way in which light intensity diminishes as the boundary is crossed, which depends on the scattering properties and the opacity of the emulsion; secondly, the way in which the light intensities are converted into densities, which depends on the characteristic curve of the emulsion. A contrasty emulsion will thus give much sharper differentiation between light and dark areas than a soft emulsion with the same scattering properties. The ability of an emulsion to give a sharp replica of the optical image falling on it is a function of the steepness of the densitometer trace of the boundary between an exposed and unexposed portion, as shown in Fig. 6, and is becoming known as the *acutance* of the emulsion.

This important function is dependent on such factors as emulsion thickness, and silver halide concentration. A thin emulsion gives less opportunity for sideways scatter than a thick one, and the distance over which light is scattered sideways is decreased by reducing the path between the grains, i.e. by reducing the gelatin to silver halide ratio. By these and other devices, films of very high acutance have recently been made in this country. They have, naturally, rather less latitude than the older double-coated type. Moreover, the sharpness of boundaries between high and low exposure can be

increased by development effect (p. 131), and developers giving high definition have been marketed.

Resolving Power

Another emulsion characteristic of significance in certain applications is its ability to render fine detail. Although this property goes roughly hand in hand with the ability to give a sharp image (in that both are favoured by finer grains), the two are not necessarily connected. Detail rendering capacity is measured by photographing on a reduced scale a test object consisting of sets of lines of diminishing dimensions (Fig. 7), separated by spaces equal to the line widths.

Fig. 7. Resolving power chart.

Below a certain width it is impossible to distinguish the separate lines when the negative is examined under a magnifier; the maximum number of lines distinguishable per millimetre is called the *resolving power* of the emulsion. Resolving power varies with the type of test object—white lines on a black background are usually photographed to give a developed image in reverse for examination. If instead of an opaque black background for the white lines the contrast of the test object is lowered by using a grey background, very different resolving power figures are obtained. Moreover,

(a)

(b)

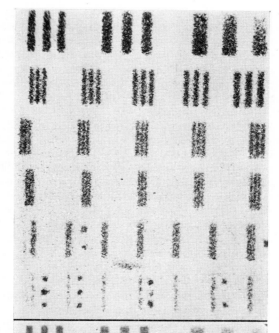

(a)

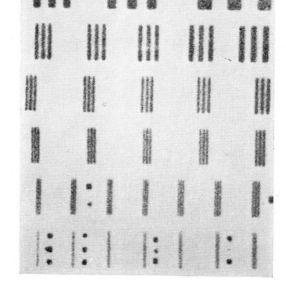

(b)

Fig. 8.

Left Photographs taken on materials of:—*(a)* Higher acutance but lower resolving power. *(b)* Lower acutance but higher resolving power.

Right Resolving power tests on materials used for photographs on facing page: *(a)* Higher acutance but lower resolving power (95 lines/mm). *(b)* Lower acutance but higher resolving power (135 lines/mm.).

in comparing two emulsions, that showing higher resolving power with a high contrast test object may show lower resolving power with a low contrast object. The resolving powers quoted for photographic materials usually refer to a high contrast test object; very slow emulsions made to give maximum resolution of detail may have a resolving power of over 1,000 lines per millimetre, medium speed pan film from 70 to 100, and the fastest negative materials about 50 lines per millimetre.

At the present time there is a tendency to attach too much significance to the resolving power of an emulsion as a representation of its ability to give a clear, sharp image. In the first place the resolving power figure is usually obtained with a black-and-white (high contrast) test object, whereas in practice, where resolution of fine detail is required, the detail is usually of low contrast. Secondly, clear sharp pictures usually depend more on acutance than on resolving power, and the two are not necessarily connected. It is quite possible in practice to obtain emulsions which excel in *either* resolving power *or* acutance, but not necessarily both (Fig. 8).

Emulsions of high resolving power are important in certain technical applications of photography where it is necessary to separate fine detail. In astronomy, for example, they are used to resolve individual stars in close juxtaposition; and in spectrography to resolving individual fine lines. In pictorial photography the overall impression of sharpness, which depends on acutance, is the more important factor.

Chapter 19

PRINTING THE NEGATIVE

HE NEGATIVE is an intermediate stage in the photo-
graphic process and is used to expose the print. The printing
stage reverses the *negative* density scale of the image to give a
positive scale in which the densities of the print image are roughly
proportional to the brightnesses of the original subject. It is, in fact,
possible to avoid the production of a separate negative by adopting
a method of processing which carries the camera-exposed image to
a finished photograph (p. 135). Sensitive materials designed for such
processing are known as reversal films and are extensively used in
colour photography for the production of transparencies and
amateur cine films. But the reversal process is not the ideal method
of obtaining a number of exact copies of the same photograph
and it is chiefly for this reason that the negative-positive process
continues to flourish. Even in terms of a single photograph it offers
the additional advantages of further control over the image in
terms of exposure, tone range, geometry (e.g. correction of verticals),
selection of subject matter (cropping), masking in contrast control,
colour balance in colour printing, and a variety of optical tricks such
as diffusion, distortion and combined images from more than one
negative. Indeed to many photographers, the printing stage is the
most satisfying part of the photographic process.

A photographic image may take two basic forms. It may be an
image on an opaque reflecting base (usually paper) for viewing by
reflected light: in this case it is known as a reflection print or more
simply as a print. Or it may be an image on a transparent base
(film or glass) for viewing by transmitted light or by optical pro-
jection on to a screen: it is then known by such names as diapositive,
transparency, lantern slide and colour slide. The two forms are to
some extent interchangeable, as a reflection print on a thin base
which has been made translucent by soaking in oil can be viewed by
transmitted light, while a 'thin' transparency placed in contact with
a white surface will give a reflection print.

Characteristics of Printing Materials

A wide range of printing materials are made and we shall deal chiefly with those used in general photography. For the most part they consist of silver halide emulsions coated on a paper base, though non-silver processes are used for such purposes as copying line drawings, when photographic quality is not a serious consideration. Examples of non-silver printing papers are blue-print papers (utilising the instability to light of iron salts) and dye-line or diazo papers which make use of certain organic compounds. They score over normal silver papers in cheapness and simplicity of handling, but are inferior in image quality and permanence. Other print materials are designed to give relief images (for colour printing, p.271), while others of a resinous nature become insoluble under light action and are used for etching (e.g. photo-resists, p.302).

Silver halide papers available at the present time are confined to development gelatin emulsions. Printing-out papers (P.O.P.), which depend on the production of a visible silver image by prolonged exposure to a strong illuminant such as sunlight, were discontinued in the early 40's.

Chloride emulsions: These are chiefly used for contact printing papers where their relatively low sensitivity is suited both to their exposure and handling. Though they may be handled in weak artificial light (hence the name 'gaslight' papers, p. 24), the use of the appropriate safelight allows a much higher level of illumination. Development is normally completed in about 40 seconds and yields a rich blue-black image.

Bromide emulsions: The emulsion consists largely of silver bromide though, as with negative emulsions, there is usually a small admixture of silver iodide. They are very much faster than chloride emulsions and are chiefly intended for projection printing. They may be coated on a paper base as enlarging papers, on film for printing cine negatives or miniature negatives, and on glass for making lantern slides. Development averages 2 minutes and yields a neutral black image.

Chlorobromide emulsions: The emulsion is a mixture of silver chloride and silver bromide and may have a speed comparable to that of a bromide emulsion. Normal development is about $1\frac{1}{2}$ minutes and produces a warm black image of a quality ideally suited to portraits and landscapes. By restrained development a much warmer tone may be obtained, in some cases extending to a brick red. This is due to a phenomenon known as light scatter (p.35), the silver

grains becoming too small with restrained development to scatter the longer wave-lengths of light.

Variable contrast papers: These consist of two different emulsions coated one on top of the other. One emulsion is of high contrast and sensitive only to blue light while the other is of low contrast and sensitive only to yellow light. Thus by means of filters, the amount of exposure affecting each layer can be controlled to give varying degrees of contrast. Used without a filter, the paper gives an exposure scale equal to a normal grade of paper.

Panchromatic papers: These are fully colour-sensitised emulsions of silver bromide and silver iodide composition designed for making black-and-white prints from colour negatives. A typical example is that of Kodak 'Panalure' paper.

The Base

Paper base: Paper to be coated with photographic emulsions must be of a high degree of purity. For example, minute specks of iron, copper or sulphur, unimportant in any other use of paper, might cause spots which would make it unusable for making photographic prints.

Paper of different weight and texture is used and may also be dyed to give such tints as 'ivory' and 'cream' to meet the tastes of portrait and pictorial workers. Prior to emulsion coating most papers are coated with a layer of finely divided barium sulphate suspended in gelatin, known in the trade as *baryta*. This gives a smooth, highly reflecting surface to the paper, the degree of glossiness being controlled by the size of the baryta crystals. Thus surfaces such as matt, smooth and glossy can be obtained. When the highest possible gloss is required, the baryta layer is *calendered,* that is, compressed between steam-heated rollers. It can also be embossed by rollers to give such surfaces as *rough* and *linen.*

The baryta coating may also contain a blue-white fluorescing dye to improve the reflection of the base, rather after the style of soap powders which give 'whiter' whites. The effect will be more advantageous when the print is viewed in light rich in ultra-violet radiation such as daylight and striplighting and less so when viewed in tungsten lighting. Such a dye becomes a disadvantage in a print which is to be used for photomechanical reproduction, since any retouching with ordinary pigments which do not fluoresce would give different results when photographed with mercury vapour lamps on a predominantly ultra-violet sensitive material.

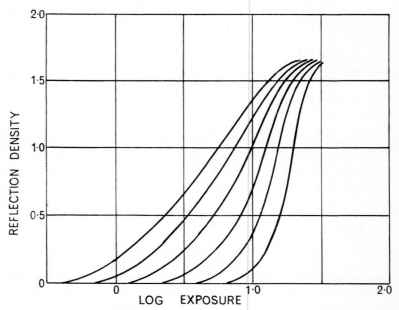

Fig. 1. Characteristic curves of a range of grades of bromide paper.

Film: Clear acetate base is used for print materials intended for film making or for film-strips. The base is usually given a sub-coating of gelatin and cellulose ester (p.104). Sheet film of thicker gauge is used when large transparencies are to be made.

Glass: This is used for print material intended for making lantern slides or when the minimum image distortion is required in technical uses. The glass is selected for its freedom from flaws and is sub-coated with a layer of hardened gelatin (p.104).

Contrast Grades

If we were confronted with a printing material having a fixed contrast or exposure scale, a print utilising the whole tone scale from white to black could only be obtained from a negative having a matching exposure scale. This is, in fact, the situation in printing motion picture negatives and also applies to a number of colour print materials. In such a situation it is therefore necessary to

control the lighting balance so as to obtain a negative of the required characteristics. Such control is not feasible in general photography and negatives of widely differing exposure scale are to be encountered. It thus becomes necessary to have a range of printing papers of different contrast grades in order to obtain acceptable prints. In the most commonly used printing papers such as those for contact printing and enlarging, as many as six grades may be available. These may be allotted names such as *extra-soft, soft, normal* and *hard,* based on the quality of the negative, or numerical grades such as 0, 1, 2, 3, 4 and 5. Characteristic curves for a range of bromide papers are given in Fig. 1.

Variation of contrast by development (as in the case of negative materials) offers very little control with print materials as the maximum black is obtained only with full development, (Fig. 2.)

Variable contrast papers provide a similar range of contrast by the use of filters over the enlarger lens. They are chiefly of interest to amateur photographers whose needs are modest and for whom a stock of several different grades of prints paper would be uneconomic.

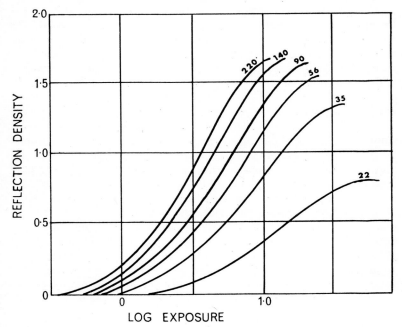

Fig. 2. Normal grade of bromide paper developed for different times (Time given in seconds).

Maximum Black and Tone Range

The range of tones from white to black depends on the reflectance of the base and the maximum black yielded by exposure and development. The maximum black depends on the colour of the image and the surface of the printing paper. Thus a highly glossy surface, being less subject to light scatter, will give the deepest black and a matt or rough surface the least. In terms of reflection density, the former may be as high at 2 above the base, giving a tone range of 100 : 1 and as low as 1·3 for a matt surface, giving a range of only 20 : 1.

Returning to the subject of tone reproduction, it can be seen that an average printing paper with a tone range of about 50 : 1 is just about adequate to reproduce the brightness range of an average subject. In fact it falls short of this requirement if one were to consider the actual brightness range rather than that of the *image* of the subject given by the camera lens. In this case the average can be taken as approximately 150 : 1.

However, the purpose of the photographer is that of producing an acceptable interpretation of the subject rather than attempting to reproduce its actual brightness range. This, of course, would be feasible for subjects of inherently low contrast, but the result to most people would be unsatisfactory and would be described by many as being too *flat*. One definition of a good print (pictorially) is that it makes use of the whole range of printing tones, even if it contains only touches of maximum black, as, for example, in high key subjects which are of predominantly light tones.

One of the major problems of tone reproduction arises from a subject having an unbalanced range of brightness. As an example we may take the case of a subject which includes part of an interior and a view through a window or door of a brightly lit exterior. The total brightness range may be as high as 1000 : 1, but it is not merely a case of compressing a long negative exposure scale into the limits of a very 'soft' printing material: the brightnesses consist of two main zones, one of which will fall on the foot of the curve and the other towards the shoulder of the negative material with a kind of empty no-man's land in between. If the printing exposure is adjusted to give the best tone rendering of the view seen through the window, then the interior will be rendered as little more than a black frame: in the reverse case, the view through the window will consist of white base.

One solution, already discussed in the chapter on exposure (p.210), is that of adjusting the lighting balance before the exposure

is made. In the example given, this could be done by increasing the illumination of the interior. But this is not always possible and it then becomes necessary to resort to local exposure control in the printing of the negative. This can take the form of shading or holding back the 'thin' areas of the negative, either by holding a piece of card or the hand in the light beam until the 'dense' areas have been adequately exposed. The effect is rather that of 'telescoping' the two brightness zones. If the dense areas are fairly small, a card with a hole in it can be used to 'paint' the areas with extra light: in the reverse case, a small piece of card can be stuck to a length of stiff wire and used to 'protect' the weak areas from too much light action.

Yet another problem is that of rendering a brightness lighter than 'white' and in case this seems like nonsense, it is only necessary to consider a scene which contains both the white sails of a yacht fully illuminated with sunlight *and* the sparkle of sunlight itself on the water. Normally the whites in a subject are represented by the clear base of the paper. How then are we to gain the effect of something brighter? If the reflections off the water given in the above example are represented as white, then clearly the white sails must be represented by a shade of grey. This is likely to be unacceptable in a print surrounded by a white border since the observer will have an immediate reference to the whiteness of white. It can, however, be acceptable if the print is mounted on a dark grey or even black card, and even more so if the image is strongly illuminated with directional light. This explains why projected transparencies can give such a good account of a subject of this kind.

Contact Printing

In this method the silver image of the negative is placed directly in contact with the emulsion surface of the printing material, an exposure being made through the back of the negative. If the two surfaces are in close contact, there is no appreciable loss of detail. As the only equipment needed is a printing frame and a few small dishes, the method has been very popular with amateurs who have not yet become enthusiasts. It is satisfactory for negatives as small as $2\frac{1}{4}$ inches square. The increasing trend towards miniature-format cameras has, however, greatly reduced its popularity.

A rather more convenient means of exposing contact prints is with a printing box which incorporates a light source. In the photo-finishing trade, automatic printers employing electronic scanners which indicate the exposure and grade of printing paper are used.

The distance and size of the light source will have some effect on the contrast of the print image. A diffuse light source, such as a pearl electric lamp used at a close distance, will give a softer image than one made with a light source of small area at a distance of several feet.

Optical Printing

Printing by optical projection is commonly known as *enlarging* and an optical printer as an *enlarger*, though in fact it may be used to obtain same-size or reduced images. It offers a number of advantages over contact printing apart from permitting changes to be made in the image size. These include selection of subject matter, local exposure control, correction of verticals and various tricks of the kind already referred to in this chapter (p.241).

The Enlarger: This is essentially a device for projecting an image of a negative on to a sheet of printing material. Its basic components are shown in Fig. 3. For convenience the components are usually arranged on a vertical column, but if very large prints are to be made, a horizontal arrangement is more serviceable.

Enlargers may vary in their system of illumination giving some-

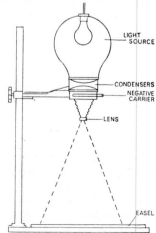

Fig. 3. Diagram of an enlarger

what different contrast results from the same negative (see p. 165). For large negatives or when only small magnifications are required, a suitable light source can be made with a lamp a few inches away from the negative with a sheet of flashed opal glass to ensure uniform illumination. For small negatives or with high magnifications more efficient use is made of the light source by employing a condenser lens system between the lamp and the negative.

The requirements of a good enlarger lens differ in some respects from those of a good camera lens. While both are required to give uniform illumination over the picture area and flatness of field without distortion, an enlarger lens requires only to be corrected for short distances. If it is to be used for colour printing, it should be reasonably well corrected for chromatic aberration. The focal length is usually based on the diagonal of the negative to be enlarged. In practice a well-corrected camera lens may serve the purpose.

With some enlargers the focusing movement is coupled to the enlarging movement (lens-easel distance) by means of a trapezium system. Additional features that could be useful are a tilt movement of the negative carrier and a swing movement of the lens to enable corrections to be made to converging verticals in the negative. However, the same effect can be obtained by tilting the printing easel and stopping down the lens.

For black-and-white printing a safelight filter is fitted so that it can be swung in front of the lens when it is required to check the focus with a sheet of sensitive paper in position. Filtering requirements for colour printing are mentioned on p. 274.

Enlarging Technique

The negative should be free of dust and masked at the edges so that there is no stray light. The selection of the area to be printed, scale of enlargement and focusing can be done by placing a sheet of blank printing paper on the easel. With a dense negative it may be advisable to use a sharp negative of normal density to obtain the best focus. This applies also to dealing with slightly unsharp negatives.

As there is little or no control over exposure errors by varying the time of development, the exposure must be accurately assessed. There is probably still nothing to better the time-honoured method of making a series of test exposures based on a part of the image which contains important detail and the full exposure scale of the negative. However, to be of practical use these test exposures

must be given normal development and be properly fixed so that they can be examined in white light. Visual perception of contrast falls at low intensities of illumination so that a print image which appears satisfactory in the darkroom safelight, may prove to be lacking in density and contrast when viewed in daylight.

Enlarging photometers and exposure meters adapted for the purpose provide a means of assessing the approximate exposure, but an actual exposure test is the only certain method of obtaining the highest print quality. Tests prints also form a guide to any local exposure control that may be needed (p. 247). Devices used for dodging and shading should be kept gently oscillating and held at a midway distance in the beam of light so as to prevent outline effects.

Processing

Development is preferably based on time and temperature and not visual observation. If dishes are used, they should be somewhat larger than the size of the print and contain sufficient solution to allow the print to be immersed without difficulty. Some form of agitation must be applied during development otherwise the oxidation products, which are heavier than fresh developer, will tend to stagnate over the surface of the paper. As the more heavily exposed areas of the print will use up more developing agent there will be a tendency for development to slow up to a greater degree in these areas than in those which are less exposed. Some workers take advantage of this as a means of reducing contrast. Agitation can take the form of a see-saw motion of the dish in both directions, but it should be of an irregular nature or a development 'pattern' may form. The use of a long, narrow camel's hair brush moved at frequent intervals over the surface would guarantee a high degree of uniformity. With very large prints, the developer may be applied with a large sponge with regular sweeping movements and frequent recharging of the sponge.

It is usually recommended to use a stop bath after development. This may consist of dilute acetic acid. It both rapidly neutralises the developer and also helps to prevent stains arising from a mixture of active developer and hypo. The two-bath method of fixation as described on p. 152 is also recommended. Prolonged immersion of warm-tone prints in the fixing bath should be avoided as it causes nometioeaching action on the finely divided silver. The need for thorough washing of prints has already been covered in the chapter on fixation and stabilisation (p. 154).

COLOUR PHOTOGRAPHY—THE ADDITIVE PROCESS

MOST VIEWS are illuminated by approximately white light, and although its quality may vary considerably, from incandescent lighting, through sunlight to light from a blue sky, the eye accepts these as variations of white. The sensation of light, shade and colour is caused by the variation in intensity and quality of light reflected to the eye from different portions of the view.

Percentage Reflections

We have seen that white light can be analysed into the colours of the visible spectrum. If a portion of a view reflects all these constituents equally, then it will appear neutral in colour (white, grey, or black), but if it reflects the constituents unequally, then it will appear coloured. A red brick wall, for example, absorbs more light at the blue end of the spectrum and consequently the reflected light is relatively richer in red and yellow than the illuminating light. If we were to plot the percentage reflection by a brick wall of different wave-lengths of light, we would obtain a curve of the type shown in Fig. 1.

A method of colour photography in which the light reflected or transmitted from that portion representing the brick wall had exactly the same curve as in Fig. 1 would give a perfect colour rendering of the brick wall. Unfortunately, although such methods exist (for example, the Lippmann and Seebeck processes), they are impracticable for normal use. How, then, can we obtain results which approximate to the original colour? It is impracticable to ensure that the percentage reflection of every individual wave-length is the same as that of the original object, but if the spectrum were divided into a number of sections, say twelve, and the average reflection from each recorded, the spectral composition of the colour record of the wall would then be as represented in Fig. 2. Clearly,

the more sections of the spectrum individually recorded, the nearer the combination approaches the ideal (Fig. 1) and the more complex the process is. What, then, is the minimum number of sections required to give acceptable colour records? It has been

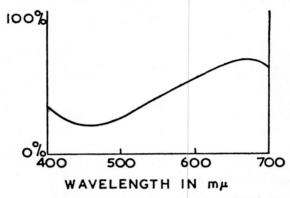

Fig. 1. Spectral reflection of brick wall (Diag).

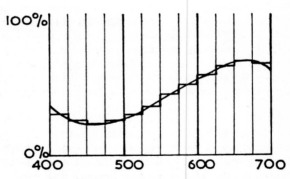

Fig. 2. Reproduction of twelve colours.

found that no more than three are necessary. The main colours of the spectrum are red, orange, yellow, green, blue and violet, and if we divide the spectrum into three sections and blend the colours within each section, they give us red, green and blue colours respectively, the primary colours of colour photography (*see* p. 263).

Practically every colour in nature can be matched by appropriate mixtures of these three wide bands of the spectrum. By such a three-colour system, the record for the brick wall would be represented by Fig. 3, and the eye could distinguish little or no difference in colour between this record and the original, Fig. 1.

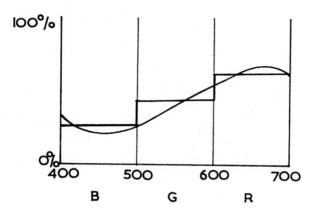

Fig. 3. Trichromatic colour reproduction.

All commercial methods of colour photography are based on the independent recording of the red, green and blue constituents of any colour, and their subsequent combination to give an approximate match with the original. There is a fundamental reason for the success of trichromatic colour photography, as the three-colour system is called. It has been known since the beginning of the nineteenth century that there is something of a triple nature in the perception of colour by the eye.

The suggestion that the perception of colour was based on a tri-colour receptor system was put forward by Thomas Young in 1801 and the theory received considerable support some fifty years later by the investigations of Clerk Maxwell. Curiously enough, it was with the object of supporting the tri-colour theory of vision that he demonstrated the first colour photograph at a lecture at the Royal Institute in 1861. It is interesting to record that he engaged a photographer to make photographs of a tartan ribbon using blue, green and red filters. The three images were then projected with three projectors each through its appropriate filter so as to give a single image on the screen. The result was remarkably good for a first attempt.

Unfortunately his demonstration was much in advance of colour sensitising and the photographic plates used were quite insensitive to green and red light. The fact that images were obtained through the green and red filters has been explained by R. M. Evans as being due to the sensitivity of the material to ultra-violet radiation which was reflected by the subject and transmitted by the filters. The success of the demonstration thus rested on a coincidence which happened to fit the theory!

A few years later, in 1869, a remarkable Frenchman, Louis Ducos du Hauron, published a book, *Les Couleurs en Photographie,* in which he suggested many methods whereby colours could be reproduced photographically. So comprehensive was his work that he anticipated most of the methods which have subsequently been applied. He proposed a modification of Clerk Maxwell's method which would make it practicable by dispensing with the three projectors. He suggested that the view should be photographed through a mosaic of minute red, green and blue colour filters, small enough to defy resolution by the eye. In this way all three records would be obtained on the same plate, each record occupying a total area of one-third of the plate.

The Separate Colour Screen

In 1895, Professor Joly of Dublin achieved success in applying this principle. Across a sheet of glass he ruled adjacent fine lines of red, green and blue dyes, about 200 to the inch. A plate was exposed in a camera behind and in contact with this screen. From the processed negative a positive glass transparency was made by contact printing, and on registering the transparency with the screen so that the lines of red, green and blue record coincided with the red, green and blue lines of the screen, the view was rendered in colours approximating to the original.

Fig. 4 illustrates the reproduction of a red colour by the Joly and similar methods. Registration of the viewing screen with the separately processed positive can be successfully accomplished only if the screen is relatively coarse; but to counterbalance this disadvantage, the method is very simple to operate, and with an improved screen it survived until recently as the *Johnson Screen Process*. This screen had 350 lines per inch and different taking and viewing screens were used. The exposure latitude was, of course, that of black-and-white photography and any number of identical copies could be obtained without the deterioration in colour rendering inherent in many other processes.

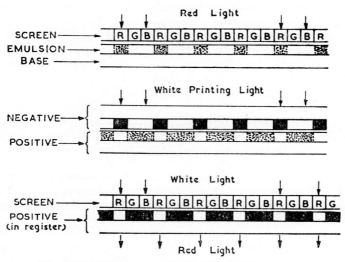

Fig. 4. Reproduction of red colour by separate screen.

Random Screen Methods

The Joly experiments showed the possibility of colour photography using a mosaic screen, and experiments were made with powdered glass, gelatin and other substances as colour elements.

The first method to be a commercial success was an ingenious one devised by the Lumière brothers and put on the market in 1907 as the *Autochrome process*. As colour elements, the Lumières used starch grains, which are minute and nearly uniform in size. Three lots of starch grain were dyed red, green and blue respectively, dried and mixed to give a grey powder. This was brushed over a glass plate coated with a tacky varnish. On removing the unattached grains, a single layer of red, green and blue grains adhered to the glass plate. The grains were then pressed into thin discs by rolling under pressure, and dusted with finely divided carbon which adhered only to the exposed tacky varnish, thus filling in the interstices between the starch grains.

Now it was impossible to register with the original screen a positive transparency, made from a negative which had been exposed behind such a screen; therefore, after an insulating varnish layer, the emulsion was coated direct on to the screen plate and processed to give a positive image by the reversal process previously described (p. 135). Since the emulsion was never separated from the screen,

registration was perfect and the Autochrome plate enjoyed deserved popularity for a quarter of a century.

The Agfacolor plate which appeared after the 1914–18 war was similar in principle, but used droplets of dyed gum arabic instead of starch grains. The elements were more transparent than the Lumières' starch grains, and as there were no interstices to fill with carbon black the results were more luminous.

The Autochrome and Agfacolor additive methods differed from other mosaic methods in that the arrangement of the elements (starch grains and gum droplets respectively) was completely haphazard. In any such random arrangement, no matter how completely the grains are mixed, by the laws of chance there is, of course, bound to be some juxtaposition of elements of the same colour. It has been calculated that in each square inch of an Autochrome plate there would be some fifty clumps consisting of twelve or more grains of the same colour and, of course, many more clumps containing fewer grains. The effective size of the colour-elements in a screen of random distribution would therefore be greater than the size of the individual elements.

Geometric Screen Methods

This disadvantage does not apply, of course, to *geometric* or regular colour screens, since there is no chance of adjacency of several elements of the same colour. Probably the best known and most successful of the regular screen additive processes was Dufaycolor, perfected as film about 1934. A cellulose acetate film base was given a coating of blue-dyed cellulose nitrate, and printed with fine parallel lines (20 per mm. or 500 per in.) of greasy ink running diagonally across the film. The film was led into a bleach bath, which removed the blue colour from the unprotected spaces between the lines, and then into a green dye bath which dyed the spaces green. The greasy ink was then removed by a solvent bath, leaving the film dyed with alternate blue and green lines, 40 per mm. in all. A second set of greasy ink lines was then printed, at right angles to the first, and the unprotected lines bleached and dyed

Plate I

(*a*) Additive colour system. Shows the effect of projecting three beams of light—red, blue and green—on to a white screen. The addition of all three colours gives white.

(*b*) Subtractive colour system. The three filters, cyan, magenta and yellow, subtract the complementary colours from the white background. Where all three filters overlap, there is a total absorption of colour.

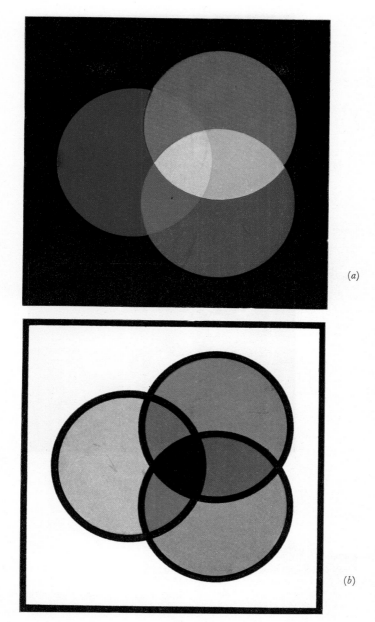

(a)

(b)

Plate II

(a) Colour photograph made without a polarizing filter of subject with strong specular reflections.

(b) The same subject exposed through a polarizing filter adjusted to give maximum absorbtion of reflections.

red. On removing the greasy ink, the screen or reseau pattern consisted of lines of alternate green and blue squares, with intermediate thin red lines (Fig. 5). After an insulating varnish, a panchromatic emulsion was applied and, as in the Autochrome

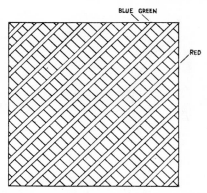

Fig. 5. Dufay colour reseau; alternate blue and green squares, crossed by red lines.

process, the emulsion was exposed through the screen and processed by reversal. With about a million colour elements per square inch the Dufaycolor film represented a triumph of mechanical printing. The colour rendering was good, and processing relatively simple.

Lenticular Screen Methods

A most elegant and ingenious method of additive colour photography—the *Keller Dorian process*—was devised in 1925, and marketed in 1928 as Kodacolor 16mm. cine film. The back of the film base was reeded (embossed to form minute parallel cylindrical lenses with axes running along the length of the film). The emulsion was exposed through the film base, and the focal length of the lens elements was such that the aperture of the camera lens was focused on the emulsion. The view was thus focused on the emulsion in the usual way, but the cylindrical lenticular elements divided the image into a series of very fine parallel bands, one behind each element. Moreover, the different portions of the image across each band were made by light passing through different vertical segments across the camera lens. The three colour records were obtained by placing over the camera lens a triple filter which divided the lens aperture by two vertical lines into three approximately equal areas, coloured red,

green and blue (Fig. 6). These three portions of the lens aperture were focused by the lens elements on the emulsion so that each band was divided into three strips, recording the red, green and blue constituents of the view. This operation is shown diagrammatically in Fig. 7.

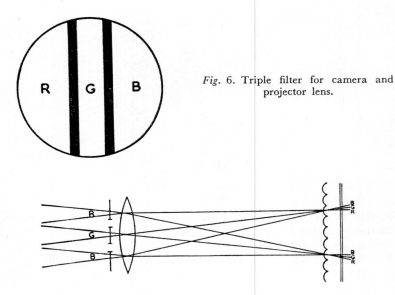

Fig. 6. Triple filter for camera and projector lens.

Fig. 7. The lenticular additive process. (Diag.)

The film was processed by reversal in the normal way and appeared to be a black-and-white film. On normal projection it gave a normal black-and-white result. However, by placing over the projector lens a similar triple filter to that used on the camera, the optical path shown in Fig. 7 becomes reversed. The strip records of the red, green and blue constituents of the view are focused by the lenticular elements on the corresponding filters on the projector lens, and the picture on the screen is in full colour.

Disadvantages of the Additive Processes

The processes so far considered are all examples of the additive process of trichromatic colour photography, the essential principle

of which is that three colour records are made which embody only the red, green and blue constituents of a view, respectively. The three constituents are then added together to give the original colour.

Additive processes suffer from two serious defects, which can best be illustrated by considering a mosaic additive process. White light in a view is rendered by the mosaic with no silver deposit. Each element in the mosaic must in theory absorb two-thirds of the light falling on it so as to transmit only the appropriate third of the spectrum. In practice it absorbs considerably more, so that the brightest highlight transmits only 20 per cent of the light falling on it. While this is a serious disadvantage in transparencies, it makes the additive process quite useless for paper prints, as white would be rendered a dark grey. The second disadvantage is that the image is divided into elements which must necessarily be large compared with emulsion grains. The pattern therefore becomes obtrusive after very limited enlargement. Neither of these objections applies to the alternative system of three-colour photography, the *subtractive process*, which will be considered in the next chapter.

Chapter 21

COLOUR PHOTOGRAPHY –
THE SUBTRACTIVE PROCESS

THERE IS AN ALTERNATIVE method of applying tri-
chromatic colour photography that avoids the defects inherent
in the additive process. While the additive process reproduces
colour by addition of red, green and blue constituents, the alter-
native, known as the *subtractive process*, does so by successive absorp-
tion of appropriate amounts of red, green and blue from white light.

The subtractive process is not easy to understand. Let us reconsider
the conceptions outlined at the beginning of the previous chapter.
A view is normally illuminated by white light, and light and shade
and colour are perceived because of variations in absorption and
reflection from different parts of the view. A black-and-white picture
is produced by a positive image of black metallic silver, which
absorbs light in proportion to the total absorption of corresponding
portions of the view. If we wish to record colour, the positive image
must absorb the correct amounts of red, green and blue indepen-
dently. We must therefore produce our colour photograph by
passing white first through a red record, which absorbs the appro-
priate amount of red—and red only; the transmitted light must
then pass through a green-absorbing record, and finally through a
blue-absorbing record. The differences between the additive and
subtractive processes are illustrated in Fig. 1. (See also Plate I
p. 257.)

Thus the three records must be positives, of which the absorbent
is not silver (which absorbs equally throughout the spectrum) but
dyes, which absorb only red, green and blue respectively. Now a dye
that absorbs only red will transmit the two remaining primary
colours—green and blue—and will therefore appear a blue-green.
Since a blue + green colour is important in colour photography and
had no name, it has been christened *cyan*. The green record is
printed in a green-absorbing dye, which transmits red + blue and
appears *magenta* in colour. Finally the blue record is printed in a
blue-absorbing dye, which is a red + green transmitting dye—and

262

a mixture of red + green is *yellow*. We can easily accept that green + blue = blue-green or cyan, and that red + blue = magenta, but we do not accept so easily that red + green = yellow. However, it is easily demonstrated by overlapping red and green lights from two lanterns, or by spinning a red and green striped top. It cannot be demonstrated by mixing pigments, as the colours are not then added, but subtracted.

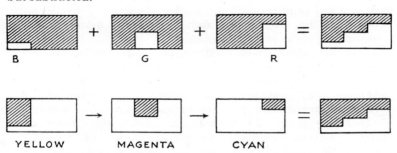

Fig. 1. The differences between additive and subtractive processes.

Thus while the three colours used in the additive process are the three thirds of the spectrum, red, green and blue, the three colours used in the subtractive process are the three remaining two-thirds of the spectrum, cyan, magenta and yellow, sometimes called *minus-red, minus-green* and *minus-blue*. The artist empirically discovered the subtractive process, and his three primary colours, red, yellow and blue, are merely an inaccurate way of describing the secondary colours magenta, yellow and cyan. He was able to obtain a wide range of colours by mixing his *primaries*, because his reds and blues were impure, and contained blue and green respectively.

The differences between colour records obtained by additive and by subtractive methods can be seen by studying Figure 1. For example, the red additive record consists of red for full red reflection and black where there is no red reflection. The same record for the subtractive method consists of white (R + G + B) for full red reflection and cyan (G + B) where there is no red reflection. This can be tabulated thus,

	Additive	*Subtractive*
Full red reflection ..	Red (R)	White (R + G + B)
No red reflection ..	Black (zero)	Cyan (G + B)

The two records are, in fact, identical except that the subtractive one has the complementary to red all over it, i.e. cyan (G + B) as can be seen from the above tabulation.

To obtain a subtractive colour transparency or print, it is thus necessary to obtain first three black-and-white negatives recording the red, green and blue constituents of a view respectively. From the negatives we must next obtain colour-and-white positives, the colour being complementary to that recorded. Thus the red record is printed in cyan, the green in magenta and the blue in yellow. It should be noted that if reversal processing is used it is not necessary to isolate and print through the black-and-white negative records; nevertheless they are formed and subsequently destroyed as an intrinsic part of the reversal process.

There are three main methods of producing appropriately coloured images. A positive black-and-white silver image can be *toned* (converted into coloured inorganic pigments or into colourless salts upon which suitable dyes may be *mordanted*, or adsorbed).

A second method is to produce an image in relief, so that image thickness is proportional to the log exposure received. If the sensitive material contains pigments in the minus colours (as in the Carbro process), the relief gives the required positive. Alternatively the relief may be impregnated with dye, which is transferred to another surface, as in the Dye Transfer and Technicolor processes. These will be considered in more detail later.

The third and most important method of producing coloured images is *colour development*.

Colour Development

When the silver halide of an exposed material is reduced to metallic silver during development, the developing agent is correspondingly oxidised. The function of sulphite in a developer is to react with the developer-oxidation products to form inert colourless compounds, to prevent their causing rapid deterioration of the developer (p. 129). However, it is possible to make good use of the reactivity of the oxidation products of some developers. Those of pyrocatechin, or to a less extent, of pyrogallol, for example, will react with gelatin to make it insoluble in hot water. A pyrocatechin or pyro developer with little or no sulphite can therefore be used as a *tanning* developer— thus if an unhardened material is developed therein, the gelatin is tanned imagewise, in proportion to the silver image formed, and subsequent washing in hot water removes the unhardened gelatin, leaving the developing image in relief.

Again, the oxidation products of paraphenylenediamine (p.p.d.) or its derivatives will react with certain organic compounds called

couplers to give dyes, the colour of which depends on the chemical constitution of the coupler. The amount of dye formed depends on the amount of oxidised developer, and therefore on the amount of silver developed.

Thus by developing a material in a p.p.d. type developer in the presence of a coupler, a dye image will be formed simultaneously

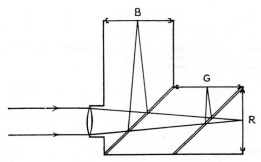

Fig. 2. One-shot camera.

with the silver image. If the latter is removed, for example, by Farmer's reducer (ferricyanide and hypo) (p. 220), the dye image remains, and images in cyan, magenta or yellow may be produced by choice of developer and coupler. The coupler may be introduced with the developer, or may be present in the emulsion.

Exposing the Three Records

For still-life subjects, the three records may be taken successively, and *repeating back* cameras, incorporating filters in a sliding panel behind the camera, have been devised. The method is, however, impracticable for general photographic work.

Simultaneous photographs may be taken on a *one-shot* camera (Fig. 2), which by a system of partial reflectors and filters splits the light to form three identical images.

Another means of obtaining simultaneous records is the *tripack*, which consists of three superimposed and appropriately sensitised films inserted in a dark slide, suitably interleaved with filters. Tripacks were suggested as early as 1897 by du Hauron, and though they have been marketed, none has survived. There is one serious objection to them: they lack definition in the lower records, after the light image has been diffused by the upper emulsion (Fig. 3a).

Multi-layer Films

By coating all layers on the same film support that single objection
may be overcome; the loss in definition is then negligible, since the
top layer is separated from the bottom layer by only a fraction of a
thousandth of an inch (Fig. 3*b*). The difficulty is to process the three

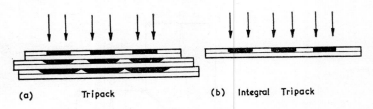

(a) Tripack (b) Integral Tripack

Fig. 3. Light diffusion by (*a*) tripack and (*b*) integral tripack.

adjacent layers separately, so as to produce a different coloured
image in each. Methods have been suggested whereby the three
layers are separated for processing and subsequently re-registered,
but they have had no commercial success. The first commercial
application of three emulsions coated on one base was introduced
in 1935 for narrow gauge cine photography under the name Koda-
chrome film. This *monopack*, or *integral tripack*, as it is more com-
monly called, proved so successful that it is the basis of practically
all colour films on the market today.

Colour by Coupler-Developers

As a typical example we shall briefly describe the currently available
Kodachrome film and its processing. The film consists essentially
of four separate coatings on the base, each extremely thin. The
simplest way is to consider them in the reverse order of application,
that is, in the order in which light encounters them. See Plate III.

The top layer consists of a non-colour-sensitised emulsion and
therefore gives the blue record of the scene. In colour sensitising we
merely add to the spectral sensitivity range; there is no known
method of satisfactorily desensitising in the blue while retaining the
induced sensitivity in green or red. Consequently, immediately under
the blue sensitive layer is a gelatin filter layer containing a yellow
dye. Immediately below that is an orthochromatic emulsion

sensitive to blue and green but, because no blue light is passed by the yellow filter, it records only the green. Finally the bottom layer consists of an emulsion dyed with a special panchromatic dye that gives high red but negligible green sensitivity. The colour sensitivities are shown in Fig. 4a, and the *effective* colour sensitivities in Fig. 4b.

Exposure thus records the red, green and blue constituents in the three layers. The appropriately coloured positive images are produced by the following reversal processing. The film is first developed in a normal developer to give a black-and-white negative image in all three layers. The residual, undeveloped silver halide now forms the positive images that must be converted into the appropriate dye image in each layer. After washing, the film is

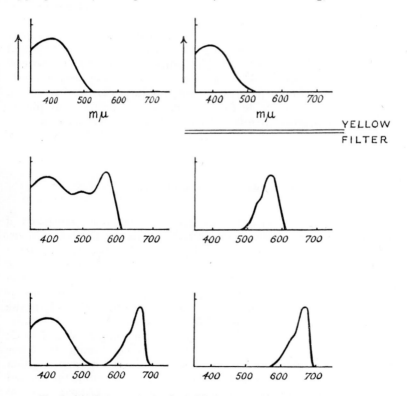

Fig. 4. (*a*). Spectrograms of emulsions used on integral tripack film. (*b*) Effective sensitivities with yellow filter layer between top and middle emulsion layers.

uniformly exposed through the base to red light, making only the red-sensitive (bottom) layer developable. It is developed in a cyan colour developer, which produces a positive cyan image in the bottom layer, together with the development of the whole of the silver in that layer. The film is next exposed from above to blue light which, because of the yellow filter, affects only the top layer. The residual silver halide in that layer is developed in a yellow colour developer. Only the silver corresponding to a positive image in the middle (green-sensitive) layer remains to be developed. Sandwiched between two completely blackened layers it cannot easily be lightfogged, so it is developed in a fogging magenta colour developer. All the silver is now developed, and is removed (together with the yellow filter layer) by Farmer's reducer, leaving the requisite three positive images in the minus colours registered to form a colour transparency.

The type of material described is capable of good colour reproduction, and the dyes formed from present-day couplers and developers are reasonably stable to light, temperature and moisture. However, the processing is so complex that only continuously running plant, and expensive control apparatus can ensure success. It is quite impracticable for an amateur or professional photographer to process an integral tripack film without incorporated couplers.

Colour Film with Couplers in the Emulsion

Processing multi-layer reversal materials would be simplified if the appropriate couplers were introduced in the three emulsions. There are two serious practical difficulties to this. In the first place it is not easy to find couplers free from deleterious action on the emulsions. Secondly, it is difficult to prevent a coupler from wandering by diffusion from its own layer into adjacent layers. When that happens, the primary colours of a view are recorded partially in the wrong colour, and colour rendering is ruined.

The problems were first solved in the Agfa Neue process of 1937; the couplers were made non-wandering by combining the active coupler molecule with a large, heavy, inert molecule. Other methods of preventing wandering have been to combine the coupler with the gelatin of the emulsion, and (as in the Ektacolor, Ektachrome and Kodacolor processes) to dissolve the coupler in a solvent non-miscible with water, and then disperse it throughout

the emulsion in minute droplets. When couplers are present, the reversal procedure is quicker and simpler. After developing the black-and-white negative image, the residual silver halide is exposed from both sides to white light and developed in a p.p.d. developer which forms the required colour in each layer. Removal of silver and yellow-filter layer leaves a positive image consisting of three dye layers.

Fig. 5. Automatic slide projector.

The methods so far described give a colour picture in the form of a transparency that is viewed by direct transmitted light, or by projection on to a screen. Kodachrome was originally introduced for amateur cinephotography and later as a miniature film for still photographers. It undoubtedly had the effect of re-awakening interest in projection viewing. Re-christened 'colour slides' instead of lantern slides, the magic lantern has again become immensely popular—under the name 'slide projector'. Current models of slide projectors include magazine loading and remote slide-changing and focusing of the projector lens. Coupled with a magnetic tape recorder, the combined effect of picture and sound can be quite impressive.

Chapter 22

COLOUR PHOTOGRAPHY
COLOUR PRINTS AND COLOUR MASKING

S O FAR, we have considered only colour transparencies. According to popular conception, however, real colour photography is that which yields coloured prints on a white reflecting base such as paper. We have already seen that for this purpose the subtractive process is a necessity. Many such processes have been evolved, and although excellent results are obtainable, they have, until recently, been too complex to be applicable to general amateur photography. Some (for example, Carbro, Vivex and Duxochrome) are based on the preparation of reliefs in pigmented gelatin layers which are subsequently superimposed. The Carbro process, which was highly popular with advanced amateurs and professionals, is briefly described as a typical example.

Carbro Process

From three separation negatives, taken through red, green and blue filters respectively, three ordinary bromide prints are made. They are squeegeed into contact with sensitised Carbro tissue—paper coated with a layer of unhardened gelatin containing a pigment of a minus colour (cyan, magenta or yellow)—and sensitised by soaking in a solution of acid dichromate, ferricyanide and bromide. The tissue selected for each print is, of course, complementary in colour to the taking filter.

The interaction is both interesting and complex. The ferricyanide and bromide diffuse into the print and oxidise the silver image to silver bromide, giving a soluble ferrocyanide in proportion to the amount of silver image. A proportion of the ferrocyanide diffuses back into the tissue, and is re-oxidised to ferricyanide by the dichromate. The latter is thereby reduced to a chromium salt which hardens the gelatin of the tissue. Thus a hardened relief image is formed on the surface of the tissue. After separation from the bromide print, the tissue is squeegeed on to a waxed celluloid and

270

washed in warm water. The soluble gelatin dissolves and allows the paper to float away, leaving a relief image of hard gelatin pigmented with the appropriate colour on the celluloid. This image is transferred by squeegeeing on to gelatin-coated paper and peeling off the celluloid. Three such images, in cyan, magenta and yellow, corresponding to red, green and blue records, are transferred in register on to the same final paper support.

Dye Transfer Process

Other processes, such as the Technicolor process for motion-picture films, and the Dye Transfer process for paper prints, are based on dye imbibition. In essence, the latter consists of preparing three positives from separation negatives by printing on film coated with yellow-dyed, unhardened emulsion. This *matrix* film is exposed through the base, and as the yellow dye absorbs the blue light to which the emulsion is sensitive, the image is confined to the emulsion layer near the base. The matrix film is developed in a tanning developer (p. 264) and subsequent washing in warm water removes the yellow dye and unhardened gel, leaving a relief image in hardened gelatin. The three positive reliefs are soaked in dyes of the appropriate minus colour and squeegeed into contact with a paper coated with mordanted gelatin, when the dye is transferred from the relief image to the paper. The successive transference, in register, of the three dye images gives a colour print. The matrices can, of course, be used to produce a number of such Dye Transfer prints.

Reversal Colour Prints from Transparencies

Although the processes of print-making so far described use comparatively simple materials, they require intricate and skilful manipulation. For popular amateur colour photography a process that requires little effort on the part of the user is necessary. The first print process of this type was offered to the American public as Minicolor prints in 1942; the name was subsequently changed to Kodachrome prints. They consist of enlargements from Kodachrome transparencies produced on a Kodachrome-type emulsion system, coated on white opaque base. At the same time a de luxe process known as Kotavachrome was introduced, which, by elaborate colour correction involving masking techniques (p. 272), produced very faithful duplicates. In these methods a double

reversal process is used, employing essentially the same type of reversal emulsions on clear and on white reflecting bases. That principle is now the basis of several commercial colour print processes. However, if positive prints only are required, a simpler and more direct method would be to use a colour negative instead of a positive transparency as the intermediate record.

Negative-positive Colour-print Process

The first popular process to produce colour negatives to yield paper colour prints was marketed in America under the name of Kodacolor (the name of the obsolete lenticular additive process, *see* p. 259), as amateur roll film in 1943, and as Ektacolor (a flat film for professional use) in 1948. Unlike Kodachrome film Kodacolor and Ektacolor (and also Ektachrome, a reversal film for the professional transparencies) incorporate couplers in the film and in the paper. The couplers are dissolved in an organic solvent non-miscible with water, and dispersed as minute globules in the liquid emulsion before coating. In that way, couplers are prevented from wandering (p. 266.)

After exposure, the film is developed in a colour developer, the oxidation products of which combine with the couplers to give minus colours in each layer. The silver and silver halide are then removed by Farmer's reducer, leaving a dye image which is negative as regards black and white and as regards the colours of the original (that is, complementary). When printed on to a similar emulsion coating on paper, it gives a positive colour print. Other negative-positive colour print processes (Agfacolor, Gevacolor and Pakolor, for example) have incorporated couplers of the Agfa type. The negative-positive colour process utilising multi-layer emulsions has now become well-established and has largely superseded those based on separation negatives. It offers a considerable degree of control and can yield results equal to the best produced by the Carbro process.

Defects : Colour Masking

A colour transparency or print could approach the ideal only if the transmissions of the three subtractive dyes were ideal, each absorbing one of the primary colours and being completely transparent to the other two. In practice such dyes are unknown. Yellow dyes, in general, come closest to the ideal, as they absorb blue and freely

transmit green and red; magenta dyes always absorb some blue along with the green; cyan dyes absorb a considerable amount of green and blue as well as red. The unwanted absorption in the green and blue adversely affects colour rendering by reproducing the reds much brighter than the degraded greens and blues. The magenta image is thus equivalent to an ideal magenta (green-absorbing) image combined with an unwanted weaker yellow (blue-absorbing) image; and the cyan image is equivalent to an ideal cyan (red-absorbing) image combined with unwanted yellow (blue-absorbing) and magenta (green-absorbing) images.

The technique of compensating for unwanted absorptions is known as masking, and is frequently carried out by combining a weak positive, made from one separation negative, with another separation negative before making the colour positive. Thus a positive of the correct contrast made from the green separation negative would, if combined with the blue separation negative, subtract from the resulting yellow positive a yellow deposit corresponding exactly to the unwanted yellow image in the magenta positive. That corrects for the blue absorption of the magenta dye. To correct for the unwanted blue and green absorption of the cyan dye, positives from the red separation negative must be combined with both the blue and the green separation negatives. The masking procedure is as difficult in practice as it is complex in theory, and though a brief account has been included for those readers who are interested in colour reproduction, it is unnecessary to know more than that the departure from the ideal absorptions of available dyestuffs introduces errors, which can, however, be cured by complex photographic procedure.

Masking by Coloured Couplers

A simple and most ingenious method of masking has been introduced into the Ektacolor and Kodacolor negative-positive processes, and as it is much easier to understand than the traditional process a description may clarify both the defect and its cure by masking.

In normal colour photography, the coupler—the organic chemical which combines with the developer oxidation product to form the dye—is colourless. In the coloured coupler technique, couplers are used in the negative material that are themselves coloured so as to absorb those colours which the final dye absorbs undesirably. For instance, the cyan dye absorbs some green and blue light, whereas it should only absorb red light. Now suppose a cyan

coupler is made to absorb the same amount of green and blue light as the final cyan dye. The developed layer will then have the same absorption for green and blue all over—both where the coupler has been converted into cyan dye and where it has not changed. The whole layer, in fact, appears as if it were made with a perfect cyan dye having no absorption for green and blue, but with a filter over it which absorbs green and blue uniformly over the whole area.

Only two coloured couplers are needed, a cyan coupler that is pink because it absorbs some green and blue like the cyan dye, and a magenta coupler that is yellow because it absorbs some blue like the magenta dye. After development, therefore, a colour negative of this type is equivalent to one made with perfect dyes, but with a uniform orange stain all over, corresponding to the colour of the couplers. That stain on the negative can easily be compensated in printing the positive by some such method as adjusting the colour of the printing light.

Exposure of Colour Prints

It is of interest briefly to note how a colour negative is printed. In black-and-white photography the major concern of the photographer is to achieve an acceptable reproduction of tones. In making a colour print, he is faced with the additional need to achieve acceptable colour rendering. The task is by no means a simple one as it is complicated by certain characteristics in the behaviour of the eye. The one that chiefly concerns the colour printer is the ability of the eye to adjust its colour sensitivity by a significant amount to the prevailing illumination. This means that a print in which the colours have been balanced to look right in daylight will not appear so well balanced when viewed in tungsten lighting.

There are two approaches to printing colour negatives in current practice. One consists of giving three separate exposures using blue, red and green filters and is consequently labelled the tri-colour method. Colour balance is achieved by varying the relative exposures through each filter on an empirical basis until the best result is achieved. The other method consists of adjusting the printing light with filters which reduce its intensity in certain regions of the spectrum. Since the printing light still looks substantially 'white', it has been labelled the 'white light' method. The filters in this case are usually inserted in the light path between the lamp and the condensers, whereas in the tri-colour method the filters are placed immediately in front of the enlarger lens.

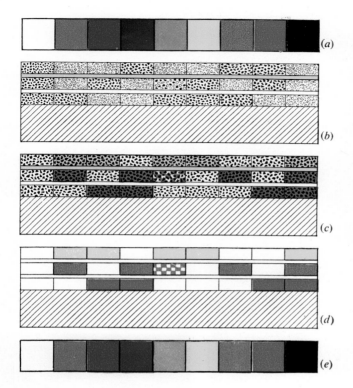

Plate III

The basis of a colour reversal film.

(a) Original colour scale.

(b) Section of colour film. After exposure in camera and first development three negative images are formed (shown by black grains).

(c) After the undeveloped emulsion is flashed or chemically fogged, colour development produces three positive silver images and at the same time three positive dye images.

(d) All the silver images are bleached and dissolved by fixation leaving only the positive dye images.

(e) Viewed by transmitted light, the three images reproduce the original colour scale.

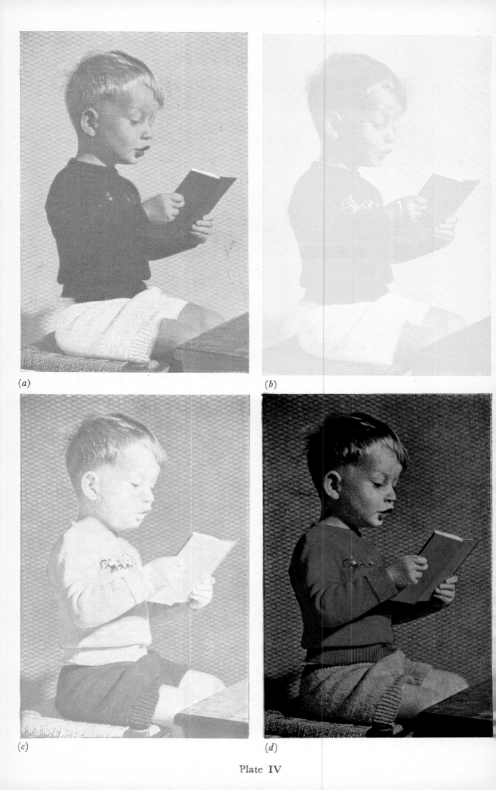

(a)

(b)

(c)

(d)

Plate IV

Chapter 23.

CINEMATOGRAPHY

THE FIRST PHOTOGRAPHS intended to depict movement were those taken by Eadweard Muybridge in 1877. He used a number of cameras to photograph a running horse. His locomotion pictures demonstrated that painters had mistaken the movements of a galloping horse. In later experiments, he used as many as forty cameras in rapid succession to photograph the movements of men and animals. Some attempts were also made to view the pictures in a manner which recomposed the original movement. However, the first animated pictures were those demonstrated by Thomas Edison in 1889 on an instrument which he called the Kinetoscope. His object was to enhance the appeal of his recently invented phonograph by adding motion pictures. These first pictures took the form of a continuous spiral on a cylinder, but he soon changed to using a continuous strip of film, perforated at the sides, which was moved through the camera with toothed sprockets. Prints from this film were then viewed through the Kinetoscope by the same means.

On the other side of the Atlantic and at roughly the same time, Friese-Green projected his first moving picture, for the benefit, so the story goes, of a London policeman who happened to be passing the inventor's studio. As his picture was a projected one, Friese-Green may rightly be titled the 'father of cinematography'. But the idea of 'movies' was very much in the air at that time and numerous patents were taken out for apparatus which was never manufactured.

It was given to the Lumière brothers to produce the first 'cinematographie' with periodic stoppage of the film, permitting

Plate IV
(a) Magenta printing image from camera exposure by green light.
(b) Yellow printing image from camera exposure by blue light.
(c) Cyan printing image from camera exposure by red light.
(d) Final reproduction of the three-colour subtractive process plus 'black'

alternately the taking of views, the printing of the positives and their projection. They were also the first to give public performances. In fact, they succeeded in obtaining near perfection at the very outset as has been shown in recent projections of their first films.

The Persistence of Vision

Cinematography relies on a characteristic of the visual process whereby the appearance of an image received by the retina persists for a brief interval, after the actual light stimulus is removed. By viewing a succession of images at frequent intervals, the impression of continuous vision is obtained. In practice a frequency of 16 frames per second is satisfactory and is usually adopted for silent films. At lower speeds a degree of flicker is seen. Sound films are taken at 24 f.p.s. to provide a longer track for the sound recording.

In 'straight' filming, the speed of the camera and that of the projector are kept the same, but cinematography offers a variable time base and can be used either to reduce the rate of movement or to increase it. This proved a source of entertainment in the early cinema, along with other tricks such as reversing movement, the use of projected backgrounds and double printing. However, it has since proved an extremely valuable aid in the study of movement and growth.

For normal cinematography the intermittent movement of the film through the camera is obtained with claws worked by cams which engage the perforations of the film. A rotary sector shutter, synchronised with the movement of the claws, gives an exposure of about 1/50 second while the film is at rest, intercepting the image while the film is being moved for the next exposure. A somewhat similar system is employed for projecting the film, the intermittent movement often being obtained by a device known as a 'Maltese cross'.

Film Size and Picture Format

Standard film is 35mm. wide with four perforations to each frame or picture. Films of narrower width (chiefly intended for amateur use) have appeared in sizes from 25 to 8 mm., but those currently in use are 16 and 8mm. Film of up to 70mm. wide has been used in the professional cinema for special wide screen effects.

The very considerable improvements in fine-grain emulsions over the last two or three decades has made it possible to obtain

a good screen image from 8 mm. film with the result that nearly all amateur cinematography is based on this gauge. At the same time, 16mm. film is now regarded as satisfactory for technical filming, documentaries and instructional films. The 8mm. width was originally introduced by Kodak as a 16mm. width *camera* film to be exposed in two stages. The first stage exposed half the picture width and the film was then reloaded in the camera and exposed for the other half. After processing, the film was slit down the middle and joined to make a double length of film. Single-width 8mm. film (Super-8), giving a larger picture area is now coming into use.

The normal picture format is that of a horizontal rectangle with a ratio of 1·33 to 1 between width and height. By using special lenses which compress the image in a horizontal direction, it is possible to include a wide picture on a standard frame. Such lenses are known as *anamorphic* and by using a projection lens of similar characteristics, the 'compressed' image is stretched to its proper width on the screen. In the Cinemascope process, a width to height ratio of 2·5 to 1 is obtained in this way.

Black-and-White Films

In the professional cinema it has always been the practice to shoot the picture with a negative film and to print the negatives so obtained on to a positive film. Both the exposure and processing are carefully controlled to produce a negative which yields a satisfactory image on a positive material of fixed characteristics (p. 210). The processing of cine film is usually carried out in special laboratories equipped with continuous processing machines. Rush prints are made for viewing and editing (or cutting) the sequences to make up a complete film. The negative is then cut to match the edited positive and any required number of projection prints can then be printed. It is frequently the practice to make a number of duplicate negatives from a master positive for distribution on a world-wide basis. Appropriate titles and sound track can then be added for language differences.

The use of black-and-white film in amateur photography has been chiefly based on reversal film. Because the amateur normally only requires one copy, it affords considerable economy since the film used in the camera becomes, after reversal processing, the positive film for projection. The reversal process offers the additional advantage of a very fine grain positive image, since in the camera exposure, the larger silver halide grains are exposed first. These are developed to form a negative image which is then

removed by a bleaching bath leaving the undeveloped and smaller grains which are exposed and developed to form a positive image, *see* p. 135.

Colour Films

Many systems have been tried over the years including both additive and subtractive processes. None of the additive systems proved commercially successful and all modern processes are based on subtractive colour films. The current practice is to shoot with either a reversal colour film and from this to make separation negatives for imbibition printing such as that of the Technicolor process (p. 271), or to use a negative colour film which is printed on to a positive colour film.

Amateur cinematography is done almost exclusively on reversal colour films. In fact, the first commercially successful subtractive colour film—Kodachrome—was introduced for amateur movies.

Fig. 1. Variable width (*left*) a variable density (*right*) sound tracks.

Sound Recording

It is interesting to note that Edison originally thought of motion pictures as an additional appeal to sound recording, but it was not until some thirty years later, when the cinema was well-established, that a practical method of adding sound to motion pictures was devised.

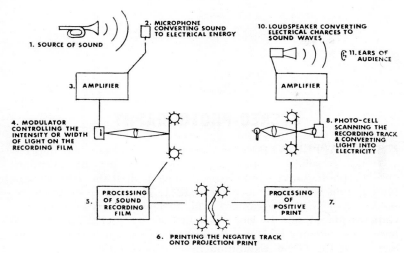

Fig. 2. Sound reproduction.

Sound recording for films can be either optical or magnetic. At the present time it is usual to provide an optical track on the projection print, but for some purposes, such as stereophonic sound, multiple magnetic tracks are added. Magnetic tracks are also used when it is required to add sound to narrow gauge films.

Optical sound tracks are of two different forms; variable density, such as that of Western Electric, and variable area (R.C.A.), (Fig. 1). However, current practice is to use a variable area track on projection prints even if the variable density system is used for the original recording. On projection the sound track is scanned photo-electrically. The stages of sound reproduction are shown in Fig. 2.

Chapter 24

STEREO-PHOTOGRAPHY

THE APPLICATION of a stereoscope to obtain the impression of solidity from two drawings pre-dated the invention of photography, but records suggest that the first stereo-photographs were made as early as 1841. These early stereos were made either with one camera from two viewpoints or with two cameras placed side by side. The first stereo-camera having two lenses was invented by David Brewster in 1849, and stereos were on display at the Great Exhibition in 1851 and later in the International Exhibition in Paris in 1855. The combined publicity resulted in a tremendous enthusiasm for this form of photography. Unfortunately, it rapidly became a kind of vulgar peep-show and by the end of the century it was virtually banned from polite drawing rooms!

A considerable revival of stereo-photography occurred with the arrival of modern colour photography and a number of excellently made stereo-cameras were put on the market as well as a variety of stereo-attachments which could be fitted over single-lens cameras. At the same time a number of stereo-viewers were marketed. Finally, polarizing filters were applied to the colour projection of both still and movie pictures.

In spite of the varied fortunes of stereo-photography as a popular medium of photography, it still offers a useful recording medium when spatial relationships between different objects are important. Thus it can be of value in recording surgical operations, archeological surveys, photogrammetry and as a display medium in advertising and commerce.

Binocular Vision

Stereo-photography is based on the binocular nature of vision. The separation of our eyes provides us with two aspects of a solid

object which are 'fused together' as a single image having the appearance of depth as well as height and width. This capacity of vision can be applied to two photographs made with a lateral displacement equal to that of the eyes—a distance normally taken as 63mm.—if the photographs are so viewed that each eye sees only one picture. Binocular vision is most effective at close and medium distances and ceases to be effective beyond 300 feet. It provides a valuable aid to assessing the relative distances of objects and in performing manual operations.

It is worth noting, however, that useful though binocular vision is—for example, try threading a needle with one eye closed—it is by no means our only means of perceiving depth and a normal sighted person has very little advantage over a person with only one eye. Geometric and atmospheric perspective, parallax motion, the relative size of objects, the size and direction of shadows may all contribute clues to depth. This explains why a flat photograph can be so readily accepted as a representation of three-dimensional objects.

The Making of Stereo-photographs

For subjects which are stationary, the two photographs can be made with an ordinary camera with nothing more elaborate than a sliding base having two stops 63mm. apart. The camera, mounted on this base, should be solidly supported on a stand. The camera should be level (laterally) though it may be tilted up or down. The use of a greater lateral separation has the effect of exaggerating depth and occurs in aerial survey photography (p. 296). For close-ups of small objects a smaller separation is used to overcome parallax.

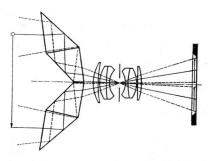

Fig. 1. Optical diagram of the Retina Stereo-Attachment

The exposures must be identical and the lens aperture should be stopped down sufficiently to give acceptable sharpness in all planes of the subject being photographed. The lighting of the subject should be such as to avoid absence of detail in either shadow or highlight areas.

For stereo-photographs to be made with a hand-held camera or of action subjects, it is necessary to use a two-lens camera or an ordinary camera fitted with a prismatic image divider (Fig. 1). The latter attachment gives two images on one frame of film.

Viewing Systems

A great many viewing systems have been devised for both still and cine stereo-photographs. We shall concern ourselves only with stereoscopy, namely the viewing of two separate photographs to obtain the effect of the third dimension.

Some people are able to view a pair of stereo-photographs without the aid of a stereoscope merely by relaxing control over the eyes so that a double image is seen. At a certain point when two of the images overlap, they 'snap' into register and a true stereo-effect is obtained. This trick can be assisted by placing a black card between the eyes so that each eye can only see the photograph directly in front of it. This is also the basis of the simple stereoscope which usually employs two magnifying lenses to enable small photographs to be seen in correct perspective.

The most practical method for viewing by projection is by the use of two projectors fitted with polarizing filters. The filters are arranged so that their polarizing planes are at right angles to each other. The screen is viewed through polarizing spectacles which are similarly orientated. Thus each eye sees only the appropriate image, the other being excluded by the effect of crossed polarizing filters (p. 36). It is necessary to use a metallised screen since a non-metallic surface will de-polarize the light.

THE APPLICATIONS OF PHOTOGRAPHY

PHOTOGRAPHY IS normally used to augment and extend visual observations. Not only does it give a permanent, detailed record of events and places for examination at leisure, but it records scenes which are too dim or events which are too rapid or too slow for the eye to perceive, responds to radiations to which the eye is insensitive, and by means of cinematography can speed up events almost indefinitely, or slow them down as much as 600,000 times. Scientists and technologists were not slow to utilise such a valuable tool, and few of their activities do not make use of photography in one or other of its aspects. Indeed, in some fields, such as spectrography, astronomy and radiography, photography plays an integral and essential part.

Spectrography

The science of spectrography, for example, depends on the fact that when substances are raised to such a temperature that they become incandescent gases, the light emitted is not a continuous spectrum, but consists of a number of individual lines or bands whose wavelengths are characteristic of the elements present in the substance examined. From a photograph of the line spectrum of an unknown substance vaporised in a carbon arc, it is possible to deduce what metallic (and a few non-metallic) elements are present. Moreover, since the emission brightness of any element will depend upon its concentration, it is also possible to calculate the proportion of each element present (Fig. 1) by measuring with a microdensitometer the densities of the lines.

Photography is an extremely valuable aid to spectrography, as vaporisation of a minute quantity of material for some seconds gives a record which can be subjected to prolonged and careful measurement in a manner quite impracticable for the emission

direct. Moreover, many of the important lines are in the U.V. to which the eye is insensitive. The technique of quantitative analysis by spectrography is known as *spectrochemical analysis*, and in some fields (for example, the analysis of alloys) has largely superseded the slower and more cumbersome chemical techniques. In many cases it will detect elements when their concentrations are too low for chemical detection.

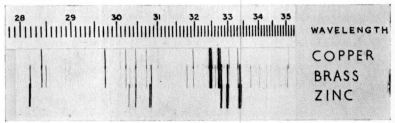

Fig. 1. SPECTROCHEMICAL ANALYSIS. Spectrograms of copper, zinc and brass. The brass is seen to consist largely of copper and zinc, but also contains small quantities of other elements.

Astronomical Photography

In astronomy, direct visual observation has been almost completely replaced by photography. There are two reasons for this. One is that a photograph is a permanent record which can be measured and checked at any time. The other is that everything which the eye can see in any given telescope can be photographed in a 5-minute exposure so that exposures of 4-5 hours will reveal objects perhaps 50 times less bright than those seen by the eye. The telescopic camera thus extends the depth of penetration of space by the square root of 50 (p. 39), that is, by about 7 times. The effectiveness of photography is probably not quite as great as indicated by these figures owing to the luminosity of the earth's atmosphere, but it is difficult to give really accurate estimates since most photographs are made with blue-sensitive plates—and for good reason. The obscuration by the glow of the sky is less for the light to which such plates are sensitive, though in some special cases a plate with a restricted range of sensitivity in the deep red can penetrate farther through the cosmic dust. Plates of other colour sensitivities can also give useful information; infra-red photography, for instance, has revealed stars otherwise invisible.

The brighter stars appear larger in photographs than the fainter ones because of the sideways scatter of light in the sensitive layer and this phenomenon is made use of in estimating the *magnitude* or brightness of a star (Fig. 2). Our information about the nature of

Fig. 2. 'Messier 51', the 'whirlpool' nebula (one of the most beautiful spiral nebulae known) is three million light years away from the earth. The magnitudes of surrounding stars are determined from the sizes of the star images. *Mount Wilson and Palomar Observatories.*

stars is obtained from photographs of their spectra. From these we can determine not only the chemical composition of the outer layers (much as in terrestrial spectrography) but also their temperatures, and other conditions such as pressure, or even, in some cases, whether they have a magnetic field like the earth. The displacement of the lines in the spectra of nebulae from the wave-lengths they have on the earth tells us that the distant nebulae are moving away from us. Photography, both direct and of spectra, has given us a good deal of information about the surface conditions and chemical composition of the atmospheres of planets.

Photography in Space

The development of rockets powerful enough to escape from the earth's gravity has also extended the frontier for photography. Cameras of some sort or another were installed in all the first rocket probes and sent back the first views of the earth from 'outer space'. With manned rockets, the crew use cameras, both still and cine, much as anyone might do from the window of a plane, (Fig. 3). However, television cameras are used to give direct visual impressions and are also used in distant probes where there is no prospect of recovering the rocket. In this case the television images are photographed to provide permanent records such as those shown in Figs. 4 and 5.

Photography outside the earth's atmosphere offers many advantages to the astronomer and when the first satellite laboratories are in orbit, we may expect further progress in this field.

Fig. 3. Photograph of Gemini 7 taken during space rendezvous in December 1965, by Major T. P. Stafford of Gemini 6. The original was made on 70 mm. Kodak Ektachrome MS film.

Fig. 4. 'Television' photograph of moon's surface sent back by Ranger 8 two seconds before impact.

Fig. 5. Photograph of the surface of Mars taken from a distance of 7,800 miles by Mariner 4, and relayed back to earth from a distance of nearly 40,000,000 miles.

Radiography

The sensitivity of photographic materials to X-rays (to which the eye is insensitive) makes it possible to produce shadow photographs of objects placed in a beam of X-rays. X-rays are electromagnetic vibrations which differ from light only in wave-length. Their relatively short wave-length allows them to penetrate many materials which are opaque to light. The wave-lengths of visible light manifest themselves as differences in colour; those classed under the general term X-rays are characterised by increasing penetration as they decrease in length.

Resistance to the passage of X-rays is an atomic phenomenon, and increases with atomic weight and with the number of atoms per unit volume. A gas will therefore offer less resistance than a liquid or solid of the same average atomic weight because there are fewer atoms per unit volume, and organic substances such as flesh or wood will be less opaque to X-rays than bone or metal because the average atomic weight is less. Aluminium is relatively transparent to X-rays, compared with other metals, because of its low atomic weight, while the most opaque substance easily available is lead, which is therefore used for protection against X-radiation.

A shadow photograph to X-rays (called a radiograph) may reveal the internal structure of a material of heterogeneous composition. Radiographs of the human body show the bone structure and may reveal fractured, diseased or mal-formed bones. They may also show abnormal conditions in non-bony portions of the body if these show differences in opacity to X-rays; in this way diseased condition of the lungs may be diagnosed and 'mass' radiography of the chest is now carried out periodically for school children to detect signs of tuberculosis (Fig. 6). Special techniques are used to examine organs which normally are not sharply differentiated on radiographs; for example, the alimentary canal can be sharply defined after the patient has eaten a meal containing barium sulphate, an inert material very opaque to X-rays, because of the high atomic weight of barium. Similarly blood vessels may be outlined by injecting into them an organic substance containing iodine, which absorbs X-rays.

Of recent years radiography has been applied to a considerable extent in industry. It provides a non-destructive method of testing a manufactured article; for example, it is widely used for testing castings for defects such as porosity, blow-holes, cracks, slag inclusions, etc. (Fig. 7) and for testing for faults in welds. The examination of light alloys does not require very penetrating X-rays, but

Fig. 6. Section of film from a 'mass' radiography for the detection of tuberculosis.

Fig. 7. (*below*).

(*a*) normal photograph of an aluminium casting.

(*b*) X-ray photograph showing defect.

(*c*) X-ray photograph of a similar casting taken after the defect had been cured.

(*a*)　　　　　　(*b*)　　　　　　(*c*)

Fig. 8. X-ray diffraction pattern of silicon carbide. *Courtesy:*
Research Laboratories of the General Electric Company, Wembley.

steel castings or welds do. In such cases X-rays of short wave-
lengths produced by large sets of high kilovoltage are used, and steel
up to twelve inches thick can nowadays be examined. X-rays of
extremely short wave-lengths, known as gamma rays, are emitted
by radio-active substances, and the recent production of artificially
radio-active elements, such as cobalt, has been increasingly applied
to industrial radiography.

X-Ray Crystal Analysis

X-rays are transmitted or reflected from crystalline substances in
certain well-defined directions only, the angles depending on the

wave-length of X-rays, the spacing and arrangement of atoms in the crystal structure, and the orientation of the crystal. Thus if (as in the original experiment on X-ray crystal diffraction) a beam of *white* X-rays (that is, with a range of wave-lengths) is allowed to fall on a crystal, a photographic plate or film placed some distance away will reveal a pattern of spots, after development (Fig. 8). For each of these spots the orientation of the crystal, and consequently the orientation of its internal structure, has been just right for some particular wave-length of X-rays to be powerfully reflected or transmitted. There are many variations of this technique, some very ingenious, all devised towards determining the arrangement of atoms in crystalline materials. The method has revealed the crystalline structure of so many materials that it can now be used for the analysis of powders of unknown composition.

Photomicrography

Photomicrography, the photography of the image produced by a microscope, is of immense value in such sciences as medicine, surgery, botany, zoology and metallurgy. Although quite elaborate apparatus is marketed, good photomicrographs can be made by attaching a simple camera to a microscope. The ability to record fine detail is measured as the number of lines per millimetre which can be resolved as separate entities, and is called the *resolving power* (p. 237). While there is no limit to the degree of magnification of the image in photomicrography, there is a limit (depending on the resolving power of the optical system) to the amount of detail which can be resolved, and magnification beyond this limit (that is, magnification which reveals no more detail) is known as *empty magnification*. The resolving power depends, of course, on the design and construction of the lens system, but however clever one is at optics there is a limit to the resolving power of an optical microscope, depending on the wave-length of the light used—one could not expect to resolve lines which are much closer together than a wave-length of light. The smaller the wave-length, the greater the possible resolving power, and in order to obtain high resolution, U.V. photomicrography is often used.

A recent important advance in photomicrography has been the use of a beam of electrons instead of light or U.V. radiations. Electrons affect photographic materials in much the same way as light. Like light, a stream of electrons behaves in some respects as though it consists of discrete particles, and in other respects as if it were travelling like waves. The wave-length of an electron

Fig. 9. ELECTRON MICROGRAPH. Individual molecules of the
Turnip Yellow Mosaic virus × 280,000. *Courtesy: R. Markham
and R. W. Horne, Cavendish Laboratory, Cambridge.*

beam, however, is much smaller than that of light ($\frac{1}{200}$mμ as against
550mμ for green light—if the electrons have been accelerated by a
50kV electric field), and hence the theoretical maximum resolving
power should be much greater. An electron beam cannot be
refracted by a lens, but it can be deflected by an electric charge
or a magnet. By passing a beam of electrons through a suitably
shaped magnet it may be brought to a focus. Such magnetic lenses,
used much as glass lenses are in an optical microscope, give electron
microscopes capable of extreme resolution. We are not yet able to
make magnetic lenses with apertures anywhere near as high as
those of glass lenses, so that we have not yet approached the theo-
retical maximum resolution an electron microscope will give, but
whereas an optical microscope can usefully magnify some 2,000
diameters, we can now obtain a magnification of up to 100,000
on an electron microscope (Fig. 9). It is even possible to resolve
individual molecules when these are large.

High-Speed Photography

Light sources such as the electric spark and the gas discharge lamp may have a duration of as little as one-millionth of a second, and can 'freeze' the most rapid motion. High speed photographs have been used in studying the propagation of flame, the discharge and behaviour of projectiles, aeronautics, the flight of insects and birds, the motions of athletes and sportsmen, and many similar problems (Fig. 10).

Great ingenuity has been expended on devising high speed cine cameras, some of which can expose at the rate of ten million frames per second, each frame being exposed for one hundredth-millionth of a second. At this rate the action studied is slowed down 600,000 times. This time magnification is far greater than is necessary or desirable for the study of most problems of high speed action, and a commercial high speed cine camera taking 16mm.

Fig. 10. Magazine rifle bullet striking glass plate (viewed edgewise) at velocity of 2,000ft. per sec. Spark photograph taken by Boys in 1892. *Courtesy: Science Museum.*

Fig. 10. (*b*) 40mm. cannon shell in flight. *Courtesy: Armaments Research Department.*

film at 3,000 frames per second, giving a time magnification of 200, is generally adequate. This camera has been increasingly applied to the investigation of high speed machinery, armament, clockwork mechanism, electrical gear and so forth. The method is particularly valuable as, apart from stroboscopy (which can be applied only to repetitive motion), cinematography is our only means of magnifying time and examining at leisure action otherwise too rapid to be perceived.

By low speed cinematography—known as *time lapse* photography—actions which are too slow to be properly observed and co-ordinated may be speeded up. The technique is to expose frames at equal but prolonged intervals, such as one per second or minute or hour or day, and project at normal speed of 16 or 24 frames per second. The time reduction is virtually unlimited, and the method has been applied to the study of plant growth, cloud formation, erosion problems and the like.

Photogrammetry

The position of different parts of an image on a photographic negative is defined by the position of the corresponding parts of the subject and the optical properties of the camera lens, modified by any dimensional changes in the negative. By using negative material of high dimensional stability (glass or specially cured film) and an accurately calibrated camera lens, it is possible to deduce from measurements of the image the path of the light rays from various parts of the subject. By taking two photographs of the same subject from two different accurately known points of view, the form and dimensions of the object photographed can be determined from the intersection of rays from corresponding portions of the object.

Such photographic mensuration is called *photogrammetry* and has been applied to terrestrial and aerial survey work, architectural and astronomical photography. In ground survey work, for example, after preliminary triangulation to give an accurate datum measurement, the theodolite may be replaced by the camera for further extensions. Calculation of measurements may then be made at leisure from the series of photographs.

But it is in aerial survey that photogrammetry has proved itself of greatest value. It was first applied to large areas, particularly in difficult mountainous country. Because it is more precise, more rapid and less costly, in some countries it has now completely replaced classical survey methods. In aerial survey (Fig. 11), a series

Fig. 11. Artist's impression showing a series of over-lapping photographs in an aerial survey. *Courtesy: Hunting Aero-surveys Ltd.*

Fig. 12. The Wild A.8 Stereo Plotter used in map making. *Courtesy: Hunting Aero-surveys Ltd.*

of overlapping photographs of a region is printed in an apparatus (Fig. 9) which can compensate for differences in height and tilt of the camera so as to produce a series of photographs standardised so far as height and angle of camera are concerned. These can be combined in a mosaic to give an accurate map of the region. The overlapping portions represent photographs of the same area taken from different points, and viewed in a stereoscope the terrain appears to be in relief. Since the distance between successive photographs of the same area is far greater than the distance between the two eyes, the apparent vertical dimension is magnified in a similar ratio. This stereoscopic effect may be used quantitatively to measure the height of the ground and prepare contour maps. Indeed, instruments have been devised with which an operator may automatically carve a relief map from a block of plastic, by tracing heights of a stereoscopic pair.

On a smaller scale, photogrammetry has been of great value in preparing records of historic and other buildings. Photographs of different aspects give sufficient quantitative data to allow facsimile reproduction if the building has to be reconstructed after damage.

Survey is not the only use for aerial photography, of course. Archaeological remains are often in slight relief, imperceptible from ground level, but easily seen on aerial photographs, especially by making use of shadows. Moreover, disturbed soil does not return to its original compactness, even after centuries, so that archaelogical features are often marked by differences in vegetation from the surrounding land. These again are unnoticeable from ground level, but are quite perceptible on photographs taken from low altitudes.

By using infra-red sensitive material, or pan film with filters, different species of trees may be recognised, and aerial photography has been most valuable in forestry work for mapping, inventory and administration. It is a most useful tool in geography and geology too, and is finding increasing use in locating minerals and oil. Other recent applications have been to studies of population distribution, and of soil erosion.

Infra-red aerial photography has been used to photograph objects over phenomenal distances—up to hundreds of miles—thanks to the ability of the longer wave-lengths to penetrate certain types of atmospheric haze. However, in spite of some spectacular successes, results have proved disappointing. Penetration depends on the size of the haze particle, and the conditions under which infra-red is most effective are not frequently met in practice. Haze penetration by infra-red, in spite of popular opinion, has been

Fig. 13. Direct photograph using infra-red film taken from a rocket 143 miles above the southwest of the United States.

concisely described as not good enough to use, not bad enough to discard. However, infra-red aerial photography had a useful wartime application in the detection of camouflage by strongly differentiating between green foliage and a matching green paint. The paint originally used reflected little or no infra-red, whereas the chlorophyl in foliage reflects it strongly.

Legal and Forensic Photography

The value of the camera for providing records and evidence in police work requires no emphasis; the scene of the crime or accident, the victim, the weapon, the convicted person—all are records of vital importance. But since modern forensic science depends on the extraction of the maximum information from microscopic specimens, U.V. and electron microscopy, radiography, X-ray crystal analysis, spectrographic analysis, and other modern techniques have all been pressed into service.

Photography has been most useful in the examination of documents suspected of forgery, obliterated by the censor or damaged by fire or other means. Infra-red photography, photography by U.V. radiation, photography of the visual fluorescence produced by U.V. radiation, photography through selective filters are all valuable

Fig. 14. FORENSIC PHOTO-
GRAPHY. Detection of
forgery on a car licence by
U.V. photography. *Cour-
tesy: Det. Supt. P. G. Law,
F.I.B.P., F.R.P.S., New
Scotland Yard.*

Fig. 15. The charred
cheque (*below*) has been
made to yield a readable
image by the use of infra-
red photography.

tools. Unless inks identical with the original have been used for
forgery, obliteration, etc., it is most unlikely that a visual match
to the eye will show no difference under other conditions of examina-
tion (Figs. 14 and 15).

Photography in Nuclear Research

The silver halide of a photographic emulsion is rendered develop-
able by passing through it charged atomic particles, the image
taking the form of a row of silver grains marking the path of the
particle. Special emulsions of high sensitivity and low gel content
(to give tight packing of the grains) are now capable of recording
electron tracks, and indeed the track of any charged particle of
any energy (Fig. 16). Photography thus provides a valuable (and
in many respects superior) alternative detection tool to the ionisa-
tion chamber, the Geiger counter, or the Wilson cloud chamber,

Fig. 16. NUCLEAR RESEARCH. Radioactive decay of a radiothorium atom in a photographic emulsion. The strong lines show the tracks of four alpha particles and the dotted wavy lines show electron tracks.
Courtesy: Dr. R. H. Herz, Kodak Research Laboratories, Harrow.

and is playing a most important part in the most fundamental of all studies—the structure of the nucleus of the atom.

Photo-Recording

This is a branch of applied photography which enables technicians to make visible records of invisible changes in electrical or mechanical quantities. Strain gauges, or similar devices, are fixed to the object being examined, and these are connected via fine wires, to a cathode-ray oscilloscope or a mirror galvanometer. When they are fed into the recording instrument, the 'signals' made by the changes in the object are greatly magnified and then transformed into visible images or 'traces'. Where cathode-ray oscilloscopes are used, the trace appears on the screen, usually as a constantly moving line of light, and this is photographed for examination. Where mirror galvanometers are used, a latent image is formed on photographic paper by means of high-intensity beams of light actuated by the changes in the object (Fig. 17). In both cases the image appears on the photographic material as a wavy line, from which the

Fig. 17. Photo-recording using mirror galvanometers. (Diag.)

Fig. 18. Oscillograph recording.

required information can be 'read off'. It is possible to record and measure phenomena lasting no more than a millionth of a second.

Photosensitive Resist

The Frenchman, Niepce, was probably the first to apply the principle of a photosensitive resist when in 1818 he devised a technique in which bitumen, coated on to a metal plate, was exposed to light. The unexposed portions of the bitumen were then dissolved from the metal in oil of lavender solution, leaving bitumen protecting certain areas of the metal. The plate was then immersed in acid which etched the unprotected metal. Niepce used this

etched image in a printing press. At the time the system had very little practical value and was temporarily forgotten in the success of the daguerreotype process.

Much later in the nineteenth century interest in photosensitive resists was reawakened in its application in the printing world in the preparation of half-tone blocks. But it is comparatively

Fig. 19. Small precision components made by photo-resist process. The scale is in centimetres. *Courtesy: Microponent Development Ltd.*

Fig. 20. Silicon slice containing hundreds of microminiature circuits of the kind shown on the right, which measures 0.05 in. across. *Courtesy Ferranti Ltd.*

recently that a new kind of photosensitive resist, consisting of an ultra-violet sensitive resin in an organic solvent, has been applied to precision engineering and the making of microminiature electronic circuits (Figs. 19 and 20).

In practice, large-scale drawings are prepared of the parts to be made, and these are photographically reduced on to a high-resolution material for printing on to the resist-coated metal. After development of the image, the unwanted metal is etched away, leaving a very accurate pattern.

Photography in Education

The use of 16mm. film and film strip for training purposes received a powerful impetus during the last war, and the value of such methods in education was well established. They are now used, with or without sound record, in schools, universities and hospitals, and in industry and commerce. They are used for training new employees in factory methods, for training supervisory staff, for explaining safety and health precautions, as sales aids for demonstrating and advertis ng, for instruction on erection of plant and for propaganda genierally.

The importance of photography in newspaper illustration and books has resulted in the technology of photomechanics. Today a graphic record of an event taking place thousands of miles away can be produced within an hour or two of its occurrence.

In the world of entertainment it has given us the vast cinema industry and in television is one of the basic mediums for recording the image which is later transmitted and received electronically.

Finally, but by no means least important, photography provides one of the most popular present day hobbies.

DOCUMENT COPYING

IT MAY SEEM SURPRISING that after reviewing the major scientific and technical applications of photography in one chapter, a second chapter is devoted to a single application—document copying. The extent to which photography is used for this purpose, however, is not generally realised. About a fifth of the world's production of photographic paper is used for document copying, and the potential use (and therefore the probable future use) of photography for this purpose is far greater than its present application.

Industry has discovered that the photographic copying of documents is a most efficient literary laxative. It is by no means a new idea. Over a century ago, at the dawn of the photographic era, Fox Talbot recommended it as being more accurate, more rapid and cheaper than other methods, and the same is true today. Photographic copies of documents may be of many different types; they may differ in the process used (silver, dye-line or blueprint), in the support (film or paper), in size, in permanence of image, and in ease and cheapness of production. The uses to which photographic copies are put also fall into two fairly well-defined categories, and naturally it has been found that specific types of copies are more suitable for specific requirements.

Copies may be required merely for storage against possible reference at some future date, for example, copies of cheques which have passed through a bank, receipts and correspondence in business houses, newspaper records, books and manuscripts in libraries, and so on. For such archival purposes copies should be as permanent as possible, lend themselves to easy storage, and be relatively inexpensive; microcopies on film base fill this specification most satisfactorily. Alternatively, copies may be required for immediate study, and be of transient importance only. That is, they may be required for frequent reference for a limited period, as, for example, copies of patents, scientific papers, formulæ, legal documents,

in insurance work for birth and death certificates, survey reports, leases, proposal forms, statistics, conveyances, licences and evaluations. Copies on paper, of the same order of size as the original, would best suit this purpose, and extreme permanence of image would not be necessary. These two main categories will now be considered.

Microphotography

Microcopying is a branch of microphotography (the production of microscopic photographic images) which has been a source of study and amusement to photographers for the best part of a century. As early as 1839, a few months after the introduction of the Daguerreotype process, a Manchester optician, J. B. Dancer, made microphotographs, but owing to the limitations of Daguerre's process, they could be usefully viewed only at 20 diameters magnification. In 1851 Scott Archer introduced the wet collodion process, and the following year Dancer applied the process successfully to microphotography. He produced commercially groups of portraits and documents in a circle of $\frac{1}{16}$in. diameter, and sold them mounted on microscope slides. Similar results were soon produced by a school of British microphotographers, who also made graticules and microscales for telescope and microscope eyepieces and diffraction gratings.

Fig. 1. *Left.* Pellicle sent by Dagron by pigeon post during the siege of Paris, 1870, shown original size.
Right. Enlargement of part of text.

Fig. 2. With Kodak Spectroscopic film it is possible for a sheet as tiny as that shown held by the young lady to contain the 29,000 pages (including margins) of this encyclopedia.

After the pioneer work in this country, microphotographs were soon produced in the U.S. and France, the foremost practitioner in France being René Dagron, who about 1860 did a considerable business in micro portraits and views. Whereas previous microphotographs required a microscope for viewing, Dagron mounted his at one end of a tiny glass rod, the other end of which was ground to a lens to form a cheap viewer. Such microphotographs were sold mounted in jewellery and toys.

Dagron's work in producing pellicles which were transmitted by pigeon post during the siege of Paris in 1870 is too well known to require review, but the magnitude of his technical achievement is not generally realised. Sixteen newspaper-size sheets, containing 50,000 messages, were copied legibly on to an area $2 \times 1\frac{1}{4}$in. to be carried by one pigeon (Fig. 1). During the last war the Germans used 'microdots' in espionage. A page of messages was copied down to very small size, and inserted as a full stop in a post card or a dot on a stamp. Fortunately, this technique was soon discovered and the original wording was replaced by messages more in the interest of the Allies, before the missives were allowed to proceed. *See* also Fig. 2.

Fig. 3. Portable microfilmer. *Courtesy: Kodak Ltd.*

Microcopying

Microcopying for commercial purposes requires the cheapest and simplest method of producing adequate results. The cost of materials and processing chemicals decreases progressively with image size, but the cost of copying and viewing apparatus, and above all labour costs, increase very rapidly as we approach extremely small microcopies. There must be an image size representing a compromise where the process is cheapest and most efficient. It is found that reduction of normal size documents on to 16mm. or 35mm. film, according to requirements and size of original, is about the optimum. There was the additional advantage that continuous processing machines were already in existence for professional and amateur cine photography.

16mm. Document Copying.—The first large-scale use of microcopying was by banking houses in 1928, for recording cheques which pass through clearing houses. A mechanised camera which copied on to 16mm. film was used. In 1945 an apparatus was marketed which photographed both sides of the cheque simultaneously at the rate of 400 per minute, the front and back of 10,000 cheques being copied on to 100ft. of 16mm. film.

The outbreak of war saw an enormous increase in document copying for security reasons, and although banks are still major

users of 16mm. microcopying, it has been adopted by many other commercial houses and by some Government departments. (Fig. 3).

Commercial apparatus for copying on to 16mm. film and for viewing the microcopies shows a high degree of specialised development, culminating in desk models which can be used for both copying and reading 16mm. photographic copies show advantages over other methods of document copying in rapidity, accuracy, security against fraud, and in durability; moreover, less fire hazard attaches to safety film than to paper copies. The economic advantages of microcopying are even more profound. The amount of sensitised material used per document is trivial; and the saving in storage space is 98 per cent.

The small volume of microcopies as against full size paper copies also introduces economies in freight, especially in air travel when copies have to be dispatched over considerable distances. To utilise this advantage, the Airgraph process was established during the war, whereby letters on a standard form were microcopied on 16mm. film, flown to the destination, and an enlarged print delivered through the local postal service. This system was extensively used

Fig. 4. Miracode system. It provides an information retrieval service of almost a million separate documents which have been microfilmed. *Courtesy: Kodak Ltd.*

by our troops; the Americans used a similar system which they called V-mail. Well over 300,000,000 letters were thus transmitted by the British Army alone, and about 700,000,000 by the American Army.

35mm. Document Copying.—While 16mm. copying is most suitable for bulk micro-filming of masses of more or less standard records, 35mm. is more suitable for copying a wide range of subjects of different sizes, for example, engineering drawings, invoices, deeds, ledgers, books and newspapers. Again specialised, photographing and viewing apparatus has been evolved. The cameras are more flexible though less efficient in output than 16mm. microcopying apparatus (Fig. 5). A speedy and complete 16mm. or 35mm. microfilm service is nowadays available to those who do not wish to purchase apparatus or to do their own processing.

Micro Prints

An alternative to micro-copying on to film is that of making a master negative on to a high resolution film from which prints for reflection viewing can be made. This system has been widely exploited in the United States in several forms. In one system, publications are reproduced on 5 × 3in. filing cards, each of which may contain as many as sixty pages. The negatives are usually made on 16mm. film and after being cut and assembled in groups printed by contact on to a special printing paper. As well as being of fine-grain, high resolution and high contrast, the paper incorporates an anti-halation baryta layer. Larger sizes have been used to provide copies of books having up to two hundred pages. The prints are viewed by magnification or with a reflection-projector.

An ingenious system devised by the Kodak Company is that of the Minicard system. In this, the cards, 32 × 16mm. in size, are on film as they also incorporate the equivalent of a punch card system. Documents are reduced sixty diameters on one half of the card while the other contains clear and opaque dots which can be scanned photo-electrically for rapid filing, sorting or retrieval.

Normal-Size Copies

There are several systems for preparing normal-size copies, the most generally used being camera-copying on to normal photographic paper. This was the first mechanised method of copying documents, and after 25 years' service it is still predominant. It is used almost exclusively by Government departments, and requests for documents from Probate Registry, Science Library, British Museum,

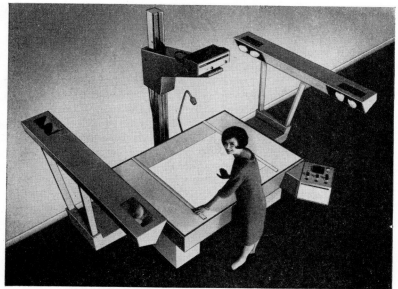

Fig. 5. Micro-file machine using 35 mm. film. *Courtesy: Kodak Ltd.*

Ordnance Survey, Town Planning, Air Ministry, War Office and so on, are invariably met by supplying this type of copy.

The document is copied on to a roll of bromide paper through a lens and prism, the latter correcting the left-to-right inversion (Fig. 6). The copy is negative—white printing on a black background—which is quite legible, but when a positive copy is re-

Fig. 6. Photostat machine. *Courtesy: Photostat Ltd.*

quired (as when half-tone illustrations are included or when multiple copies are needed), the negative can again be copied to give a positive replica of the original. The system is designed for ease and rapidity of working, and operates under normal office lighting; little photographic skill is required and reduced or enlarged copies can be produced if desired. The system may be coupled with other copying processes by producing a print on translucent paper, to be used as an intermediate for obtaining dye-line or blue-print copies.

Copying Line Drawings.—Diazo or ferroprussiate papers are normally used for bulk copying of engineering drawings, architectural plans and similar documents, but it is common practice to produce such copies from a master copy produced by the silver process. The master copy could be produced by a camera copy on translucent paper or sensitised tracing linen, but specialised apparatus is marketed for copying on to half-plate film, which can be readily filed, and the same apparatus may be used for producing enlarged copies therefrom up to 60×40in. (Fig. 7). This system

Fig. 7. Precision copying of large documents
(60 × 40in.). *Courtesy: Photostat Ltd.*

was evolved during the war, when many industrial concerns realised that their major asset lay in drawing office records, and that copies were essential for security. Other applications were at once discovered. It was often necessary to transfer records overseas, or to send a series of drawings to shadow factories in this country. Major ships carried half-plate film copies of drawings of their equipment,

so that after action, repairs could be carried out at sea. Such copies are more accurate, and easier and cheaper to produce and file than tracings.

Office Methods

Perhaps the greatest scope for photographic document copying in the future lies in the ordinary office, where the amount of work may not justify the expense of a specialised copying camera. Same-size copies can be obtained by using the actual documents as

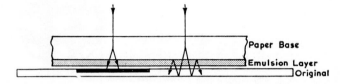

Fig. 8. Reflex copying.

negatives if they are fairly translucent and printed on one side only, the resulting copies being in reverse (white on a black background). When the document to be copied is printed on both sides, or is fairly opaque, it cannot conveniently be used as a negative, and an ingenious method of copying known as *Reflex Copying* is used.

Reflex Copying.—The document to be copied is laid face upwards and sensitive photographic paper laid over it, face downwards. The paper is exposed from above, through the back of the reflex copying paper, using (by the interposition of a yellow filter) only the longest wave-length to which the paper is sensitive, as these rays are less scattered and absorbed by the emulsion. The portions of the sensitised paper opposite the black print are exposed only to the incident light (after absorption and reflection by the paper support of the sensitive material), since the black ink prevents back reflection. The portions opposite the white parts of the original document receive the same exposure plus an excess due to multiple inter-reflections between the white document and the white paper base of the sensitive material (Fig. 8). The exposure is rather critical, and is adjusted so that the exposure corresponding to the black portions produces a low density on the paper, when the added exposure given by the white portions gives, with the high contrast of the reflex paper emulsion, a satisfactory high density. The method is rapid, simple and economic, but gives laterally reversed, white-on-black copies. This is corrected by using the reflex copy as a

negative, and printing on to high contrast paper to give as many copies as are required.

Alternative Methods.—Of recent years much effort has been expended in devising alternative methods to the normal silver process. In general these methods avoid the lengthy wet processing of the normal silver process (which usually entails some photographic skill), and some require only the simplest of equipment for exposure and processing.

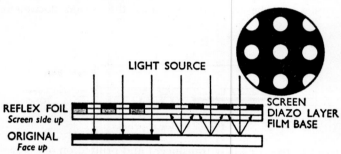

Fig. 9. Diazo reflex copying. *Courtesy: Ilford Ltd.*

Diazo Reflex.—The contrast of diazo paper is normally too low to allow its successful use for reflex copying. An ingenious modification which overcomes this defect is the use of a diazo layer on film base attached to a removable grid consisting of a close mesh of narrow clear holes on a yellow background. When exposed for reflex copying through the grid, the latter casts a sharp shadow through the non-scattering diazo material so that only the portions behind the clear holes are bleached. Light reflected from the white portions of the original is highly scattered, and bleaches the sensitive material protected by the grid. The differentiation thus becomes from clear white to near maximum density (Fig. 9). After exposure, the grid is stripped and the diazo film processed and used for subsequent copies. Although this material is relatively expensive, subsequent copies on diazo paper are cheap and dry processing in bright light favours the method for document copying where image permanence is not critically important.

Solvent Transfer Methods.—The principle of the solvent transfer method has been described in Chapter 19 (p. 138). In its application to document copying, the sensitive paper containing developing agents is exposed to give a laterally reversed image (for example, by reflex copying), and after wetting with an alkaline sulphite

solution, is squeegeed into contact with a receiving paper which contains hypo and a small concentration of finely divided silver. When the latter is separated, it bears a positive image of the original document. Fig. 10 shows a diagrammatic representation of a typical

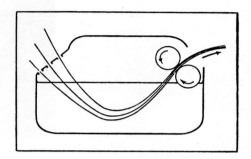

Fig. 10. Solvent transfer processing. Images are being simultaneously transferred to both sides of the central transfer paper.

developing machine. Images are being transferred to both sides of the central receiving paper. An advantage of the method is the ease of processing, as the copy is produced semi-dry, and requires no further treatment.

A modification of the method combines both negative and reception layers on the same paper support, the negative layer being subsequently removed by warm water washing.

Soft Gelatin Transfer Method.—A second modification of the normal silver process consists of a paper coated with an unhardened emulsion of high contrast, containing a tanning developer. After exposure by the reflex method, the paper is developed in an alkaline solution which also reacts with constituents in the emulsion layer to give a pigment. On squeegeeing the wet developed negative into contact with ordinary paper the unhardened (unexposed) pigmented portions of the gelatin layer partially adhere to the ordinary non-sensitised paper to give a laterally correct positive copy. Up to six such copies can be made from each negative. This process gives an immediate permanent semi-dry print on any available paper.

Direct Positive Papers.—Methods are known whereby emulsions can be made which yield a positive instead of a negative image on direct processing. A paper with this characteristic has recently found considerable application in the field of document copying. The emulsion used is completely fogged, and shows the Herschel effect (p. 206) to a marked degree. On development without exposure, it gives a uniform maximum density, but exposure to yellow light, or even

Fig. 11. 'Verifax' Signet Copier.

to tungsten light, destroys the latent image in the exposed portions and so gives a direct positive, instead of a negative image. The speed of the material is such that it can be handled in bright artificial light.

Light Sensitive Duplicating Skins.—The silver halide process has been applied to the rapid production of stencils which can be used for producing large numbers of inked copies by normal office duplicating techniques. An unhardened emulsion is coated on both sides of an unsized long fibre paper support. After exposure, the paper is developed in a tanning developer, and the unexposed part (original lines) washed out. Subsequent treatment renders the image capable of acting as a stencil in the normal way. Processing is simple and the material may be handled in artificial light.

Special Processing Techniques.—A recent improvement is the replacement of the fixation and washing processes by the single stage *stabilisation* process (p. 154). A stabilised image is less permanent than a properly fixed and washed one, but under normal filing conditions will remain unaltered for years, which is sufficiently permanent for most office needs. A stabilised image, moreover, may be rendered permanent at any time by applying normal fixation and washing. The main advantage of stabilising is not merely that two lengthy processes can be replaced by one rapid one, but that two very wet processes can be replaced by a semi-dry one. The application of stabilising has made it possible to devise methods whereby the paper is merely damped, so that the copy is immediately available without washing or drying.

As a guide to the intending reader books have been classified as (L) suitable for layman (S) for scientist and (T) for technician: they are also classified as dealing with (Pr) practice or (Th) theory.

GENERAL

The Focal Encyclopedia of Photography, 2 vols. (Focal Press, 1965). L; Th, Pr.

Fundamentals of Photographic Theory, 2nd ed. by T. H. James and G. C. Higgins, (Morgan and Morgan 1960). S; Th.

Gevaert Manual of Photography: a Practical Guide for Professionals and Advanced Amateurs, by A. H. S. Craeybeckx (Fountain Press, 5th ed. 1962). T; Pr.

History of Photography, by J. M. Ader, translated by Epstean (Columbia University Press, Oxford University Press, 1945). S.

The History of Photography, by H. & A. Gernsheim (Oxford University Press, 1955). L.

The Ilford Manual of Photography, (Ilford, 5th ed. 1958). T; Pr.

Photography: its Materials and Processes, by C. B. Neblette (Van Nostrand, 6th ed. 1962). S; Th, Pr.

Photography, Theory and Practice, being an English edition of *La Technique Photographique,* by L. P. Clerc (Pitman, 1954) . T; Pr, Th.

Photographic Chemistry, Vols. 1 & 2, by P. Glafkides, being an English edition of *La Chimie Photographique* (2nd ed.) translated by K. M. Hornsby (Fountain Press, 1958 and 1960), S; Th, Pr.

The Theory of the Photographic Process, 3rd ed. by C. E. K. Mees (Macmillan, 1965). S; Th.

Photographic theory: Liege Summer School, 1962 (Focal Press, 1963). S; Th.

OPTICS AND LENSES

Camera Lenses, by A. Lockett (Pitman & Greenwood, 5th ed. 1962). L; Pr.

Lenses in Photography, by R. Kingslake (Barnes, 1963). T; Th, Pr.

Photographic Optics, by A. Cox (Focal Press, 13th ed. 1966). L; Th, Pr.

Photographic Optics, by A. R. Greenleaf (Macmillan, 1950). S; Th.

Photographic Lenses, by C. B. Neblette (Fountain Press, 1965). L; Th, Pr.

CAMERAS

Camera Guides (Focal Press). L; Pr.

Cameras: the Facts; how they work, what they will do, how they compare, by W. D. Emanual and A. Matheson (Focal Press, 1959). L; Pr.

Newnes Complete Guide to the Miniature Camera, by T. L. J. Bentley (Newnes, 1963). L; Pr.

LIGHT SENSITIVE MATERIALS

Photographic Emulsion Technique, by T. T. Baker (Amer. Phot. Pub. Co., 2nd ed. 1948). T; Pr; Th.

Photographic Emulsions, by E. J. Wall (Chapman & Hall, 1929). T; Pr, Th.

Making & Coating Photographic Emulsions, by V. L. Zelkman & S. M. Levi (Focal Press, 1964). T; Pr, Th.

LATENT IMAGE AND PHOTOGRAPHIC EFFECTS

Exposure: the Fundamentals of Camera Technique, by W. F. Berg (Focal Press, 3rd ed. 1961). T; Th, Pr.

Exposure Manual, by J. F. Dunn (Fountain Press, 1958). T; Pr.

DEVELOPMENT, FIXATION AND AFTER-TREATMENT

Developing: the Negative-Technique, by C. I. Jacobson (Focal Press, 16th ed. 1966). T; Th, Pr.

Photographic Chemicals and Chemistry, by J. Southworth and T. L. J. Bentley (Pitman, 3rd ed. 1957). L; Th, Pr.

A Textbook of Photographic Chemistry, by D. H. O. John and G. T. J. Field (Chapman & Hall, 1963). T; Th, Pr.

SENSITOMETRY

Sensitometry: the Technique of Measuring Photographic Materials, by L. Lobel and M. Dubois, translated and adapted by E. F. Teal from the French ed. Manuel de Sensitometrie (Focal Press, 1955). T; Th, Pr.

Sensitometry in Practice, by K. M. Hornsby (Greenwood, 1957). L; Th, Pr.

General Sensitometry, by Yu. N. Govokhovskii and T. M. Levenberg (Focal Press, 1965). S; Th, Pr.

COLOUR SENSITIVITY AND FILTERS

Spectral studies of the Photographic Process, by Yu. N. Govokhovskii (Focal Press) 1965). S; Th.

Kodak Wratten Filters, 2nd ed. (Kodak, 1961). T; Th, Pr.

Filter practice, by H. Clauss & H. Meusel (Focal Press, 1964). L; Pr.

POSITIVE PROCESS

Complete Art of Printing & Enlarging, by O. R. Croy (Focal Press, 1962). L; Pr.

COLOUR PHOTOGRAPHY

History of Colour Photography, by J. S. Friedman (Amer. Phot. Pub. Co., 1944). T.

Manual of Colour Photography, by E. S. Bomback (Fountain Press, 1964). L. Pr, Th.

Principles of Colour Photography, by R. M. Evans, W. T. Hanson and W. L. Brewer (Chapman & Hall, 1953). S; Th.

The Reproduction of Colour, by R. W. G. Hunt (Fountain Press, 1957). T; Th, Pr.

APPLICATIONS OF PHOTOGRAPHY

Photography in Commerce & Industry, by A. F. Taylor (Fountain Press, 1962). L; Pr.

Longmore's Medical Photography, by P. Hansell & R. Ollerenshaw (Focal Press, 1962). T; Pr, Th.

Kodak Data Book of Applied Photography, 5 vols. (Kodak). T; Pr. Th.

DOCUMENT COPYING

Document Copying and Reproduction Processes, by H. R. Verry (Fountain Press, 1958). T; Pr.

Camera Copying and Reproduction, by O. R. Croy (Focal Press, 1964). L; Pr, Th.